A Pimpernel Garden Classic

This Book
Belongs to

Double
Flowers

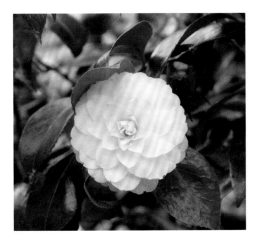

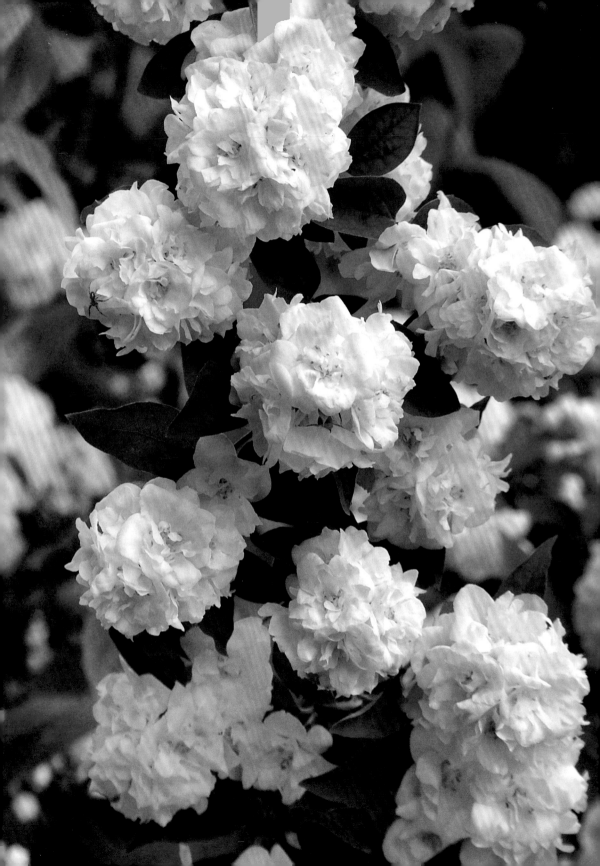

Double Flowers

The Remarkable Story of Extra-Petalled Blooms

NICOLA FERGUSON

WITH CHARLES QUEST-RITSON

PIMPERNEL
PRESS LTD
www.pimpernelpress.com

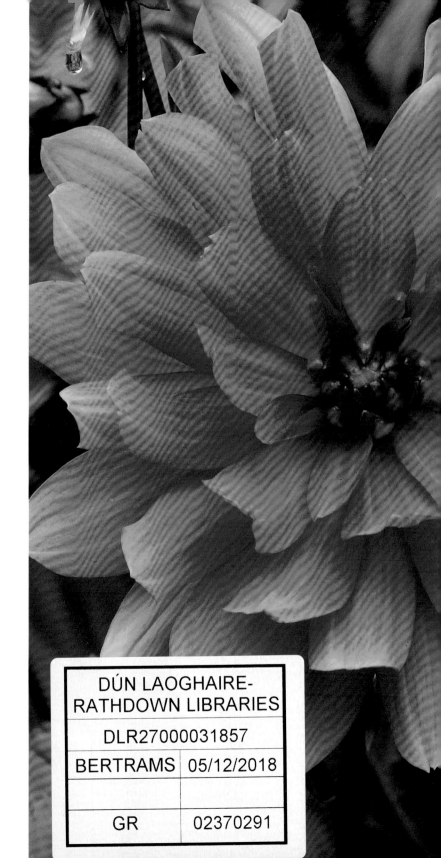

Pimpernel Press Limited
www.pimpernelpress.com

Double Flowers
The Remarkable Story of
Extra-Petalled Blooms
© Pimpernel Press Limited
2018
Text © James Ferguson 2018
Photographs © James
Ferguson 2018
Except as noted on page 296

A catalogue record for this
book is available from the
British Library.

Designed by Becky Clarke
Typeset in Miramar

ISBN 978-1-910258-88-0
Printed and bound in China
by C&C Offset Printing
Company Limited

9 8 7 6 5 4 3 2 1

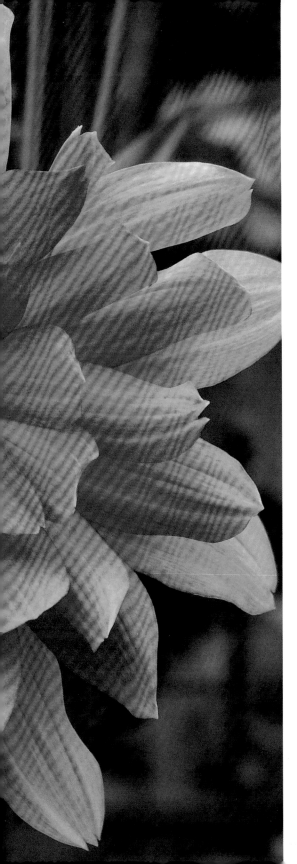

Contents

PAGE 1 *Camellia japonica* 'Twilight'
PAGE 2 *Philadelphus* 'Boule de Neige'
LEFT *Dahlia* 'Champagne'

Preface

This book has had a difficult birth: the author, my wife Nicky, died unexpectedly in 2007 and only half the manuscript had been completed by then. Nicky and Charles Quest-Ritson had known and respected each other for many years; when he heard about the state of the manuscript, he offered, very bravely, to finish the book and to select the photographs. He has done this with great skill. It could not have happened without him: the chapters to which he has contributed have been done very much in Nicky's style. I am extremely grateful to him for this and also for his support and his great attention to detail, with which Nicky would have been very pleased.

Nicky had considerable advice from the Royal Botanic Garden in Edinburgh and particularly from Henry Noltie and Toby Pennington, who vetted the botanical part of what she had written. This was much appreciated by her. Steve Blackmore, fomer Regius Keeper of the Botanics and Queen's Botanist, has also taken an interest in the book over the years.

This book would not have been produced without Lucy Perriam's dedication to the project and the enthusiasm of Pimpernel Press, who have produced such a stylish book.

James Ferguson
September 2016

Nicky in the garden

Foreword

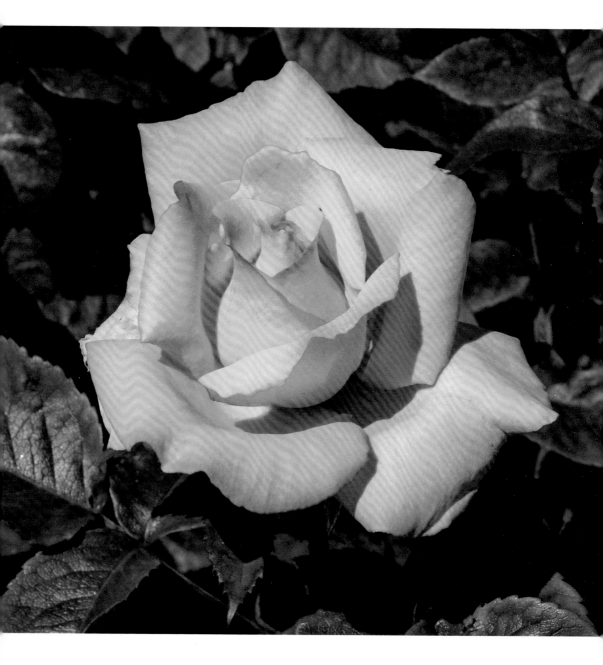

Nicola Ferguson's death at the early age of fifty-seven robbed the horticultural world of a writer of superb originality and intellect. She was neither a horticulturist nor a writer by background – Nicola was an academic psychologist – but her interest in plants and gardens was awakened in the early years of her marriage to James, when they bought a house in Heriot Row in Edinburgh. Their garden was small and shaded, and she hunted for a book that would tell her which garden plants could be relied upon to grow well and give good value in particular conditions. Nothing was available which addressed the problem, so she decided to write one herself.

The result was *Ferguson's Garden Plant Directory*, first published in 1984 but later reworked and extended as *Right Plant, Right Place*, in which she described and photographed 1,400 dependable plants, chosen for their performance in every possible garden situation. Then she cross-referenced them under such headings as Plants for Chalky Soils, Plants for Autumn Colour and Flowers for Cutting and Drying. Every page was imbued with her remarkable intelligence, acute observation, clear style of writing and an intensely practical focus. The formula answered a deeply felt need, appealing to experts and beginners alike. In its various editions, *Right Plant, Right Place* sold nearly half a million copies.

In 1998 she published *Take Two Plants*, which took the theme further. Its subtitle was *Over 400 Tried-and-Tested Plant Pairs for Every Garden Site* and it showed how plants might be successfully combined to set off each other's qualities and provide harmonies of colour, shape and form. Again, there was a strong practical emphasis: every combination was based on a pairing which she had seen and photographed, and she explained why it worked. Both books appealed alike to confused novice gardeners and experienced horticulturists in search of inspiration. Both are modern classics.

The blooms of *Rosa* Especially For You exemplify the classic shape of a Hybrid Tea rose.

And now we have her book about plants with double flowers, which was preceded, with characteristic diligence, by several years of thought, observation and research. The manuscript was well advanced when she died: four of its eight chapters had been

written in full, while the remaining four had been sketched out in considerable detail. Nicola begins with an historical survey of the emergence and development of plants with double flowers, and sets out the structure of the book. Her second chapter on 'The What, the How and the Why of Double Flowers' is by far the best summary yet to be published by way of an explanation for the phenomenon of doubling. Nicola's formidable intellect is wonderfully displayed in this masterly explanation of the scientific basis for the doubling of flowers.

After the two introductory chapters, there follow six further studies, each of which seeks to show how double flowers may change the character of a plant. Here Nicola shows herself to follow in the tradition of great horticultural essayists like E.A. Bowles and Christopher Lloyd. It was not how she first conceived the book: her original idea was to supply an A-Z list of double-flowered plants and to illustrate their uses with pictures, showing plant associations as well as individual flowers. But she was persuaded that the book would have a greater resonance if she made it discursive and comprehensive, carrying her prose style the whole way through.

Nicola grouped plants with double flowers under such chapter titles as 'The Romantic and the Ethereal', 'Companionable' and 'The Quaint and Charming'. These categories are subjective and do not reflect an accepted system of categorization, because no such system exists. The defining characteristics can take several forms: flowers may be romantic because their scent is suggestive in a particular way, or because of their historical associations or, more vaguely, just for cultural reasons that will differ from place to place. Furthermore, Nicola's system of categorization can equally be applied to single-flowered plants. Delicacy and grace are virtues more commonly found in single-flowered plants than among doubles. So too, almost by definition, is simplicity. She concluded that 'it is equally unreasonable to praise all double flowers', though formality, curiosity value and perhaps also beauty are more frequently – though not always – to be found in double-flowered plants

Nicola points out that doubles find favour with flower arrangers because they last longer than singles and are often more intensely coloured and substantial. The same is true of double-flowered plants in a garden, where their extra qualities make them especially useful in the compositions that increasingly engage garden-makers with an eye for artistry. When plants that normally bear single flowers exhibit the phenomenon of doubleness, the overall effect of their flowering

usually changes and is often magnified. The result of transforming stamens into petals is to give the flower a different shape and, usually, more substance and solidity, so that the complexity of the double flower contrasts favourably with the simplicity of the single. More petals do not always bring more elegance nor, even, more beauty, but they do intensify the flower power of the plant as a whole and thus increase its potential usefulness to gardeners and florists. And the shadows between their layers of petals create colour effects that alter our overall perception. Thus a double flower may be bold or formal while its single-flowered antecedent is best described as graceful, dainty or even modest. Double-flowered forms of *Ranunculus asiaticus* are the embodiment of flamboyance, but nothing could be as slender, dainty and ephemeral as its wild forms.

The double forms of *Ranunculus asiaticus* are sometimes known as the 'Turban' ranunculus. First bred in Ottoman Turkey, they are now popular in all Mediterranean-type climates. Their solidity stands in marked contrast to the apparent fragility of the single-flowered wild forms. This illustration comes from Louis van Houtte's *Flores des serres et des jardins de l'Europe*, vol. 16, t.1679 (1845).

It was typical of Nicola that she should tackle a subject that was completely unexplored by other writers and draw it together in a manner that was both scholarly and readable. An enormous amount of learning underpins this book. The observations that she articulated are not just original but also lucid, valid and valuable. Even the most expert of gardeners is made aware of how much more there is to be learned if one looks at plants and gardens from a different perspective. That is the measure of Nicola Ferguson's achievement, both with this title and in her earlier books. It is appropriate to consider what other masterpieces of observation and analysis she would have given us if she had been granted another twenty-five years to live.

Charles Quest-Ritson
September 2016

1 Introduction

Rosa 'Centifolia' is the best known of several multi-petalled roses developed in the Netherlands in the sixteenth century.

That outstandingly accomplished and observant plantsman E.A. Bowles used to leave the self-sown seedlings of his meadow cranesbill (*Geranium pratense*) until they flowered, in case, in 'a fresh miracle of metamorphosis', they produced some interesting semi-double and double offspring. All extra-petalled flowers, whether they occur spontaneously in the wild or are selected and bred by humans, are variants from the norm. As such, they are products of a fundamental, seemingly miraculous process of continual change which powers the wonderful diversity and variability of the natural world.

Variation is, of course, the foundation stone of Darwin's theory of natural selection. Particularly in the years immediately following the publication of *On the Origin of Species* in 1859, Darwin's radical ideas enthralled a wide range of people – including gardeners. A contributor to the horticultural periodical *Gardeners' Chronicle* in 1865 neatly summed up evolution from a gardener's point of view: 'To produce new varieties of plants . . . is the undeviating course of Nature.' The present book looks at some of the many thousands of double-flowered 'new varieties' produced before, during and after 1865.

The term 'double flower' is used, particularly by gardeners, horticulturists and flower arrangers, to cover a wide range of flower forms. However, what all these flower forms have in common is a greater than normal number of petals or petal-like structures. For most purposes, including the purposes of this introductory chapter, this shared characteristic of extra petals serves well enough as the defining feature of double flowers (but for more detailed definitions and descriptions, see the following chapter).

It seems probable that the very first floral mutation recorded in writing in the Western world was a double flower. In the third century BC, Theophrastus, the Greek philosopher and naturalist, noted in his observations of roses that 'some are even hundred petalled'. We know from Pliny the Elder's *Natural History* of AD 77 that, at that time, double roses were common in the Roman Empire. And we can see from the herbalist John Gerard's list of the plants growing in his own garden and from his *Herbal* (of 1596 and 1597 respectively) that, by the end of

the sixteenth century, there were numerous double-flowered plants in cultivation in Europe. Doubtless, there were flowers with extra petals long before these writers made their comments.

Just why human beings find double flowers interesting and worth recording is, in itself, interesting. Michael Pollan in *The Botany of Desire: A Plant's-Eye View of the World* (2001) has suggested that plants rely not only on animals and insects but also on humans in order to ensure their reproduction and dispersal. He proposes that humans instinctively find blossom attractive because it indicates where fruit will be found at a later season. If indeed we are drawn to petals, then perhaps we cannot help but notice flowers that are superabundant either in petals or in structures that look like petals. Perversely, however, these many-petalled blooms do not produce more than usually large quantities of fruit; rather the reverse. But, fortunately, flowers with extra petals are sufficiently rare in the wild to ensure that our hunter-gatherer forebears did not go hungry.

We may or may not be instinctively drawn to petals and, perhaps, to a superabundance of petals, but other aspects of human nature very probably play a part in our interest in double flowers. One important factor must be our propensity to categorize and systematize information, whether that information is postal addresses or library books or, indeed, plants. Interestingly, the process of categorizing and systematizing seems, in itself, to foster observant behaviour. The comparing and contrasting involved in categorizing any body of information makes details that, in the past, might have been overlooked suddenly appear conspicuous; it also throws anomalies and irregularities, such as extra petals, into relief.

It is much easier to compare and contrast and to spot oddities, including double flowers, when plants are conveniently to hand and seen nearly every day in the growing season. By the time substantial records of double flowers existed, in the sixteenth century, numerous plants had been brought into gardens either from the surrounding countryside or from further afield. Not surprisingly, many of the double flowers of early record were mutated forms of useful plants (and a remarkably wide range of plants was regarded as domestically or medicinally useful in sixteenth- and seventeenth-century Europe and North America). But some mutant plants will have been discovered in the wild and cultivated primarily for their aesthetic or curiosity value.

Achillea ptarmica 'Perry's White'. Sometimes the weight of extra petals proves too much for a plant. This is true of some double-flowered forms of yarrow. 'Perry's White', however, holds its flowers upright on stiff, stout stems.

Many double-flowered plants produce only a little viable seed; a few are sterile. If they arose in the wild, these plants would have to rely heavily upon vegetative propagation in order to survive. Some of them may be able to perpetuate themselves by, for instance, suckering (as many wild roses do) or having running roots (as *Achillea ptarmica*, or sneezewort, does) or producing rooting stems (the strawberry, *Fragaria vesca*, and the lesser periwinkle, *Vinca minor*, are equipped in this way). Other plants have swollen roots – bulbs, rhizomes and so forth – which increase in various vegetative ways. By so doing they give double-flowered variants of, for example, snowdrops, wood anemones and lesser celandines the chance to self-perpetuate. Especially if their roots grow only a few inches deep, these sorts of plants may be lucky enough to be aided in their multiplication by the pecking, scratching and digging of birds and other creatures.

All these plants have the wherewithal to sustain their mutant forms. Nevertheless, if a double-flowered wildling is brought into cultivation,

then its chances of survival beyond a season or two are greatly increased. Being a double-flowered plant in the wild is precarious enough; being a wild, double-flowered plant that is sterile or of limited fertility is especially perilous. But part of the appeal of double flowers is undoubtedly due to the recognition that these blooms' very existence is unpredictable and their perpetuation is hazardous.

EVEN BEFORE HYBRIDIZATION AND GENETICS were understood and humans could create new double flowers, the perpetuation and distribution of existing doubles was largely due to human intervention. Many early collectors and cultivators of plants were amateurs, but particularly as the Renaissance blossomed and botanical gardens were established, professional collectors became more common. The ordered, systematic nature of botanic gardens, then as now, created ideal conditions for noticing and conserving mutations. From the sixteenth century onwards, those in charge of botanic gardens corresponded with each other and with keen amateur plantsmen. They disseminated knowledge about plants of all sorts, including those with double flowers and, in exchanging specimens, they disseminated the plants themselves.

While the collecting of double-flowered plants by professional researchers and growers has always been important, amateur collectors have also played a very significant role. The activities of the so-called florists' societies, which were in existence from the sixteenth to nineteenth centuries in Britain, were especially important. In this context, the word 'florist' does not mean a seller of cut flowers or a professional arranger of plant material. Instead, it denotes an amateur enthusiast who developed and displayed new varieties of certain, specified categories of plants; the word had this older meaning for about three hundred years from its first recorded usage in 1623.

The exquisite creations of the florists were anything but wild and natural. Through the centuries, their immaculately patterned, impeccably shaped floral fabrications have celebrated 'nature controlled', as Sacheverell Sitwell, in *Old Fashioned Flowers* (1939), observed of their auriculas in particular. Noting that the florists' societies flourished in Puritan and also Victorian England, Sitwell set the florists and their activities in a wider context and asserted that 'it is certain that the strength of religious convictions makes for a determination to subdue nature'.

Florists were, above all, competitive growers and exhibitors, and the rules governing what was submitted for judging were strict and remarkably detailed. There were, eventually, eight approved categories of florists' flowers: tulips, carnations, pinks, auriculas, polyanthus, hyacinths, anemones and ranunculus. All these plants are naturally variable in form and colour and, therefore, fruitful sources of new varieties. Amongst these varieties there were numerous doubles including, for example, the highly prized double anemones and double auriculas of the seventeenth century, and the double pinks of the eighteenth and nineteenth centuries. At first, florists obtained new varieties by selection, but hybridization became more widely practised during the nineteenth century. The older florists' societies were probably at their zenith during the 1840s.

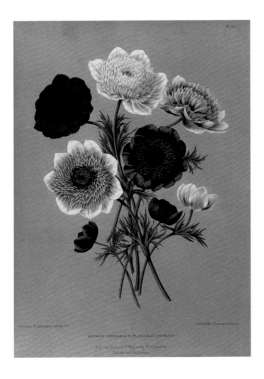

Double-flowered anemones (forms of *Anemone coronaria*) were popular among 'florists' from 1700 onwards. This illustration from A.C. van Eeden's *Flora of Harlem* dates from the 1870s.

We can see how, with a relatively small range of plants available, any variants of those plants would have a special appeal. When, from the mid-eighteenth century onwards, the range widened dramatically with the importation of all sorts of exotic plants from several continents, some older flowers and their varieties ceased to be so popular. Other factors played their part too. The most fashionable gardens of the eighteenth century, from about 1740 onwards, were sweeping, naturalistic landscapes designed by men such as William Kent and 'Capability' Brown; flowers played a relatively small part in these designs.

However, Mark Laird, in *The Flowering of the Landscape Garden* (1999), has demonstrated how eighteenth-century English gardens were much more flowery places than conventionally supposed. And old-fashioned herbaceous and bulbous plants, and their double-flowered varieties, will certainly have continued to be quietly appreciated in numerous, less ambitious 'pleasure grounds' and walled gardens.

The stream of new plants from several continents turned into a deluge at the beginning of the nineteenth century – a deluge that stimulated a widespread craving for horticultural novelty.

The production and supply of new varieties were accelerated by significant advances in science and technology, such as cheaper and more efficient glasshouses and improved techniques in hybridization. Many of the novelties were doubles: as the nineteenth century progressed, huge numbers of double-flowered varieties of such exotica as fuchsias, zinnias and dahlias became available; and, interestingly, the yearning for the new also stimulated the production of new varieties of some familiar flowers, such as carnations and hyacinths.

SCIENCE AND TECHNOLOGY ALSO PLAYED A PART in the nineteenth-century craze for collecting. From ferns to fossils and birds' eggs to butterflies, the natural world was plundered to satisfy a desire to accumulate and classify (and to do so really thoroughly). The plundering was facilitated by factors as diverse as the expansion of the railways, the publication of Darwin's *On the Origin of Species* and improvements in the design and production of microscopes.

Some collectors had a special interest in freaks and oddities – including double flowers. The first English-language work devoted to plant abnormalities appeared in 1817 and was entitled *Flora Anomala*. Although this is a relatively modest affair compared with some later productions, its author, Thomas Hopkirk, recognized – as Goethe did – that close examination of plant abnormalities and comparison of the abnormal and the normal 'might contribute greatly to the advancement of Physiological Botany'.

Probably the best-known work on plant abnormalities is *Vegetable Teratology* (from the Greek word *teras*, meaning a monster or marvel). Published in 1869 and a testament to Victorian thoroughness, this major compendium is the work of twenty years by its author, Maxwell T. Masters (who dismissed Hopkirk's *Flora Anomala* as 'a book now rarely met with, and withal very imperfect'). In *Vegetable Teratology* Masters gathers together numerous examples of 'exceptional formations' (including turnips with leaves growing within their root cavities, and branches of separate trees which had spontaneously grafted and grown as one). A whole chapter of his book is devoted to double flowers and a separate appendix lists the names of over three hundred double-flowered plants. Soon after the publication of *Vegetable Teratology*, the artist, illustrator and author Edward Lear published some 'nonsense botany'. This includes specimens of *Tigerlillia terribilis*, with appropriately arranged tigers in place of

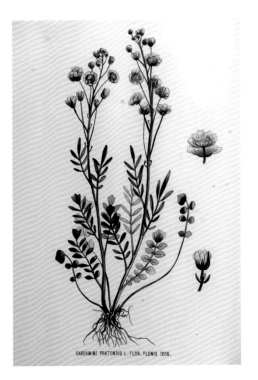

CARDAMINE PRATENSIS L. FLOR. PLENIS. 1206.

Double-flowered forms of *Cardamine pratensis* (lady's smock or cuckoo flower) are frequently found in damp meadows in Europe. Their thin stems impart a sense of delicacy that makes them acceptable in wild gardens. This illustration comes from *Flora Batava*, vol.16; t.1206 (1881).

petals, and *Tickia orologica*, the floral spike of which is made up of pocket watches. These whimsical creations look remarkably like parodies of Masters's 'exceptional formations'.

Keen interest in plant abnormalities continued for some time after the publication of *Vegetable Teratology*. Of the various collections of plant 'monstrosities' which were formed, the best known is probably that at Myddelton House (near Enfield, in what is now Greater London). Created by E.A. Bowles in the early years of the twentieth century, and referred to by him as the 'Lunatic Asylum', it contained double-flowered varieties of many plants (including strawberry, day lily and lesser celandine), as well as such curiosities as the corkscrew hazel (*Corylus avellana* 'Contorta'). After Bowles's death in 1954, and as a memorial to him, the Royal Horticultural Society devoted a part of its garden at Wisley in Surrey to plants associated with Bowles; still included in this site are many of the specimens of the Lunatic Asylum. (Incidentally, one of Bowles's presents on his sixth birthday was Edward Lear's book of 'nonsense botany'.)

Inevitably, there was a reaction against novelties and curiosities. As a reaction specifically against the craze for formal bedding, and the new, tender plants that bedding required, came William Robinson's plea for a more naturalistic, less short-term style of planting. His highly influential book *The Wild Garden* was first published in 1870. It might seem that a move towards naturalism must also have meant a move away from double flowers. However, the Robinsonian garden was not just trees and shrubs and native British plants. Robinson recognized that certain double flowers have a delicacy and informality about them but, at the same time, are sufficiently showy to make their mark in the garden. Amongst the double-flowered plants recommended in *The Wild Garden* are varieties of wallflower, daffodil, sneezewort (*Achillea ptarmica*), marsh marigold, lady's smock (*Cardamine pratensis*) and gorse or furze (*Ulex europaeus*).

It was not only Robinsonian ideas that dealt some plant novelties a blow. The latter half of the nineteenth century saw an enthusiasm for historical revivalism, one manifestation of which was the Arts and Crafts movement, with its emphasis on conservation and the pre-industrial vernacular. The Arts and Crafts movement did much to shape the thinking of perhaps the most influential of all garden designers – Gertrude Jekyll. Though she used a very wide palette of plants in her designs, her interest in old-fashioned flowers, and in the cottage gardens in which they were often found, certainly influenced her planting style. William Morris, leading light of the Arts and Crafts movement, but much less knowledgeable about plants than Jekyll, warned: 'be very shy of double flowers' (though, because they were ancient, the old double roses were acceptable doubles which Morris regarded as a 'gain to the world'). Jekyll, however, was not shy of double flowers. She recognized how the novelties of the nineteenth century had swept away very many older plants and she sought out, propagated and distributed antique plants, such as double primroses, double violets and double-flowered forms of sweet rocket.

NOSTALGIA FOR OLD GARDEN FLOWERS and the feeling that too many of these flowers have been lost are nothing new: the herbalist and plantsman John Parkinson was bemoaning the loss of old favourites in the seventeenth century. Today there is a flourishing conservation movement, much interest in heritage or heirloom plants (many of which have double flowers), and a ready market for new roses and new pinks, for example, that look like old roses and old pinks. A rather lavish, Jekyll-like interpretation of the cottage garden, along with many romantic, cottagey flowers, remains remarkably popular.

Just what kind of garden style is currently most popular at any one time obviously affects the popularity of double flowers, whether they have decorated gardens for centuries or have only recently been introduced. When naturalistic styles are fashionable, some double flowers fall from favour. But not everyone had the acres to create either sweeping, Capability-Brown landscapes in the eighteenth century or Robinsonian wild gardens of the following century. Some contemporary gardeners will feel that even the 'new naturalism' and prairie-style plantings of the twentieth- and twenty-first centuries do not suit their small, enclosed and often shaded plots.

After all, human intervention is an essential part of creating a garden; if a piece of land is completely natural, it is not a garden. Gardeners who acknowledge that gardens are essentially artificial also understand that plants which are variants are, in a way, particularly appropriate for inclusion. Deliberately selected, nurtured and perpetuated, the precarious future of many variants – and double-flowered variants especially – is often assured by humans. And humans, after all, are as much creatures of this earth as the other animals who assist in the propagation of plants.

John Parkinson's *Paradisi in sole, paradisus terrestris* (1629) has illustrations of many cultivated flowers. This portrait of eight different lychnis includes double-flowered forms of *L. coronaria* and *L. chalcedonica*.

In any case, as long as there are plants and gardens, there will be plant enthusiasts who will be unable to resist what Margery Fish in *A Flower for Every Day* (1965) called 'the charm of the unusual' and who will want to grow variations, rarities and oddities, including double flowers. Such is the variety of forms arising from the presence of extra petals – ranging from the meticulously formal, through the simple and relaxed, to the frankly zany – that all gardeners should be able to find double flowers which give them pleasure. To condemn all double flowers on the grounds of their appearance is irrational, but it is equally unreasonable to praise them all; additional petals can clearly mean a regrettable loss of delicacy and grace in some cases.

There are plenty of people who claim that they dislike all double flowers. However, these are often the self-same people who delight in growing, for example, nineteenth-century roses, or peonies from before the First World War, or old-fashioned pinks from goodness knows when. The vast majority of these plants have blooms that are crammed with petals. Yet, so esteemed and admired are they that their extra petals have long ago become an intrinsic part of their appeal; in their case, it is the forms with single flowers that tend to be regarded as unorthodox. One might even say that, as far as most people are concerned, 'a rose is a rose is a double rose', and plenty of plants were initially known to Western gardeners only in their double varieties (for example, *Kerria japonica* 'Pleniflora', *Prunus triloba* 'Multiplex' and many roses).

Some gardeners are even susceptible to altering their low opinion of certain double-flowered plants once they are informed that they have

been grown since Elizabethan times or were bred by eighteenth-century muslin weavers. Rarity and a high price can also colour judgement of how attractive certain double flowers are; the same flowers might not be half so alluring if they were widely available and cheap. And there are plenty of gardeners who 'as a rule' detest doubles but find themselves making quite a few exceptions to the rule. The plant hunter and rock-garden enthusiast Reginald Farrer, for example, in *My Rock Garden* in 1907, admitted that 'I am afraid I hate doubles but [*Anemone nemorosa* 'Flore Pleno'] is extremely charming, and so is a monstrosity called *bracteata*' – and these were not the only double flowers he liked.

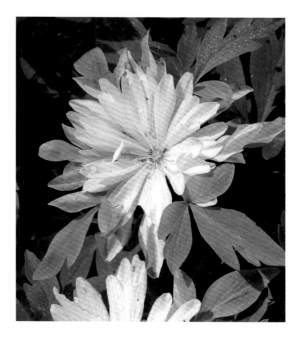

Anemone nemorosa 'Bracteata' is a double-flowered form of the European wood anemone; some of its extra 'petals' are green bracts and provide an attractive base for the flower.

Thirty years later and on the other side of the Atlantic, Louise Beebe Wilder was also beguiled by the double white wood anemone (and completely captivated by about a dozen double daffodils), even though she declared that 'one may not care for double flowers generally'.

In contrast, some gardeners remain remarkably open-minded about all sorts of plants, including those with double flowers; Gertrude Jekyll and Christopher Lloyd are outstanding examples. Jekyll's view of any plant usually depended heavily upon how it could be used in association with other plants as part of an overall planting scheme. She was, for example, happy to include various types of double-flowered marigold in her plantings because they produced the strong colours and the appropriate shapes and textures she sometimes required. Writing in 1908 about plants that had been central to Victorian bedding, she understood that it was 'not the fault of the plants that they were misused or employed in dull or even stupid ways'. Both she and Christopher Lloyd used double- as well as single-flowered plants in informal settings, recognizing that even meadows and informal areas near water need effective flowers. 'I believe that . . . we should shed our prejudices about doubling in general and judge each example individually,' wrote Christopher Lloyd in 1998; a typically independent and wise observation.

Being concerned mainly with species rather than varieties, botanists have tended, in the past especially, either to ignore doubles completely or to frown upon them as horticultural fripperies. When botanist and nurseryman William Curtis included some 'double or improved flowers' in the *Botanical Magazine* during 1793, it was claimed that every botanist 'must feel the degradation Mr Curtis submitted to . . . to give double flowers . . . knowing they are esteemed monsters by botanists.' More recently, however, plant scientists and geneticists have become interested in double flowers as sources of information about the developmental patterns of single flowers (see the following chapter).

ONE SET OF PEOPLE who do not normally need much persuading when it comes to seeing the good points of double flowers are flower arrangers. This applies particularly to those who practise Western styles of arrangement: many-petalled blooms are such an integral part of, for example, sixteenth- and seventeenth-century Dutch flower paintings that it is difficult to imagine them with single rather than double roses, anemones, carnations, and so forth.

First and foremost, perhaps, flower arrangers value doubles because they make longer-lasting cut flowers than singles. Many double flowers have a limited ability to set seed and they postpone dropping their petals. The petals also tend to unfold more slowly, especially if they are tightly packed, and then, having lasted longer than normal, to fall en masse when they have all faded, rather than dropping one by one. Double flowers that are male-sterile are also pollen-free and, therefore, particularly suitable for the bouquets of brides with allergies and pure white dresses.

Flower arrangers also appreciate the way many doubles look more substantial than singles (and they are sometimes actually larger). This is an important consideration. Flowers in containers are rather like actors on stage: both need certain features heightened if, in their own particular rather artificial settings, they are not to lack visual impact. Double flowers are especially useful to flower arrangers when it comes to creating impressions of lavish generosity, impressive formality or spectacular theatricality. In addition, the blooms of double-flowered varieties are often more intensely coloured and more fragrant than their single counterparts: compared with single roses, many-petalled roses are generally much more popular and their

extra-powerful scent must be an important factor. The tendency of double flowers to begin flowering later than singles is sometimes useful too. As a bonus, double flowers often air-dry more successfully than singles since the extra petals prevent their blooms from drooping out of shape.

MANY OF THE ADVANTAGES of double flowers for flower arranging are advantages for garden use too. Gardeners like the way doubles last well. They appreciate how they flower over a longer period than singles and how they produce individual blooms that open more slowly, thereby prolonging the display. In the garden, as in indoor arrangements, the greater visual impact of doubles is often very valuable indeed. Possibly even more advantageous to horticulture than to the cut flower trade is the tendency for double-flowered varieties to bloom later than their single-flowered counterparts, and thereby to extend the flowering season of a species or genus.

The limited fertility of many doubles has its advantages in the garden too. Few double-flowered plants are the self-sowing nuisance that some singles can be. The various double-flowered varieties of meadow cranesbill (*Geranium pratense*), for example, are charming non-proliferators, and certain double-flowered trees – such as the horse chestnut *Aesculus hippocastanum* 'Baumannii' – are useful for street planting not only because their flowers are showy, but also because they produce neither messy fruits nor troublesome seedlings. Limited fertility also means that double-flowered plants bloom reliably from year to year, in contrast to certain single-flowered plants which tend to flower poorly in the years following good crops of fruit.

There are drawbacks to doubles, of course, though some of these are perceived rather than actual disadvantages. It seems to be a commonly held belief that all double flowers are completely sterile and therefore of no use to wildlife. This belief persists even though there are numerous double-flowered plants in seed catalogues (indeed, a sizeable number of doubles will come true from self-sown seed). Completely sterile double flowers are rare; doubles that are at least partially fertile are much more usual. Very commonly, doubleness and fertility vary over the flowering season, with late-season blooms tending to be pollen-producing semi-doubles or even singles.

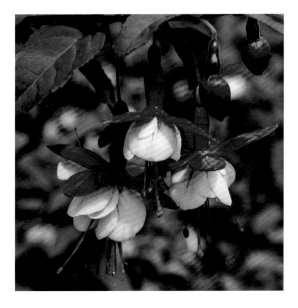

Fuchsia 'Snowcap'. Fuchsia flowers are protected by their sepals and their pendulous habit. Double-flowered fuchsias are quite unaffected by heavy rainfall.

Nevertheless, a wildlife-friendly garden should not be stocked entirely with double-flowered plants. However, there is one group of plants that produces varieties with extra petals and, at the same time, plenty of pollen and nectar. This is the *Compositae* or daisy family. Many botanists do not consider doubles of this horticulturally important family to be true doubles, but gardeners certainly do.

Another myth is that all double flowers are unnatural and man-made. Though many doubles are the result of deliberate breeding, others have arisen as chance mutations in gardens, and numerous doubles have been and continue to be discovered in the wild. Breeding certainly has resulted in some flowers having so many extra petals that various problems arise. A superabundance of petals has produced peonies and daffodils, for example, with flowers that are too heavy for their stems; it has also produced blooms, including those of some hibiscus and tulips, which are prone to waterlogging and subsequent rotting; and it has created roses, for example, crammed with so many petals that they are folded within the flower and are, at least in some gardeners' eyes, simply misshapen. Unlike their single counterparts, some double flowers, *japonica* camellias included, hold on to their faded petals rather than dropping them. This is particularly unsightly when a plant produces flowers in succession and old, brown, faded blooms detract from later, newly opened flowers.

These sorts of drawbacks present practical problems for the grower in the form of staking, dead-heading and so forth. In areas of high rainfall, the particular problem of waterlogging is best dealt with by avoiding those doubles that are liable to become saturated and choosing instead plants with, for instance, relatively few extra petals, or with pendent and therefore more or less 'self-draining' double flowers (such as fuchsias, most snowdrops, and certain cherries and columbines). In garden soils of low fertility, disappointing performance may be the main problem since some double-flowered

varieties require a rather richer soil and more careful cultivation than their single-flowered equivalents. In really poor growing conditions, a few double-flowered varieties – in a desperate attempt to survive and to perpetuate their genes – may produce fewer petals and more numerous fertile parts.

All these drawbacks will be cheerfully disregarded by those who cannot resist sumptuous but heavy-headed peonies or romantic roses even if they all too easily turn soggy and brown in wet summers. In the same way, all the advantages of double flowers will be ignored by those who are determined to grow only the simplest and most natural-looking flowers.

Most people's attitude to double flowers is probably somewhere in between these two extremes: they will find many doubles delightful, but there will be some that they find rather disconcerting; others they will find interesting. These plants may lack poise and elegance, but they can intrigue and surprise, and this can give as much enjoyment as contemplating beauty. Double-flowered plants are variants, and variants have long held a special appeal for all those who are interested in the details of plants. In particular, they appeal to collectors – who may or may not be concerned with the beauty of a flower.

Today's collector of doubles might, like a seventeenth-century florist, concentrate on only one kind of flower: auriculas, violets or primroses, for example, of which there are antique as well as modern doubles. Or they might be interested in double-flowered varieties of daffodils, lilacs and other plants which have been worked upon only relatively recently by breeders. Some collectors might enjoy creating a collection of oddities, as E.A. Bowles did; others will search out rarities. And some collectors will particularly enjoy developing new varieties, thereby ensuring that their collection is always comprehensive but enticingly not quite complete.

A gardener's outlook on double-flowered plants will be rather different from that of a collector or, indeed, a flower arranger. How a single bloom appears when viewed at close quarters will nearly always be of lesser importance to gardeners than the overall impression the whole plant makes when grown with other plants. Or it should be. The irresistible intricacies of many double flowers lure many a gardener into forgetting the bigger picture.

Rosa Bonica 82. Double-flowered roses have become so universal that today we expect even our landscaping roses to be double-flowered.

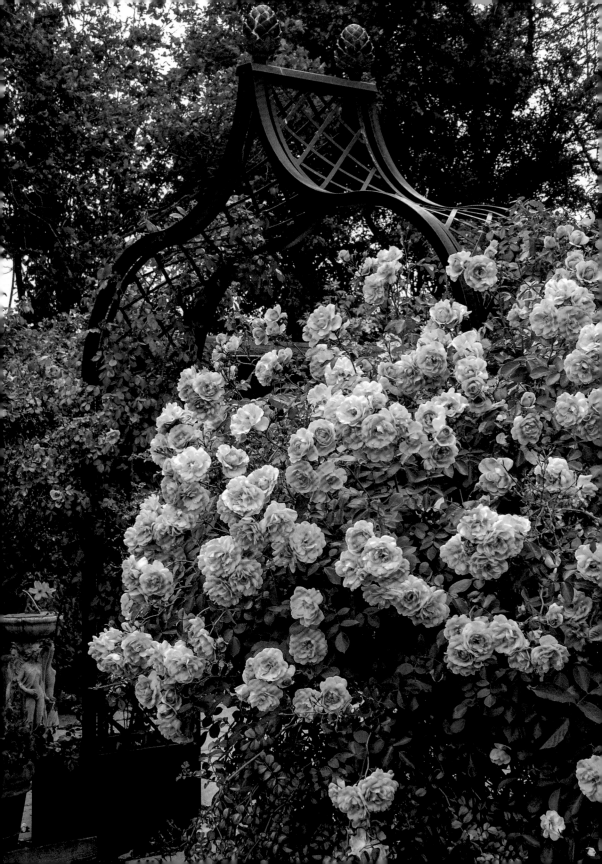

By concentrating on the details of individual blooms, it is all too easy to misjudge some aspects of doubles. They can, as a class, seem rather formal. At close range, the petals of a Pompon dahlia, for example, may be arranged in a very precise and symmetrical manner. However, at a distance, these same flowers may simply appear rather denser than usual; and, importantly, the plant's habit of growth may be quite informal so that, overall, the effect is far from formal. In any case, many double blooms are thoroughly relaxed in appearance. These relaxed flowers often have relatively few extra petals in an asymmetrical arrangement and this can produce anything from an amusingly idiosyncratic to an innocent and artless effect.

So, gardeners should assess each double-flowered plant – and not just its inflorescence – as a whole and on its own merits. Because doubles come in such variety, it is nearly impossible to draw up a list of garden- and flower-arranging dos-and-don'ts for using plants with extra petals. A stiff, formal plant, densely covered in big, solid, uniformly petalled flowers of a searing violet, is not going to create anything like the same effect as something that moves softly in the breeze and is scattered with buoyant-looking little flowers of palest yellow. Exactly how each plant looks is the result of a complex interaction of many factors including habit of growth, the colour, size, texture and specific form of the flowers and leaves and the patterns they create. How they are arranged in a garden, or indoors, also affects their appearance: quite informal plants can be made to appear surprisingly formal if they are marshalled into regular, geometric patterns and, conversely, some formal plants can look almost casual in naturalistic settings. There are also many other, less tangible elements which might play a part when choosing double flowers. Certain historical associations or, at the other end of the time scale, currently fashionable garden styles, for example, can mean a particular double-flowered plant is either admired or derided.

DESPITE THE WIDE VARIATION in double-flowered plants, there are one or two very general points that are worth bearing in mind when using these plants in the garden (and in indoor arrangements, too). First of all, flowers with extra petals tend, of course, to be more conspicuous than their single-flowered equivalents. This has many advantages. The complexity and extra visual 'weight' of doubles makes them well suited to all sorts of plantings where a certain

Rosa **The Pilgrim**. The individual flowers are complex and formal, but their cumulative effect is quite relaxed.

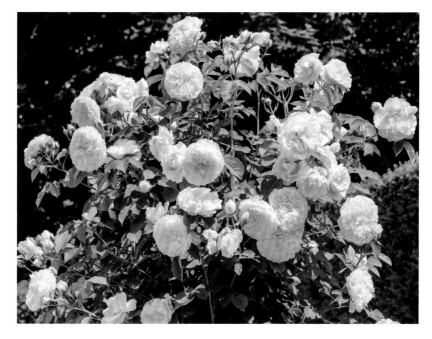

amount of impact is necessary. The added visual weight of double-flowered street trees, for example, enables them to hold their own against the inert mass and solidity of buildings and road surfaces. The complexity also ensures that blooms of rich, fully saturated colours do not 'disappear' in the garden scene. If a flower of a really deep maroon, for instance, has extra petals, the complexity created by these petals ensures that the flower is 'full of exquisite shadows' (as the American gardening writer Celia Thaxter wrote of a double poppy, in *An Island Garden*, 1894). And, whatever the colouring, differences in light and shade catch the eye.

However, because of their added impact, doubles can sometimes unbalance a planting scheme. Adding yet more doubles is not always the answer, although there are double-flowered plants which might best be described as flattering companions rather than scene-stealers (see chapter 7); these showy-but-not-too-showy plants can be very useful partners for the more dominating kinds of doubles. Other solutions include adding other plants which are striking, not because of their flowers, but perhaps because they have boldly shaped foliage or an unusual outline. Quite modest plants can be used too, but in larger-than-normal quantities. All these strategies strengthen the 'fabric' of the planting so that it is not completely eclipsed by any multi-petalled prima donna.

Because the most floriferous double-flowered plants are so eye-catching, they make dramatic focal points. It is an advantage, clearly, that doubles last longer than singles but they are, nevertheless, ephemeral and some thought has to be given to what happens once their show-stopping blooms have faded. In some garden situations, a plant which produces double flowers and also forms a shapely mass of evergreen leaves is able to provide year-round interest or, at least, a permanent backdrop for other plants. In addition, there are, for instance, double-flowered plants that have colourful autumn foliage and, contrary to accepted wisdom, not only do some doubles produce interesting seed heads or – like hydrangeas – 'dead heads', but there are even some plants which have double flowers and variegated foliage too.

A second, general point to be kept in mind about double-flowered plants is that, though not all of them are formal, some undoubtedly are. These plants are especially useful where a sophisticated effect is wanted or where a strictly regimented pattern needs to be created; naturalistic sweeps of soft simplicity are not appropriate in all situations. Gardeners and flower arrangers with plenty of experience are often able to combine the formal and the informal successfully, sometimes with really interesting results. For most people, however, it is not an easy trick to pull off, and in ineptly handled mixes of formal and informal plants, there is always the risk that the informal plants will look scrawny and the formal plants will look heavy and unrefined.

One floral feature which can affect the impression of formality is the presence or absence of an 'eye'. Eyes are often created by stamens and other sexual organs, or tiny, tightly packed disc florets. Extra-petalled flowers with visible eyes are often referred to as semi-doubles, and they tend to emanate a certain uncomplicated charm, whereas fuller doubles – with numerous petals and no visible eyes – can have a more formal quality about them. When a fairly relaxed effect is wanted in a planting scheme, semi-doubles are worth considering: their extra petals give emphasis, while their eyes lend an air of informality.

The wealth of different flower forms and plant types among doubles should satisfy anyone with an open mind and an interest in plants. Some of the most loved and admired doubles have been known to win over even the sternest of horticultural hearts. Many a strict-minded gardener has found him- or herself being charmed by old-

fashioned double primroses and double buttercups; or overawed by the enormous, princely blooms of double-flowered tree peonies; or captivated by the sheer oddity of roses and strawberries with many-petalled green flowers. From the quaint and the charming, through the formal and the elegant, to the rare and the peculiar (fluid categories that overlap, of course), the following chapters encompass double flowers of remarkable beauty and intriguing bizarreness.

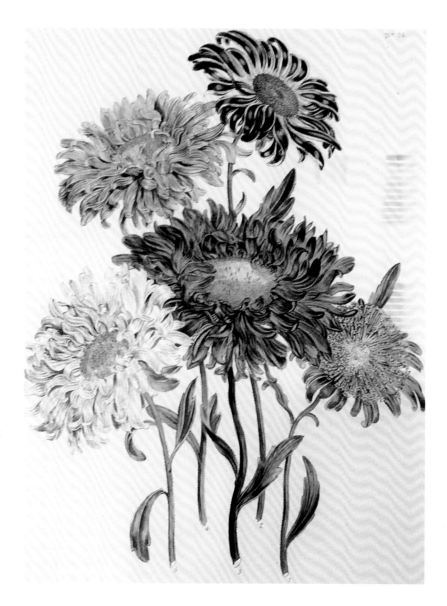

China asters – cultivated forms of the annual *Callistephus chinensis* – are often double when they first flower but tend to produce fewer petals as the season progresses. This early illustration comes from Mrs (Jane) Loudon's *The Ladies' Flower-garden of Ornamental Annuals* (1843).

2 The What, the How and the Why of Double Flowers

DOUBLE FLOWERS, WHICH ARE THE PRODUCT OF GENETIC VARIABILITY, ARE IN THEMSELVES VARIABLE. COMBINE THIS INHERENT VARIABILITY WITH THE WIDE RANGE OF PEOPLE WHO ARE INTERESTED IN DOUBLES AND IT IS HARDLY SURPRISING THAT DEFINITIONS OF DOUBLE FLOWERS VARY TOO.

ABOVE
The sepals of this hose-in-hose polyanthus are part petaloid and part leafy, but the flower itself is single.

LEFT
Double-flowered herbaceous peonies are popular garden plants.

Double flowers are of interest – and some considerable importance – to botanists, biochemists and geneticists, for example, as well as to gardeners and horticulturists, flower arrangers and florists, and garden historians.

A very loose and general definition – 'double flowers have more petals or petal-like structures than normal' – is suitable for most, everyday purposes ('normal' here refers to the flowers of species in their wild state). This is a thoroughly serviceable definition when it is only the overall visual appearance of double flowers that matters and the identity and origins of the various structures of these flowers are not relevant.

A more elaborate and detailed version of this definition draws distinctions between fully double, double and semi-double flowers. The 1992 edition of the RHS *Shorter Dictionary of Gardening* states, first of all, that the terms 'double' and 'semi-double' both denote 'any flower with many more than the basic number of petals, sepals, florets or coloured bracts'. However, it goes on to distinguish fully double blooms, which 'have densely packed rounded heads in which stamens are totally obscured or absent', and which are 'usually sterile', from semi-double blooms which 'have two or three times the basic number of petals, sepals or florets, arranged in several rows with stamens conspicuous'. The Royal Horticultural Society also defines two very distinctive kinds of doubling: 'hose-in-hose' and 'anemone-centred'. Hose-in-hose is 'a form of doubling in tubular flowers where one perfect [whorl of petals] develops within another; frequently found in primulas and rhododendrons' (see chapters 5 and 8 for examples of these flowers). Anemone-centred is a term applied to flowers such as chrysanthemums and dahlias, where the florets of the inner disc 'are enlarged to form a kind of cushion, sometimes of a

contrasting colour to the [outer, strap-shaped] florets'; it is also applied to the flowers of peonies and camellias when they exhibit a similar floral arrangement.

By and large, however, the practical and commercial branches of the horticultural world do not spend much time drawing fine distinctions between different kinds of doubles, and the terms 'fully double', 'double' and 'semi-double' are all used fairly loosely (and often interchangeably). For example, California poppies (*Eschscholtzia californica*) which have only one row of extra petals will often be called double, but so too will roses with many extra rows of petals; at the same time, some camellias with more than two extra rows of petals will be referred to as semi-double. Inconsistent though this is, it reflects a pragmatic and flexible approach to the matter of doubleness. It takes account of the fact that some plants produce so-called double flowers in which there are only ever a few extra petals, while other plants routinely produce doubles with dozens, or even hundreds, of extra petals. If a rose is described as double, we are not surprised if it turns out to be a lavish confection with many extra petals, but we assume that a double-flowered California poppy will be quite a simple affair with relatively few extra petals. The term 'double', therefore, alters in meaning depending upon which plants are under consideration and, in any case, it is used to refer a wide range of floral forms.

Matters are more consistent in those genera – *Rosa*, *Camellia* and *Paeonia*, for example – where plant breeders and selectors have been busy, often for centuries, and their labours have resulted in very large numbers of varieties. Amongst roses, the terms semi-double, double and fully double denote 8–20 petals, 20 petals or more, and over 30 petals, respectively. Extra-petalled camellias and peonies are divided into several different categories (in North America, up to seven categories for peonies) which are based principally on the presence or absence of sexual organs. However, in practice, it is really only breeders, keen collectors and growers, and exhibitors who apply these categories and definitions consistently and systematically.

At this point, it might be useful to say what double flowers are *not*. First of all and most importantly, they are not one-off freaks, caused by, for instance, some short-term damage to the embryo bud of a plant. Damaged crocus bulbs, for example, have been known to produce flowers with extra petals but these 'double-flowered' plants soon revert to producing only single blooms. True double flowers are, in contrast, inherited abnormalities that are permanent

– though the double flowers of individual plants are often rather variable in appearance. Second, the term 'double flower' does not apply to a bloom in which each petal (or a 'cup' within, say, a daffodil flower) is fringed or deeply cut but the number of petals is normal. Although a busier, fuller effect is produced, these flowers are not doubles. Third, some tulips and daffodils, for example, produce two or more flowers on each stem. These plants are sometimes referred to as 'bunch-flowered' or 'multi-headed', but – though common sense might decree otherwise – they are not necessarily double-flowered (though see page 216 for a bunch-flowered daffodil that has double flowers). Finally, there are unusual cases where either a flower bud grows out of the centre of a 'parent' flower, or several smaller flowers, each with their own stalk, emerge from beneath the 'parent' flower. These abnormalities are referred to as proliferous flowers. They are not generally regarded as double flowers (but, for some examples, see chapter 8).

As far as botanists are concerned, daisy-shaped flowers with extra petals are not true doubles either. However, this is not an opinion shared by horticulturists and gardeners. What to a gardener is a

Bellis perennis 'Habanera Rose' appears to have double flowers, but botanists maintain that it just has more ray florets than ordinary daisies.

daisy-shaped *flower* (whether it is single or double) is to a botanist a daisy-shaped *flower head*. This is because, botanically, a 'daisy' is made up of many individual flowers or florets: the inner disc consists of numerous, tiny, tubular flowers (each called a disc floret) and the outer ring of usually strap-shaped 'petals' is also composed of separate flowers (each called a ray floret). In what gardeners call double 'daisy' flowers, some or all of the disc florets have mutated into ray florets. While botanists see this change in terms of an alteration in the proportion of disc and ray florets, gardeners take it at face value, as it were, and view it as an increase in the number of petals. Of course, both parties are right from their own particular standpoint, but in this book daisies with extra ray florets will be considered full members of the double-flowered club. However, in order to begin to understand how the floral structures of double flowers are arranged and how they might have originated, then something more like a botanist's attitude to doubles of all sorts is what is needed.

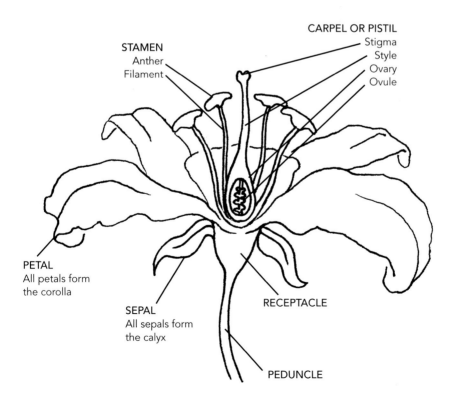

CARPEL OR PISTIL
Stigma
Style
Ovary
Ovule

STAMEN
Anther
Filament

PETAL
All petals form
the corolla

SEPAL
All sepals form
the calyx

RECEPTACLE

PEDUNCLE

To go exploring, as botanists do, among stigmas and stamens, and corollas and calyces, it may be helpful to have a simple, generalized map of the territory. The diagram opposite shows a stylized flower that has both male and female parts.

Looking in more detail at how double flowers are constructed underlines their remarkable diversity. Almost any part of a typical flower can mutate and end up looking like a petal. Starting from the outermost layer of the flower shown opposite, the protective, leafy and usually green calyx is sometimes replaced by structures that are shaped and coloured just like petals. This is what has happened in the majority of hose-in-hose flowers where, as in the case of some campanulas and primulas, for example (see chapter 8), one flower appears to grow out of another. Sometimes this extra flower may be repeated, so that several flowers seem to grow out of each other.

In the typical flower, the next whorl of structures consists of petals and another type of doubling arises when the normal number of petals is augmented by extra petals. In this particular kind of doubling, seen in begonias and violas, for instance, there is little or no alteration in the number of other structures, such as sepals or stamens.

The commonest form of doubling, to be seen in many different plants, takes place when the next whorl of structures in the typical flower – the stamens or male parts – are converted into what appear to be petals. These transformed structures are often referred to as petaloid stamens (if they are sterile, they are usually rather slender and they are called staminodes). Frequently, there is some degree of splitting in these structures and this heightens the impression of fullness. In some cases, not only the stamens but also the pistil – the innermost, female floral structure – may be converted into petal-like structures. Lastly, there is the special case, discussed above, of composite or daisy-like flower heads which gardeners regard as double, but which botanists either ignore or sometimes refer to as pseudo-doubles.

All of these different types of double flower can be variable, not only in terms of size, colour and so forth, but also in terms of the number of extra structures produced. Indeed, it is a feature of double-flowered plants that the number of petal-like structures varies greatly – between plants of different genera, between different double-flowered varieties of a single species, between individual specimens of a

particular variety, and even between the individual, double flowers of a single specimen. (Any attempt to make the number of floral parts of double flowers fit neatly into some mathematical scheme, such as the Fibonacci sequence, soon founders among the remarkable diversity and variability of these flowers.) In contrast, the number of petals or petal-like structures in any particular species or single-flowered variety varies very little indeed.

Double flowers can even vary according to whether they show one or more kinds of doubling in a single bloom. The flowers of some peonies, for example, have an additional row or two of petals and also an intricate central mass of slender, modified stamens; and certain campanulas develop petaloid stamens as well as hose-in-hose arrangements of enlarged, petal-like sepals. There are even some doubles in which the normal sequence of floral parts is disrupted: some daffodils, including 'White Lion', have multiple petals in the normal position outside the 'cup' of the flower *and* between the cup and the stamens (which in this variety are petaloid); and *Rosa chinensis* 'Viridiflora' is one of several plants with flowers which are made up entirely of sepal-like, leafy structures.

IN ALMOST EVERY RESPECT, in fact, double flowers are variable. But perhaps most significantly, they vary in terms of fertility. Indeed, some of the multi-category classificatory systems which nineteenth- and twentieth-century botanists devised for double flowers were based on differences in fertility. In late-nineteenth-century post-Darwinian Britain especially, these differences were linked to the evolutionary 'distance' of various double-flowered plants from each other and to notions such as 'reversions to the ancestral form'.

The commonest type of doubling, where the stamens of a flower are replaced by petal-like structures, shows a particularly wide range of variations. And since stamens are involved, these variations are, of course, connected with variations in fertility. It is not, however, a straightforward case of single flowers having perfect, fertile stamens and double flowers having all their stamens replaced by true, sterile petals. Some double flowers do indeed have all their stamens converted into petal-like structures, but the majority of doubles exhibit a mixture of modified stamens that look like petals alongside normal stamens.

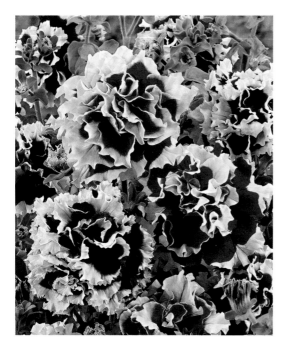

Most double petunias produce viable pollen.

To complicate matters further, a whole range of forms intermediate between perfect stamens and true petals are found in double flowers. These transitional forms can be seen clearly even within the flowers of a single specimen of a plant and often within a single bloom. In double-flowered varieties of evergreen azalea, for example, the pollen-bearing anther of a stamen may disappear completely when that stamen is converted into a petal-like structure. But often the anther remains and is present on the surface of the 'petal'. Sometimes, the filament as well as the anther is present in the new 'petal', forming either a thickened edge or a central ridge. These petaloid stamens are, clearly, neither true petals nor perfect stamens but stamens masquerading as petals – though the disguise is not always complete.

Structures somewhere between petals and stamens have been observed in numerous other double-flowered plants too, including roses, petunias, columbines and daffodils. The extra petals of, for instance, the double daffodil *Narcissus* 'Cheerfulness' nearly all contain pollen-producing areas, though in varying proportions. Swellings containing pollen are also present in the extra petals of double columbines (*Aquilegia vulgaris* var. *flore-pleno*) and petunia hybrids with double flowers. When tested, a surprisingly high proportion (70 per cent) of the pollen within the swellings of the petunia 'petals' was found to be viable and therefore capable of initiating successful fertilization. Indeed, not only did most of the pollen in these swellings ripen normally but it was also shed normally.

But pollen is not always buried away in flowers with extra petals and, except in the very fullest doubles, complete sterility is rare. The majority of doubles have both sets of reproductive organs present, and many doubles are capable not only of setting seed but also of coming true from seed. There is, however, wide variation here too. Some fully double daffodils – 'White Lion' and

'Cheerfulness', for instance – produce abundant seed, while others, such as 'Swansdown', are sterile. Even among individual plants of double-flowered Welsh poppies (*Meconopsis cambrica*), there are some flowers with no ovary and no pollen, while other specimens have either stamens or ovaries which are at least partially functional. It is quite common for organs of only one sex to be affected when doubling takes place: the double petunias mentioned above produced plenty of good pollen but few of these flowers had normal female parts; the male organs of double-flowered sweet williams (*Dianthus barbatus*), on the other hand, are often sterile but the ovaries are more or less completely unaffected.

However, as long as one set of sexual organs functions normally, plant breeders can often work on double-flowered varieties. The common double snowdrop (*Galanthus nivalis* f. *pleniflorus* 'Flore Pleno'), for example, is a parent of many of the newer varieties of double snowdrop. It is female-sterile and therefore cannot set seed, but it does produce pollen and this can be used to fertilize the female parts of such species as *G. plicatus*. Unfortunately, the presence of stamens and pistils does not always mean that flowers are fully fertile: some double-flowered ornamental cherries, for instance, have both male and female floral parts but the pollen and egg cells they contain do not develop completely.

Breeders and propagators also take advantage of the fact that there is wide variation in the extra-petalled blooms of some plants. As mentioned above, even a single plant of 'double' Welsh poppy can vary in terms of just how double (and therefore how fertile) all its flowers are. It has also been noted – in 'double' hollyhocks (*Alcea rosea*), for example – that single, semi-double and fully double flowers can all appear on one stem. (As long ago as 1730, that most elegant of early plant catalogues *Twelve Months of Flowers* listed a hollyhock which claimed to be 'always double'.) Commonly, doubleness varies over the growing season too. Early-season doubles followed by late-season semi-doubles or singles is the standard pattern in the older double clematis, for example, but it is also a feature of other double-flowered plants such as China asters (*Callistephus chinensis*), certain strains of hellebore (*Helleborus*), and the double-flowered strawberry (*Fragaria vesca* 'Multiplex') – the later, semi-double blooms of which ripen into red fruits. In some plants, including varieties of tree peonies (*Paeonia suffruticosa*) and marigolds (*Calendula officinalis*), the terminal or 'crown' flower

Clematis 'Vyvyan Pennell' shows varying degrees of doubleness in its first flowering, but produces only single flowers later in the year.

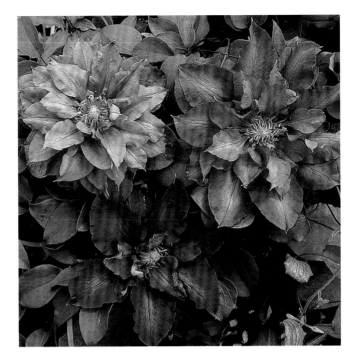

matures first and is double, while the lateral flowers develop slightly later and are semi-double and of greater fertility.

All these variations make the older classificatory systems for double-flowered plants, based as they were on fertility, of rather limited use. But variations in fertility do provide useful opportunities for propagating doubles from seed and for creating new double-flowered varieties. Of course, traditional methods of vegetative propagation and the more modern method of micropropagation by tissue culture allow even sterile doubles to be reproduced. But not all plants are suitable candidates for either of these means of increase, and in many instances seed has advantages such as cheapness.

So, VERY BROADLY SPEAKING, and at least to some extent, degrees of doubling are usually correlated with variations in the amounts of pollen and seed produced. In nectar-secreting plants, degrees of doubling can also affect the amounts of nectar produced. Here too, however, the picture is not straightforward. The double flowers of some plants, including soapwort (*Saponaria officinalis*) and petunias,

secrete little or no nectar. But other doubles appear to produce nectar in large quantities. Bees have been recorded repeatedly visiting the flowers of double columbines (*Aquilegia vulgaris* var. *flore-pleno*) and it has been noted that these flowers set seed in quantities comparable to the quantities of seed set by their single-flowered counterparts. They are, therefore, examples of doubles that are good sources of nectar and which, because they can be successfully fertilized, set plenty of seed.

The largest group of double flowers that are also rich in nectar are those belonging to plants with daisy-like blooms. As discussed above, in these doubles – or, from a botanical point of view, pseudo-doubles – there is a change in the proportion of disc and ray florets, rather than any modification of individual flower structures. The tiny disc florets of these daisy flowers, each of which has stamens and a pistil, are receptacles for nectar. Except in those cases where the central disc has become significantly smaller, these doubles might therefore be expected to be at least reasonably good sources of nectar and, in the case of marigolds (*Calendula officinalis*), for example, double- and single-flowered forms have been found to secrete similar amounts of nectar.

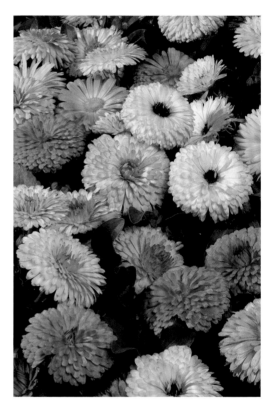

Double marigolds, forms of *Calendula officinalis*, carry just as much nectar as single forms.

Nectar and pollen may both be present in double flowers but just how visible and accessible these foods are to various insects and birds is another matter. (And how nutritionally valuable they are, compared to nectar and pollen from single flowers, is yet another interesting question.) A double flower may have plenty of sugar-rich nectar and protein-packed pollen, but if there are numerous petals and they are intricately arranged, foraging creatures may be deterred from entering the flower and, in some cases, the food sources may be inconspicuous. And if all foraging creatures are deterred, then the flower will not be fertilized and no seed will be

set, despite the presence of functioning sexual organs. However, it seems that bees were not deterred from visiting, and revisiting, the double columbines described above (most of which had 15–25 tightly stacked petals), and studies have shown that bumblebees can learn how to forage successfully and efficiently from morphologically complex flowers with which they were previously unfamiliar.

DOUBLENESS AND FERTILITY ARE OBVIOUSLY LINKED, at least in the commonest type of doubling where some, though not necessarily all, stamens are replaced by structures which are petal-like and often sterile. The relation between the sexual parts of flowers and doubleness was noted, in some prescient observations, as early as 1790. In that year, Goethe – a gifted scientist as well as a literary giant – put forward a theory to explain the differentiation of the various floral organs in distinct whorls. Basing his theory upon the observation that petals often occur where stamens and pistils would normally develop, he proposed that all the different floral organs are very closely related and that all plant structures are expressions of one form – the leaf.

Although there are aspects of his theory which appear implausible in a post-Darwinian world, Goethe's observations about double flowers are astute and his proposition that *abnormal* forms – including double flowers – are valuable sources of information about *normal* forms has had a profound influence on science. (This proposition was first alluded to, but not pursued, by the Swedish botanist – and founder of modern taxonomy – Linnaeus, in 1744.)

That petals and sepals are actually modified leaves had been suggested by the English botanist Nehemiah Grew in 1672; in 1768, the German scientist C.F. Wolff proposed that stamens and the casings of many seeds and fruits were, in fact, both foliar structures. However, as in other areas of enquiry, it was Goethe who – though he was ignorant of the work of both Grew and Wolff – drew together disparate ideas into a cohesive set of proposals which stimulated a great deal of later research.

If science and technology had been more advanced in the late eighteenth century, Goethe's speculations about double flowers might soon have led to much interesting work on the developmental

patterns of flowers in general. However, the scanning electron microscope and micropropagation by tissue culture were both in the distant future and, for many decades, work in floral morphology consisted principally of descriptions of mature flowers and their parts.

From the middle years of the nineteenth century through to the early years of the twentieth century, much of this morphological work was inspired by a widespread fascination with plant abnormalities – including double flowers. There were several large studies of the subject; Master's *Vegetable Teratology*, published in 1869, is the classic English-language work on the subject. Though this and similar works are highly impressive in terms of the sheer quantity of mutant forms collated and described, often in meticulous detail, they are essentially lists. And they have some fundamental drawbacks: for example, one-off freaks are not distinguished from permanent, inherited abnormalities, and the sources of information must be of at least questionable reliability since only some of the mutations listed were observed first-hand by the authors.

Darwin's *On the Origin of Species* was published 1859 and it is therefore not surprising that several works on plant abnormalities, including *Vegetable Teratology*, assign a place in evolutionary history to floral abnormalities. The most commonly accepted (but highly speculative) view was that these flowers were reappearances of remote ancestral forms. However, Darwin himself, who was always interested in double flowers, only very tentatively put forward the idea of reversion to a more primitive form in his 1868 work, *The Variation of Animals and Plants under Domestication*.

A major limitation of *Vegetable Teratology* and similar encyclopedic compilations is that they describe the anatomy and morphology of mature rather than developing flowers. This limitation and the lack of any proper understanding of genetics obstructed progress in studying various related topics, such as the differentiation and development of floral parts and the patterns of inheritance of these parts (in normal as well as in mutant flowers).

However, Gregor Mendel's work on heritable characteristics in peas, which he carried out during the mid-nineteenth century in what is now the Czech Republic, was rediscovered in 1900. A full appreciation of this work's immense significance, together with the publication of Mendel's *Principles of Heredity* in English in 1902,

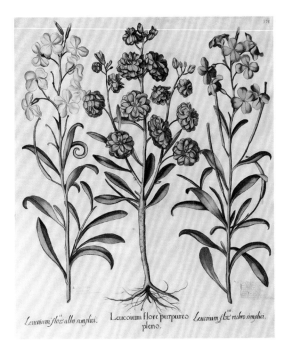

Leucoium flore albo simplici. *Leucoium flore purpureo pleno.* *Leucoium flore rubro simplici.*

Stocks, single and double, from Bessler's *Hortus Eystettensis*, vol. 2, fig. II (1620). Double forms of *Matthiola incana* have been known for centuries, but the heritability of their characteristics was not understood until after Gregor Mendel's work was published.

marked the beginning of modern genetics. Armed with this 'new' knowledge, scientists began, first of all, to investigate patterns of heredity in various organisms, including plant mutations such as double flowers. Later, when analytical techniques became sufficiently sensitive, it became feasible to carry out molecular studies of the differentiation and development of the various parts of flowers.

Outstanding among the early studies on the patterns of heredity in plants were those undertaken by the pioneering geneticist Edith Saunders. For a period of some twenty years, from the first decade of the twentieth century, she carried out experiments on double-flowered stocks (*Matthiola incana*). These doubles, which have long been commercially important as cut flowers, are completely sterile but, interestingly, the seed of a particular strain of *single*-flowered plants regularly produces a large percentage of *double*-flowered offspring. Over the years, growers of stocks had attempted to devise various methods of cultivation to maximize the output of double-flowered stocks. Saunders's work on what she called 'ever-sporting', single-flowered stocks (which could produce both double- and single-flowered offspring) confirmed that, first of all, doubleness was a genetically transmitted trait and, second, that the gene for this trait was carried in the male cells of the single-flowered plants.

As RESEARCH INTO THE GENETICS of doubleness in various different plants continued, it became clear that the mechanisms and patterns of inheritance of this feature vary from genus to genus, from species to species, and even from variety to variety. The probability that no single gene for doubleness exists has been substantiated by studies of gene identity and gene sequences in double-flowered plants

of different, but closely related, genera. These studies have revealed that the genes for doubleness in different plants are embedded in different genetic sequences and are not, therefore, derived from a single ancestral gene.

The complexity of the inheritance of doubleness in plants must, at least partly, be due to the term 'double' being routinely used to describe several distinctly different arrangements of floral parts. In *Double Flowers: A Scientific Study* (1983), an informative work devoted entirely to the examination of double flowers, Joan Reynolds and John Tampion consider a number of double-flowered plants of different types. The developmental pattern of each double and its various floral parts are examined in detail and, from the descriptions of these patterns, it is clear that no one genetic base is likely to be responsible for all types of double-flower arrangements.

Technological advances have enabled the most recent studies to analyse the molecules involved in the differentiation and development of the various floral parts and to identify the genes that control them. In particular, mutant flower forms – most commonly doubles – have proved rich sources of information about how genes control floral development. Detailed examinations of double flowers, together with comparisons between them and single flowers, have led to experiments in which plants have had certain floral-part genes 'switched off'. Scientists have reprogrammed plants in this way so that they produce flowers with, for instance, nothing but sepals, after the genes controlling all the other floral parts – petals, stamens and pistils – have been switched off. These reprogramming techniques, as well as gene-transference technology, may soon enable the creation of, for example, new, genetically engineered, double-flowered varieties of street trees so that messy fruits and inconvenient self-sown seedlings are problems of the past.

From observing the flowers of these reprogrammed plants and comparing normal and abnormal flowers (including doubles), models of floral development have been created that seem to apply to many different flowering plants. A fundamental attribute of the original and still widely used model is that the *four* floral parts (sepal, petal, stamen and pistil) are controlled by *three* genes. Two – the sepal and the pistil – are each controlled by a single gene. Both these genes are also involved, in combination with a third gene, in the control of petals and stamens: the initiation and development of petals comes

about through the interaction of the sepal gene and this third gene; similarly, stamens are controlled by the interaction of this third gene and the pistil gene.

The presence of shared genes clearly supports the proposition, put forward by Goethe, that all the different floral organs are closely related. Recent work also suggests that all the different floral organs – sepals, petals and so forth – can be produced in almost any whorl. It seems clear too that what floral part develops in any particular whorl is independent of what is happening in adjacent whorls; if there are any rules governing the position of the different floral organs, then those rules are very flexible indeed.

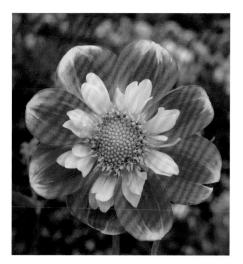

Dahlia 'Golden RIver'. Semi-double collarette dahlias often have a ring of petaloid florets whose colour contrasts with that of the outer petals.

Shared genes and the fact that there is interaction between these genes may help to explain why it is that double flowers so commonly involve the replacement of stamens by petal-like structures. Stamens and petals share a gene and, in both cases, they arise as the result of interaction between two genes (whereas sepals and pistils are each controlled by a single gene). Since any system that involves interaction is inherently complex, it might be expected that the layers of cells which normally turn into petals and stamens would be particularly susceptible to mutation and, therefore, most likely to produce structures of variable appearance.

The fact that petals and stamens are each controlled by two genes (including a gene that they share) may also begin to explain why the extra 'petals' in double flowers are, most commonly, an amalgam of stamens and petals. Of course, for betwixt-and-between structures of this sort to occur, there must be interaction between the two sets of genes involved (and possibly between these genes and other genes too). And since one double flower can produce extra 'petals' which range from almost completely normal stamens right through to almost normal petals, the nature of this interaction would appear to be quite complex. So complex, it would seem, that the dominance of one structure over another is a matter of considerable fluidity and very variable expression.

IF THE MOLECULAR MECHANISMS that regulate floral parts are generally this complex and fluid, then perhaps floral mutations (including double flowers) should be regarded as inevitable by-products of a complicated system. However, it seems that not all floral arrangements are equally prone to mutation. While some genera develop many distinct doubles, other genera seem rarely, if ever, to produce varieties with extra petals.

Genera with many-petalled, symmetrical flowers are most likely to produce doubles (the fact that multiple organs tend to be the most variable has long been recognized – by Darwin, among others). Genera with tubular flowers made up of joined petals do not produce so many doubles (and when they do, the double flowers tend to take a particular, 'hose-in-hose' form. Fewest doubles are produced by genera with bilaterally symmetrical flowers, such as those in the pea family. Some plant families produce flowers which, even in their single form, have somewhat variable numbers of floral parts; this too seems to increase the likelihood of double-flowered varieties. Such families include the *Ranunculaceae* and the *Rosaceae*: in the first family there are, for example, the numerous double-flowered buttercups, columbines and clematis; the second family encompasses the many varieties of double-flowered cherry and geum, and countless double roses.

So it would seem that it is floral parts that are already numerous and variable in number – rather than few and of a constant number – that are most likely to become yet more numerous and yet more variable. In the world of floral parts, variability seems to set the scene for further variability.

Sometimes this variability will materialize as double flowers and, in the wild, some of these double flowers will not persist since they are sterile or of limited fertility. But perhaps this is a price worth paying for a system which is flexible and always ready to adapt. Petals send vital signals to many pollinating creatures and, if a plant has the molecular resources to vary the number and arrangement of its petals, it may be able to evolve and survive where plants of greater genetic stability would perish. More petals – but not too many petals, of course – could mean an enhanced ability to attract pollinators. In evolutionary terms, an increase in the number of petals might well be connected with a shift away from the vagaries of wind pollination to the relative reliability of insect pollination.

Hose-in-hose primulas – this one is a form of cowslip, *Primula veris* – have petaloid sepals that join together to create another 'flower' below the true one.

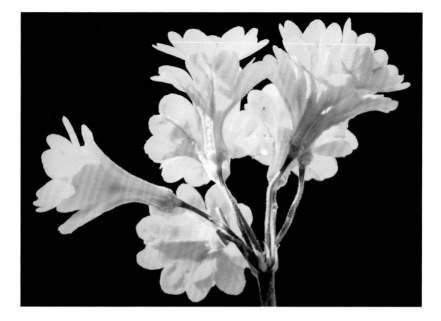

Since it is the more primitive plants that are wind-pollinated, it would seem that the extra insect-attracting petals of double flowers are evidence of a more advanced floral structure and not, as certain nineteenth-century botanists thought, a reversion to a remote ancestral form.

IN THE REAL WORLD, genes are not suspended in some sort of remote and isolated vacuum. On the contrary, it is clear that environmental factors precipitate floral mutation. For well over a hundred years now, many plants have been forced for the cut-flower trade (including, for example, lilacs – *Syringa vulgaris* cultivars); these forced plants have been a notable source of colour differences and other mutations.

Environmental factors can also affect whether or not a mutation is expressed, and there are various examples of double-flowered varieties behaving differently in different temperatures. Commercial growers of freesias are aware that 8°C is the optimal temperature for producing double-flowered specimens of these plants; at 18–20°C, double-flowered freesias produce single flowers. (Though these flowers are smaller and less colourful, and shorter-lasting as cut flowers than the doubles, they are fertile and therefore useful for breeding.) However, high temperatures routinely induce some single-flowered

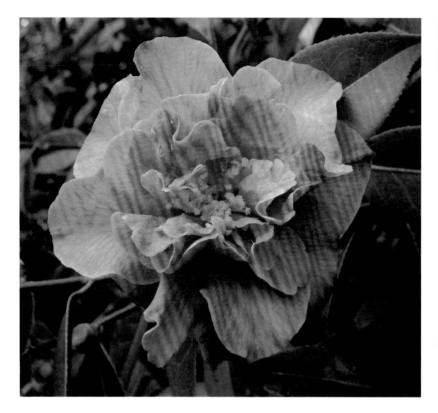

day lilies (*Hemerocallis*) to produce more, rather than fewer, petals than normal. When grown outdoors, the exceptionally hardy *Camellia* 'Leonard Messel' produces flowers with few visible stamens and numerous petals, but when grown indoors its flowers have relatively few petals and its stamens are numerous and conspicuous. In contrast, *Camellia sasanqua* 'Jean May' is at its best in warmer regions, where hot summers and mild winters result in its flowers being much more double than they are in cooler areas. It would seem therefore that a plant may be genetically predisposed to be double-flowered, but for the genetic code to be expressed and for extra petal-like structures to appear, then certain environmental conditions must pertain. And the evidence from some double-flowered camellias, in particular, suggests that the environmental conditions needed for extra petals to appear are species- and variety-specific.

Interaction between a genetic code and environmental conditions is also evident in those cases where doubleness is linked in some way

to the growth and development of an individual plant. The pattern of early-season doubles followed by late-season semi-doubles and singles has already been mentioned. Variation over the growing season is common, but doubleness can also vary with the age of a plant: older specimens of the double-flowered heather *Calluna vulgaris* 'Alba Plena', for example, are particularly erratic producers of double blooms, and Louise Beebe Wilder, in *Adventures with Hardy Bulbs* (1936) is not the only gardener to have noticed that, over time, some double daffodils become 'less fully rosetted than when young'. On the other hand, it has been noted that seedlings of double-flowered roses do not reliably produce fully double blooms until they have flowered for two or three years, and it is said that seedlings of the famous Barnhaven strain of double primroses are sometimes single at their first blooming and double-flowered only from their second flowering onwards.

A complex combination of interrelated factors is obviously at work in the examples of double flowers given above. As well as temperature and hours of daylight, other factors may include a plant's ability to take up nutrients efficiently – an ability that varies with age. Despite the renewal of scientific interest in floral morphology during the late twentieth century, little detailed enquiry or scientific study has focused on how external factors influence the expression of doubleness.

AN INTEREST IN THE EXTERNAL CAUSES of doubleness is certainly nothing new; they have been a matter of speculation and conjecture for hundreds of years. Parkinson, in *Paradisi in sole, paradisus terrestris* (1629), thought that doubling might be due to 'some constellations, and peradventure changes of the moone'. Later, it was thought that nutrition was the most important influence. Gardeners have long noted that, if some double-flowered varieties are not to revert to the single-flowered form, they need richer soil and more careful cultivation than their single-flowered counterparts. (Unfortunately, much horticultural information about the relationship between growing conditions and doubleness tends to be unsystematic and lacking in detail.)

Indeed, the eighteenth-century apothecary, botanist and writer John Hill optimistically thought that since 'a neglect of culture will reduce double flowers to their original single state . . . there is no reason to

doubt but good management will as regularly make the single double.' The 'good management' included frequent transplanting, as well as pond mud and cow manure. (The extraordinary John Hill was a hugely energetic man of very considerable talents who was so maddeningly difficult, deceitful and eccentric that he was – and still is – largely ignored or ridiculed.)

With an understanding of genetic inheritance still far in the future, it was not only John Hill who assumed that because growing conditions might sometimes maintain doubleness, these conditions must also cause doubleness. Indeed, almost a hundred years later, in 1845, a strikingly similar recipe for doubling the flowers of *Anemone wightiana* (now regarded as a conspecific with *A. rivularis*) was being proposed by the physician and botanist Robert Wight. In 1875 Darwin was putting forward a slightly more complex but comparable proposition: he suggested that the fundamental cause of double flowers was their lack of fertility and that this lack of fertility was most commonly due to 'long-continued cultivation in rich soil'. Today's scientists would disagree with Darwin over his view that lack of fertility was the primary *cause* of doubling; contemporary opinion sees lack of fertility as a clear *effect*, or at least a concomitant, of doubling.

Anemone wightiana, from *Icones plantarum indiae orientalis* (1834). Robert Wight, a pioneer botanist in India, had some success in doubling the flowers of this anemone by altering its growing conditions.

Descriptions of floral abnormalities became increasingly sophisticated and detailed during the eighteenth and nineteenth centuries, but little or no progress was made on discovering the true causes – internal or external – of these abnormalities. John Hill's ideas about the origin of double flowers and instructions for producing doubles from singles were published in 1758. Yet the basic ideas in these writings remained in circulation, in some form or other, for another hundred years and more. According to Hill, extra petals in tulips, for example, are the result of a great quantity of 'fleshy substance' in the stalks of these plants and the 'luxuriance' of

their stamens. With the right growing techniques, this propensity to 'fleshy substance' and 'luxuriance' can be augmented. And then – Hill claimed, but was unable to demonstrate – double tulips and doubles of other plants too can be produced, whenever required, from the seed of single-flowered plants.

This concept of some sort of superfluity being channelled into the production of extra petals is reiterated by many writers, including Darwin, who wrote of 'organizable matter in excess' becoming 'converted into petals'. It goes hand in hand with another widely accepted principle of plant morphology, put forward by Goethe, which stated that the differentiation and development of the various plant organs were controlled by sap progressing from node to node, up the plant, and, in progressing, becoming increasingly refined. When the sap failed to become 'purer and stronger' as it rose, then there was a failure in differentiation of the various flower parts. We may smile indulgently at notions of sap and refinement but it was these notions that were the seedbeds in which modern biochemistry germinated.

The many important scientific and technological advances of the twentieth century allowed botanists and plant geneticists to describe the differentiation of floral parts in an awe-inspiring detail that would have astonished earlier investigators. Most significantly perhaps, advances in the understanding of genetics revealed how no amount of cow manure and pond mud will make consistently double tulips out of single tulips. But genetics alone cannot explain how it is that many double-flowered plants – including those mentioned above – sometimes produce double flowers and at other times produce single flowers (and sometimes produce singles and doubles simultaneously). The study of molecular genetics has made it possible to switch off floral-part genes in the laboratory – but when a new double flower appears in the 'real' world outside the laboratory, what has triggered switching-off in that case?

These and similar issues are the subject matter of epigenetics – the study of how environmental factors can change gene function without altering the genetic code. From an epigenetic point of view, double-flowered plants may always be genetically coded for doubleness but when and how that genetic coding is expressed may be controlled by various environmental stimuli. That is, the genetic code may remain intact but the reading out or implementation of that code may be subject to alteration.

Epigenetics, in tandem with genetics, may begin to make sense of some observations about doubling and its incidence in successive generations of plant specimens. Before dismissing Darwin's notion that 'long-continued cultivation' is a factor in doubling, it might be worth remembering that propagating a particular species or variety of plant over a long period often leads to permanent, heritable mutations in that plant. But just how, exactly, long-term cultivation, and repeated propagation in particular, make genetic mutations more likely is not at present fully understood.

It has also been noted that mutations after 'long-continued cultivation' are more likely to arise if large numbers of specimens are grown together and propagation takes place on a large scale. Plants are not the only organisms that appear to show an increased incidence of variability when numbers are large: in large populations of butterflies the proportion of variant wing patterns is significantly higher than in small populations.

Is population size another source of epigenetic variation? And could this be connected to some requirement to avoid the pitfalls of inbreeding? Given that there is commonly a reduction in fertility when extra petals are formed, is it possible that, in the particular case of double flowers, the changes are sometimes a method of population control? Or, as discussed above, is the driving force behind most doubling an evolutionary one: more petals meaning more animal and insect pollinators and therefore more efficient pollination? If this is the case, then doubling might more accurately be represented as part of a Darwinian natural-selection type of gradual transformation, rather than a number of unconnected, sudden mutations.

Or, in the end, do most doubles arise relatively independently of environmental influences? Perhaps most doubles are best thought of as the result of inevitable glitches in the workings of a system so complex that it is bound to produce some aberrations. But some 'glitches', including double flowers, occur frequently, repeatedly and in many different genera, and this interpretation is surely just an admission of ignorance and bewilderment.

One of the more likely treasure troves of information about genetic mutations such as double flowers is so-called 'junk DNA'. More or less unexplored as yet, these DNA segments do not code for proteins and so are not straightforwardly the 'building blocks of life'. They were, therefore, thought to be redundant. But recent investigations point to

the possibility of their having some kind of regulatory role: segments of this seemingly superfluous DNA may play a part in determining when genes are active and when they are silent. If the genes involved in the differentiation and development of petals are affected by 'junk DNA', then these segments would be, of course, important in the formation of double flowers. In broader terms, 'junk DNA' may be the repository of all sorts of potentially valuable mutations and, if it is, then it might well be regarded as the card-dealer of evolution.

But how is 'junk DNA' itself controlled? Whatever the answer to this and many other questions arising from the examination of double flowers, it is clear that these floral 'monstrosities' are at least as informative about the development of flowers as Goethe suggested they might be. They have also yielded important insights into patterns of inheritance and they are beginning to shed useful light upon the evolution of flowering plants. Goethe realized that double flowers can 'unveil the secrets' that normal flowers conceal from us. It is a tantalizing thought that some of these secrets may still be so obscure that, at the moment, we cannot even begin to guess at their nature.

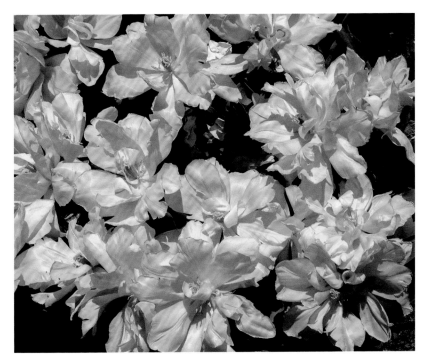

Tulipa 'Monte Carlo'. Plant breeders have been selecting double tulips for more than three hundred years. Their shapes are now very variable.

3 The Quaint and Charming

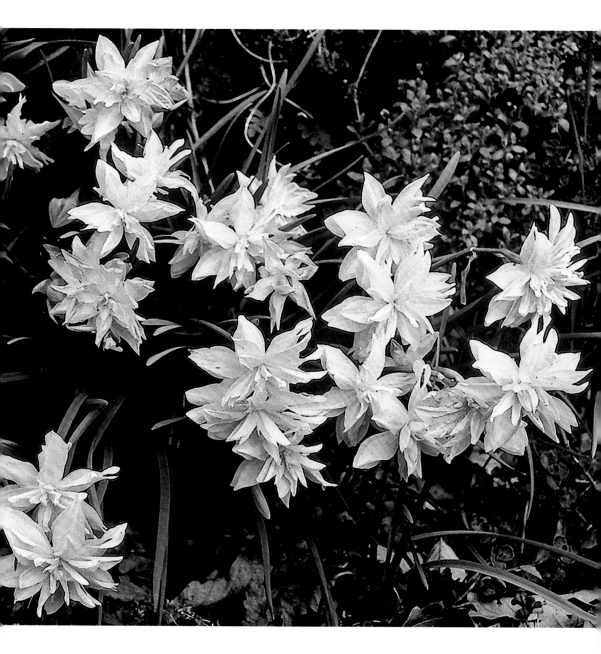

ONLY THE MOST STONY-HEARTED GARDENER COULD FAIL TO ACKNOWLEDGE
THE APPEAL OF AT LEAST SOME OF THE PLANTS IN THIS CHAPTER. INDEED,
THESE QUAINT AND CHARMING DOUBLES COULD WELL BE DESCRIBED AS THE
ACCEPTABLE FACE OF EXTRA PETALS.

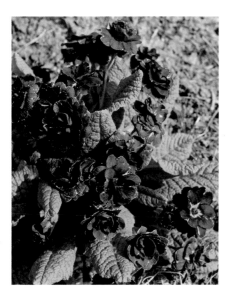

ABOVE
Double primroses are
often less flamboyant
than single forms,
partly because their
extra petals hide the
bright yellow eye of
the flower.

LEFT
The dainty simplicity of
Queen Anne's double
daffodil (*Narcissus*
'Eystettensis') appeals to
all who see it.

Even gardeners who claim that their delicate sensibilities are offended by the presence of any extra petals will find themselves admitting that they are beguiled by old-fashioned, often small-scale beauties such as double primroses and double-flowered wood anemones. When they are reminded of, for instance, the delicious scent and exquisite patterning of 'laced' pinks or the sweet simplicity of Queen Anne's double daffodil (*Narcissus* 'Eystettensis'), then they have to admit that, maybe, there might be some exceptions to their dogma of 'Oh! single flowers only, *please*!'

There are, of course, those who take a rather different view of old-fashioned plants and who feel that they will scream if they read about another knot garden or another 'olde worlde' collection of herbs. For them, there are some double-flowered varieties of old-fashioned plants that have a welcome, extra assertiveness that stops them being just too whimperingly modest and unassuming. To these gardeners, only the double-flowered varieties of plants such as *Ranunculus acris* (bachelor's buttons) or *Matthiola incana* (stock) are worthy of a place in the modern garden; growing the singles is a silly affectation.

Such gardeners will be relieved to read that not all the double-flowered plants in this chapter are uniformly meek, dainty and ancient with an air of 'sunbonnets and print frocks', as Margery Fish put it in *Cottage Garden Flowers* (1961). An effect of quaintness or of charm can be produced in a number of different ways. To be sure, one of these ways is indeed based on many gardeners' prejudices in favour of plants that have a long garden history. In *Colour Schemes for the Flower Garden* (1919), Gertrude Jekyll wondered whether we find such plants attractive because of the force of old association, or was it that our ancestors had the

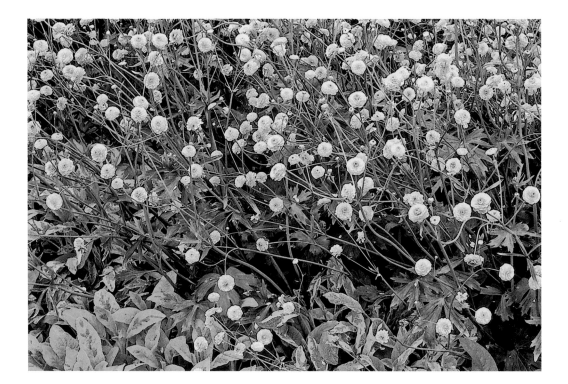

sense to get hold of the most delightful flowers? We know not; but we only feel that what we know as old-fashioned flowers have a kind of charm that makes them more lovable than all the fair plants of more recent introduction.

Force of association is certainly an important factor in making 'heritage' plants seem endearing. Indeed, there are modern plant breeders who have taken this into account and who have produced new plants that look like old plants. But some of those described below are relative newcomers that no one has bred to look old-fashioned. They include some paler-flowered quinces (*Chaenomeles*) with extra petals and double-flowered varieties of rock roses (*Helianthemum*). These newer plants may not look quaint in the way that, for instance, the older pinks (*Dianthus*) and columbines (*Aquilegia*) look quaint, but they do have charm.

The features shared by many of the newer, charming doubles include either a pale or an exceptionally deep flower colour, attractive scent, and – frequently – a small flower size. These, of course, are features that the majority of old doubles have in common too, and it would

The double form of *Ranunculus acris* (the European meadow buttercup), known as bachelor's buttons, bears much more solid flowers than the wild species.

The scarlet double rock rose, *Helianthemum* 'Mrs C.W. Earle', is remarkable for its vigour. (See page 95 for a close-up view.)

seem, therefore, that these are the attributes of double flowers that charm us whether the plants that produce these flowers are old or new.

The modesty of so many of these small, pale, often fragrant flowers, whatever their age, does need to be taken into account when placing the plants in the garden. Just dotting two or three of the smaller double-flowered daffodils in among large shrubs or in broad sweeps of grass is bound to produce a fairly lacklustre effect – if, indeed, the flowers are noticed at all. Of course, some of these little plants will be accommodating and will multiply in the garden, but to produce sufficient impact from the beginning, they need to be planted in reasonably generous quantities.

One way to make sure that modest flowers are not overlooked is to position them in pots or in raised beds where small details can be easily appreciated. However, making a raised bed can be quite an undertaking, and protection from frost damage as well as the demands of regular watering are drawbacks to growing treasures – large or small – in containers.

Another approach to the problem is to accompany potentially inconspicuous flowers with another plant of similar colouring. Unassuming little blooms can look lovely at close range; at a distance, however, they can, most dishearteningly, merge with their surroundings. Repeating the colour of such flowers has the effect of highlighting and amplifying them. For examples of this effect, see the image on page 58 of yellow-flowered buttercups (*Ranunculus acris*), where the tight little button-like blooms have been partnered with long-lasting yellow-variegated foliage.

A related consideration is the background against which small and subtle flowers are to be seen. Little white flowers are probably going to disappear when viewed against whitewashed walls; deep maroon-red flowers may well merge with dark wooden fences. However, even if the background is of similar colouring to the flowers chosen, a contrast in texture and pattern can throw modest little blooms into relief just as effectively as a contrast in colour. For example, Bowles's golden sedge is of similar colouring to the closely packed yellow petals of *Ranunculus constantinopolitanus* 'Plenus', but the sedge's airy mass of slender leaves creates a pattern against which the dense flower heads are clearly visible.

Ranunculus constantinopolitanus 'Plenus' combines well with *Carex elata* 'Aurea', Bowles's golden sedge.

Perhaps the most important point to bear in mind when using quaint or charming double-flowered plants in the garden is that many of them have a general demeanour that is rather restrained, and their flowers are frequently neat and precise in form. Jason Hill in *The Curious Gardener* (1932) likens the 'rather stiff design' of some sixteenth-century plants to 'the conventionalised patterns of Tudor embroidery'. He contrasts these plants with 'the looser, more opulent build of our modern border plants' and suggests that the older plants should be placed with their contemporaries, rather than with more modern plants.

However, not all old doubles resemble pieces of Tudor embroidery and not all modern plants make unsympathetic partners for these historically early flowers. To take just a very few examples, there are

ABOVE AND OVERLEAF *Rosa banksiae* 'Lutea', the hardiest of the Banksian roses, makes a useful background to many other spring-flowering plants.

low-key foliage plants, such as the quieter varieties of ajuga, *Hedera helix* and heuchera, as well as many grasses – *Milium effusum* 'Aureum', for example – that would not jar when set beside older doubles. Certain modern varieties of geranium. erigeron and the smaller-flowered hardy fuchsia would also make suitable companions. Among the huge variety of roses, three modern varieties, pink Rosy Cushion, purple Yesterday and white Kent spring to mind. None of these roses was introduced before 1974 and, as well as combining sympathetically with older flowers (and looking older themselves), all are charming in their own right. In warmer gardens, the early-nineteenth-century *Rosa banksiae* 'Lutea' would make a delicately coloured but floriferous background to any planting of old-fashioned flowers.

Many quaint and charming doubles are the sort of small-flowered, gently coloured plants that were cultivated in European gardens long before the influx of showier plants from tropical and subtropical regions or the deluge of dazzling plants produced by hybridization. Quite a few of these old doubles will be the sports of species that were cultivated for various culinary, household and medicinal purposes. An extraordinarily wide range of plants was considered useful in the sixteenth and seventeenth centuries. (That some of these plants were poisonous and produced serious side effects, including severe skin irritation, violent vomiting and even death, does not seem to have limited their recommendation.) The most useful of these plants were cultivated in gardens, where any mutations, including double flowers, would be more readily noticed. Other, less commonly used plants and those that grew abundantly in the surrounding countryside will have been gathered as required. In the process of gathering, variants such as double flowers will have been discovered and some of them brought into the garden as curiosities. The curiosities may well have been just as useful as their single-flowered progenitors, but their additional decorative value will have ensured their perpetuation centuries after they ceased to have any practical use.

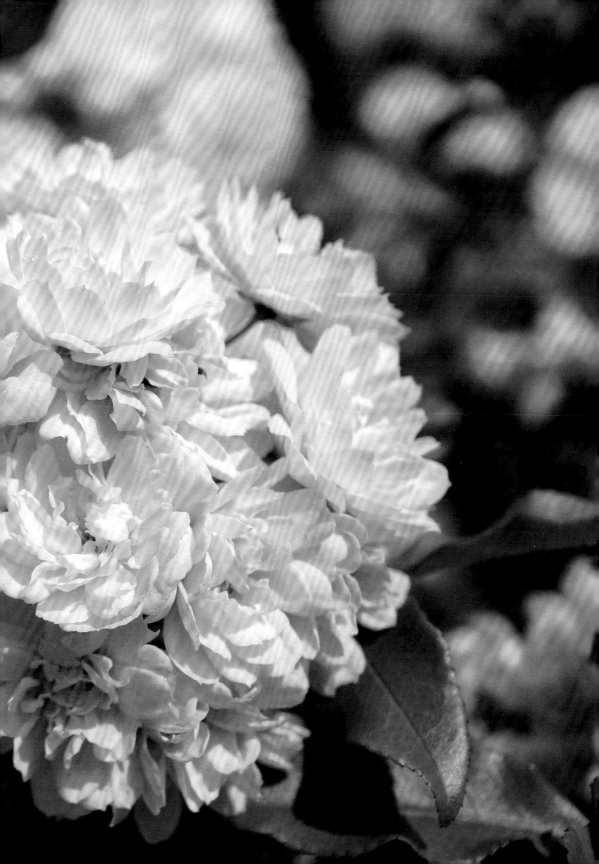

Not many people in Western European and North American gardens now use soapwort (*Saponaria officinalis*) to wash their everyday clothes, or grow lady's smock (*Cardamine pratensis*) as a salad ingredient, and they are even less likely to use greater celandine (*Chelidonium majus*) to cure poor vision and warts. But these once purely utilitarian plants persist, in some form or other, as ornaments to our gardens, partly because of their vigour (and the single-flowered species may be rampant rather than simply vigorous) and partly because of the decorative qualities of their double-flowered varieties.

SNOWDROPS (*Galanthus*) are, to many people, quintessentially quaint and charming flowers. In the past the plants were, however, very rarely used medicinally (though they may have an important role to play in the future, in the treatment of Alzheimer's disease). It is possible that the common snowdrop, *G. nivalis*, may have been grown in Britain since Roman times (though researchers have not been able to trace it back before the sixteenth century), but a double-flowered variety seems only to have been cultivated, in both America and Britain, since the early eighteenth century. The 'original' double, *G. nivalis* f. *pleniflorus* 'Flore Pleno', is a vigorous plant that flowers in late winter and increases almost as readily as its single-flowered counterpart, sometimes more so. New and old, all double snowdrops are an intriguing mixture of the austere and the lavish.

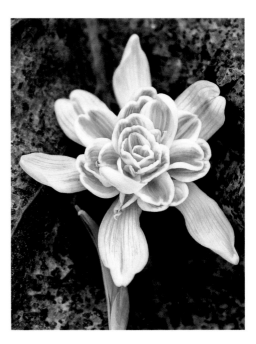

Galanthus nivalis f. *pleniflorus* 'Flore Pleno'. Double snowdrops are heavy with extra petals, but winter rain runs out of the nodding flowers. And their slender stalks hold them daintily.

Though these winter blooms look chaste from a distance, close examination reveals extravagant extra floral parts.

Today there are thousands of named varieties of snowdrops and enthusiasts get excited about what, to more ignorant eyes, seem barely perceptible differences. There are, however, certain very distinctive snowdrops and some of these are doubles. Their unusual appearance may be due to colour: on established plants of *G. nivalis* f. *pleniflorus* 'Lady Elphinstone' (found in 1890) the numerous inner

segments of the flowers are usually marked with apricot-yellow rather than green. Other doubles, such as G. 'Jacquenetta' and G. 'Ophelia', have exceptionally large green markings on the inner segments of their blooms; G. nivalis f. pleniflorus 'Blewbury Tart' (found in 1975) is also strongly marked with green but these markings are made yet more conspicuous by the strange way in which the flowers point outwards. G. 'Jacquenetta' and G. 'Ophelia' are two examples of so-called Greatorex doubles which were bred by H.E. Greatorex, from the 1930s to the 1950s, in Norfolk in England. Most of these doubles bloom during the period from late winter to early spring, though 'Ophelia' often begins flowering in midwinter. They are all distinctively tall plants (at least 18–20 cm/7–8 inches high) with characteristically full but rather shallow, fairly small flowers (often just 2 cm/¾ inch across). G. 'Hippolyta' is a reliable neat-flowered variety of this type about which Beth Chatto wrote, in *Beth Chatto's Shade Garden*, 'If I had to choose one double snowdrop I think it would be *Galanthus* 'Hippolyta' . . . until I look at 'Desdemona' and 'Dionysus' [also Greatorex doubles]. It would be hard to choose between these.'

The Greatorex doubles all arise from crossings of G. nivalis f. pleniflorus 'Flore Pleno' (which cannot set seed but does produce pollen) with G. plicatus, a robust species with shapely, elegant, single flowers. Just how the inner segments of these particular doubles are arranged varies somewhat. The inner segments of 'Jacquenetta' – about 25–30 in number – are unusually symmetrical in their arrangement, but one of the densest and neatest of all rosettes is produced by an unrelated variety, G. 'Hill Poë' (found c.1911). In contrast, the common double snowdrop, G. nivalis f. pleniflorus 'Flore Pleno', has a jumble of inner segments which are often misshapen. However, this gentle dishevelment appeals to those gardeners who like snowdrops to have a certain unsophisticated and informal air.

Another charming inhabitant of deciduous woodlands, the winter aconite (*Eranthis hyemalis*), makes a good partner for snowdrops. Though it can be grown in sites which are slightly drier and sunnier than most snowdrops would enjoy, it grows well in the humus-rich soils that snowdrops really appreciate. But whereas there are dozens and dozens of double-flowered snowdrops, double and semi-double forms of *E. hyemalis* are few and far between. Occasionally, the double-flowered *E. hyemalis* 'Noel Ayres' (found pre-1974) is offered for sale. Its green-ruffed, buttercup-like flowers are, like those of

the species, each about 2.5 cm/1 inch across and of a glorious, sunny yellow; they are filled with varying amounts of extra petals. Double-flowered forms of *E. hyemalis* Tubergenii Group also occur from time to time; some of these have green petals.

The heart-warming yellow-and-green colouring of winter aconites is also present in a much more readily available little plant – *Anemone ranunculoides* 'Pleniflora', a variety of yellow wood anemone. This rhizomatous perennial, 12 cm/5 inches tall, has been grown in British gardens since the sixteenth century. Its slender-lobed leaves die back in summer, but at flowering time they provide a flattering background for the 2 cm/¾ inch, semi-double, green-eyed 'buttercups' which open mainly from mid-spring onwards. For a white-flowered plant of approximately the same size and appearance and with a similar liking for shady places and moist, leafy soils, there is a form of sorrel, *Oxalis magellanica* 'Nelson'. This vigorous, mat-forming plant is only about 2.5–5 cm/1–2 inches high. It usually begins to open its rounded, rather relaxed double flowers late in spring but the season of their unfolding seems to vary considerably with geographical location. Each of these green-centred blooms, held just above the clover-like leaves, is less than 1 cm/½ inch across. In lighter positions, the foliage is often tinged with bronze.

For gardeners who like more than just one or two double-flowered varieties of a species to choose from, a pair of delightful and easy-

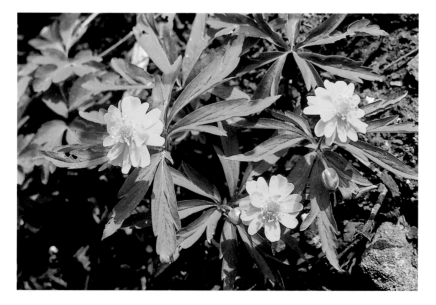

Anemone ranunculoides 'Pleniflora' is a useful woodlander for shady gardens. Its flowers last much longer than those of the single-flowered forms.

going spring-flowering woodlanders provide rich pickings. Variants of wood anemone (*Anemone nemorosa*) and lesser celandine or pilewort (*Ficaria verna*) have been grown for centuries: in 1665 horticulturist John Rea recounted finding a double-flowered pilewort in a field and distributing it, and a 'Double Pilewort' appears in Robert Furber's *Twelve Months of Flowers* (1730); John Gerard grew a double white *A. nemorosa* (*Catalogue of Plants*, 1596), and varieties of the species were commonly collected in the seventeenth century.

Though Reginald Farrer was referring to a single-flowered variety of wood anemone when he wrote about its 'Quakerish loveliness' in *My Rock Garden*, his description applies just as well to the winsomely quaint, double-flowered forms. It is particularly apt in the case of the clean, white variety 'Vestal', each flower of which has a dense, central pompon of regularly arranged petaloids. These luminous blooms, each up to 2.5 cm/1 inch across, are produced in mid- to late spring; 'Knightshayes Vestal' flowers slightly earlier and its pompons are surrounded by yellow anthers, while 'Alba Plena' is a name used to cover several white doubles, usually with rather small flowers and irregularly arranged petaloids. The white, semi-double blooms of 'Bracteata Pleniflora' have their own special, delicate charm (and they are remarkably variable – Bowles observed, in *My Garden in Spring* (1914), that the plant 'never comes two seasons alike'). The petals are sometimes tipped with green and, distinctively, each 4–5 cm/1½–2 inches flower 'sits' on a ruff of

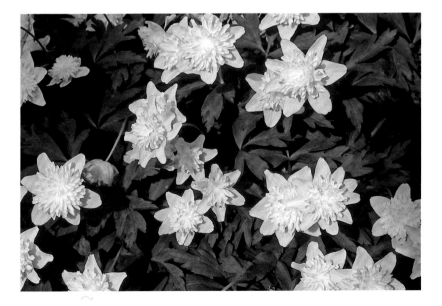

The cultivated forms of *Anemone nemorosa* are worth collecting for their delicate charm. 'Vestal' has an exceptionally pretty arrangement of petaloids at its centre.

often white-marked, green tepals which are themselves surrounded by a fringe of leaves. Less common but interesting varieties include 'Blue Eyes', which has violet-blue centres to its large, shaggy, double white flowers, and 'Hilda', which produces variably double to single white flowers that turn pink as they age.

All these rhizomatous perennials form loose, slender-stemmed carpets of ferny leaves which die down by midsummer. Nurseries specializing in small and bulbous plants may stock the double form of *A. apennina*, which has many-rayed, clear blue daisies on 10–15 cm/4–6 inch stems in spring. These nurseries may also list the similarly sized, *nemorosa*-like *A. trifolia* 'Semiplena', a mainly spring-flowering semi-double with white flowers over dainty, rue-like foliage.

It sometimes seems as if there is no end to the variability of *Ficaria verna*. Wild colonies of these celandines have thrown up a plethora of variants, including doubles, and there is a brain-scrambling muddle over names. In Canada and the United States, the invasive nature of this non-American species has made gardeners understandably wary of it and its mutants. However, many of the doubles are either sterile or produce little seed. Double-flowered varieties include those with flowers that are anemone-centred or daisy-like (*Ficaria verna* 'Double Bronze' – yellow, sets little seed) or pompon-shaped (*F.v.* Flore Pleno Group – varying shades of yellow, usually green-centred, infertile). The shiny-petalled blooms, each about 2.5 cm/1 inch across, open in early spring and are accompanied by tufts of shiny, heart-shaped leaves. The plants, all round about 8–15 cm/3–6 inches tall, die back completely by late spring. Though they thrive in fertile, moisture-retentive soil they can be grown almost anywhere. (For a more general discussion of celandines see chapter 8.)

If collecting wood anemones seems too straightforward and collecting lesser celandines seems too perilous, then hepaticas and anemonellas may appeal. Hepaticas are woodland beauties which have been grown in Western gardens since at least the beginning of the seventeenth century. Parkinson (1629) grew two double forms of *Hepatica nobilis*, a blue and a purple; 'Double Peach-coloured' and 'Double blue' hepaticas are also illustrated in *Twelve Months of Flowers*. Interest in these long-lived but slow-growing little perennials has varied over the centuries and the last revival of their popularity

Double cultivars of *Hepatica nobilis* have been bred and selected for hundreds of years in Japan. This picture hints at the complexity and variability of cultivated forms.

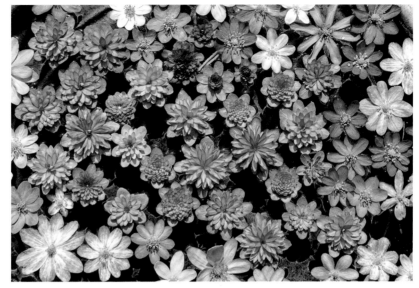

was in late Victorian times. However, interest is again rising and expensive varieties are beginning to arrive in Western nurseries from Japan – where numerous, remarkably varied forms of Asian, European and hybrid hepaticas are avidly collected. Cheaper, readily available varieties, more suitable for general garden planting, include the deep pink *H. nobilis* 'Rubra Plena', some double blue and double white *nobilis* varieties, as well as the blue, semi-double *H. transsilvanica* 'Elison Spence'. All of these dainty flowers, each 2.5 cm/1 inch or so wide, appear early in spring and they are all of exquisite precision and prettiness. The plants, which form small mounds of lobed leaves and grow about 10–15 cm/4–6 inches tall, are most at home in well-drained, humus-rich soils and partially shaded sites.

Anemonella thalictroides or rue anemone is sometimes placed in the genus *Thalictrum* but, whatever it is called, its double-flowered varieties produce quaint little pompons of striking neatness and density; the effect of orderly prettiness is heightened by the plants' fine, ferny, blue-tinged foliage. In the fully double forms, both stamens and pistils are replaced with petal-like sepals; the often graceful semi-doubles have some extra petals, but their flower form is not pompon-like and the presence of yellow stamens is part of the attraction. As well as a number of white doubles and semi-doubles, there is the deliciously coloured, rose-pink double, *A. thalictroides* f. *rosea* 'Oscar Schoaf', which was found in a Minnesota graveyard

in the mid-twentieth century. These slender, slow-growing plants flourish in sandy, humus-rich soils and woodland settings. Their clusters of flowers are produced, on stems rarely more than 15 cm/ 6 inches long, over a long period, though they appear mainly in mid- and late spring.

The charming precision and symmetry of double hepaticas may elicit admiration but double primroses inspire affection, as they obviously did in the case of William Robinson when he wrote of them in *The English Flower Garden* in 1883: 'No sweeter or prettier flowers ever warmed into beauty under a northern sun than their richly and delicately tinted little rosettes.' These endearing plants have a long history: both Gerard (1597) and Parkinson (1629) mention double yellow primroses; later, double reds are recorded and by the end of the eighteenth century there are several double purples and mauves, and a double lavender. The most famous Victorian introduction is 'Marie Crousse', which is light purple with a very narrow white edging and occasional white flecks in the petals. Today there are numerous varieties. We can grow lovely, neat whites, such *Primula vulgaris* 'Alba Plena' and the late-twentieth-century *P.* 'Dawn Ansell' – who comes complete with leafy green ruffs around her ivory-white flowers. There are pretty pinks (*P.* 'Ken Dearman') and desirable violet-blues (*P.* 'Blue Sapphire'), and deep and dangerous colours are present in, for example, the dark violet, white-edged blooms of *P.* 'Miss Indigo', and the rich reds of *P.* 'Captain Blood' and *P.* 'Corporal Baxter'. Not all of these are old cultivars by any means, and it seems likely that the original double-flowered variety of *P. vulgaris* no longer exists (although frilly *P.* 'Val Horncastle' is one lovely, pale yellow alternative). *P. vulgaris* 'Lilacina Plena', however, may well be the same as the 'double lilac Primrose' illustrated in the *Botanical Magazine* of 1793 (its synonym, 'Quaker's Bonnet', would not find favour among modern plant-namers). Recent developments have resulted in semi-double Primrose Group primulas for conservatories, spring bedding and so forth. They include mixtures, such as the Primlet Series, with flowers that are, at first, neatly scrolled and which can begin to open from late winter onwards.

Double polyanthus-type primulas (which have several flowers gathered at the top of each stem) have existed since at least the late eighteenth century. 'Two thousand double Spinks', an old word

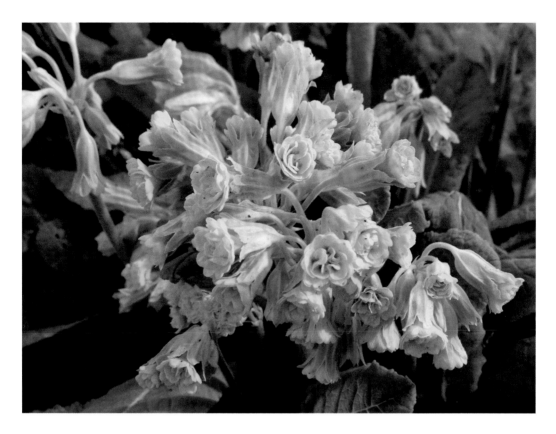

Primula veris 'Katy McSparron' is a modern form of the double cowslip – a vigorous grower and strongly scented.

for these plants, were specified for borders at Heriot's Hospital in Edinburgh in about 1720. Compared with double primroses, the current range of widely available, named varieties is much smaller. Like double primroses, they too retain a certain simplicity, despite their extra petals. Interestingly, that champion of the informal, William Robinson, recommended both single and double polyanthus-type primulas for the planting of mossy banks, alongside uncomplicated shade lovers such as dog's tooth violets, lily of the valley and cyclamen. Although the Elizabethans grew double and hose-in-hose varieties of cowslip (*P. veris*), nowadays only one newish introduction, *P. veris* 'Katy McSparron', is readily available; its clusters of multi-petalled flowers are rich yellow. Unlike double primroses, which tend to be only very lightly scented, the flowers of this plant have a pronounced fragrance that is sweet and clean. Cool, lightly shaded places and moist soils are ideal for all these captivating spring flowers, some of which may not be very vigorous but all of which repay frequent lifting and dividing by producing numerous blooms.

As quaint as double primroses and with a garden history that is probably just as long, the older, small-flowered double daisies (*Bellis perennis*) make surprisingly delicate ingredients for spring planting schemes. Indeed, in *Wall and Water Gardens* in 1913, Gertrude Jekyll was advocating the inclusion of a 'white double Daisy' in a yellow-and-white grouping that also featured 'double Arabis . . . palest yellow Wallflower [and] yellow Primrose'. White varieties of *B. perennis*, including 'Alba Plena' and 'Miss Mason', have long been popular, but the soft pink 'Dresden China', with its quilled ray florets, is also much admired and there are several crimson forms that are sold under the name 'Rob Roy'. The densely double flowers are usually not much over 3 cm/1¼ inches wide and the plants themselves are only about 10–15 cm/4–6 inches high; at least in the mature blooms, the central yellow disc florets are visible. To ensure they produce double rather than single flowers from year to year, these daisies need to be divided frequently. *B. perennis* Pomponette Series varieties are similarly small-flowered doubles, available in white, pink and red, which are usually seed-raised and treated as biennials. All these plants like well-drained, moisture-retentive soil and a fairly open site.

No tour of quaint and charming doubles would be complete without violets. In northern gardens, double-flowered Parma violets need to be grown under glass, but other descendants and hybrids of *Viola odorata* with double flowers will bloom happily outside, mainly from early spring but from late winter in mild regions. Their tufted carpets of semi-evergreen growth are happiest in lightly shaded places and in rich, retentive soils that do not dry out in summer. Small (commonly about 1–2 cm/½–¾ inch wide) but powerfully scented, the flowers of sweet violets, double and single, have been cherished for centuries. The *Camerarius Florilegium* (about 1590) shows *Viola odorata* beside three double-flowered variants – a white, a pale pink and a purplish form; for centuries after this illustration was created, the enormous sweet violet industry throve in Britain and France, until rising labour costs and other factors caused its disappearance before the Second World War. Recently, gardeners have become interested in these old-fashioned plants again and some varieties once thought lost forever have been rediscovered. One such rediscovery is *V.* 'Mrs David Lloyd George' (1915) a semi-double variety with mauve and white flowers of rather uneven

Narcissus 'Rip van Winkle', a Victorian daffodil, makes a small, neat clump despite its scatty array of petals – a good choice for damp shady meadows.

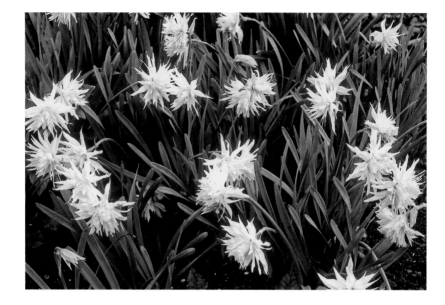

shape but a beautiful sweet scent. Slightly fuller double-flowered varieties include *V.* 'Comte de Chambord' (1895) and the self-explanatory *V. odorata* 'Alba Plena', both vigorous plants and suitable for small-scale ground cover, the latter with palest cream, spicily scented flowers. The exceptional scent of double white violets has been noted by many gardeners, including Francis Bacon (1561–1626), who wrote 'that which, above all others, yields the sweetest smell in the air, is the Violet, specially the white double Violet.'

Even the double-flowered varieties of violets are modest creatures, but there are two other spring-flowering genera which offer some engaging double flowers and which are of richer colouring and less diffident demeanour: *Narcissus* and *Caltha*. Many of the extra-petalled daffodils are showy, others have a romantic air and some are elegant. But there are also one or two that are charming in a thoroughly unsophisticated way, and they include *N.* 'Telamonius Plenus' and *N.* 'Rip van Winkle'. First recorded as flowering in England in 1620, *N.* 'Telamonius Plenus' has long been naturalized in parts of Britain and North America. It is a vigorous and also a variable plant, and though growing conditions appear to affect flower shape, there may well be several forms of this variety. Flower size can vary considerably, from 6 cm/2½ inches to 10 cm/ 4 inches wide, and in some cases the trumpet alone is filled with extra petals, while in others the whole flower is an exuberant,

disorganized burst of yellow with touches of green and even some all-green petals. *N.* 'Rip van Winkle' (1884) has quirky little blooms, each about 5 cm/2 inches across, which are carried on 20 cm/8 inch stems. The quill-like petals are often green-tinged and their uneven length adds to the lively, unpretentious charm of the flowers. Both varieties begin to bloom towards the end of the early spring period. They are easily grown in most soils, in sun or light shade, and in short grass as well as in borders, but they are not suitable for hot, dry positions.

Yellow-flowered doubles of a very much tidier and thoroughly antique appearance are produced by varieties of *Caltha palustris* (kingcup or marsh marigold). Most of these flowers are tightly ruched, glistening 'buttons', each around 2.5 cm/1 inch across, their rich colouring underlined by the plants' shining, deep green foliage. Unfortunately, their names are a good deal less well ordered than their petal-like sepals, though the most commonly grown double, *Caltha palustris* 'Flore Pleno', is nearly always correctly labelled. This variety has been grown since the very early seventeenth century (its dense, green-centred blooms appear in several paintings by Jan Brueghel the Elder). *C. palustris* var. *radicans* 'Flore Pleno' is a similarly sized plant – about 25 cm/10 inches tall – but it produces long, rooting stems and its flowers are even denser and more fully double. For a more relaxed flower form, there is the semi-double *C. palustris* var. *radicans* 'Semiplena', with only two rows of lighter yellow 'petals'.

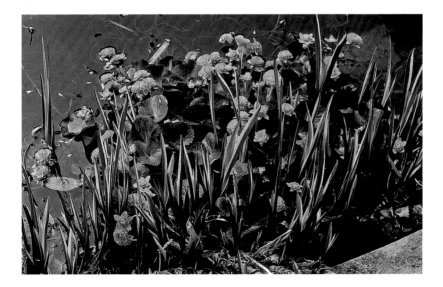

Caltha palustris var. *radicans* 'Flore Pleno', a double form of kingcup or marsh marigold, is a dependable plant for damp soils. It flowers over a long period in late spring.

These moisture-loving plants flower for weeks in mid- to late spring and are at their best in wet and boggy soils in sunny spots.

So many of the quaint and charming early-flowering doubles grow close to the woodland floor that some taller plants are welcome. Cultivated since the eighteenth century, *Polygonatum odoratum* 'Flore Pleno' is a variety of Solomon's seal with gently zigzagging stems that reach about 60 cm/2 feet high. From these stems are suspended clusters of pale cream bells with a heavy, sweet fragrance. The flowers appear in late spring and, though they are small (1–2 cm/ ½–¾ inch long), they are not only fuller than those of the species, but much more conspicuously marked with green. Like so many of the smaller plants described above, this perennial is an inhabitant of cool, lightly shaded places and retentive soils; unlike them, however, its habit of growth is sufficiently striking to make its colonies of leafy, arching stems decorative features in their own right.

Reaching higher still are the dark-twigged growths of *Chaenomeles* (flowering quince), the finely made, flower-filled branches of *Leptospermum scoparium* and the tendrilled stems of some early *Clematis*. Whereas the single-flowered forms of *Chaenomeles* are austerely elegant, the semi-double varieties – especially those in pale colours – are altogether more winsome. Varieties such as *C. × superba* 'Cameo' and *C. speciosa* 'Geisha Girl' are delectably peachy, and the white flowers of the less common *C. speciosa* 'Yukigoten' have the added attraction of being a beautiful pale green on first opening. *C. × superba* 'Cameo' grows to about 1.2 m/4 ft high but the other two varieties are taller, more upright plants; none produces anything other than a few apple-like fruits. All the blooms of *Chaenomeles* with extra petals are semi- rather than fully double and their conspicuous central 'eyes' of yellow anthers lend a charming simplicity to the blossom. These are thoroughly adaptable shrubs which produce their flowers, each up to 5 cm/2 inches wide, over a long period throughout spring (the earliest flowers open before the leaves emerge and may even begin opening in late winter).

Leptospermum scoparium (manuka or tea tree) produces flowers which are only about 1 cm/½ inch wide, but they appear in very large quantities among the tiny, narrow leaves. The fully double blooms of the popular variety 'Red Damask' resemble ruffled, deep crimson buttons, and 'Crimson Glory' has burgundy-coloured foliage as well as dark red flowers; in addition, there are doubles and semi-doubles

with white and with pink blossom. These Australasian shrubs, many of which are about 1.8–3 m/6–10 ft high, are plants for mild regions and moist, acid soils.

With their quantities of buoyant-looking, blue or violet-blue flowers, *Clematis alpina* and *C. macropetala* make the springtime world seem full of promise. European *C. alpina* has enlivened British gardens since the late eighteenth century, but it was not until 1910 that seed of Asian *C. macropetala* arrived in England. The nodding blooms of both these clematis have inner, modified stamens which are pale and petal-like, and these lift the tapering outer petals (which are, strictly speaking, sepals). The effect is more pronounced in the flowers of *C. macropetala* and its relations, all of which have long staminodes, than it is in the simpler blooms of *C. alpina*. However, there are selections and derivatives of *C. alpina* which appear fuller than the species, and these include deep purplish pink *C.* 'Constance' (1992) and paler *C.* 'Pink Flamingo' (1993), as well as the more recent (2005), almost fluffy, light blue *C.* 'Ocean Pearl'. There are interesting relatives of fuller-flowered *C. macropetala* too, such as the rich blue 'Maidwell Hall' (1956) and the unusually dark, purple-blue 'Purple Spider' (1993); paler varieties include 'White Swan' and the popular 1935 introduction, 'Markham's Pink'. As the illustration opposite shows, the soft mauve-pink flowers of this last variety make really pleasing embellishments of variegated shrubs such as *Weigela* 'Praecox Variegata'. Indeed, one of the advantages of these tough and trouble-free clematis is that they are not overly vigorous. Most of them tend to be no more than 3 m/ 10 ft tall and to have flowers roughly 8 cm/3 inches wide in the case of the *macropetala* types, around 5 cm/2 inches wide as far as the *alpina* types are concerned. They will prosper in most reasonably fertile, well-drained soils, particularly if they have a cool root run and their top growth has good light. After their flowers have faded, there are delightfully wispy seed heads to enjoy.

The other small-flowered clematis that many gardeners enjoy – and then sometimes regret planting – is *C. montana*. It may not flower for long during late spring and into earliest summer and, at 9 m/30 ft or more high, it may prove all too vigorous in some sites, but its blossom is produced with spectacular freedom. There are double-flowered varieties of this species too, many of them introduced in the 1980s and 1990s, and a few of them, such as the bronzed-leaved, fruity pink *C.* 'Broughton Star', are slightly more restrained in growth than the species. Both 'Broughton Star' and the cream-and-pink *C.* 'Marjorie'

Clematis macropetala 'Markham's Pink' flowers in mid- to late spring and, like most clematis, looks well when climbing through a shrub. The host in this picture is *Weigela* 'Praecox Variegata', which has flowers of the same shade of pink, but a little later in the season.

Easy-to-grow *Clematis* 'Maidwell Hall' combines well with almost all other plants. Its nodding flowers are impervious to rain.

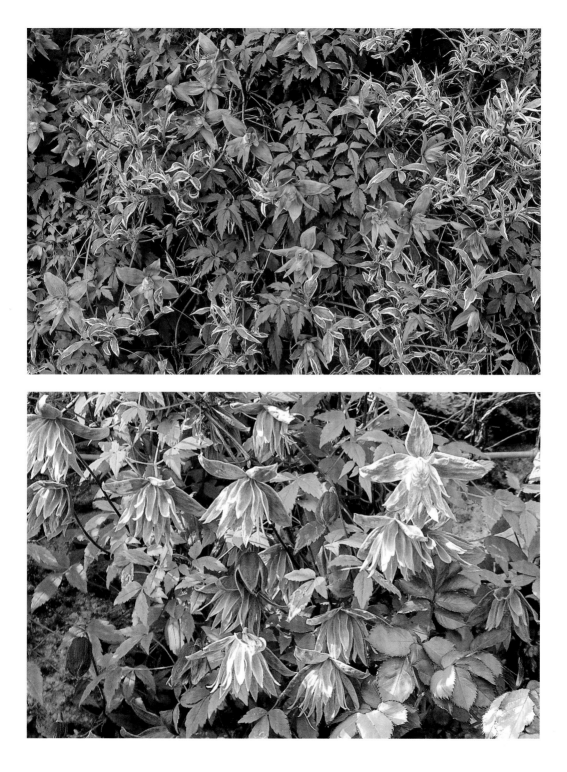

have one or two extra layers of petals surrounding greenish anthers. These two varieties produce their 5–8 cm/2–3 inches flowers freely but the pale yellow blooms of *C.* 'Star' (1996) appear in smaller numbers and they soon fade to white. For late-season small-flowered clematis see pages 98–99; for large-flowered double clematis see pages 258–260.

AS SPRING DEVELOPS INTO SUMMER, *C. macropetala* and its relations continue to produce their decorative, refined flowers. They are joined by numerous nostalgic doubles, including varieties of *Aquilegia* (columbine) and *Ranunculus* (buttercup) to which they are related, and evocatively scented, double forms of *Erysimum* (wallflower).

Double-flowered columbines are almost all derived from the highly variable species *Aquilegia vulgaris*, the offspring of which will readily interbreed to produce yet more variations on the theme. Varieties of *A. vulgaris* var. *stellata* have flowers made up of numerous pointed sepals; these plants associate very successfully with a wide range of other plants. Varieties of *A. vulgaris* var. *flore-pleno*, on the other hand, have distinctive, thoroughly quaint blooms composed of what appear to be bonnets-within-bonnets. Both these sorts of double columbine are easily grown in sun or light shade and any well-drained soil.

Further along the cottage garden path, in moister ground, is a trio of beguiling and well-behaved buttercups. They all have small, sterile and therefore long-lasting, densely petalled flowers which are of a thoroughly satisfactory neatness. *Ranunculus acris* 'Flore Pleno' (see page 58) is known as bachelor's buttons and has been delighting gardeners with its airy sprays of bright, shiny rosettes for over four hundred years. *R. constantinopolitanus* 'Plenus' is a relative newcomer, probably from the eighteenth century (though possibly earlier). Its vivid yellow, green-centred buttons are rather larger (up to 5 cm/2 inches wide) and they are carried, either in small sprays or singly, on lower-growing plants. In *Garden Flowers* (2000), Christopher Lloyd described the final member of the trio as a 'scintillating plant' and certainly the combination of precise white flowers and deeply cut dark green foliage shines with superior quality. This star of the buttercup world is *R. aconitifolius* 'Flore Pleno', or fair maids of France (though sometimes the maids come from Kent). At about 60 cm/2 feet tall, it is somewhere between the two yellow-flowered doubles just described and

The gleaming white flowers of *Ranunculus aconitifolius* 'Flore Pleno' catch the eye because they are held well above their foliage. They are not large, but repay close scrutiny because each is neatly packed with row after row of tiny petaloids.

happier in shade than either of them. In midsummer, after its long-lasting flowers have faded, the whole plant dies down. Even those plantsmen, such as Sir Arthur Hort, who wince at the very thought of almost any double flower, can manage to say that there is 'nothing distressing' about the doubleness of this plant.

Varieties of the snowdrop anemone, *Anemone sylvestris*, such as 'Elise Fellmann' and 'Flore Pleno', are yet more clematis-columbine-buttercup relatives which produce dense, white, double flowers at the end of spring and beginning of summer. Compared to the white buttons described above, however, these larger (5 cm/2 inches wide), green-centred pompons lack clarity and precision. They are inclined to appear rather patchily over the carpets of deeply divided leaves (in sprays held about 25–38 cm/10–15 inches high) but they are long-lasting and also lightly fragrant, and the plants are easily grown in most soils, either in sun or in light shade.

All these spring-into-summer plants are from the Old World but there is one group of distinctly different and delightful New World plants, some of which produce flowers with extra petals. Selections of *Lewisia* such as *L. cotyledon* Ashwood strain and *L.* Sunset Group have variable proportions of semi-doubles and doubles in pinks, oranges and yellows – some of these candy colours are bright, others are soft and sweet. The flowers of these selections are elaborated

stars, each up to 4 cm/1½ inches wide, which are carried in generous sprays above succulent, evergreen foliage. Not always easy to grow outdoors in wet-winter climates, lewisias appreciate a humus-rich soil and require excellent drainage (they are very much at home in cracks and crevices). Interspecific hybrids which are more weather resistant are in the process of being developed and some of these plants also produce semi-double and double flowers.

Many quaint and charming double-flowered plants, though more elaborate than their single-flowered counterparts, are still sufficiently simple and natural-looking that they do not seem out of place in, for instance, meadow or woodland settings. Even in informal areas, it is often a distinct advantage that most of these plants do not spread or seed as widely as the single-flowered species. Blooming mainly during late spring and the earlier part of summer, these modest-but-not-too-modest plants include varieties of Old World perennials such as *Filipendula vulgaris* (dropwort), *Meconopsis cambrica* (Welsh poppy) and the greater celandine, *Chelidonium majus*.

The stems of *Filipendula vulgaris* 'Multiplex' are so laden with pretty flowers that they tend to bend over unless propped up by other thick plantings.

Chelidonium majus 'Flore Pleno', which has probably been grown since the seventeenth century, produces double yellow flowers (each about 2.5 cm/1 inch wide) in loose heads. Its slender, upright stems are about 75 cm/2½ ft high and clothed in divided foliage; the whole effect is gentle and unassertive. The plant grows – and generates numerous, predominantly double-flowered seedlings – almost anywhere. *C. majus* 'Laciniatum Flore Pleno' has semi-double flowers and finely cut leaves; it too comes mostly true from seed.

Lovely and luminous though its simple yellow or orange poppies are, *Meconopsis cambrica* produces so many seedlings in some British gardens that it becomes a nuisance. The various forms sold under the name *M. cambrica* 'Flore Pleno' are much more restrained self-seeders. Their 5 cm/2 inches wide, thin-stemmed flowers vary from

double to semi-double (often within a single specimen) and they are most commonly some shade of orange. The apricot-coloured semi-double 'Anne Greenaway' is almost sterile but it is not sold by many nurseries. All these varieties grow 30–45 cm/1–1½ ft tall and are in flower for many weeks. They are very adaptable plants, though they are happiest in a little shade.

Just the presence of a few extra petals also curbs the vigour and the self-seeding propensities of *Lotus corniculatus*, the bird's foot trefoil. When grown in grass, as part of a meadow mix for example, the extra petals of *L. corniculatus* 'Plenus' ensure the effect is not too thin and ineffective. Like the species, this is a variable plant which, when mingled with grasses, can be up to 30 cm/1 ft tall, but when grown at the front of an open border may be only 10 cm/4 inches high. The 1 cm/½ inch long, bright yellow pea-flowers emerge from orange buds above a ground-covering mass of spreading stems and tripartite leaves. This is a plant for light soils and sunny sites, conditions which also suit *Filipendula vulgaris* 'Multiplex', the double-flowered variety of dropwort. In rich, moist soils this plant's slender, 45 cm/1½ ft flower-stalks tend to flop, but given a sparse, preferably alkaline diet and some grass to compete with, the 10 cm/4 inch wide heads of tiny, bronze-budded, ivory-white flowers remain upright.

Like the double-flowered dropwort, the double-flowered variety of meadow saxifrage, *Saxifraga granulata* 'Flore Pleno', is a charming, old-fashioned perennial (it is the 'pretty maids all in a row' of the nursery rhyme). Its long-stalked clusters of little white flowers are looser but they too rise above low tufts of foliage and, even though it is often less than 30 cm/1 ft tall, this is another plant that is inclined to flop and therefore benefits from being grown in grass. Its preference is for moist soils and a little shade. The plant dies down and disappears during summer.

In sites that are moister still – streamsides and cool, damp meadows, for instance – the various double-flowered varieties of *Cardamine pratensis* (lady's smock or cuckoo flower) make captivating additions. Interestingly, whole populations of exclusively double plants are not uncommon in the wild, for even though the flowers lack any normal sexual parts, the plants reproduce themselves by means of plantlets which form in the basal leaf rosettes. Double varieties were popular plants in the eighteenth century (a 'Double Cuckou Flower' appears in *Twelve Months of Flowers*, 1730) but they were cultivated well before

then and a double form is illustrated in the 1629 edition of *Hortus Eystettensis*. Nowadays, most plants sold under the name *C. pratensis* 'Flore Pleno' have loosely double flowers (each about 2 cm/¾ inch wide) of a tender, lilacy pink; the plants are about 23 cm/9 inches tall. *C. pratensis* 'William' is slightly smaller and has double flowers which are a deeper lilac; 'Edith' is also small but its strange flowers-within-flowers are carried in broader, more conspicuous spikes.

Another little moisture lover, *Lychnis flos-cuculi*, or ragged robin, has a double-flowered variety that is useful where the effect of the species' relatively few, very deeply cut, pink petals would be just too wispy and sparse. Double-flowered ragged robins have a long history and both pink and white varieties were familiar plants during the nineteenth century in Britain and America. However, until the introduction of *L. flos-cuculi* 'Jenny' a few years ago, they seem to have disappeared from late-twentieth-century gardens. Like the species, the variety is a slender plant with its 4 cm/1½ inch flowers sitting on top of upright stems about 60 cm/2 ft high.

A heady scent combined with a long history is enough to make some double flowers seem irresistibly quaint and charming. Gardeners have treasured double wallflowers certainly since the seventeenth century, probably for longer, and they were very fashionable ingredients of Georgian and Victorian planting schemes. The simultaneously warm, spicy and refreshing fragrance of wallflowers is even more potent in the double-flowered forms. Some seed companies may list one or two semi-double varieties but, nowadays, the best known of the doubles are two sterile perennials which must be propagated from cuttings. Both the deep brown-red *Erysimum cheiri* 'Bloody Warrior' and the clear yellow *E. cheiri* 'Harpur Crewe' are fairly short-lived plants, though full sun and really good drainage will help to prolong their lives. They both grow about 30–38 cm/12–15 inches high and their upright spikes of 2 cm/¾ inch wide flowers open over a long period from about mid-spring onwards. The variety 'Harpur Crewe' was discovered – or probably rediscovered – by the Victorian clergyman Henry Harpur Crewe, but the black and the greenish yellow doubles mentioned by Margery Fish in *Cottage Garden Flowers*, in 1961, await a twenty-first-century rediscovery (though there are those who doubt if they ever really existed – see Brickell and Sharman's *The Vanishing Garden*, 1986).

Latter-day Harpur Crewes have been successful in rescuing some almost extinct double-flowered varieties of *Hesperis matronalis* (dame's violet or sweet rocket). Early in the nineteenth century, there were several double-flowered varieties of these short-lived, sterile perennials, including – in Britain – a striped double; until recently, any double was hard to find, but the white 'Alba Plena' and the lilac 'Lilacina Flore Pleno' are now available once more. Compared with the single-flowered varieties, these doubles are longer lasting and their sweet fragrance is even stronger. They are happy in sun or light shade and a reasonably moist and fertile soil, where their loose spikes of 2 cm/¾ inch flowers will reach about 60 cm/2 feet high.

The captivating little pendent bells of lily of the valley (*Convallaria majalis*), with their charming recurved tips, emit one of the richest and most delicious of all floral fragrances. In cool-summer climates and in shady sites with moist, leafy soils the species itself can spread so widely that it becomes a nuisance; the double-flowered form, 'Flore Pleno', increases much more slowly. Although two double-flowered varieties were recorded in late-eighteenth-century England, only the

plain white double remains, and the striped double seems no longer to exist; a double lily of the valley was being grown in New York State in 1829. Some double-flowered plants are sold under the name 'Prolificans', which should be reserved for a form where each flower is replaced with a little cluster of single flowers.

OLD-FASHIONED OR MODERN, single or double, pinks (*Dianthus* cvs) are, for many gardeners, the most charming of all flowers and the epitome of cottage-garden quaintness. Whether they are punctiliously patterned in Persian-carpet colours or immaculate in white or pale pink, these seemingly demure flowers are voluptuously fragrant. This extravagantly rich, deep, often clove-like scent is the sort that demands to be sniffed again and again.

Multi-petalled pinks appear in medieval illuminations, but the old-fashioned pinks that are popular today have their origins in the eighteenth and nineteenth centuries (a few may even be direct descendants of these old plants). 'Dad's Favourite' and the very

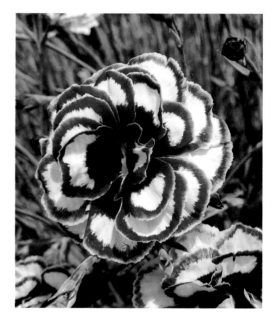

The double-flowered laced garden pinks such as *Dianthus* 'Dad's Favourite', shown here, are eye-catching and richly scented.

similar 'Paisley Gem' are examples of so-called 'laced', old-fashioned pinks. Their white petals are conspicuously margined in crimson and deep purple respectively and their 3–5 cm/1¼–2 inch flowers have deeply coloured central zones. There are also varieties that are an unadorned single colour: 'Rose de Mai' produces its fringed, exceptionally fragrant flowers earlier than most pinks and these 2 cm/¾ inch blooms are a uniform mauve-pink; 'Inchmery' has comparatively few petals, with almost smooth edges and of a soft, pale pink, and altogether the 3 cm/1¼ inch blooms have an air of neat and delicate simplicity; in contrast, the slightly larger, fringed and heavily scented white flowers of much-loved 'Mrs Sinkins' are splendidly untidy and the blooms of 'Bat's Double Red' are a rich pinkish red. This last plant, which is probably about three hundred years old, was thought lost until it was rediscovered in Oxford Botanic Garden in 1950.

Generally, old-fashioned pinks are in bloom for about three weeks from earliest summer; they are about 23–30 cm/9–12 inches high with tufts or mats of slender, greyish, evergreen leaves. These collectable little beauties are ideal for viewing at close quarters (as the eighteenth- and nineteenth-century florists knew well), but many of the oldest varieties have a rather weak constitution. Modern pinks are stronger growing and they produce several flushes of flowers from early summer to early autumn; they tend, therefore, to make rather better garden plants.

There are laced varieties of these newer pinks too, such as 'Gran's Favourite' and 'Laced Monarch' (the former, white with cerise-maroon edging and eye; the latter, bright pink with maroon-crimson centre and margins). Usually even more vigorous than these laced varieties are modern pinks with more-or-less uniformly coloured petals, including the famous, clove-scented, soft-pink 'Doris' (which does have red blotches at the centre), salmon-pink 'Diane', 'Haytor White' with its neatly formed and well-scented flowers, and 'Devon Wizard', also fragrant, with red-centred, bright cerise blooms. These last four plants are roughly 30–38 cm/12–15 inches high. Their strong-stemmed flowers are about 5 cm/2 inches or more wide and good for cutting. The hundreds of varieties of pinks, old and new, all revel in sunshine and well-drained, preferably alkaline soil.

Though the development of pinks with highly decorative blooms now has a long history, these flowers were originally used to impart their clove-like scent and flavour to food and drink and, at that time, their colouring and form were quite simple. Not surprisingly, there are plenty of other plants with a similar history, and these include double-flowered varieties of medicinally useful plants such as camomile (*Chamaemelum nobile*) and feverfew (*Tanacetum parthenium*). Indeed, it is the double flowers of *Chamaemelum nobile* 'Flore Pleno', with their smaller than normal yellow central discs and lower proportion of very potent alkali, that are used to produce camomile teas. The deeply lobed, sharply aromatic leaves, rather than the flowers, of feverfew were used to prepare a tonic, and to act as a moth-repellent. Several double varieties of *Tanacetum parthenium* are available, including full doubles, some of which come true from seed ('Plenum' and the ivory-white 'Snowball', for example) and some of which, like 'Rowallane', are sterile or nearly so; yellow doubles, such as 'Butterball', also exist. Throughout the nineteenth century in America, *C. nobile* 'Flore Pleno' was very popular for

The double forms of feverfew, *Tanacetum parthenium*, are useful companion plants for the front of the border.

edging and bedding, and it is still useful as a pretty and rather demure accompaniment for many plants. The double flowers of camomile and feverfew are buttony daisies, up to 2.5 cm/1 inch across, with central discs which are nearly always yellow and sometimes only partially visible. 'Flore Pleno' flowers at the beginning of summer and forms a mass of sprawling stems and divided leaves which is less than 30 cm/1 ft tall; double feverfews are more upright plants that bloom a month or so later and are usually around 30–60 cm/1–2 ft tall. Both plants like light soils and sunny sites, though feverfew will tolerate a little shade.

Other double daisies with unassuming charm include the double form of scentless mayweed, *Matricaria perforata* 'Bridal Robe'. This old-fashioned cottage-garden plant produces pure white, yellow-disced flowers, each about 4 cm/1½ inches across, which 'are good both in the garden and for cutting', said Jekyll. It is an easily grown, sun-loving hardy annual, up to 45 cm/1½ ft high, with a low mass of dark, finely divided foliage. *Kalimeris pinnatifida* 'Hortensis' also has white and yellow flowers, each 2.5 cm/1 inch or so across, with a ring of well-spaced white petals around a lemon-yellow anemone centre. This upright perennial blooms for several months from early summer, is about 90 cm/3 ft high and is easily grown in a range of soils, including those that are quite moist. It flowers best in sunny positions. Marguerites (*Argyranthemum* hybrids), including popular

Argyranthemum 'Vancouver' flowers all through summer and autumn. However it is slightly tender; some back-up plants taken as cuttings in early autumn will provide useful insurance against a hard winter.

pinks such as anemone-centred 'Vancouver', double 'Summer Melody' and pompon-shaped 'Mary Cheek', are slightly tender to half-hardy daisies often used for filling summer containers in sunny sites. They are exceptionally free-flowering plants which produce their white, pink or yellow flowers from late spring to early autumn, and their finely cut leaves and rather open habit of subshrubby growth give them an informal grace and delicacy which are most appealing.

One group of daisy-like flowers, often regarded as thoroughly old-fashioned and quaint, is the various 'everlastings'. Crisp-textured and very precisely pointed, the petal-like bracts of these flowers retain their shape and colour beautifully when dried. The height of their popularity, both in America and Europe, coincided with their use during the nineteenth century as 'chimney flowers' – that is, for setting in empty fireplaces in summer – and, especially in France, as components of funeral wreaths (and this was a time, too, when northern regions did not import cut flowers from around the world during the colder months). Taller varieties of, for instance, strawflower, including *Xerochrysum bracteatum* Monstrosum Series, are still popular for cutting and drying today, while smaller, bushier varieties, like *X. bracteatum* Sundaze Series, are used for edging or filling containers (the former plants are seed-raised and treated as half-hardy annuals; the latter are vegetatively

propagated). Their 5–8 cm/2–3 inch double flowers come in various sunny and pastel colours. The plants thrive in full sun and fertile, well-drained soils.

Non-daisy denizens of the cottage garden include various members of the *Lychnis* and *Silene* genera, which usually bloom in summer. Double-flowered forms of rose campion (*L. coronaria*) were more popular than singles in Britain in the eighteenth century, but later they seemed to have vanished from gardens (the double red was still grown early in the twentieth century in the USA). However, in recent years, the variety Gardeners' World has appeared. Its pale, widely branching, 60 cm/2 ft stems rise above grey, felted leaves and carry deep red double flowers (each just over 2.5 cm/1 inch wide). These are long-lasting and sterile – and therefore not the extravagant seed-producers that the single blooms of the species can be. *L. viscaria*

Silene dioica 'Flore Pleno'. The double-flowered forms of wild campion turn a hedgerow weed into a first-class garden plant for late spring display. They flourish in shade where they do not dry out at the roots.

'Splendens Plena' flowers slightly earlier in summer than *L. coronaria* 'Gardeners' World' . Its loose little rosettes of searing magenta-pink punctuate dark, sticky, upright stems about 30–38 cm/12–15 inches high. Earlier still – often starting in late spring – and about 60 cm/ 2 ft tall, *Silene dioica* 'Flore Pleno' produces similar, loosely double, white-centred flowers of intense rose-pink, again on erect stems. This variety of red campion was very popular in Elizabethan times. Today, there are various pink-flowered doubles and semi-doubles, all with clumps of neat, dark green foliage – except for 'Thelma Kay', which has variegated leaves. All the *Silene* varieties are easy-going plants with a preference for a little shade and a moist but well-drained soil. In contrast, the *Lychnis* like sunny sites; *L. coronaria* thrives in poor, dry soils, while *L. viscaria* will do well in all soils with good drainage.

For fragrance as well as cottage-garden charm there are the various double-flowered forms of soapwort (*Saponaria officinalis*) and sweet

william (*Dianthus barbatus*). The soapworts are erect-stemmed, usually invasive plants which have been cultivated for several centuries (a white double, for example, appears in *Twelve Months of Flowers*, 1730). They are easily grown in most soils with reasonable drainage. In late summer, their slim buds open into sweet-scented, rather relaxed double flowers which are carried in clusters up 60–75 cm/2–2½ ft stems. Each bloom is about 2 cm/¾ inches wide. The variety 'Alba Plena' has white flowers that fade to pale pink (the flowers of the less widely available variety 'Betty Arnold' remain pure white as they age); 'Rosea Plena' has pale pink blooms; 'Rubra Plena' has red flowers that fade to pink. Gertrude Jekyll included double pink soapwort in her September aster border, along with *Sedum spectabile* and Japanese anemones.

Nowadays, most sweet williams are single. The low-growing, double, dark crimson form, grown since the seventeenth century, may have disappeared, but the Victorian 'Duplex Mixture' has been reintroduced and some seed catalogues list their own 'Double Flowered' mixtures. These mixtures include double, semi-double and some single flowers in various shades of red, pink and purple, as well as some bicolours and white – combinations of colours and patterns that sparkle and glow. The most fragrant of the flowers emit a sweet, spicy fragrance. They are carried in dense heads, 8–12 cm/3–5 inches across, on strong stems about 38–50 cm/15–20 inches high; they last well when cut. The plants, which are usually treated as biennials, prosper in sunshine and a well-drained, slightly alkaline soil.

THE FRAGRANT SUMMER FLOWERS most frequently associated with the cottage garden are, of course, roses. Quaint or charming double roses that look as if they might have grown in an English cottage garden (typically of the nineteenth century) tend to have flowers of a rather flat or a globular shape. Though these flowers are full, they are not usually densely crammed with petals.

Amongst the huge number of possible varieties, there are, for instance, old American Noisettes from early in the nineteenth century, including the deliciously pale pink, spicily scented 'Noisette Carnée' (which is best grown as a climber) and globular-bloomed, sweet-scented Bourbons, such as carmine-pink 'Reine Victoria' (1872) and its silvery pink sport 'Madame Pierre Oger' (1878). The Moss roses and their relatives also have old-fashioned charm. They include dark crimson 'Nuits de Young' (1845) and pure rose-pink *R.* × *centifolia*

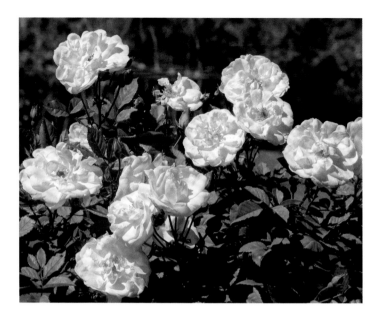

'Cristata' (1826), both of which have a rich, warm scent (as a quirky bonus, 'Cristata' has thickly 'mossed' buds that are said to resemble the shape of Napoleon's hat).

There are quaint and charming flowers among the Polyanthas too: the sweet-scented, pale shell-pink flowers of the Sweetheart Rose, 'Spray Cécile Brünner' (1881; and its sport, 'Climbing Cécile Brünner', 1894) are, at first, just like perfect, scrolled hybrid teas in miniature, while the flowers of 'White Pet' (1879) and 'The Fairy' (1932) are white and pale pink, respectively. All these pretty Polyantha flowers, each around 4 cm/1½ inches across, are produced in generous sprays over many weeks.

Of more recent introduction, the so-called English roses combine old-fashioned charm with a long flowering season and excellent fragrance. Many produce large blooms and these are lavish and romantic rather than charming, but some smaller-flowered varieties include Scepter'd Isle (1996), with cupped soft pink flowers, and Snow Goose (1996), which has relaxed white pompons and which can be grown either as a shrub or a climber. There are smaller-flowered plants among Patio roses too. They include Sweet Dream (1988), which is one of the best-selling British roses ever. Its many-petalled flowers are a soft peach-pink, slightly fragrant and each about 5cm/2in wide; they are produced over a period of several months.

LEFT TO RIGHT *Rosa* 'Noisette Carnée'; *R.* 'Madame Pierre Oger'; *R.* 'Nuits de Young'. These nineteenth-century cottage garden roses, all double-flowered or semi-double, have scent and charm.

Miniatures of all sorts have a special charm and the fairly recently developed Miniature Climbing roses, such as yellow Laura Ford (1989) and salmon pink Nice Day (1994), may be only slightly fragrant but they are clothed from top to bottom in neat, semi-double or double flowers, each less than 5 cm/2 inches across. Given a warm, sheltered wall, the much older rambler *R. banksiae* 'Lutea' (1824) produces masses of fully double flowers of an exceptionally delicate yellow. Each scentless late spring bloom is only 2–2.5 cm/¾–1 inch wide. Older still (from 1789 or perhaps earlier) is the miniature Centifolia rose 'De Meaux' with its neat, many-petalled rosettes of a pert mid-pink. Each slightly scented bloom is only 4 cm/1½ inches across and the plant itself is no more than 90 cm/3 ft high. Captivated by the 'quaint demure charm' of this particular rose, Eleanour Sinclair Rohde made the arch observation in *The Scented Garden* (1931) that 'all the old diminutive roses' have 'the same fascination as paintings of children by the old masters'.

OVERLEAF
'The Fairy' is a popular Polyantha rose, one of the most useful shrubs for mixed plantings and very easy to grow.

Plenty of alluring miniatures are to be found among what might loosely be called rock-garden plants, and some varieties of these produce charming double flowers in summer. Most widely available are various forms of *Campanula* and *Dianthus*. *Campanula cochlearifolia* 'Elizabeth Oliver', for example, was discovered in 1972 in an English garden.

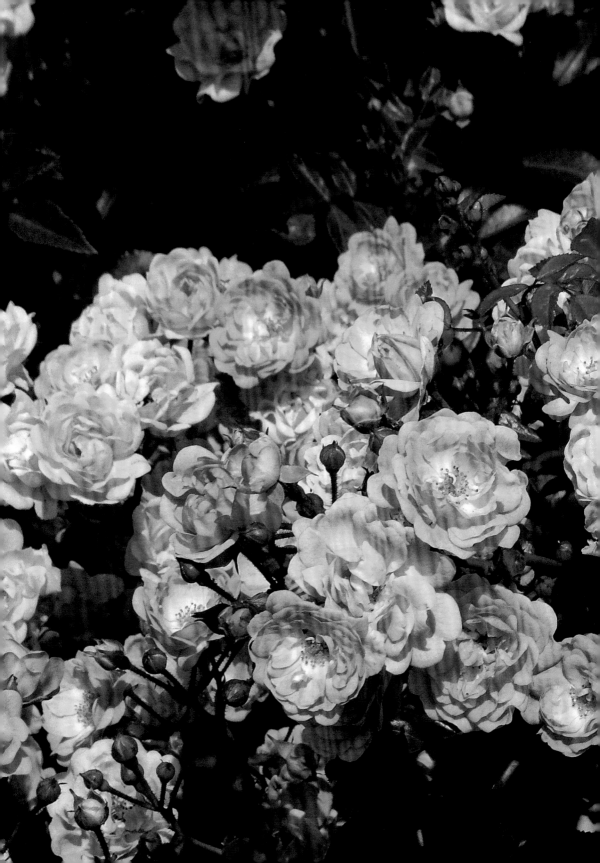

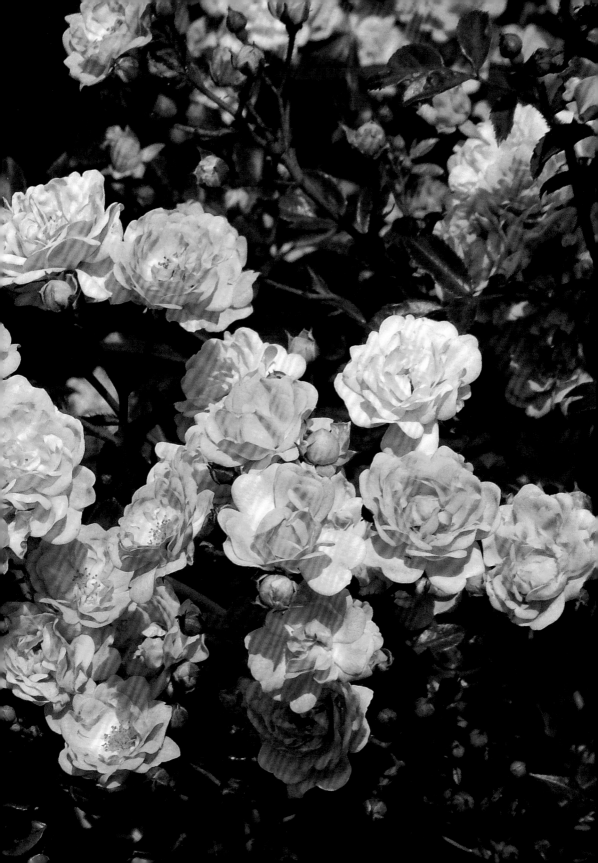

It has bell-shaped flowers of a pale, greyish lavender-blue, and though each of these nodding flowers is only about 1 cm/½ inch long, they appear in blithe-looking crowds above the slowly creeping roots of this little plant. *C. × haylodgensis* 'Plena' is an older, related hybrid – the original, single-flowered cross was raised in Scotland in 1885 – with almost fluffy, light blue, bowl-shaped flowers of about twice the size (there are also double white varieties of this hybrid). Both these plants like sun, good drainage and a moisture-retentive soil. Of the two, 'Elizabeth Oliver' is the earlier flowering, more accommodating and much less rust-prone; it can be grown in light shade.

The choice of doubles and semi-doubles is considerably wider among the so-called alpine pinks. These include enchanting little miniatures, none more than 15 cm/6 inches high, such as the pale mauve-pink, crimson-eyed *Dianthus* 'Little Jock' from the 1920s, and the equally pretty, fuller-flowered 'Pike's Pink'; there are also some pure whites, such as 'Devon Arctic Star', while the stronger-coloured varieties include deep carmine-pink 'Warden Hybrid'. The flowers of all these sun lovers are sweetly or spicily fragrant and 2.5 cm/1 inch or less across; they are carried above mats or cushions of thin, grey or glaucous, evergreen leaves. There are even a few double-flowered forms of the famous Cheddar pink (*D. gratianopolitanus*): 'Flore Pleno', which has been known since the sixteenth century, is yet more intensely fragrant than the species; 'Tiny Rubies' is a recent North American variety. Both varieties are about 10–15 cm/4–6 inches high with rose-pink flowers and tight, tufted mats of grey-green foliage; they relish a really well-drained alkaline soil and plenty of sunshine.

Outside of these two genera, there are few readily available double-flowered varieties among traditional rock-garden plants, though this is partly, of course, because rock gardening is not nearly so popular as it once was. *Saxifraga granulata* 'Flore Pleno' looks more at home in grass or at a border's edge than in a rock garden, while of the little 1930s mossy saxifrages with double flowers in white, red or pink, only the deep pink 'Dartington Double' is offered by more than a very few suppliers. *Petrorhagia saxifraga* 'Rosette' was first introduced to Britain in the mid-eighteenth century and its wiry-stemmed heads of fluffy pink flowers are as pretty as ever, but the plant is rarely for sale. The various double-flowered alpine asters – such as *Aster alpinus* 'Nancy Perry', a lavender-blue introduction of 1915 – have also fallen from favour. *Silene alpestris* 'Flore Pleno' is a little easier to find. Its numerous, starry white

flowers hover, on 15 cm/6 inch stems, above a tussock of slim, shiny leaves and last for weeks in early summer. Even longer-flowering and more readily available is *Erodium × variabile* 'Flore Pleno'. This close relative of the hardy geraniums produces 5 cm/2 inch high clumps of pretty scalloped leaves and these are spangled with semi-double, red-veined, pink flowers throughout the summer months.

Many contemporary gardeners associate rock gardens with a certain stiff artificiality and aim for a more relaxed look to their own plantings. For them, there are plenty of easy-going, summer doubles with a charming air of informality about them. As well as the *Silene* and *Saponaria* mentioned above, there are such plants as rock roses (*Helianthemum*), sea campion (*Silene uniflora*) and various poppies.

Helianthemums were highly popular in early-nineteenth-century Britain, until the exceptionally cold winter of 1837–8 killed most of them – including some half-dozen double-flowered varieties. The delightful, tissuey blooms of these hummock-shaped plants are individually very short-lived, but numerous buds open in succession. Compared with the singles, the smaller double flowers – each about 2 cm/¾ inch across – last all day, rather than dropping their petals by early afternoon. Yellow-flowered varieties, such as 'Boughton Double Primrose' and 'Jubilee', are usually the strongest-growing doubles, but

Double-flowered rock roses such as *Helianthemum* 'Jubilee' (LEFT) and *H.* 'Mrs C.W. Earle' (RIGHT) keep their flowers for longer than the single cultivars. The petals may be untidily arranged but they never lose their colour or their overall impact.

there are good double pinks (such as 'Annabel') and double reds ('Mrs C. W. Earle', for example), as well as a few varieties with coppery or white flowers. All these little shrubs form hummocks of growth around 20–30 cm/8–12 inches high, and thrive in light, free-draining soils.

The double-flowered variety of sea campion, *Silene uniflora* 'Robin Whitebreast', is another sun lover with pretty, many-petalled blooms and a relaxed demeanour ('Swan Lake' is a very similar plant). Its white flowers, each about 2.5 cm/1 inch across, have an appealingly ruffled look and the plant sprawls happily in the sharply drained soils that suit it best. When the deeply notched petals have faded, the intriguing little inflated calyces behind them remain.

Sometimes it is the soft, obviously ephemeral growth of annuals that is just what is needed in informal plantings. However, in certain situations – where these short-lived plants are to grow beside the firmer forms of perennials perhaps – the single-flowered species may not have quite enough visual impact. Some of the very prettiest of fuller-flowered annuals – and most selections of these doubles do not have many extra petals – are to be found among poppies of various sorts, including the corn or field poppy (*Papaver rhoeas*). Thomas Jefferson grew 'Papaver Rhoeas flo. plen. double poppy' at Monticello in 1807 but forms of these double poppies have been cultivated since at least the early seventeenth century. Today, the best-known doubles and semi-doubles are selections and developments from the Angels' Choir Group and from the late-nineteenth-century Shirley Group; especially among the doubles of these groups, pale colours, such as misty lilacs and pinks, usually predominate over reds and oranges. These easily grown plants thrive in sunny places and well-drained soils. Their gossamer-petalled flowers, which are carried on stems 60–75 cm/2–2½ ft high, can be up to 8 cm/3 inches wide.

For drier, less fertile soils and really sunny places, dazzling drifts of the California poppy (*Eschscholtzia californica*) look entirely at home. Mixtures of these delicately made but exuberantly coloured plants include the vigorous *E. californica* Thai Silk Series. Their semi-double and single flowers are up to 6 cm/2½ inches across and their fluted petals come in shades of cream, pale yellow, orange, pink and red (there are also attractive single-colour Thai Silk selections such as 'Rose Chiffon' and 'Lemon Bush'). The semi-double and double flowers of the Ballerina and Monarch Art Shades mixtures come in a wide range of colours (Ballerina includes some bicolours and there

is a high proportion of 'hot' colours in Monarch Art Shades). Most of these plants are around 23–30 cm/9–12 inches high, with blooms up to 6 cm/2½ inches across and finely divided, often blue-grey leaves which contrast flatteringly with the colours and shapes of the flowers.

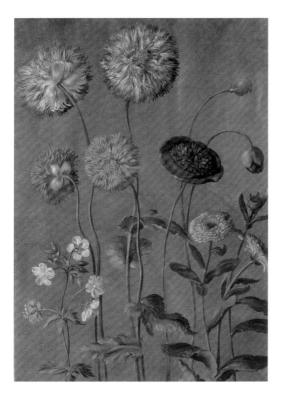

Iceland poppies (*Papaver nudicaule*) are perennials which are normally treated as annuals and biennials. Varieties produce flowers which, at up to 12 cm/5 inches across, are rather larger than those of the other poppies described here. However, the proportion of blooms with extra petals is usually quite low, and so the overall effect remains informal. Popular varieties include Meadow Pastels Group plants which include semi-double and double flowers of fiery as well as soft colours. Their clouds of satiny, crinkled flowers are carried on strong stems up to 60–75 cm/2–2½ ft tall. All double and semi-double Iceland poppies do, however, have to be regarded as fleeting pleasures since, when they self-sow, the forms with extra petals soon disappear. To grow well, *P. nudicaule* and its varieties need plenty of sunshine, as well as good drainage, but they do not thrive in hot-summer climates.

Double-flowered poppies have been known since at least the seventeenth century. This watercolour is by Johann Jakob Walther (1600–1669).

Papaver rupifragum 'Flore Pleno' also produces pretty, informal poppies with some extra petals. The silky semi-doubles, each about 5–8 cm/ 2–3 inches across, are of a most attractive pale terracotta shade and, although they are individually short-lived, there are numerous buds from earliest summer or late spring onwards. The plant is a short-lived perennial around 60 cm/2 ft high, with wiry stems which rise above grey-green lobed leaves. It is easily grown in any well-drained soil and, though preferring a sunny site, it will tolerate some shade. This semi-double form of the so-called Spanish poppy comes true from seed.

Many of the preceding plants are at their best in really well-drained or even dry soils, but there are one or two moisture-loving doubles

with winsome little flowers that open in mid- to late summer. They include the double-flowered arrowhead, *Sagittaria sagittifolia* 'Flore Pleno', with its dense white pompons, and *Houttuynia cordata* 'Flore Pleno', which has quaint little conical blooms, also white. However, the arrowhead's long flower spikes and handsome foliage make it a rather formal plant overall. In contrast, the houttuynia's orange-scented, decoratively heart-shaped leaves are fairly small (about 8 cm/ 3 inches long), and its flowers are dispersed over a leafy, 30–45 cm/ 1–1½ ft high mass of upright stems in a more modest arrangement. Though adaptable and vigorous, *H. cordata* 'Flore Pleno' needs some shade in hot-summer climates; elsewhere it can be grown in full sun in ordinary, moisture-retentive soil, though it will also do well in very shallow water.

A final, long-lasting flourish of charming double flowers is supplied by two small-flowered clematis. Looking like some delectable embellishment of superior upholstery (the Irish gardener Helen Dillon remarked that they reminded her of the hats that old ladies wear to church), the dense rosettes of *Clematis* 'Purpurea Plena Elegans' first begin to open in midsummer and continue into early autumn; each flower is about 6 cm/2½ inches wide and of a soft rosy purple. This clematis has been grown since at least the early seventeenth century. It seems very probable that *C. viticella* 'Flore Pleno', which was rediscovered and renamed 'Mary Rose' in 1981 and which has similarly shaped smoky purple flowers, has been cultivated for a similar length of time. Of the two plants, 'Purpurea Plena Elegans' is more vigorous, but neither will reach much above 3 m/10 ft high. Their slender growths and unobtrusive leaves make them ideal for growing through other climbers and shrubs, and most soils that are reasonably well-drained and moisture-retentive are suitable.

Clematis 'Purpurea Plena Elegans' is a useful late summer selection for growing through once-flowering shrubs like old roses. The flowers open slowly over a long period. Note the contrast provided by the paler backs of the unopened tepals.

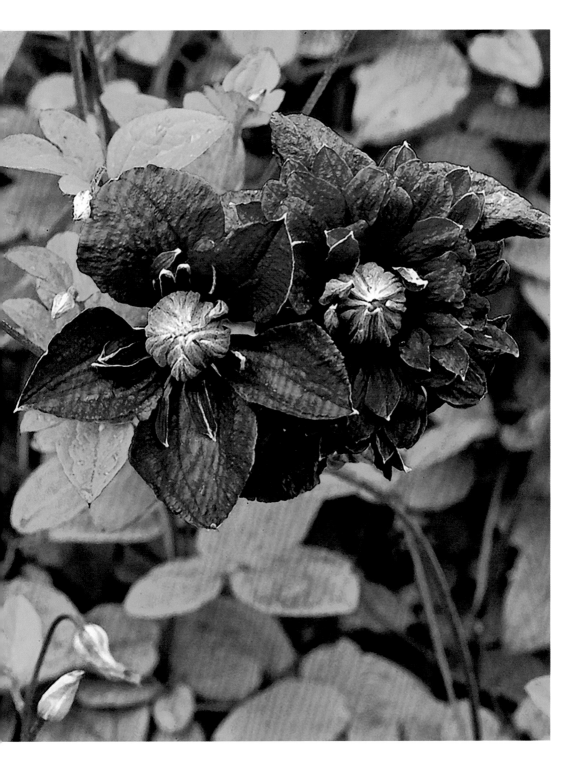

4 The Romantic and the Ethereal

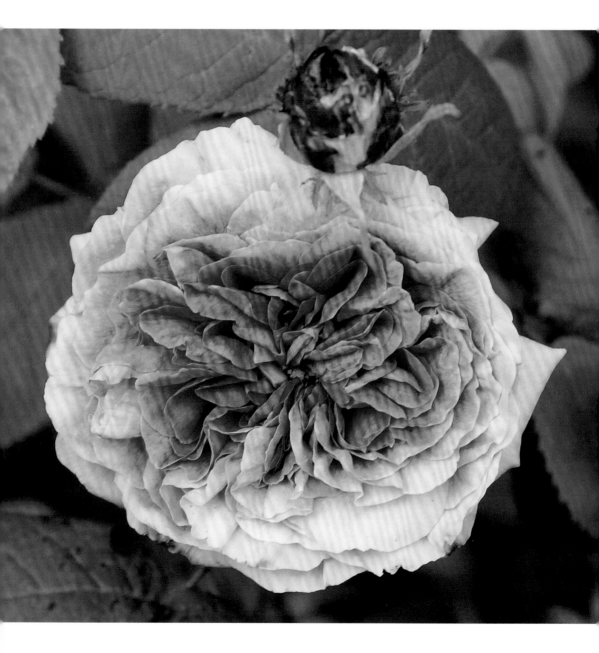

Here are the voluptuous roses and the voluminous peonies that so many gardeners find difficult to resist. And here too are the diaphanous floral clouds produced by *Gypsophila* (baby's breath) and *Thalictrum* (meadow rue).

These romantic and ethereal flowers combine to create a soothing, secluded and softly planted garden. They play complementary roles in creating this particular kind of garden effect but, in many cases, their contrasting styles combine very successfully, both outdoors and indoors, as the now-hackneyed duo of roses and gypsophila demonstrates. As a general rule, romantic doubles tend naturally to step into the limelight, while ethereal doubles are supremely successful as members of the supporting cast. But the traditional cottage style of planting them, where shapes and colours are thrown together without regard for how they relate to each other, may also be perceived as romantic.

In contrast to the doubles of the previous chapter, many of which are small-flowered, early-season charmers from the woodlands of the world, romantic and ethereal doubles tend to unfurl in the warmth of summer – though there are, of course, exceptions. Fully opened, their flowers or flower heads are often relatively large, with petals that are arranged in an informal style. Moreover, most romantic doubles produce multitudes of petals within their individual flowers, whereas ethereal doubles create great, gauzy masses with their numerous tiny flowers. All these floral features lend an air of fulsome generosity to both of them. As well as an aura of abundance, the two types of doubles share a somewhat similar colour palette. Deep, velvety maroon-purples and reds may be typical of the more luxurious romantic doubles, but there is a preponderance of pinks, whites and gentle blues among both romantic and ethereal double flowers.

The shape, colour and scent of *Rosa* 'Président de Sèze' combine to make it one of the most romantic of roses.

Romantic doubles can be florally sweet and cosy and among them are many nineteenth-century plants which, over a hundred years later and in their own particular way, have become imbued with the romance of the old. In this way, some of the double roses of the

previous chapter – certain Bourbons, Polyanthas and Moss roses, for instance – have acquired romantic connotations. So too have some double-flowered varieties of plants such as pinks (*Dianthus*) and columbines (*Aquilegia*), plants that are archetypical denizens of that haven of horticultural escapism, the nineteenth-century cottage garden. Though many of these older plants are softly coloured, some are of the deep, rich exotic tones which are redolent of heavily ornate and comfortable Victorian upholstery.

No matter how they have acquired their associations, many of the flowers that are perceived as romantic are fragrant. And since the cells that exude scent are often situated on petals, it follows that many blooms with extra petals are even more intensely fragrant than their single-flowered equivalents. The particular fragrance may vary considerably, but the essences that create the scent are usually an inextricable part of the allure of a romantic flower. Our perception of the miraculous pink confection that is *Paeonia* 'Sarah Bernhardt' would be very different if it were devoid of scent. And the so-called English roses, such as generous, cerise-pink Gertrude Jekyll, would not have been such a worldwide success without their intense fragrance.

The nineteenth-century 'language of flowers' (a somewhat inconsistent but once widely understood code for sending wordless messages between lovers) has also contributed to the belief that some flowers will for ever be regarded as romantic. It may be no more than a bit of Victorian whimsy, but the meanings that this language ascribed to certain flowers have persisted, even if the language itself has become obsolete. In the twenty-first century, both myrtle (*Myrtus communis*) and roses still signify love; jasmine, which in the past meant amiability, has become vaguely associated with romantic love too. Each of these 'significant' flowers was a customary ingredient of a Victorian bride's bouquet, and they all share a feature which many people consider essential to any flower that might be described as romantic: once again, that magical quality is fragrance.

There is also a special romance attached to plants with a long history or legend. It is triggered by the knowledge that, hundreds of years ago, these same flowers were loved and cherished by our ancestors. The flowers cited and praised in Shakespeare's plays and sonnets, Spenser's 'gather the Rose of love, while yet is time', and the pinks and columbines that adorn a fifteenth-century Italian painting of the Virgin and Child – these link us directly to a time and place that glow with nostalgia and romance, be it Elizabethan England or Renaissance Italy.

ROSES TOP THE LIST; they are almost by definition romantic. Their shapes, their scents, their long history and their omnipresence in both Western and Asian culture have made them the most romantic flower in the world. The rose is the national flower of several countries, including England and the United States, and roses are the favourite flowers in many others – the most grown and purchased, whether as a cut flower or for planting in gardens. You do not need to know the language of flowers to recognize the significance of one long-stemmed red rose, given or received. Scent is part of their mystique. Pliny the Elder in the first century AD observed that a freshly gathered rose 'has a more powerful smell at a distance, and dried when brought nearer', but the smell of plants was stronger in the morning, declining as noon approached. It may be that roses have been popular through the centuries precisely because they have always been fragrant – and, for most roses, that fragrance is intensified by having double flowers.

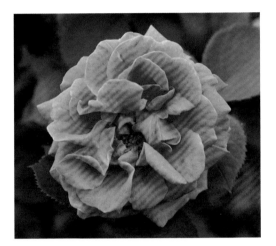

Sweetly scented *Rosa* 'Conrad Ferdinand Meyer'.

The sweet, warm fragrance of the Damask roses is still the key ingredient of the most prized (and expensive) perfumes of Grasse. Tea-scented roses often include in their perfume the scent of violets, which blends perfectly with the overriding aroma of China tea. Musk roses have the ability to float their perfume on the air, so their scent is perceptible from a distance. Many of their descendants among the Multiflora Ramblers, the Noisettes and the Hybrid Musks have inherited this carrying power. But Musk roses produce their spicy fragrance in their stamens rather than their petals. In double-flowered forms the stamens are converted to petaloids and so the scent is diminished. In most roses, however, the scent is carried by the petals, so double roses are indeed more strongly scented than single and, perhaps, also more romantic as a result. The wild *Rosa gallica* has a delicious scent – pure and sweet, but delicate – but fully double Gallicas like multi-petalled 'Ypsilanti' (1821) and swirling 'De la Maître-Ecole' (1831) have a more intense fragrance, of the same sweetness as their wild ancestor, but much stronger. The same is true of *R. rugosa* and its double-flowered descendants: the wild species has a sweet smell, but the double-flowered 'Conrad Ferdinand Meyer' (1899) and 'Rose

à Parfum de l'Haÿ' (1901), for example, have a luscious fragrance that far exceeds it. The English rose breeder David Austin employs a retired parfumier to advise him on scent; only a professional has the vocabulary to describe with complete accuracy the many different smells that roses offer.

Despite the expectation, however, that they should be powerfully fragrant, colour may change how we perceive a particular rose. Mary Rose (1983) is an easily grown David Austin rose with large flowers, each a loosely ruffled mass of pure pink petals, lavishly borne. It is the sort of rose that you expect to have a smell – and it does not disappoint. Instinctively you bend to inhale its spicy scent, an intriguing mixture of sweetness and myrrh. Mary Rose produced a white sport called Winchester Cathedral in 1988: it is exactly the same as Mary Rose in all its details, except for its colour. But it does not tempt you to give it the merest sniff. In fact, it smells as strongly as Mary Rose and shares the same complex fragrance; the point is that we do not expect it to do so – pink roses are more promising, more romantic than white. Yet striped roses, many of which are the result of mutation, often seem more exciting to us than the more sober varieties from which they sprang. The enchanting semi-double *R. gallica* 'Versicolor', commonly known as Rosa Mundi, is much more of an eye-catcher than the red rose of Lancaster, *R. g.* 'Officinalis', from which it sported. Striped roses appear more showy and artificial; the irregularity of their markings renders them at once romantic and old-fashioned, with a suggestion of quaintness and quirkiness, and also companionable, in so far as their several colours make them useful for linking other plants to a complex colour scheme.

ABOVE LEFT
People are often surprised to realize that white *Rosa* Winchester Cathedral has the same delicious scent as its parent, rose-pink Mary Rose.

ABOVE RIGHT
Rosa gallica 'Officinalis', the red rose of Lancaster, has a romantic history but is less immediately appealing than (RIGHT) its striped sport, 'Versicolor', commonly known as Rosa Mundi.

Rosa 'Alba Semiplena', the white rose of York, can be identified in paintings dating from many years before the Wars of the Roses.

The history of roses in cultivation is a long one. Indeed, roses were the first double flowers to be described in writing, by Theophrastus in the third century BC. In the classical period cut roses were imported to Rome from Egypt, where they flowered earlier; in Rome itself astute nurserymen pruned their plants hard and late, so that they could be had in flower when all other roses were spent. We cannot know whether any of the roses that we grow today are actually varieties that were grown by the Romans, though it seems unlikely. The oldest of which we have a record are Gallica roses in thirteenth-century paintings. One of them is associated with St Francis and still grows in the cloister of his basilica at Assisi, but it is, to modern eyes, a fairly weedy plant with an unimpressive flower. Varieties like *R. gallica* 'Officinalis' and *R.* 'Alba Semiplena' begin to be recognizable in paintings from about 1400 onwards and these were soon followed by the first Damask roses and, in the seventeenth century, by the opulent Centifolia roses that we associate with Dutch flower paintings.

The horticultural history of the rose and its cultural resonances are, of course, intertwined. Before Henry VII surrounded the white rose of York with the red rose of Lancaster as his personal affirmation of dynastic legitimacy, roses had moved from their connection with pagan festivals to their endorsement by St Benedict in the sixth century

as emblems of the Virgin Mary. In *The Name of the Rose* (1980), Umberto Eco described the rose as a paradox: 'the rose is a symbolic figure so rich in meanings that by now it hardly has any meaning left.' Few gardeners or lovers of flowers would agree with that. For them a rose means beauty – ravishing, super-saturated beauty – quite apart from what it has contributed to our literature, religion, art, pharmacy and, of course, our gardens.

It comes as a surprise, looking back, to discover that roses did not become the most popular flowers in Europe and North America until about two hundred years ago. Pinks and auriculas were more highly esteemed in the eighteenth century, despite the championing of roses by porcelain-makers, couturiers and eminent fashionistas like Mme de Pompadour. In 1750, probably no more than twenty rose varieties were grown in Europe and North America, of which the most conspicuous were the almost globular, sweet-scented Centifolia roses – so-called because they have at least a hundred petals – including the mossy cultivar 'Muscosa'. Three factors combined in about 1815 to set the rose on its track to stardom. First, there was a sudden increase of interest in horticulture generally. Second, there was an explosion of rose breeding by French nurserymen. And third, a number of repeat-flowering roses were introduced from China which, when crossed with the once-flowering Gallicas and Damasks in Europe, gave rise to such hybrids as the Bourbon roses and Hybrid Perpetuals, which combined the best of both parents. By 1840, hundreds of new roses were being introduced every year and the whole rose trade was bent on improvement and novelty. Almost all modern roses, including the Hybrid Teas and Floribundas, are the result of crossing the older European roses with varieties from southern China, notably the tender Tea roses and the hardier China roses. These oriental roses have a long history of cultivation – 'Old Blush' appears in a tenth-century Chinese painting – but they made a crucial contribution to the development of the fully double, repeat-flowering, strongly scented roses that we expect and enjoy today. It may not seem like constant progress to us, looking back, but rosarians have always believed that new roses are better than old. Most of the myths that beleaguer roses are also modern: Damask roses were not brought from the Holy Land by returning crusaders, nor was the gorgeous striped Gallica Rosa Mundi, named for Henry II's mistress 'the Fair Rosamund'. Nevertheless, myth is sometimes more potent than truth, and the fact that these stories have been deeply absorbed into popular culture contributes considerably to the romance of the rose.

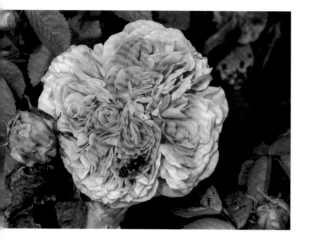

Double roses come in many different shapes. The elegance of the Teas, and more especially of their stronger-growing descendants the Hybrid Teas, is seen at its best in the shape of their half-open buds. Few are so seductive, however, when their flowers are fully open. By contrast, the older roses, notably the Gallicas, Damasks and Centifolias, hold little promise while still in bud but display their greatest beauty when their flowers are fully open. Often their petals (strictly speaking 'petaloids') are arranged in a complex pattern that may be described as quartered, scalloped or rosette-shaped, though on other occasions they may be too loosely held and ruffled to form a consistent pattern. This variability is part of their charm, part of the fascination they hold for all flower lovers. More than fourteen thousand different varieties of garden roses are sold around the world today; add in the special cultivars grown for cut flowers and the thousands of long-forgotten roses that still survive in someone's garden somewhere, and you have the measure of their enduring popularity.

We do not expect other plants to flower continuously, but since most roses are repeat-flowering, we tend to assume that all roses will be. However, most old roses flower only once; nonetheless, these varieties have such spectacular colours, shapes and scents that they have survived through to modern times despite open competition from perpetual-blooming roses. Old Gallicas are the quintessence of romance, beautifully set off by soft green leaves and so useful for cutting. 'Président de Sèze' (1836) opens out to reveal a quartered centre and an enchanting mix of pink, magenta, lilac and grey; 'Gloire

ABOVE LEFT
Rosa 'Gloire de France' is the epitome of the romantic Gallica rose, but flowers only once.

ABOVE RIGHT
Rosa 'Jacques Cartier' is a repeat flowerer, rain-resistant and strongly scented.

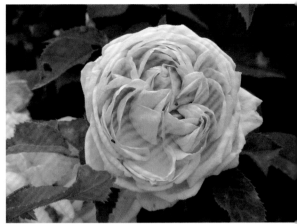

ABOVE LEFT AND RIGHT *Rosa* 'Mme de la Roche-Lambert' and *R.* 'Mme Louis Lévêque' are Moss roses. The mossy growths upon their sepals and calyces smell of pine trees, but the flowers themselves have a sweet rose scent. Both are repeat flowerers.

de France' (1828) offers an even more complex swirling mass of pink and palest pink. Both are easily grown and very hardy shrubs whose huge flowers usually have more than a hundred petals and a delicious sweet fragrance.

A few old roses flower more than once: the best known is 'Quatre Saisons', the reblooming form of the original Damask rose, as elegant and sweetly scented in autumn as in summer and an easy garden plant, happy in all soils, that reaches 1.5 m/5 ft. Portland roses are dependably remontant, as well as being tough, hardy and easy to grow – look out for 'Rose de Rescht', whose round buds open to exquisitely neat, pale crimson flowers, and 'Jacques Cartier' (1868), whose flowers are stuffed with pale pink petals and stand up well to rain. Almost all the Bourbon and Hybrid Remontant roses are likewise easy and vigorous, including the 'thornless' rose 'Zéphirine Drouhin' (1861), whose stems are completely without prickles – a wonderful shrub or short climber whose semi-double flowers have the richest, sweetest scent of all. The oldest Moss roses – their sepals, calyces and pedicels are covered in a green or brown growth that resembles moss but is hard and sticky and smells of resin – are all once-flowering, apart from 'Quatre Saisons Blanche Mousseuse' (as sweetly scented as the Damask rose from which it sported), but the later Moss roses like crimson 'Mme de la Roche-Lambert' (1851) and clear pink 'Mme Louis Lévêque' (1898) frequently flower again well into autumn. Victorians loved Moss roses; the presence of moss gave the flowers an extra dimension. Although it is simply assumed nowadays that roses will flower repeatedly, even continuously in a warm climate, their status as the world's most loved

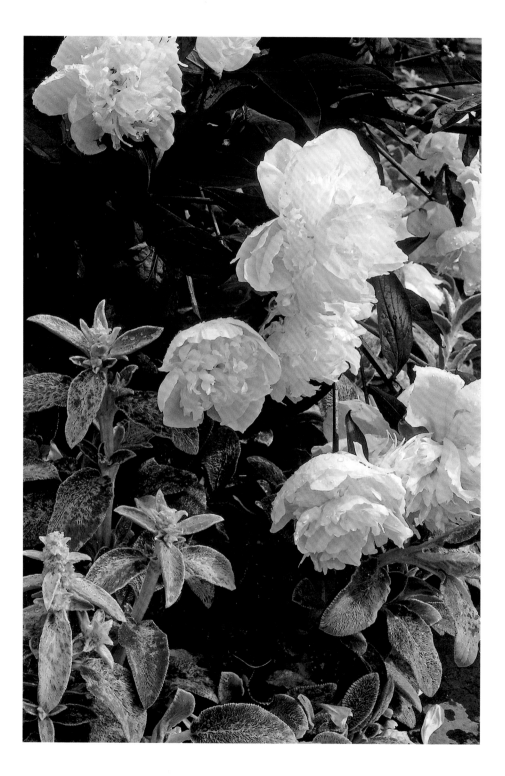

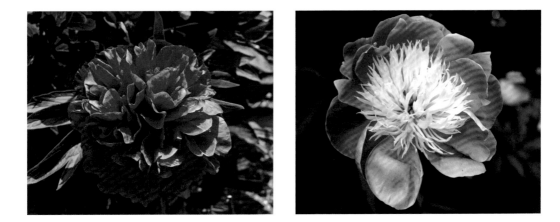

ABOVE LEFT
Paeonia officinalis
'Rubra Plena'.
The oldest known
double peony,
traceable back to the
sixteenth century.

ABOVE RIGHT
Paeonia 'Bowl of
Beauty', which has
a mass of petaloids
at its centre, has
remained popular
ever since its
introduction in 1949.

LEFT
Paeonia 'Duchesse
de Nemours' is a
hardy, vigorous and
popular nineteenth-
century peony.

and most romantic flower comes from the size and shape of their flowers and their exquisite scent. And they are the most abundantly flowering of garden plants, too.

WHAT CAN MATCH ROSES for their romantic connotations? No herbaceous flowers are more generous, spectacular and drop-dead gorgeous than peonies. Size matters – peonies are large and voluptuous. Single and double forms of *Paeonia officinalis* and *P. mascula* were certainly grown in European gardens in the sixteenth century. By 1629, Parkinson could comment that *P. officinalis* 'Rubra Plena' was common in 'everie Garden of note'. William Robinson grew it in long grass and commented, rather to his surprise, on how attractive the flowers were and how they well the plants grew in such conditions. The rarer white *P. o.* 'Alba Plena' also has a quiet, rich charm. These 'old cottage peonies' were the only ones known in Europe until a double form of *P. lactiflora* called 'Fragrans' was introduced from China in 1805. When several other varieties followed, all of them with a sweet scent (reminiscent of roses, too), the possibilities for breeding scented peonies with double flowers was too good to miss. French nurserymen started hybridizing in the late 1840s. Among their first introductions were two fully double white varieties that remain among the most popular of all herbaceous plants: rose-scented 'Festiva Maxima' has a few crimson splodges towards the centre of the flower, while 'Duchesse de Nemours' just has a hint of cream or yellow. These were followed by many other blowsy beauties with masses of petals: fully double, pale crimson 'Félix Crousse'; pale pink, semi-double 'Lady Alexandra Duff'; richly double, palest lemon yellow 'Laura Dessert'; pale pink 'Sarah Bernhardt',

whose ruffled petals create dark shadows towards the centre of the flower; and pale pink, very double 'Monsieur Jules Elie'. All are easy to grow in almost any sunny position, provided the soil is not too wet; they may need a few years to get established and grow to their usual height of 80 cm/2½ ft, but thereafter they will bring forth more and more flowers year after year.

When English and American breeders started to produce hybrids a generation later, there was no end to the wonderful peonies introduced into gardens in the twentieth century. So many were raised by American breeders that only a small number of them are known in Europe. But one European hybrid stands apart from all these floral battalions – P. 'Bowl of Beauty', which was introduced by a Dutchman, Aart Hoogendoorn from Boskoop, in 1949, and has bewitched plant lovers ever since by its rich pink flowers absolutely crammed with regularly shaped, creamy-white, petaloid stamens. So popular did it become in the 1960s and 1970s that a number of snobbish gardeners opined that actually it was rather vulgar or, at least, not quite in the best of taste. The truth is that it is a masterpiece of the hybridist's art and has deservedly remained popular ever since its introduction – in some countries, it is still the most widely sold of all peonies.

All double peonies make wonderful cut flowers and many are scented, too. They are not easy to place in an arrangement, because the heavier varieties with long stems do not always stay in place. But if they are shown in a vase of their own, crammed in together and cut not too long, they look sumptuous – the double whites, like P. 'Duchesse de Nemours' and P. 'Festiva Maxima', are especially stunning. In the garden, each variety performs differently. They do not all flower simultaneously but at varying times over a period of about six weeks – each cultivar being at its best for perhaps a week or ten days. For flower arrangers this is a positive quality, because it means that the high season for double peonies is prolonged and they are available for a long period. The dates and sequence of their flowering vary a little from year to year. Lovers of cut flowers can adjust to this – they see what is looking promising in the garden with a view to cutting it, whereas gardeners try to make contrasts and harmonies in their beds and borders and may be disappointed if, in the event, these do not always synchronize as planned. But none of these qualifications can ever detract from the voluptuous loveliness of double peonies – the most sumptuously romantic and the least ethereal of all herbaceous plants.

ABOVE
The ornamental
cherry *Prunus*
'Accolade' flowers
in February,
providing a
foreshadowing of
summer's romantic
opulence.

THERE ARE SEVERAL FLOWERING TREES that can properly be
described as romantic, and they all put on their best display before the
roses and peonies of early summer. Theirs is the blossom of spring,
of brighter skies and lengthening days and dewy dawns, when a
young man's fancy turns to love. Flowering cherries are harbingers
of summer's lazy, romantic opulence. The Japanese cherries belong
mainly to chapter 6, but the history behind their arrival in our gardens
fits more easily here. When Japan was opened up to Western travellers
in the middle of the nineteenth century, visitors were intrigued by
the very high level of civilization among the Japanese, and baffled by
the strangeness of their culture. The cult of the cherry blossom was
one aspect that particularly fascinated them. Throughout Japan, but
especially at Kyoto and Edo (Tokyo), people would admire the cherry
trees in flower in spring with much greater intensity, almost a spiritual
reverence, than Westerners reserved for their favourite flowers.
Families and friends would meet to eat and drink under the branches
of a cherry tree. Cherry blossom was a symbol of purity and simplicity,
it was fragile and ephemeral, it cleansed and revived the spirit, and
it represented a new beginning. Its fleeting beauty was moreover a
reflection on mortality.

OVERLEAF
Prunus 'Shirotae'

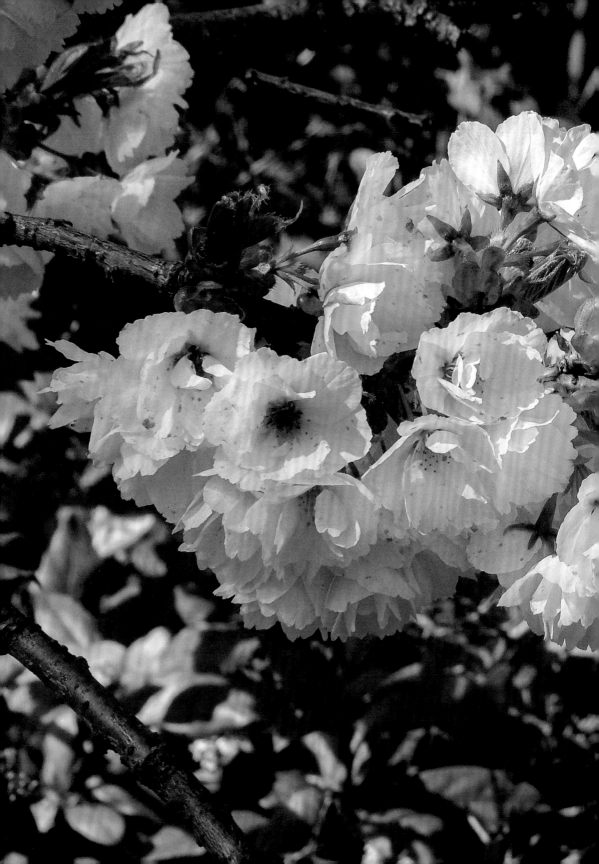

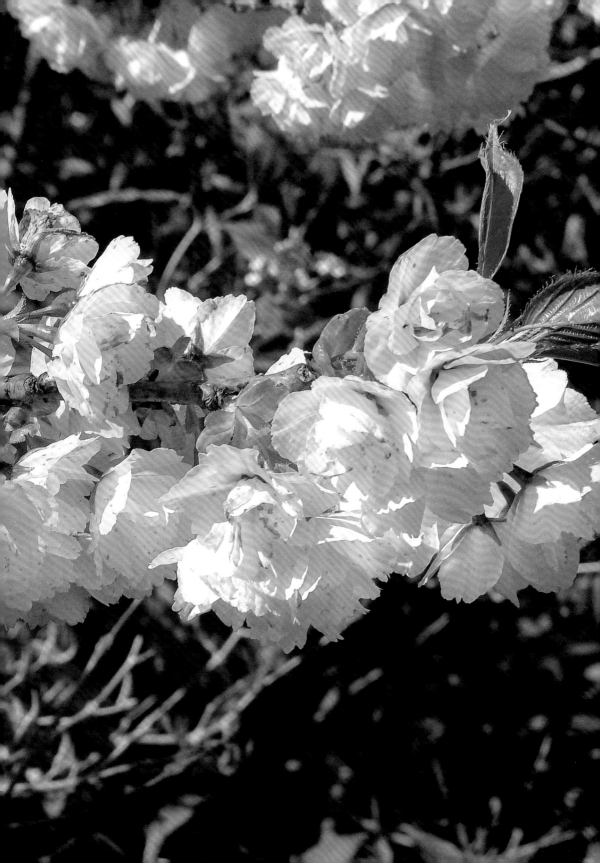

These were difficult concepts for Westerners reared on Christian spirituality, and they interpreted the Japanese love of cherry blossom as something more romantic – a worship of beauty, a symbol of young womanhood, a stylized profession of love. Then, safely back home in Europe or North America, they planted cherry trees for love of their delicate transient beauty.

There are more than two hundred varieties of flowering cherries in Japan. Taxonomists usually place them under *Prunus serrulata*, but some are closer to *P. speciosa* and many are hybrids with *P. subhirtella*, generally known as *P. × yedoensis.* Two further species, *P. sargentii* and *P. incisa*, may also have contributed to the genetic mix. All are easy to grow, if often short-lived, and they are never so tall that they will not adorn even the smallest garden. *P.* 'Shirotae' (syn. *P.* 'Mount Fuji') carries mainly semi-double white flowers, about 5 cm/2 inches in diameter, with 10–20 petals and an almond fragrance. The flowers have a sweet simplicity and open earlier than most varieties; as a bonus, the tree has magnificent autumn foliage, rich orange-yellow and red. Even earlier into flower is *P. × subhirtella* 'Autumnalis', an old Japanese variety that opens its first flowers in autumn and produces them intermittently in mild weather right through until spring. In the dry winters of Tokyo and Kyoto, when the absence of rain turns lawns and grasses brown, the small, semi-double pale pink flowers of 'Autumnalis' are a welcome reminder that life endures. Other forms of *P. × subhirtella,* such as 'Pendula Plena Rosea' (sometimes called *P.* 'Yae-shidare-higan', and all the more romantic for its elegant weeping shape) flower only in spring, albeit early. *P.* 'Accolade' often flowers in February in the south of England. 'Accolade' has a curious origin: it was raised from seeds sent from the Arnold Arboretum in Massachusetts to the Knap Hill Nursery in Surrey and is thought to be a cross between *P. sargentii* and *P. × subhirtella*; its dark pink buds open to pale pink flowers 4 cm/1½ inches across, with about 10–15 petals. It has an air of ethereal delicacy lacking in the dazzling abundance of later-flowering, more fully double cherries.

One further *Prunus* species bids fair to be considered romantic for the promise it brings by flowering in late winter: the Japanese apricot, *P. mume.* A cultivar called 'Omoi-no-mama' is immensely popular in China for its white or palest pink, semi-double, cup-shaped, sweet-scented blooms, 2½ cm/1 inch across, on bare stems. It is not a prolific flowerer in cool, temperate countries but puts on a magnificent display in a Mediterranean climate.

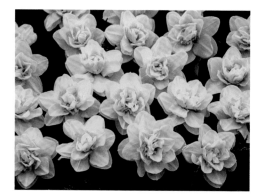

Narcissus 'Jack the Lad' is a tall, strong, modern double daffodil that makes a long-lasting cut flower.

IT IS PERHAPS ONLY NATURAL to conjure up visions of flowering cherries in an English garden, but their blossom is all the more rewarding if it is underplanted by daffodils. It is difficult to generalize about the *Narcissus* varieties, because they are so variable. Some are flamboyant, many are rare and some are certainly romantic, but what is true of a single-flowered species may not be so correct when dealing with double-flowered hybrids and horticultural selections. Doubleness among *Narcissus* can take many different forms – extra perianth members, extra petaloid stamens, and split and duplicated coronas. Individual varieties may also vary in the structure of their doubleness and in any case there are enormous differences of size and shape between the different sections of the genus. The English expert Michael Jefferson-Brown came to the conclusion that it was best to consider double daffodils as 'interesting, useful and beautiful flowers even if regarded primarily as flowers and only secondarily as daffodils'. And although we know that all daffodils are really narcissi, it is not true that all narcissi are daffodils.

Though probably much older, double-flowered narcissi are recorded from the sixteenth century onwards. Tazettas, jonquils and pheasant-eye doubles had all been described by about 1730. Others certainly date back as far. No one knows when Queen Anne's Double Daffodil (*N.* 'Eystettensis', syn. *N.* 'Capax Plenus', see page 56) first emerged (it appears in Clusius's *Historia* of 1576), nor is it certain after which Queen Anne it was named. Some authorities link it to Richard II's wife, Anne of Bohemia, in the fourteenth century. In any event, part of the romance of this narcissus is its association with a queen far back in English history. It is also a flower of extraordinary beauty whose extra petals, uniformly cream-coloured, lie neatly layered up on top of each other, progressively smaller, in six little starry heaps piled up against the perianths. For many plantsmen, one glance at it is enough: love at first sight.

Nowadays the world of daffodils divides *Narcissus* varieties into thirteen sections. One of those is called 'Double' and it is the slot into which all double-flowered narcissi are placed, whatever their size, shape or colour. This makes it difficult to know what you are

buying from a bulb catalogue: the double-flowered narcissus may turn out to be much bigger or smaller than you expect. In effect, you are choosing a variety that might, if single, belong to any of the other twelve sections. It is no use turning to the lists of *Narcissus* varieties that have received an Award of Garden Merit from the Royal Horticultural Society, because the market is largely driven by novelty and most of the recommended varieties have been introduced in the last twenty years. It is a problem that complicates other flowers, such as roses and dahlias: new is beautiful, old is passé.

If new varieties disappear from catalogues and gardens after a few years, it is likely that your grandmother's wonderful old double-flowered daffodils are only to be found in old gardens. *Narcissus* 'Telamonius Plenus' (see pages 73–74) is one of the oldest double yellow daffodils – untidy but laden with nostalgia, and still widely grown, if seldom seen for sale. There is a special romance about a variety that is not much sold commercially but remains ubiquitous just because people fall for it and beg a bulb. Also widespread is *N.* 'Butter and Eggs', a double-flowered sport of *N.* × *incomparabilis*, which is an ancient cross between the sweet-scented *N. poeticus* and a trumpet daffodil. And *N.* 'Cheerfulness' (see page 216), a double-flowered sport of the Tazetta hybrid 'Elvira', is enchanting – just enough of the stamens have been converted into white petaloids to obscure the orange corona and turn it into a substantial three-dimensional flower. Its scent is one of the strongest and sweetest among all narcissi – a fragrance to inhale and savour and remember for ever.

THE AMERICAN POET ALAN SEEGER elegized the time 'when Spring comes back with rustling shade / And apple-blossoms fill the air.' Few flowers symbolize the pleasures of spring so completely as apple blossom, whose scent is so fresh and sweet and different from that of any other flower and whose pollen attracts thousands of insects. Stand in romantic expectation under an apple tree in flower and listen to the industrious hum of bees: it is one of the greatest joys of spring. Domestic apple varieties do not produce double flowers – it would reduce their fertility and limit the size of their crop in autumn – but there is great beauty among the flowering crab apples, and their slightly later season of bloom helps them to take over and extend the delights of spring blossom when Japanese cherry trees fade and drop their petals. They are naturally companionable because their soft colours combine so well with the great abundance of late-spring-

The pretty pink flowers of *Malus* 'Van Eseltine' are followed by small crab apples.

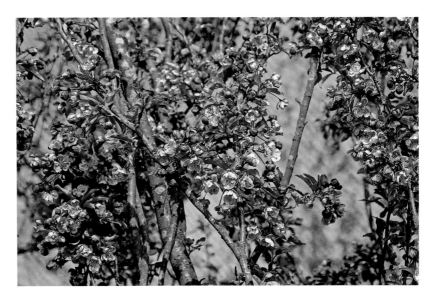

flowering plants, but they are also romantic in the way that so many flowering trees are – scent, colour, shape and profusion all seduce the senses.

Most of the ornamental apples with double flowers are only semi-double, so that they still produce a good crop of crabs in the autumn. *Malus* 'Katherine', for example, has small, bright red-and-yellow fruits in great abundance, following on from its semi-double pink flowers and their deep pink buds. *M.* 'Pink Perfection' is an exception: although its covers itself so thickly with pink-and-white flowers that the branches are invisible at blossom time, it only produces a few yellow fruits in autumn, though they are enough to give it a second season of interest. *M.* 'Snowcloud' is attractive for its large white semi-double flowers, which open from pink buds, are sufficiently numerous to give the tree its name, and produce a few small, yellow fruits in autumn. It has rather an upright habit but the most obviously fastigiate of crab apples – the apple equivalent of *Prunus* 'Amanogawa' – is the peerless *M.* 'Van Eseltine', whose habit is very narrow indeed, making it a really useful choice for small gardens. Its pale pink, semi-double flowers (5 cm/2 inches across) open from crimson buds and are followed by small yellow apples that have a red flush but tend to drop early in autumn. All are very hardy and easily grown in most soils, eventually reaching no more than 5 m/16 ft in height and flowering in late April or early May.

Two American crab apples are outstandingly beautiful and perform especially well in areas with hot summers that help next year's flower buds to form and mature, though they also require acid soil and are therefore not suitable for chalk gardens. *Malus ioensis* and *M. coronaria* are very similar, though the natural range of *M. ioensis* is centred on Missouri, Iowa and Illinois while *M. coronaria* comes from Indiana, Ohio and Wisconsin. Their double-flowered forms are very widely grown all over the world. *M. coronaria* var. *dasycalyx* 'Charlottae' produces quantities of large 4 cm/1½ inch semi-double, rose-pink flowers which smell strongly of violets, which is an unusual fragrance among trees and shrubs (though shared by the double-flowered form of *Rosa banksiae*). Graham Stuart Thomas described it as 'that most beautiful of flowering crab apples'. *M. ioensis* 'Plena' just smells sweetly scented, with no trace of violets, but also has large, pale-pink, semi-double flowers. There is little to choose between them for their combination of beauty and scent. Both *M. ioensis* and *M. coronaria* flower late, often not until June when the leaves are almost fully grown, and both have stupendous autumn colours of scarlet, orange and yellow. The trees will eventually reach 8 m/26 ft in height and their large, deliciously scented flowers last well if cut for indoor decoration.

SCENT IS A VERY IMPORTANT ATTRIBUTE of plants. It lifts them from the ordinary to the romantic, so that we associate them with love and happiness. The popular name for the flowers of *Philadelphus* is 'mock orange blossom', and their association with weddings is strong. Part of their appeal is the pure brilliant white of their petals, but even more suggestive is their rich, sweet smell. The bushes that bear the flowers are, apart from a few with variegated or yellow leaves, as dull as can be imagined, but once you cut the flowering stems and pull off the leaves, the flowers on the naked branches are transformed into objects of great elegance. Most of the hybridizing between species was undertaken in the nineteenth century, above all by the industrious Victor Lemoine of Nancy between 1880 and 1910. 'Bouquet Blanc', 'Dame Blanche', 'Manteau d'Hermine' and 'Virginale' are names that speak of whiteness; all were bred by Lemoine and all have double flowers. 'Manteau d'Hermine' makes a small, rounded bush, no more than a metre (three feet or so) tall, with little leaves and small but shapely flowers, while 'Virginale' may grow gawkily to as much as 3 m/10 ft and has larger flowers in longer sprays. And there are differences in their flowering time, too: by careful choosing,

one can enjoy *Philadelphus* in flower from May to August. All are easy-to-grow, unfussy shrubs, possessed of the strong, sweet, heady scent that characterizes the whole genus – a scent so strong that Gerard in his *Herball* of 1597 complained that 'in my judgement they are too sweete . . . I once gathered the flowers, and laid them in my chamber window, which smelled more strongly after they had lien together a few howers, [and] they awaked me from sleepe, so that I could not take any rest until I had cast them out.'

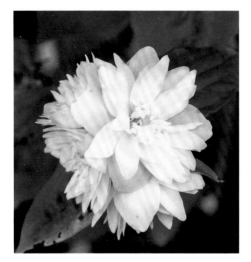

The sweetly scented flowers of *Philadelphus* 'Minnesota Snowflake' are popular for bridal bouquets.

In the twentieth century, American breeders took up Lemoine's reins and from about 1930 onwards bred *Philadelphus* hybrids that were hardy in the coldest parts of the United States and Canada. 'Buckley's Quill', 'Miniature Snowflake' and 'Minnesota Snowflake' are all double-flowered and highly scented. As with the Lemoine hybrids, they differ in size and habit: the English writer Robin Lane Fox described the 'clouds of snowing, scented flowers' of 'Minnesota Snowflake' all 'along its rounded shape, rising to eight feet [2.5 m] and curving to the ground', though its vigour may eventually render it almost tree-like in size.

'Mock orange blossom' is only one of the popular names for *Philadelphus*. There is another one that has given rise to much confusion – 'syringa'. Although syringa-with-a-small-'s' may be fine as a common name, *Syringa* (in italics with a capital *S*) is the botanical name for lilac – and it is the romantic charms of lilacs that we consider now. 'Go down to Kew in lilac-time (it isn't far from London!) / And you shall wander hand in hand with love in summer's wonderland,' wrote the poet Alfred Noyes. Actually, lilacs flower not in summer but in late spring, but that does not prevent the Royal Botanic Gardens from using the ditty to advertise the delights of a visit to Kew in May. It is the time of the year when many gardens look their best, and the sweet, rich smell of their flowers is one of the reasons why lilacs are so romantic, even though parfumiers say that the scent is difficult to make or copy, because lilacs do not exude an essential oil.

There is more symbolism attached to lilacs than one might suppose. In some versions of the Victorian language of flowers, lilacs symbolized

first love. In Kazakhstan, if you can find a lilac blossom with extra petals, it is considered lucky – provided you then eat it. But lilacs are grown all over the old world because of their extreme hardiness. In much of Eastern Europe, Russia and central Asia, lilacs are the most glamorous of the few flowering trees that always survive the winter cold. Nevertheless, the first extensive efforts to improve them took place at Nancy in France where, once again, Victor Lemoine and his family introduced 153 named varieties of lilac between 1876 and 1927. The first double lilac was a miserable plant; its tiny flowers had an inner ring of staminodes and very limited fertility. In occurred in a Belgian nursery in 1843 and Lemoine bought it in 1850. Lemoine's wife hand-pollinated this difficult, small-flowered, limited-fertility lilac during the occupation of Nancy by German troops in the Franco-Prussian War (1870–71). From these first crossings, made under such difficult conditions, only seven seeds resulted but one of the seedlings, which first flowered in 1876, was both larger flowered and double, and therefore easier to work with; it became the parent of numerous important lilac cultivars.

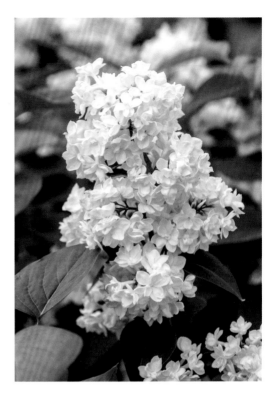

Syringa vulgaris 'Madame Lemoine' commemorates the lady whose careful pollinations gave us the first double lilacs.

Most of the earliest double lilacs are no longer in cultivation. *Syringa* 'Michel Buchner' (1885) is the oldest of the Lemoine varieties still fairly widely available. It has large, dense heads of palest lilac-mauve petals and conspicuously darker, pinker petal-backs, and is very sweetly fragrant. Other varieties followed that are still widely grown, above all 'Madame Lemoine' (1890), which is by far the best white lilac, with large, brilliant white flowers in dense, heavy flower heads. This is the most commonly encountered white lilac, and important in the cut flower trade, too; given Mme Lemoine's very important contribution to the development of modern lilacs, it is appropriate that this variety should remain so admired. Later came lilac-mauve 'Belle de Nancy' (1891), wine-red 'Charles Joly' (1896) and pale mauve-pink 'William Robinson' (1899).

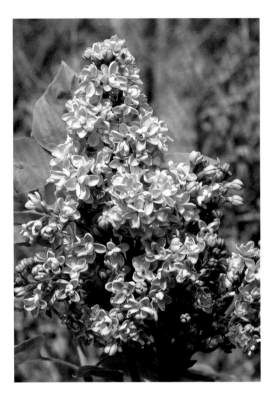

Syringa 'Katherine Havemeyer' is one of the most widely grown double lilacs.

More double lilacs have been raised in other parts of the world. The incomparable *Syringa* 'Katherine Havemeyer' (1922) was bred on Long Island by Theodore A. Havemeyer and named for his wife. A form of 'Katherine Havemeyer' with variegated leaves is sometimes seen in plantsmen's gardens and underlines the sad truth that most lilacs are rather dull trees and shrubs outside their glory weeks of flowering. But all these older lilacs are immensely hardy and tolerant of exposure and neglect; more than any other plant, they are found as romantic relics of cultivation on the site of long-abandoned cottages. And, though they will eventually grow to 5 m/17 ft, they are best pruned as bushes and kept to 2 m/6½ ft. Leonid Alekseevitch Kolesnikov (1893–1973) bred even larger-flowered lilacs in Moscow – the best known is *Syringa* 'Krasavitsa Moskvy', with huge pearly-pink double flowers. Richard Fenicchia (1908–1998) bred many exquisite doubles in Rochester, New York, and Father John Fiala (1924–1990) introduced multi-petalled double varieties in Ohio, including the exceptional 'Atheline Wilbur'. Meanwhile, Descanso Gardens near Los Angeles has for fifty years been selecting lilacs for hot climates where winter cold is not a prerequisite for flowering. Back in Western Europe, 'Madame Lemoine' is still widely forced in the Netherlands for cut flowers in winter and early spring. Give it to your beloved for St Valentine's Day; a sprig of sweet-scented white double lilac in February says much more about your commitment than a bunch of scentless red roses.

The common myrtle has been a symbol of love for thousands of years. In ancient Greece it was considered sacred to Aphrodite, the goddess of love, and it is still an integral part of wedding bouquets today. There is a plant of myrtle at Osborne House on the Isle of Wight that was planted by Queen Victoria and from which sprigs have been carried in bridal bouquets at royal weddings ever since.

This shrub is the single-flowered species, *Myrtus communis*, whose small white flowers have long stamens that seem to explode like a powder puff. Sweet-scented and dainty, it is a charming symbol of a bride's purity and her love for her husband. The double-flowered form, *Myrtus communis* 'Flore Pleno', is much more substantial, because each of the stamens is transmuted into a long petal, turning the dainty ephemeral flower into a gleaming mass of sweet-scented whiteness. As a symbol of love it is all the more reassuring than the nebulous single-flowered form, but both have an ethereal quality that makes them good companions for other plants, whether in the garden or in a vase.

HEATHERS ARE NOT INTRINSICALLY romantic plants – their flowers are too small to make a big statement, but they are very much bound up with romantic notions of the Scottish Highlands and lassies as sweet as the heather on the hills. White heather is considered lucky, or so the gypsies who sell it will tell you, and two excellent forms with double white flowers are *Calluna vulgaris* 'Kinlochruel' and *C. vulgaris* 'Alba Plena' (syn. *C. v.* 'White Bouquet'), which is, however, not reliably double in old age. Other good forms include shell-pink 'H.E. Beale', perhaps the most beautiful of all heathers, and early into flower too, as is its lavender-pink sport 'Elsie Purnell'; 'J.H. Hamilton', also bright pink but low-growing; and the short-growing,

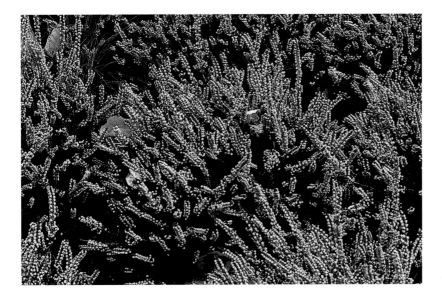

Double heathers are romantic reminders of Scottish legends. *Calluna vulgaris* 'H.E. Beale' is noted for its early flowering.

long-lasting 'County Wicklow', so laden with large puffy blossoms of bright shell-pink that they almost obscure the leaves. The flowers last for many weeks. What these all have in common is a beauty that is not lost by doubling, as happens unfortunately to the closely related daboecias, but actually enhanced because the flowers carry much more colour on their stems. Alas, since the 1960s and 1970s, fewer and fewer nurseries and garden centres stock anything but a very limited of number *Calluna vulgaris* varieties. Though northern gardeners still appreciate their good qualities, and they make excellent plantings for moorland gardens, it is a shame that these once highly popular plants have fallen from grace in most of Britain. Fashion is fickle, even when romantic. The same fate afflicts the double-flowered form of the Irish heath *Erica mackayana* f. *multiplicata* known as 'Maura', which produces vast numbers of bright pink flowers with their stamens replaced by petal-like segments that puff up the barrel-shaped bells. Even the Award of Garden Merit that 'Maura' once received from the Royal Horticultural Society has now been taken away from it and, like so many heaths and heathers, it has become a very rare plant. Fashion has a lot to answer for: formally designed heath gardens were popular in the 1830s and 1840s but very much less so by the end of nineteenth century. Then, in the 1960s, informal heather gardens were much made and much admired, whereas now their beauty and their romantic associations count for little.

THE FORMAL BEAUTY of many multi-petalled water lilies is celebrated in chapter 5, but it would be a pity not to celebrate other varieties since their beauty and the sentiments they evoke render them as much loved for their romantic associations as for their intrinsic charm. Long before the water lilies in Monet's garden at Giverny became the main study of his mature years, the flowers were already dear in our ancestors' affections. Their size, their regular shape, their pure colour and the way they emerge so pristine from muddy waters were sources of wonder long before the Lady of Shalott saw them from her tower. To know them well, to see them closely, to come face to face with their beauty, you should punt across the surface of a still lake in July or August, when dragonflies and damselflies rest on the lilies' leaves and foraging bees are mired in sticky, yellow pollen. Water lilies are romantic both for their sheer loveliness and for their place in history, poetry and art.

Until recently, Monet's little lake at Giverny was somewhat overrun by *Nymphaea odorata*, a sweetly scented but rather aggressive American species of water lily. Recent restoration has brought back many of the varieties that Monet is known to have planted. One of the most useful sources for identifying the correct ones turned out not to be his paintings but the order books of Latour-Marliac, the leading French water lily nursery, then and now. Among the varieties that Monet bought are pinky-red 'Arethusa' (Dreer, 1902); deep red 'Atropurpurea' (Latour-Marliac, 1901); *Nymphaea flava* (syn. *N. mexicana*), a species from Florida; deep pink 'James Brydon' (Dreer, 1889); pink 'Laydekeri Rosea' (Latour-Marliac, 1892); yellow 'Sulphurea Grandiflora (Latour-Marliac, 1888); and deep red 'William Falconer' (Dreer, 1899). Despite the great number of their petals, which make them look like doubles, these are actually single-flowered cultivars; true double-flowered water lilies have yet more petals. All are easy to grow, provided they are put in still water at the correct depth; vigorous varieties will flourish in shallow water, but short-growing water lilies cannot survive in water that is too deep for them.

Monet's experiments at Giverny – with colour and light, water and sky, reflection and reality – would have been all the more intriguing if he had had access to many of the water lily varieties that have been introduced since his death (one could say the same about Fantin-Latour and his roses). *Nymphaea* 'Charlene Strawn' is a modern classic with lovely, long, golden stamens and delicate, pale yellow flowers held well above the mottled leaves, while *N.* 'Perry's Pink' has shining mauve-pink flowers with orange stamens at the centre and leaves that open copper before turning green.

Lakes, ponds and pools are also havens for water irises. Most people's image of an iris is a 'bearded' iris (the section of the genus with fat rhizomes on the surface of the soil) but double flowers are widely found only among three quite different classes of irises – the Siberian *Iris sibirica* and two Japanese species, *I. laevigata* and *I. ensata* (which includes *I. kaempferi*). All are hardy and easy to grow, and manage to combine grace with beauty. *Iris sibirica* is the more useful since it combines with everything else in a not-too-dry border and brings the other plantings together. This explains why Siberian irises are also invaluable as cut flowers – they look well with everything. *I. ensata* and *I. laevigata* are less accommodating and do not associate so well in mixed plantings or in the vase, because they are such gorgeous

beauties in their own right (especially *I. ensata*) that they tend to steal the show. They may not be such good mixers, but it is hard to resist their powers of seduction.

There are hundreds of varieties of *Iris ensata* from which to choose. In Japan, they are among the most popular and highly bred of plants, so that only a fraction of the extraordinarily beautiful and variable forms has found its way into Western nurseries and gardens. Wild irises have a simple structure: they have three petals, which are called 'standards', and three sepals, which are usually larger and known as 'falls'. There are also three ways in which irises may become double-flowered. First, the stamens and style may be converted to petaloids. Second, another flower may appear within the first, creating what is essentially a hose-in-hose structure, even though it looks like a flower with six petals. Finally, irises may become double if their standards develop the same shape and colouring as their falls, in which case the flower keeps its stamens and style (unless they, too, are converted to petaloids, which is rare). *I. ensata* 'Moonlight Waves' is an example of this type; it appears to have six white petals, with a greeny yellow stripe down the middle. Other dreamy *I. ensata* varieties include violet-and-mauve 'Hercule', with flowers that curl down like an umbrella, and pale pink 'Pink Frost', whose falls have a pretty wave to their edges. All love damp, acid soil, while *I. laevigata* is really happier in water: two good Laevigata cultivars are 'Colchesteriensis', which has violet-blue markings around the edge of its petals, and white 'Snowdrift', whose styles have a purple stripe down the middle. As for *I. sibirica*, a highly variable species in the wild, the selection of improved forms is still in its early stages, but the variety known as 'Double Standards' shows what promise lies ahead; not only does it have six large standards that resemble the falls, but sometimes the falls also double up, making a swirling mass of violet petals streaked with the golden tiger-markings of the type.

The upright inner petals ('standards') of *Iris ensata* 'Moonlight Waves' are the same size as the outer petals (the 'falls'), giving the effect of a double flower.

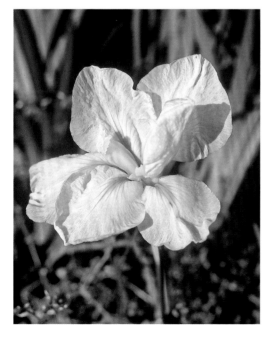

ETHEREAL FLOWERS THAT ENHANCE the beauty of romantic plantings are important both in the garden and in arrangements of cut flowers. Columbines are among the most evocative of old garden plants and there is a romance attached to their long history in cultivation. Their Latin name is *Aquilegia*, because the petals resemble the soaring wings of eagles and the spurs their heads and necks. The double-flowered forms were widely known by late medieval times. John Gerard described the double columbine as having flowers that are 'very double . . . thrust one into the belly of another', which is a vivid description immediately recognizable today. John Parkinson in 1629 noted that 'the double kinds do give as good seed as the single ones do, which is not observed in many other plants', which is also an accurate observation, though he did acknowledge that the results of trying to grow double columbines from seed were variable. Nevertheless, 'Double Columbine' appears in the 1691 seed list of Edinburgh seedsman Harry Ferguson and, even today, aquilegias are often grown from seed and the variations that turn up among their seedlings is one of their charms. That variability comes from the attraction that their flowers hold for visiting bees; columbines are among the most promiscuous of garden flowers.

ABOVE
Aquilegia vulgaris var. *stellata* 'Greenapples' is a spurless columbine with layers of petals prettily piling up upon each other.

There are at least three double-flowered aquilegias that have been known for long enough to be considered 'old' varieties. One of the oldest of these forms is *Aquilegia vulgaris* var. *stellata* 'Nora Barlow'. *A. v.* var. *stellata* 'Greenapples' is probably a hybrid with 'Nora Barlow' as one of its parents; its new leaves are lime green, as are its masses of newly opened, spurless flowers which, in maturity, are creamy-white, tipped with green, and then plain creamy-white. *A. vulgaris* 'Adelaide Addison' was certainly known in Victorian times, but is probably much older. Its flowers have a hose-in-hose structure, usually with three or four layers stacked up on top of each other. The outer petals are blue and the inner petals white with blue edges; the contrast between the charming ruffle of white petals at the centre and the blue outer petals gives the flower the same flouncing prettiness as a double fuchsia. Double columbines come into flower a week or two before single-flowered plants and keep their petals longer.

RIGHT
Aquilegia vulgaris var. *stellata* 'Nora Barlow'. All columbines make wonderful partners for other plants in mixed borders.

The plants are longer-lived too – aquilegias are often rather short-lived, though they can be made more perennial by cutting them down to the ground immediately after flowering. Clumps of new leaves will appear within a month. Their foliage is one of their great assets, because it emerges early in the year and the bright green leaves look wonderful alongside spring bulbs. And they are one of the easiest of plants to grow, happy in all soils, sun or shade. Some people say that aquilegias look particularly good growing alongside old roses, but in fact they flower before the roses get going properly and are better with the earlier-flowering hybrids of Scots roses like semi-double 'Nevada' (1927) and 'Marguerite Hilling' (1959), for which their elegant flowers, long stems and dainty foliage make excellent companions. Nevertheless, it is also worth remembering that aquilegias make wonderful cut flowers in their own right, sporting an ethereal beauty that does not depend upon other flowers for its effect.

China asters – a wonderful accompaniment to other plants – are all selected forms of an annual called *Callistephus chinensis*, a monospecific genus whose seeds were first introduced to the West (actually, to Paris) in 1728. Double-flowered forms were known in Britain by 1752 and forms with quilled petals were first produced in Germany in the nineteenth century. Later came plants with branched flowering stems (1893) and forms with peony-shaped flowers (1930s). Gertrude Jekyll was one of their champions and made a small symmetrical formal garden for them at Munstead Wood. 'I have often had the pleasure of showing it to some person who professed a dislike to them, and with great satisfaction have heard them say with true admiration: "Oh but I had no idea that China Asters could be so beautiful."' Jekyll's preference was for tall-growing varieties in 'clear, clean tints' and one that is still sold is called 'Ostrich Plume'. It grows to about 60 cm/2 ft and bears wispy-looking double and semi-double flowers with reflexed petals in shades of pink, crimson, red and violet. Gertrude Jekyll also wrote that, when the seed catalogues arrived, she found irresistible the 'fluffy heads and ravishing colours' of China asters, 'their dusty pinks and powder-blues, strawberry reds and amethyst purples'.

Despite their seduction of an elderly English spinster one hundred years ago, China asters are not intrinsically romantic flowers, even though they fill a very useful gap in late summer by flowering so prolifically and in a clean and pretty range of colours. Nor are they 'ethereal', being too substantial for that. Their real value is in a

supporting role, either as fillers in the rose garden when many of the perennial companion plantings have finished flowering, or as cut flowers, where their clear, sweet colours are immensely useful in arrangements that seek to avoid the yellow and orange tints that pervade the choice of available material in late summer and early autumn. The petals of most varieties nowadays are quilled and some are especially slim and give a feathery or spidery look. In this, their floral forms resemble the various types of chrysanthemums. The main choices in today's catalogues are between groups selected as dwarf bedding plants and the taller varieties grown for picking. All are easy to grow, but should not be sown until late in spring, typically at the end of May, when the soil has warmed up. Full doubles consist entirely of ray florets and are seedless, but most mixes have a good proportion of nearly full doubles. The Milady Series is an example of a dwarf strain popular for bedding and containers; its flowers are up to 7 cm/3 inches across on a plant no taller than 30 cm/12 inches. The plants of the Duchesse Series may reach 45 cm/1½ ft, while the newer Japanese Matsumoto Series, bred for disease resistance, has recently given us the Serenade Series of semi-double flowers (3 cm/1¼ inches across) in large sprays of the usual white, pink, mauve, violet and red – plus some bicoloured forms. These grow to 70 cm/2½ ft and are good for cutting. Note the name 'Serenade', with its romantic connotations – and consider how completely Gertrude Jekyll would have been seduced by them today.

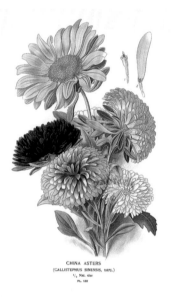

CHINA ASTERS
(CALLISTEPHUS SINENSIS, HORT.)
¹⁄₂ Nat. size
PL. 122

China asters, *Callistephus chinensis*, are annuals grown from seed, and the number of varieties offered for sale has been increasing ever since the eighteenth century. This 1897 illustration by Edward Step shows the range of varieties available more than a hundred years ago to Gertrude Jekyll, one of their greatest champions.

Gypsophila is such a useful plant in flower arrangements that it is grown in many gardens as a cut flower for the vase, but it also serves the same function as a garden plant – that of combining well with almost every other flower, especially the fat, bold blooms of many roses and peonies. It is an excellent example of an 'ethereal' plant that complements 'romantic' flowers. So well do its sprays of tiny flowers fulfil this function that it is widely used to blur the conflicts that arise between blocks of jarring colours. The plants form a bushy mound up to 1.5 m/5 ft high and bear foaming clouds of airy little flowers in strong, branching heads; flower arrangers plant gypsophila in drifts, for it is one of the most useful cut flowers,

a gift not just for its ability to combine with almost everything else but also because it enhances the romantic quality of the flowers with which it is placed. But this flower arrangers' dream also offers a delicate romantic enhancement to difficult beds and borders. The most widely grown double-flowered *Gypsophila paniculata* is 'Bristol Fairy', introduced in 1905 and bred in Ohio, from which one can deduce that gypsophila is both hardy and wind-resistant. Each flower is a tiny explosion of white petals on slender stems with narrow, silvery-grey foliage. 'Compacta Plena' is shorter and perhaps more showy, but with slightly less shapely flowers. 'Schneeflocke' (syn. Snowflake) has an extra whorl of petals with petaloid stamens and, occasionally, a green eye. The best double-flowered pink gypsophila is 'Flamingo', whose pale sugar-pink flowers have a hint of mauve and are shaped like miniature cherry blossom. It brings a warm tinge to flower compositions, whether in the garden or when cut, and makes a wonderfully frothy companion to pink roses.

Thalictrum aquilegifolium vies with gypsophila for recognition as the most ethereal of all plants and enhances everything with which it is placed or planted. It has an airy see-through quality which

Ethereal *Gypsophila paniculata* 'Bristol Fairy' is a plant that is useful both in herbaceous plantings and in flower arrangements.

Thalictrum delavayi 'Hewitt's Double' is a tall, see-through perennial that can be planted right at the front of a border. It is useful as a cut flower, too.

means that it can be planted right at the front of a border, though it is better placed further back, among roses, lilies, foxgloves and peonies. The frothy inflorescence produces a lilac-mauve haze that combines with almost every other colour. 'Thundercloud' is the double-flowered form to look for; every flower has been converted into miniature starburst. The closely related *T. delavayi* 'Hewitt's Double' is quite different; each of its flowers is a mini-rosette, but they come in tall panicles and last a long time. Both grow strongly in any soil to 1.5 m/ 5 ft and have pretty, blue-green, pinnate leaves, reminiscent of columbines.

CAMPANULAS ARE ALSO AMONG THE MOST supportive of herbaceous plants. One might not call them romantic (let alone luscious or voluptuous) but few plants combine so well with old roses and double peonies when summer is at its most opulent and enticing. The double forms of *Campanula persicifolia* come in a wide range of shapes, including hose-in-hose, cup-and-saucer and fully double. Margery Fish wrote in 1965 that the double forms did not have the 'same charm' as the singles though 'the cup-and-saucer varieties certainly have', but present-day gardeners have taken them all to their hearts. *C. p.* 'Boule de Neige' is very double indeed, with rounded ends to its petals that fold back so that the flowers resemble a double white rose. Its name is sometimes confused with *C. p.* 'Fleur de Neige', which has rather a different construction – three layers of petals with pointed lobes in a flower that eventually opens out nearly flat. Other popular white forms are 'Gawen', which has creamy, cup-and-saucer flowers, and the very similar 'Hampstead White'. Among the blues are semi-double 'Coronata', with two, sometimes three, rows of violet-blue petals, and the popular 'Blue Bloomers', whose hose-in-hose flowers are very large (5 cm/2 inches wide). And perhaps the most charming of all is 'Frances', whose flowers have about three rows of wavy white petals that are flushed or tinged with violet-blue

along their edges. Their colours, season of flower and elegant spikes, 60–75 cm/ 2–2½ ft high, make for a perfect marriage with shrub roses of every type.

Campanula punctata has also produced some double-flowered forms that are handsome complements to the romantic flowers of summer. All grow well and easily in almost any soil. *C. punctata* 'Alina's Double' is a pale, dusky pink colour; 'Pantaloons' is a more lavender pink and 'Wedding Bells' is white flushed with palest pink; all have hose-in-hose flowers and will grow to 35–50 cm/ 14–20 inches. Like the forms of *C. persicifolia*, these campanulas have no scent and no higher purpose than to combine with other plants, whether in the garden or as cut flowers. They may not themselves be A-listers, but every garden needs some not-too-pushy flowers to improve the look of its star performers.

Campanula punctata 'Wedding Bells' combines well with other plants, especially roses; its flowers are substantial, but they never dominate the composition.

Platycodons are pretty, campanula-like plants, charming in their own right but even better when they accompany other plants in the border or in the vase. They are the classic escorts for rich and romantic flowers – especially roses, though the great rosarian Graham Stuart Thomas observed that they were also 'lovely with fuchsias'. There are two varieties, fairly widely available, which double their own charm by bearing an extra circle of petals that peep out behind the first. Structurally they are hose-in-hose flowers, whose effect is to turn a five-pointed bell into one with ten points. The colour of *Platycodon grandiflorus* 'Hakone Double Blue' is set off by its creamy white stamens and stigma, and its petals have slightly darker blue veining. *P. grandiflorus* 'Hakone White' is just white, through and through. Without being romantic in their own right, both add lustre to other flowers and help them to look their best. They grow to about 60 cm/ 2 feet and are unfussy about soil types, as well as being very hardy.

GARDEN PINKS OF EVERY SORT qualify as 'romantic' because of their luscious scent, which can on occasions be so strong that they bid fair

to overpower the roses with which they combine so well. Pinks have a long history, too. The colour that we call 'pink' is commonly known as 'rose' in other languages, and indeed 'rose' was the word used in England to describe the colour until the seventeenth century. Pinks turn up in medieval illuminations (legend had it that they sprang from the tears that Mary shed as she followed her son to Calvary) and remained fashionable throughout Renaissance times. Doubles appeared from at least the sixteenth century on and usually had a tuft of small petaloids in the middle of their flowers. When laced pinks took over towards the end of the eighteenth century, these were fully double, sometimes with a dark blotch at the base of the petals, though the most famous old pink, 'Mrs Sinkins', is pure white apart from a hint of cream at its centre. Modern favourites have the same sumptuous scent but flower continuously in a great range of colours. All are borne on skimpy plants, little more than a threadbare mat of blue-grey leaves that hug the ground and throw up their flowers to a height of about 30 cm/12 inches. They are hardy and easily grown in full sun in well-drained soils, the perfect choice to plant around the edge of a rose border.

'Brompton Stocks' are double-flowered forms of *Matthiola incana*, a Mediterranean plant now naturalized in parts of Britain and Ireland. Their sweet, spicy scent is penetrating.

There is a luscious quality to the smell of night-scented stocks that is all the more delicious for its being measurably stronger in the evening and at night. These stocks are shaped like small hyacinths and are double-flowered forms of a short-lived perennial called *Matthiola incana*; in practice, they are treated either as annuals or as biennials. Their heavy scent and ability to combine with other flowers ensures that they are widely used as a cut flower by modern florists. They would be nothing like so popular or so romantic if they had no scent.

Stocks have been popular for hundreds of years, and double-flowered forms were already widely grown in Britain by the sixteenth century. They were especially associated with Edinburgh gardeners. Some strains are known as 'Ten-Week Stocks' and grown as annuals, usually sown under glass in March and April to flower at midsummer. Others need longer to develop to flowering size, and are treated as biennials. These are often referred to as 'Brompton Stocks'.

Intermediate varieties (sometimes called 'East Lothian Stocks', as they originated in Edinburgh) may be treated as either annuals or biennials. Sown under Scottish conditions in late spring, they flower handsomely in late summer and early autumn. Parkinson noted that the doubles 'set no seed', so that seed had to be collected from a 'patch of mixed single- and double-flowered plants'. As with primroses, the gene for producing double-flowered stocks is a simple recessive, but seedsmen claim that with careful cultivation they can increase the percentage of seedlings with double flowers from 25 per cent to more than 50 per cent. The colours of stocks vary from white to crimson through pink and purple and, at one time, striped flowers were known. Nowadays the best strains are probably *Matthiola* 'Brompton Stocks Mixed' and the Legacy Series for biennial sowing, and the Cinderella Series for annuals. It is hard to think of any seed-grown plant that yields such rewards so quickly and so abundantly.

LILIES ARE AMONG THE MOST luscious of romantic flowers, substantial beauties with thick petals, richly scented and large. They are not inexpensive to buy, so a bouquet of lilies presented to a lady is a serious commitment and leaves no doubt as to the giver's intentions. One of their few disadvantages as cut flowers is that they tend to drop sticky nectar from their stigmas and large quantities of pollen from their stamens. The florists' answer to this problem is to cut off the pollen sacs and style. A gardener or flower arranger who knows about lilies will immediately notice this removal of the flower's sexual parts and consider it rather less attractive in consequence.

Double-flowered lilies are a natural way of resolving this dilemma, because the stigma and stamens are usually transformed into extra petals. It would not be true to say that double-flowered lilies are twice as romantic or twice as opulent and meaningful as single ones, but their shapes bring an extra quality to the range now widely available to gardeners, growers and flower arrangers. Some of the modern double-flowered Oriental hybrids are of remarkable beauty, and they mark the beginning of a very interesting phase of development which will greatly increase our choices. More are expected in the near future, but three outstanding varieties are already widely grown: *Lilium* 'Elodie' is a short-growing plant with shell-pink, semi-double flowers (the stamens are changed into small petals, though their exact shape and size differ from flower to flower) and the petals have darker pink markings and brown

freckles towards the base of the petals. 'Fata Morgana' is a uniform yellow colour, a good middling sort of yellow, darker than lemons but paler than buttercups. Its flowers, too, are only semi-double, and sometimes not all the stamens change into petals, which reveals a few red freckles towards the centre of the flower. 'Miss Lucy' is fully double, and of extraordinary beauty. Its petals are white, with pale pink edges, and a green midrib towards the base. It also has a few crimson freckles, but its shape is what makes it so special – there may be as many as twenty petals pouring out of the centre and curving back elegantly to make a flower that more resembles a water lily (except that there are usually three or four flowers on a stem that is typically 1.5 m/5 ft long). This is the shape of many more double lilies to be introduced in years ahead.

The doubleness of *Lilium* 'Fata Morgana' varies from flower to flower.

EVEN THE MOST EVANESCENT OF ANNUALS can be used to complement the beauty of shrubs. Clarkias have that sweet prettiness that goes with cottage gardens – artless, charming and admirable. The wild species that come from the north-western states of the United States have squinny little flowers with four thin petals, but once they were worked upon by clever hybridizers to produce double forms as summer annuals, they leapt from insignificance to became flowers of substance. The two main species responsible for this change of status are *Clarkia pulchella* and *C. unguiculata* (syn. *C. elegans*), one short and the other tall; their hybrid offspring are usually about 30–40 cm/12–15 inches tall and double enough to appear as a mass of curling petals in a wide range of pinks and purples. A good white seed strain is called 'Snowflake', and a vintage one from the 1920s still offered for sale is 'Appleblossom' (actually more salmon-pink than pink-and-white), while the most commonly sold mixture of colours goes by the name of 'Love Affair'. If names are anything to go by, there can be no doubt that clarkias are romantic.

But there is no end to the helpful plants that enhance the quality of roses and other romantic plants. Double and semi-double hollyhocks are quintessential cottage-garden plants in darkest maroon, crimson, apricot, pink, cream and white, and invaluable for giving height to a composition. Canterbury Bells – little more than biennial – are useful because they flower late: *Campanula medium* var. *calycanthema* 'Dwarf Double Melton Bells' is a strain (not very dwarf at all) with extra petals in the centre of the flower. The double-flowered forms of wood sage, *Salvia nemorosa*, purple 'Pusztaflamme' (syn. *S. n.* 'Plumosa') and winey 'Schwellenburg', combine with everything. *Silene dioica* 'Thelma Kay' is a double-flowered campion which also has variegated leaves – never spectacular but always charmingly splashed with cream and white. Beautiful, ephemeral opium poppies, the double-flowered forms that are lumped together as *Papaver somniferum* Paeoniiflorum Group, come in a wide range of colours – pink, maroon, white and lilac, often with fimbriated petaloids. Their glaucous leaves and slender stems set off shrubs so well. Another annual, love-in-the-mist (*Nigella damascena*), is an invaluable, easily grown and popular plant for mixed borders and flower arrangements. Though first recorded as a single-flowered plant

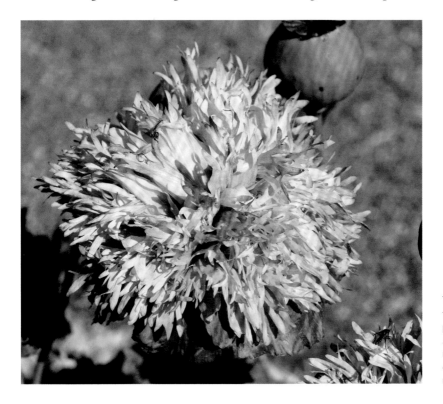

The double forms of opium poppy, *Papaver somniferum*, are natural enhancers of roses and other romantic flowers.

Dahlia 'Bishop of Llandaff' has leaves so dark that its bright red semi-double flowers seem to float in the air. Place it among grey-leaved plants, however, and the mass of its leaves takes on substance and acts as a fine foil.

in a manuscript dating from the thirteenth century, it now comes both as semi-double and double forms (with five to twenty-five sepals) and in a wide range of colours, including dark blue, pale blue, white, pink, mauve and all manner of in-between shades. And the blackish purple-green leaves of *Dahlia* 'Bishop of Llandaff' are a wonderful foil not just for its own semi-double deep scarlet flowers but also for any plants with grey or variegated leaves or with flowers that are cream or white. *Dahlia* 'Bednall Beauty' is shorter (about 60 cm/2 ft) with flowers that are rather more crimson than the bishop's, but its foliage is just as dark and handsome. Romantic or ethereal, luscious or lithe, there is no end to the double-flowered plants that please the senses, whether as companions in the garden or as cut flowers to admire and arrange indoors.

5 The Formal

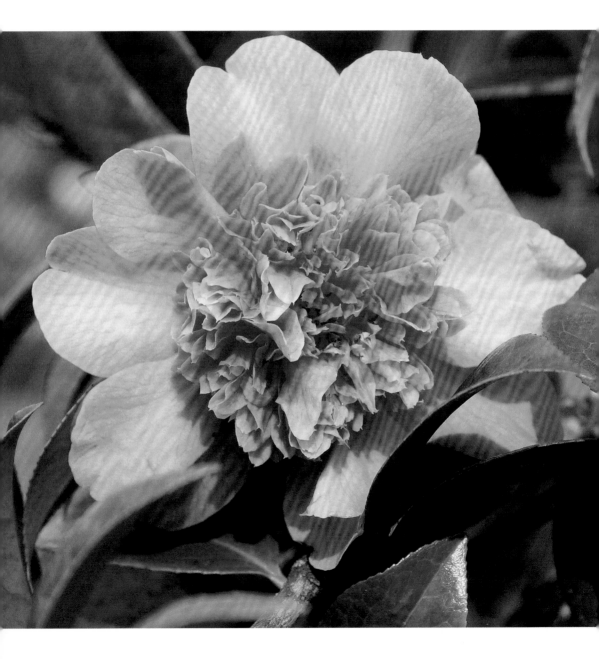

Many of these formal ideals were first developed by generations of plantsmen in China and Japan, and then adopted as standards of beauty by Westerners. Perfection comes in many forms, but much of this chapter will be concerned with the flower shapes that we consider formal, while also looking briefly at the use of double-flowered plants in formal plantings.

Camellias provide a good example of a plant that has developed flowers of great formality, with petals so regularly arranged that they might have been designed by a geometrician. We know that camellias were cultivated as ornamental plants as long ago as the third century AD, when they were described as 'classic flowers' by Chinese writer Zhang Yi in Sichuan. The first camellias to flower in Europe were single-flowered, but it was known that double-flowered varieties existed in China. James Cuninghame, a Scottish physician stationed with the British East India Company in China between 1698 and 1702, commissioned at least two pictures of camellias on behalf of James Petiver, a London apothecary. One has a red anemone form and the other a pink double flower.

The cultivated camellias that came to be most admired had an imbricated shape. Imbrication means that the petals overlap neatly, rather like fish scales; row after row of neat petals form circles that decrease in size as they swirl towards the centre. The result is a flower so formal in its outline, with petals so regularly spaced, that it is hard to believe that it could ever have been produced naturally. The first imbricated cultivar introduced to the West was *Camellia* 'Alba Plena', which arrived from China in 1792 along with the semi-double 'Variegata'. They were acquired for Gilbert Slater of Knotts Green, near Leyton, who was the principal owner of the East Indiaman *Carnatic*. In the same consignment was a garden rose from China which became known as 'Slater's Crimson' and is the ancestor of all the bright red roses whose colour we take for granted in our gardens today. Another imbricated camellia, 'Middlemist's Red', was brought to Kew from China in 1804 by John Middlemist, a nurseryman in Shepherd's Bush. Then, in 1807, came a red camellia

Camellia × williamsii 'Ballet Queen'. A modern hybrid with the formal anemone-shaped flower developed as an ideal of beauty by ancient Chinese gardeners.

LEFT
Camellia japonica
'Anemoniflora' was the first
anemone-shaped camellia
to be introduced from China
into Western gardens.

RIGHT
Camellia japonica 'Pozzi
Vera'. An early example of
a Western hybrid with the
imbricated shape developed
by the Chinese.

named 'Anemoniflora' and an imbricated variety with pale pink petals that was named 'Lady Hume's Blush' in memory of Amelia, the wife of Sir Abraham Hume, who is also credited with importing the important China rose 'Hume's Blush'. It was a time when garden varieties of many Chinese plants were being introduced into the West by patrons of the East India Company.

Imbricated camellias are usually fully double flowers in the sense that they have no 'eye' at the centre, and this gives them a formal quality. Some imbrications are more lax, so that the flower looks romantic rather than formal. The venerable striped camellia 'Contessa Lavinia Maggi' (1858) (see page 187) is often described as 'imbricated', as is the magnificent modern 'Margaret Davis' (1963), but both are too loosely petalled to present themselves as formal overall. Camellias are not the only flower where imbrication occurs: the complex shapes of chrysanthemums provide another example, most notably the giant 'Chinese' varieties whose disc florets are completely concealed by incurved petals. And many garden roses are described as 'imbricated' because all their stamens have been converted into petals and only the carpel remains at the centre, as with the beautiful white damask rose 'Madame Hardy' (1832). Nevertheless, the arrangement of their petals is never so orderly or perfectly proportioned as it is among imbricated camellias.

Some of these early introductions set seed and produced plants which were propagated and sold for high prices, so that within a few years camellias became extremely fashionable. One reason for this vogue was that they were believed to need hothouse conditions to survive,

CAMELLIA JAPONICA
POZZI VERA *Bocquine*

which was a luxury that only the very rich could afford – as with orchids later in the nineteenth century. In *Garden Shrubs and their Histories* (1963), the garden historian Alice Coats observed dryly that camellias 'being the most expensive of flowers, [were] considered the symbol of elegance.' And the imbricated form is still much admired and sought by modern breeders; it is seen to perfection in the icy-white 'Matterhorn' (1981), sugar-pink 'Berenice Perfection' (1965), striped 'William Bartlett' (1958) and white 'Sea Foam' (1962), which also has a hint of yellow at its centre.

Nowadays, we think of camellias as handsome garden shrubs, easily grown and seen at their best in a large woodland garden on acid soil. The formality of their flowers is only apparent in close-up; it is by admiring the neatness of its petals and their arrangement in overlapping layers that the flower is judged. Competitions at camellia exhibitions promote the perfect shape, and the elegant formality of imbricated flowers is the quality for which exhibitors and judges look. And yet there is paradox about such varieties because camellia flowers are held on a bush that is far from formal – often bulky, sometimes lanky – and the individual flowers are carried in a haphazard way along the branches. The glossy evergreen foliage has always been admired and esteemed, and it is the perfect foil for showing the flowers to their best, but one could never cut a branch of camellias to give structure to a formal arrangement of mixed flowers in a vase. They do not stand firm and define the arrangement in the way that florists' roses or gladioli will. There is a stark contrast between the exquisite flowers and the unruly plant that bears them – and this is true of almost all the plants with 'formal' flowers in this chapter.

CHRYSANTHEMUMS HAVE BEEN CULTIVATED for at least 2,500 years in China, and were greatly developed even before they were first taken to Japan in the seventh century AD and grew to become a symbol of Japanese imperial majesty. We know that, by the end of the twelfth century, at least thirty-five different cultivars were grown in China, and some three hundred by 1708. The first quilled, feathered and tightly incurved blooms arrived in the West at the end of the eighteenth century and immediately created interest: chrysanthemums were popular right from the start – seventy new seedlings were introduced by European nurserymen between 1820 and 1830. For gardeners contemplating chrysanthemums, it is the flower shape and size that count; thereafter it is just a question of choosing a colour.

Chrysanthemums are very variable in their shapes. Modern growers split them into no fewer than seventy-five different sub-groups.

Formality is a desired quality in the flowers of most chrysanthemums. It is the sort of formality that results from a regular shape, a perfectly circular outline and the presence of florets all of similar shape and length. The category known as 'regular incurved', formerly called 'Chinese' chrysanthemums, is a good example, because the flower is intended to be globular – a perfect sphere, equal in breadth and depth, composed of a dense mass of ray florets that curve towards the centre of the flower; it is a form much esteemed by competitive exhibitors in search of floral perfection and popular, too, with flower arrangers. The flowers are not as large as those that belong to some other chrysanthemum categories, but they may be up to 12 cm/ 5 inches in diameter and they lend structure and substance to large flower arrangements. Faultless specimens of gleaming white 'Alison Kirk', lemon-yellow 'Golden Snowdon' or deep lilac 'Stockton' are awe-inspiring for their regular arrangement of ray florets. Their petals curve over, so it is their undersides that give colour to the whole confection – hundreds of florets shaped to create a perfect globe.

The upturned, incurved ray florets are what gives the 'regular incurved' chrysanthemums their floral perfection, but it is not the only spherical form that has been developed. When the ray florets curve down and outwards, as opposed to up and inwards, the flower is known as a 'reflex' chrysanthemum. It, too, is large and round, but

Chrysanthemum 'Max Riley' embodies the formality and solidity of the large-flowered, incurved group of chrysanthemums.

it lacks formal elegance or balance; Reginald Farrer once likened it unkindly to 'a moulting mop dipped in stale lobster sauce'.

Two further types of double chrysanthemum have a formality that is distinct and remarkable – the Pompons and the Anemone-flowered, categories that are also known to lovers of dahlias. Both were developed first in China and then in Japan before reaching Western gardens. Robert Fortune introduced the Pompon chrysanthemums from China in 1846 and the Anemone-flowered forms arrived in the 1860s, by which time some European nurseries were already listing hundreds of Western-bred varieties. Among the best hardy Pompon chrysanthemums today are 'Cameo', with neat, intricate white flower heads (rather more yellow towards the centre) and scalloped petals; 'Fairie', whose pink pompons grade to burnt orange at the centre; and bright yellow 'Poppet'. 'Mancetta Buttercup' is a good example of the floral perfection of Anemone-flowered chrysanthemums today; its great central dome of neat, yellow florets dwarfs the few salmon-pink ray florets. Formality is also to be found among the hardy garden types of chrysanthemum that are popular for late summer and early autumn display. 'Max Riley' is an early-flowering variety with incurved golden yellow, claw-like ray florets; its sport 'Bronze Max Riley' has the same precise shape, with hundreds of short petals curving over to form pale orange spheres.

In some Western countries chrysanthemums are considered the flowers of the dead. In much of Europe, for example, they are bought to place on family graves for the feast of All Saints. Woe betide the visiting foreigner who buys them to give to his hostess. This is, however, a completely modern perception which goes no further back than 11 November 1919, when the French President Georges Clemenceau put out an appeal to lay flowers on the graves of all the French soldiers who had been killed during the Great War.

The only available flower at that time of the year which nurserymen could produce in sufficient quantities (and which could also resist a mild frost) was the chrysanthemum, and so began the association between chrysanthemums and commemorating the dead. Soon the practice spread to Belgium, Italy and many other countries, even to Austria and Hungary, which had been the enemies of France. Later on, the persons honoured and remembered with chrysanthemums expanded beyond those who had died in the war to include all the dead, so that nowadays almost every grave in many European churchyards is decorated with chrysanthemums at the beginning of November. The type of chrysanthemum most grown for commemoration is the Korean, largely developed by American nurserymen in the 1930s – neat, hardy and easily raised for sale in pots. Their flowers are double, flat, well shaped and regular – well suited to the formality of the parades and wreath-laying that are a feature of public life not just on All Saints' Day but also on Remembrance Day (11 November). Many are no more than semi-double, but 'Bronze Fairie' is a fine example of a modern Korean chrysanthemum, forming a mass of rusty orange pompons with scalloped petals. All grow very satisfactorily in pots and are easily raised from cuttings or by division of the roots in spring.

In the United Kingdom and North America there are no taboos attached to chrysanthemums, which have become one of the most widely grown and esteemed of late autumn flowers, much loved by flower arrangers for their long vase-life. In Australia, chrysanthemums are the flowers most often given on Mother's Day. Gardeners grow the hardy Korean chrysanthemums, exhibitors try their skills with the huge decorative varieties, and florists sell them as useful, long-lasting sprays. Each of these markets concentrates on a different type of chrysanthemum and it is worth explaining that the genus, a huge one with over twenty thousand horticultural varieties, is now for the purposes of classification split into thirteen different groups and some seventy-five sub-groups. Given the immense differences between the groups, it is clear that chrysanthemums have come a long way since the first crosses were made 2,500 years ago between two insignificant wild Chinese species, *C. indicum* and *C. sinensis*.

DAHLIAS STAND ALONGSIDE CHRYSANTHEMUMS as stalwart plants for autumn flower. It is hard to know which are more widely grown

Chrysanthemums are a memorial flower in many European countries. This photograph is of a French village cemetery on La Toussaint (All Saints' Day), 1 November.

all over the world, since both are gardeners' favourites and both have developed a variety of complex shapes as a result of breeding and selection. But there is a significant difference between them that is worth considering: chrysanthemums were developed in China and Japan over many centuries and the first plants that arrived in the West carried fully double formal flowers. Dahlias, by contrast, first came to the West as wild flowers from Central America and only as a result of hybridizing and selection by Western gardeners and nurserymen did the double-flowered forms that we think of as typical come into existence. Wild dahlias have up to eight petals and look not so very different from many other members of the daisy family; modern hybrids may have as many as three hundred ray florets, intricately arranged on flowers that resemble giant drumheads, each a miracle of tight-packed construction. Look at them closely: with rows and rows of neat quills, the effect is quite enchanting. It is hard to believe that anything so perfectly arranged is a living flower.

As with roses, it could be said that there are too many dahlia varieties in commerce, many of which are offered for sale by many nurseries. For the enthusiast, however, each one is obviously different from the next and all are worthy of cultivation. Experts divide dahlias into fifteen different classes, four of which carry flowers that have an intricately formal structure – Ball dahlias, Pompons, Waterlily types and Decorative dahlias. These classifications may seem strange to those who do not know dahlias, but they provide a tool essential to understanding how the genus has developed in cultivation, and invaluable to enthusiasts who show them competitively.

Dahlias in the Ball group have flowers built up from hundreds of identical florets, packed together in row after row and apparently so double that their inflorescences are either completely spherical or slightly elipsoid. The petals usually have rounded tips, but their sides curl up and rub against each to create continuous circles with hundreds of immaculate fluted florets spiralling up to the apex.

Their complexity is a revelation of beauty – an astounding construction. There is little to choose between varieties except for colour: formal perfection is present in all. 'Cornel' has 10 cm/4 inch pompons in bright purple; 'Jomanda' is a pale scarlet colour with deeper colours within the individual florets (this is true of all Ball varieties); 'Mary's Jomanda' is a deep pink sport of it; and 'Wootton Cupid' has light, clear pink flowers, tinged with lemon-yellow, which is more noticeable towards the centre. All are neat in their overall shape, and miraculous in their detail.

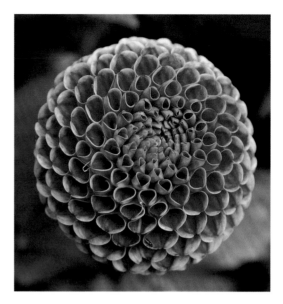

Dahlia 'Franz Kafka' exemplifies the neatness and complexity of Pompon dahlias.

Pompon dahlias are smaller and even neater – so tightly and intricately curled that the flowers make perfect spheres, about the size of a golf ball, typically 5 cm/2 inches in diameter, and much loved by gardeners. Some are uniformly coloured, like the crimson globes of 'Willo's Surprise', or dark pink 'Franz Kafka', but others are bicoloured, with the edges of the petals tricked out in one colour and the central part in another. Among the best are lilac-and-white 'Noreen' and orange-and-yellow 'Minley Carol'. The regularity of their flowers is extraordinary; it is hard to imagine that anything so complex and formal could actually be a flower head. Small wonder that dahlias are among the world's most popular plants, useful both in the garden and as cut flowers.

The formal shape of Waterlily dahlias commends them more strongly to exhibitors than to ordinary gardeners, because their beauty lies in the formal arrangement of their petals, even though the varieties differ considerably in the size of their flowers. Waterlily dahlias have ray florets around a very tightly closed, dome-shaped middle, with four to seven rings of fairly well-spaced florets emerging from it. Their overall shape is indeed reminiscent of water lilies and, seen from above, it is easy to imagine them floating on the surface of a pool or lake. 'Pearl of Heemstede' is a small-flowered variety whose colour runs from deep pink at the centre to white among the outer petals. The petals have little folds which appear as shadowy lines running from base to tip, which contributes much to their distinctive

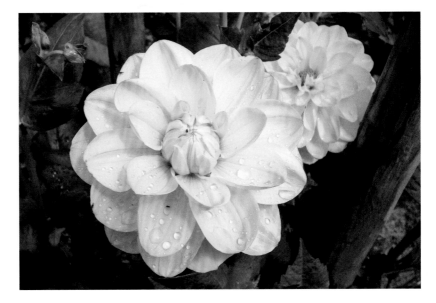

Dahlia 'Glorie van Heemstede' is very popular with exhibitors and flower arrangers, but is also a good garden plant. Formality is a feature of all the Waterlily dahlias.

beauty. 'Arabian Night' is larger-flowered, with petals that are dark red at the edges but grade to crimson-black at the centre. 'Taratahi Ruby' is something of a misnomer, as its flowers, though only medium-sized, are a very dramatic bright vermilion colour. 'Glorie van Heemstede' is lemon-yellow at the edges, but intense buttercup-yellow at the centre, while scarlet 'Grenadier' has dark leaves, more black than purple. All these have a formal regularity and exactness to their shape that intrigues and satisfies our visual senses. And they are extremely useful for flower arrangements.

Best known among dahlias are the formal Decorative sorts, which are both colourful and regular in their shape. As with the Waterlily dahlias, the plants may be of any height and the flowers of any size, because it is the construction of the flower that counts. These are fully double, with no sign of stamens in the middle, and they usually have flat petals, not curving round to create a pompon shape. One of the best Decoratives is 'Alva's Supreme', a yellow whopper that fades to cream and white; 'White Alva's' is a sport that is usually completely white, though the younger florets at the centre of the flower may remain cream-coloured. 'Ellen Houston' has smaller, orange and scarlet flowers that show up well against its near-black foliage. 'Kidd's Climax' is a giant-flowered variety, which sums up the diversity of Decorative dahlias, because its florets are pink with a yellow blotch at the base, and this colour contrast is most noticeable after they have just opened, before the first florets are overlain by

more of them opening. Then the florets tend to reflex as they age so that a typical flower will appear to have rounded petals in the centre and spiky ones around the outside. As a complete contrast, there is an excellent miniature Decorative dahlia called 'David Howard', whose flowers are pale orange with a brighter, redder centre, set off by very dark, bronzy-black leaves. It is widely grown as a good garden plant even by those who tell you that they do not 'do' dahlias. A certain hostility to dahlias was for many years *de rigueur* among snobbish gardeners, but flower lovers everywhere are now discovering what beautiful and useful flowers they are – not just the formal ones celebrated in this chapter but also the rather more wacky 'Fimbriated' and 'Double Orchid' classes. All are remarkable testament to the skill of Western gardeners over two hundred years in developing such complex and regularly shaped flowers out of a handful of weedy species.

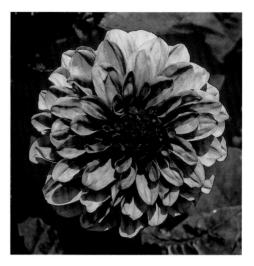

Dahlia 'David Howard' is a small Decorative cultivar with purple-black leaves, very useful in mixed borders.

ZINNIAS ARE ANOTHER GENUS of composites that have shown themselves to be possessed of enormous potential for floral development. The simple ancestors of these annuals and short-lived perennials, native mainly to central America, would have difficulty recognizing their complex and elegant descendants which are now such a standby for summer display. The doubling of zinnias has had the same effect upon the flowers as the doubling of dahlias, so that the best of them are enormously formal in shape, composed of hundreds of neat, regular petals. The scale is different, of course: dahlias are tuberous perennials that have been bred for size, while zinnias are annuals for summer bedding, with new strains constantly introduced, for better or for worse, that are shorter and more compact than ever. Some of them are particularly useful in creating harmonious colour schemes, but the taller strains were bred for the cut-flower market and the neat intricacy of their comparatively large flowers places them firmly among those formal beauties that are so useful in indoor arrangements.

Zinnia peruviana was grown in Britain by 1753 and *Z. elegans*, one of the most important for breeding hybrid strains, was introduced in 1796. Double forms first appeared in France in the 1850s, though some authorities claimed that the French got their seeds from India. An admiring American journalist, writing in *The Horticulturist and Journal of Rural Art and Rural Taste* in 1871, said of *Z. elegans* 'It is remarkable for its great symmetry ... by the side of the double varieties, the single ones seem but little better than weeds.' Such comments are not uncommon when the beauty of double-flowered plants is compared to the simplicity of their single-flowered ancestors. Modern, large-flowered zinnias were mainly bred by the Dutch in the 1920s. These make stout, erect plants and are best suited to hot climates. Up to now, the smaller-flowered varieties have been more successful in cool-summer climates like Britain's. However, the increasing frequency of hot summers may make growing the large-flowered varieties less of a gamble in future.

Most zinnias are seed strains, and come in mixed colours. *Z.* 'Big Boy', for example, which grows to about 1 m/3 ft, has flowers up to

The complexity of modern zinnia flowers, bred in Europe and the United States, makes a fair match for the chrysanthemums bred by the Chinese over so many years.

13 cm/5 inches across that bloom in a bewildering mix of shades, including orange, pink, apricot, red, yellow, white and mauve. The flowers are variable in size and shape, too, which is often a problem with seed strains. Most are nearly double or fully double, though some stamens may be visible when the flower has opened out completely. Nevertheless, a fair percentage could be described as having the formal shape so reminiscent of Pompon dahlias. *Z. elegans* 'Dahlia-flowered Mixed' has large flowers, but fewer that are truly double, and fewer still that resemble Decorative dahlias. One of the best is *Z. elegans* 'Lilliput Mixed', which has dense, 4–5 cm/ 1½–2 inch diameter flowers packed with petals and 45–60 cm/ 1½–2ft high, in a variable range of colours; most of them resemble Pompon dahlias and they are one of the most shapely strains available. But perhaps the most formal of all are plants from the *Z. haageana* 'Aztec Sunset' strain, which produces a high proportion of bicoloured flowers, typically maroon with yellow tips, reminiscent of some rudbeckias. The plants are short, perhaps 15–22 cm/6–9 inches high and 5 cm/2 inches across, and offer a fair proportion of doubles, but the bicoloured effect emphasizes the formality of the flowers whether they are fully double or only semi-double.

ONE FURTHER MEMBER OF THE DAISY FAMILY is capable of bearing flowers of great formality – the marigold. African marigolds (varieties of *Tagetes*) are praised in chapter 7; in this chapter we are concerned with traditional 'English' marigolds, *Calendula officinalis*. These popular annuals are easier in a cool climate than zinnias and offer considerable variation of shape and colour – though this is more limited than with zinnias, since all *Calendula* strains have ray florets that are orange or deep yellow. *C. officinalis* has been cultivated since at least Roman times and the single-flowered type was a popular herb in cottage gardens until it was overtaken by the nursery trade's preference for double flowers and became hard to find. Gertrude Jekyll often used calendulas in her plantings because of their strong colouring and cottage-garden demeanour. They also make good cut flowers. Children love them: the curly seeds are intriguing and the flowers are both bright and distinctively scented.

Double-flowered marigolds have been known since at least the sixteenth century: Gerard (1596) mentions growing yellow doubles. By the 1840s, Mrs Loudon observed that the double variety was 'still . . . very generally grown', though the common marigold had gone

Calendula officinalis 'Fiesta Gitana'. A seed strain of double and semi-double marigolds.

'out of fashion'. As with many composites, the flowers of a marigold are really flower heads made up of central disc florets surrounded by ray florets. Scientists writing in the *Annals of Botany* in 2001 noted that double marigolds carry the same quantity of nectar as the singles, and this they attribute to the fact that in calendulas, 'doubling involved a change in the proportion of disc and ray florets rather than modification of individual flower structure.' Further research may yet show this to be true of all double-flowered composites.

Double-flowered marigolds can be one of three shapes. First come the anemone-centred marigolds, part of whose central disc is converted into a large puff of tightly quilled petaloids set off by the ring of ray florets that surround them. At their best, these are the prettiest of marigolds, with a shape so regular and formal that it cries out for admiration. 'Kablouna' is one of the best strains. Next come the forms of marigold with quilled petals. 'Radio' is a good example: its flowers are globular and have a dense mass of pointed petals, curled back in such a way as to make them look spiky. Only when fully open is the centre of the flower visible, but at every stage the flowers are both beautiful and striking in their regularity and formality. 'Needles and Pins' is another such form, and its synonym 'Porcupine' is a good description of the impression it creates of bristling with a mass of floral spikes. Last come the marigolds that just appear to have rather more ray florets than normal, with many rings of petals arranged in neat circles but with stamens still standing at the centre of the flower.

Some of these are sold by colour, for example 'Apricot Tart', which
is not exactly apricot-coloured, but something between orange and
yellow, and whose flowers are usually fully double, though not always.
'Indian Prince' and 'Touch of Red' are examples of two-tone varieties.
'Crimson', 'warm red' and 'plum-coloured' are some of the adjectives
that people have used to describe them, while the undersides of the
petals are usually a brownish sort of 'mahogany-red' or 'wine-red'.
These seed strains produce flowers that are variable in colour, and not
always very double. And this seems to be the problem with double
marigolds – it is hard to find seed strains that are consistent in their
colour and in the shape of their flowers. There is too much variation
because the lines have not been stabilized. However, seen to perfection,
a double-flowered marigold is a small marvel, its petals arranged
with such invention and precision that one could not believe such
complexity and formality to coexist.

WE HAVE SEEN THAT it is to Chinese and Japanese gardeners of
centuries past that we owe the formality and artificiality of many
masterpieces of horticultural selection. Can one talk of an oriental
aesthetic that admires formality in flowers? Perhaps, but these
gardeners did not admire formality in the plant as a whole; the
fluid shapes of bonsai give a better idea of their aesthetic and these
shapes are seen to advantage when the plants are covered in flowers.
Japanese cherries (see also chapter 6) are a case in point; many have
an elegant weeping shape, and a few are fastigiate, but only a few can
be said to have flowers that are formal.

Cherry trees (*Prunus* species) were much admired by the first Western
visitors to Japan in the nineteenth century, but it was a while before
any were actually seen in the West. The German plant collector
Philipp Franz von Siebold knew of double-flowered cherries in temple
gardens during his long sojourn on Deshima island in the 1820s, but
did not send any back to Europe. The first large-scale importation
of Japanese cherries began when the Chelsea nurseryman Sir Harry
Veitch was able to import some directly from Japan in the early 1890s.
The frothy extravagance of Japanese cherries places them among the
most romantic and flamboyant of cultivated trees, but there are also
among them a few whose flower structure exhibits a formality unseen
elsewhere in the genus. Collingwood ('Cherry') Ingram (1880–1981)
was for sixty years the great European expert on Japanese cherries and
one of the cherries that he came across in Japan in 1926, now known as

Prunus glandulosa 'Sinensis' is an old Chinese garden plant – small, bushy and upright in habit.

'Geraldinae' (syn. 'Asano'), is remarkable for its doubleness. It carries about a hundred petals in each flower, which are often arranged in formal layers but may also be held in a chaotic muddle as a result of pressure from other flowers on the same branch. It is an exuberant display – an interesting mixture of the ephemeral and the showy – and an important factor in the tree's creation of a spectacle is that its branches are either leafless or the leaves have only partially emerged when the clouds of flower burst forth.

Very occasionally, this combination of formality and showiness is found in other flowering cherries. A good example is the shrubby little *Prunus glandulosa*. The wild species is a relation of the almond *P. dulcis*, but usually grows no taller than 2 m/6½ ft high, typically less, with pink flowers, simple but pretty. The Scottish plant hunter Robert Fortune introduced two old garden varieties from China – pure white double-flowered 'Alba Plena' in 1843 and sugary double pink 'Sinensis' (syn. *P. g.* 'Rosea Plena') in 1846. They are altogether much more substantial plants than the slender species. In both varieties, the flowers make a brilliant show by clothing the upright stems all along their length and finishing their display just as the leaves start to open. The flowers last only for a week, but are so dazzling that they have long been popular both in the garden and as conservatory plants, grown in pots and brought inside for their brief reign of glory. The individual flowers are full of incurved petals, not formally arranged but so profusely borne and apparently so artificial that they transform the bush into something quite unreal. Lined up in pairs, they are wonderful for formal plantings.

FORMALITY OF FLOWER is also a distinguishing characteristic of several genera that were developed in eighteenth-century England as 'florists' flowers'. Two were dominated by the search for the perfect double shape – auriculas and pinks (and, later, also carnations). Auriculas have been grown in English gardens since at least the

sixteenth century (Gerard was growing eight different varieties in the 1590s) and the first records of double auriculas date from the seventeenth century. Alexander Marshall illustrated a double auricula in about 1650 and John Rea listed a double yellow auricula in his *Flora, Ceres and Pomona*, published in 1665. Such plants were rare, and they had to be vegetatively propagated because they did not set seed readily and very little was known at the time about hybridizing, which tended to be seen as a blasphemous interference with the natural world that God had ordained. It seems, however, that many of the early double auriculas were striped, a trait that has not survived through into modern times. In John Rea's time, auriculas were not considered of sufficient interest to merit special cultivation; they were grown in the open ground, often in mixed plantings as, for example, in the large Dutch-style formal gardens that William III inspired. By about 1700, however, gardeners began to grow auriculas in pots and, during the eighteenth century, to develop them as proper florists' plants, with competitive shows and auricula theatres to display them. Auriculas reached the height of their popularity in the 1840s but double varieties have always been valued because they flower over a longer period than singles.

The old florists developed strict criteria for assessing the excellence of auriculas at shows, whether double- or single-flowered. Desirable characteristics included the regular flower shape that gives these highly developed plants their prim formality. Sacheverell Sitwell in *Old Fashioned Flowers* (1939) referred to their 'trained artificiality' which represents 'nature controlled' and serves as a reminder of 'a period of deliberate design'. A comparison with double primroses is a useful one to make: the regular shape of double auriculas is more formal and sophisticated than that of double primroses. The long history of auriculas as florists' flowers has created highly stylized standards of excellence by which to judge their beauty.

There is a very large number of double auricula varieties in cultivation, but that is because a very much larger number of auriculas of every type is offered for sale – well over two thousand of them. Single-flowered auriculas have a firm formal outline, derived from years of establishing the ideal shape to which they should conform – a circular outer edge to the petals, an equally clear, circular edge to the patch of farina at the centre, a neat shape to the corolla and the presence of five clearly visible stamens (they must be 'thrum-', not 'pin-eyed'). But all these criteria for floral perfection

AURICULA (DOUBLE) PURPUREA.

Primula auricula cultivars have been developed as 'florists' flowers' since the eighteenth century.

are lost in the double-flowered forms: the flowers no longer lie flat, the petals are often ruffled, the farina and corolla-edge are unseen and most of the stamens are converted into petaloids. Yet they present themselves in clusters at the top of a long stalk and, however they are grown or shown, they command respect. Their underlying artificiality is still immediately apparent. 'Camelot' is rich violet-purple and vigorous, 'Matthew Yates' so very dark red that its flowers appear almost black, set off by smooth grey-green leaves, while 'Trouble' is pinkish buff, with café-au-lait petal backs, a most unreal and arresting combination of colour and shape.

Scented pinks and carnations are far too companionable and romantic to be seen as plants for formal settings and their habit of growth leaves much to be desired, but the individual flowers can be immensely formal in their structure. The huge florists' carnations and the spray carnations that are so useful in flower arrangements have wonderfully neat flowers – regular in outline but full of ruffled character within – and come in such a range of colours that they have intrigued and delighted gardeners for hundreds of years. Parkinson listed nineteen carnations, mostly singles, in 1629, but when Redouté painted carnations, two hundred years later, all were doubles.

Border carnations are beautiful hardy plants that have rather fallen from fashion in recent years. The Royal Horticultural Society lists scores of them as worthy recipients of its Award of Garden Merit, but primrose-yellow 'Golden Cross' and 'Irene Della Torré' – white with crimson edges and flashes – are almost the only varieties that are ever seen. Each has a neat formality to its flowers that is typical of almost all double-flowered *Dianthus* varieties. But when one considers the modern greenhouse carnations (not the old Malmaison varieties which are wonderfully clove-scented but rather ragged in their outline) it is no wonder that these remain one of the most widely grown and sold of florists' flowers. Greenhouse carnations have always been bred for a long life as cut flowers, and new and improved varieties are constantly introduced. A fine formal shape is something you can take for granted.

The main criteria by which to judge them are whether they flower continuously, whether they are self-coloured or 'fancy' varieties with flecks, strips or piping (usually in shades of red) on a paler ground, and whether or not they are scented – not least because there has been an unfortunate tendency in recent years to promote size, productivity and shape in preference to scent. Some exhibitors declare 'Crompton Princess' to be the best pure white carnation, but it has only a moderate scent, whereas 'Fragrant Ann' is very strongly scented. Among the reds, 'Jess Hewins' has a strong scent and is a wonderful rich deep crimson colour, while 'Joanne's Highlight' is more moderately scented, but probably the best all-round pink variety – a pale azalea pink with a very pretty, rounded shape.

Carnations are usually sold as bunches of the same variety, but the available choice is enormous. Exhibitors have firm rules for assessing their qualities; these include the regularity of shape that makes a perfect bloom a formal masterpiece.

'Elsie Ketchen' is the best green carnation (quite a novel colour – in Oscar Wilde's day, white carnations were greened by placing them in green ink), though it is only really green in the shadows that form between the petals, but it does have an acceptable amount of scent. Among the 'fancies', 'Crompton Classic' is white with purple edges and lots of purple splashes and has a classic strong scent of cloves, while 'Kristina' is also strongly scented, with purple piping on a very pale pink ground. Violet piping on a pale yellow ground is very pretty in 'Ann Franklin' but this is one of those varieties whose shape is more important than its scent. What is the point of a carnation, you might ask, without that delicious spicy fragrance? Nevertheless, all modern carnations exhibit a formality of shape that would satisfy the most demanding of eighteenth-century florists.

Extra petals are one of the elements that plant breeders look for when they start to develop a genus. The size and colour of flowers are further factors that they seek to improve, and may take precedence over floral perfection. This does not always lead to the development of double flowers or of even semi-double flowers of a regular, formal shape. A simple example is the Hybrid Tea rose. Almost all are double-flowered, even though their shape when fully

open may be messy. It is the buds or the half-open flowers that are admired for their neat, formal, conical shape and every rose lover knows what is meant by the classical shape of a Hybrid Tea. There are, however, a few varieties that open out with such a degree of regularity that they offer a certain formality both as a bud and as a fully blown flower – 'Peace' is a good example. As for the classic shape of the Hybrid Tea rose, this can be traced back to the original Tea roses introduced from China during the early years of the nineteenth century and, once again, the origins of this shape, as well as its adoption and its development, owe much to the aesthetic choices made by ancient Chinese gardeners.

The shape of a Hybrid Tea is an ideal of beauty that has become refined by breeders, standardized by florists and defined by those who grow roses for exhibition. This means not just amateurs competing to produce the largest and most elegantly formed flowers to win prizes in competitions, but also rose growers who sell their plants by exhibiting them at shows with up to fifty perfect stems of the same variety in a vase. The long, pointed buds and their elegantly recurved outer petals are the epitome of formality. Popular show varieties – never easy to grow to perfection unless protected from wind and rain – include 'Don Charlton' (pale pink with a slightly darker pink on the back of the petals), Red Devil (scarlet-crimson with cherry-red reverses) and St Patrick (yellow with a hint of orange-gold at the centre). And a tight bunch of florists' roses, all of the same colour, shape and stem length, is almost the last word in formality – a formal shape, formally arranged and formally presented.

Many roses were bred in the nineteenth and twentieth centuries to win prize money at shows and competitions. These roses have huge flowers with many petals which are slow to open out and last well in water – there are stories of the same flower being taken from show to show and winning prizes over a period of several days – but these qualities make them good cut flowers, too. The structure of a formal arrangement is supplied by the solid, substantial flowers of just one variety. The same qualities of regular shape and long vase-life are also essential for commercial cut roses. Scented or not, few flowers are as rigidly formal as the identical bunch of six, twelve or twenty-five roses we buy from a florist. Nevertheless, this lack of variability (in which they differ from more charming and romantic roses) makes them a dependable product and thus the basis of their commercial success. For many years, the best known florists' roses came from the house

of Meilland in Provence: pale salmon-pink Sonia (1970) and its scarlet-vermilion parent Baccará (1954) were grown in their millions with just one perfectly shaped flower at the end of a stem that might be as much as one metre (more than three feet) in length. Nowadays, the cut-rose trade is much more competitive, and many other breeders have entered the market, while most of the roses themselves are grown in Kenya for the European market and in Venezuela for the North American. The commercial life of a new cut-rose variety is correspondingly very short; it is unlikely to be widely grown after a few years, because it will be replaced by a similar variety that is perceived as an improvement. It should not be forgotten, however, that florists' roses are no more than a form of Hybrid Tea, and that many of them grow splendidly as garden plants, their long stems thrusting up like the spears of a floral army.

Florists' roses, however, do not appeal to the more sensuous and romantic side of human nature – not least, because they are usually scentless and many people declare that they cannot understand the point of a rose that does not have fragrance. It seems that the gene that brings scent to roses is closely, but inversely, related to their longevity. Scented roses do not last as long as those without scent, which explains why we have to accept that the roses we buy for St Valentine's or Mother's Day may be perfect in their formal beauty but seldom have any fragrance. Fortunately, modern breeders realize that they need to find a way to combine long vase-life with the sort of scent we all expect of roses, so we may not have to wait long for them to come up with a solution to the problem.

The half-open buds of Red Devil and Sonia present good examples of the formal shape expected of Hybrid Tea roses.

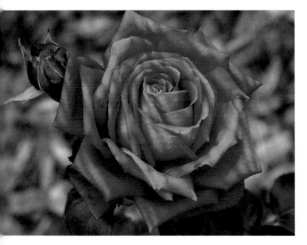

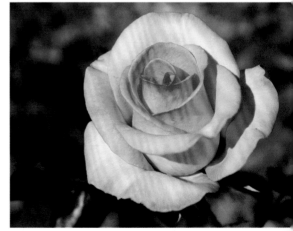

Most old roses are romantic flowers but only a few varieties are renowned for their formal shape. The formality of a heraldic rose was an iconic symbol of the Tudor dynasty, and the red rose of Lancaster (*Rosa gallica* 'Officinalis') and the white rose of York (*R.* 'Alba Semiplena') were both seen as exemplars of formality and complexity in the fifteenth century. Few plants of any kind bore double flowers at the time, and so the extra layers of petals that these two roses exhibited gave them a special place in men's estimation of the natural world. Both were, in fact, no more than semi-double, but the white roses were associated with the Virgin Mary and the red ones with St Francis of Assisi. When they were adapted and displayed throughout England as the royal Tudor rose, they were portrayed as rigidly stylized and flat – the idioms of heraldry are invariably formal. In fact, very few of the older roses have a formal shape in the real world. Many are described as 'imbricated', but they do not exhibit the perfectly neat and regular imbrication of camellias. Some might argue that the shape of some damask roses – 'Marie Louise' (1811) and 'Botzaris' (1856) come to mind – is so intricate as to be formal, and the same has been suggested for some of the modern roses in the old style bred by David Austin – Jude the Obscure (1995), for example, has rows and rows of curved petals within a globular flower – but it is difficult to sustain this argument in the face of the overwhelming conviction that roses are romantic.

The old pink damask rose 'Marie Louise' and yellow English rose Jude the Obscure do not show their formal shape until fully expanded.

One of the paradoxes of double flowers is that they may appear very formal, regular and neat when each bloom is carefully studied but

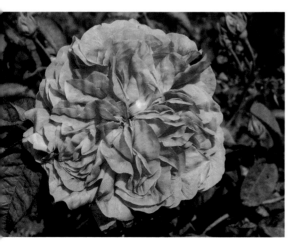

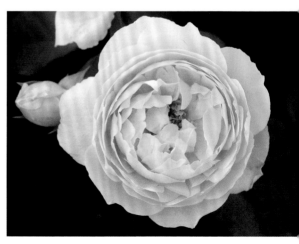

Rhododendron 'Rosebud', a popular double-flowered evergreen azalea.

be borne on a lax, loose plant. Double-flowered rhododendrons and azaleas are a good example of loosely shaped shrubs bearing formal flowers, though there are very few of them. Best known are the Ghent hybrids and their sweetly scented descendants, the Rustica hybrids. Several stand out for the shape that their 'doubling' takes. Often this is a hose-in-hose flower that manages to be formal rather than curious or flamboyant. *R.* 'Cannon's Double', for example, is a modern American hybrid, with funnel-shaped hose-in-hose flowers whose overlapping petals appear almost imbricated, and a fascinating combination of colours too – the deep pink buds open out as apricot-pink flowers with pale yellow towards the base. Good autumn colour is a bonus. *R.* 'Corneille' is a much older variety, dating back to the 1890s, with crimson buds and rich pink hose-in-hose flowers that pale with age, though their long, red stigmas, curving upwards into the air, do give the flowers a slightly comic appearance – if it is possible to be both comical and formal at the same time. The double flowers of *R.* 'Homebush' are deep carmine pink, so densely held in a pompon-like truss and so numerous that the cluster resembles a ball. Other double azaleas may also be called formal, notably the hose-in-hose *R.* 'Narcissiflorum' (a pretty primrose-yellow hybrid

Delphinium 'Susan Edmunds' is a gift to flower arrangers. Its frilly, neatly arranged double flowers combine well with other plants in the vase as in the garden.

raised in the 1830s) and brilliant white *R.* 'Whitethroat'. And yet, one could never say that azalea bushes are formal in shape, just as one would not say as much of camellias; it is the neat regularity of their double flowers that commends them to lovers of formality.

Delphiniums are by their very nature formal plants. Tall and erect as guardsmen, they need to be staked if they are to be kept standing but they have always been used to add structure to a planting. In Victorian times they were sometimes used as bedding plants; nowadays we think of them as essential components of herbaceous and mixed borders, where their upright bearing makes them wonderful companions for romantic plantings of roses. Double delphiniums have an extra solidity, even in a slender, elegant spike like that of *D. elatum* 'Alice Artindale', which is an old variety, known since at least the 1930s, whose flowers are sometimes fertile and produce seed – a rare feature among the double-flowered delphiniums. It is immensely useful for its neat, blue-and-mauve rosette-like flowers, and particularly good for cutting. If cut to the ground after flowering, and properly encouraged by feeding and watering, it will flower again in autumn. If its stems are hung upside down and dried, the flowers do not close up or wilt, and this is true of many double flowers. As with all delphiniums, its value in large, formal flower arrangements applies whether the flowers are fresh or dried. 'Can-Can' is a more modern variety, a paler shade of blue (with a hint of mauve, too) and fully double, with very regularly shaped flowers, but some of these double delphiniums are only really semi-double, including 'Fenella', which has long, dense spikes of rich mid-blue, and 'Lord Butler', which is appropriately Cambridge blue and has neat, closely packed flower-spikes. But best of all is 'Susan Edmunds', whose flowers are fully double, neat and rather flat, with masses of mid-blue petals that are slightly paler towards the centre – a gift for flower arrangers.

IT MAY SEEM SURPRISING, but this is the chapter in which to praise the formal shapes of water lilies. Almost all water lilies are species and varieties of *Nymphaea*, a pretty name for a pretty flower. They are among the most primitive of plants, in that they evolved early, and one can see a superficial resemblance between their flowers and those of magnolias, one of the most primitive of trees. Water lilies are unusual in that almost all the species bear flowers that are naturally double; they have four or five sepals, but many more petals, which merge gradually with the stamens at the centre. The flowers of the European *Nymphaea alba*, celebrated by pre-Raphaelite painters, have at least twenty petals, while those of the slightly smaller *N. odorata*, a very hardy species from New England, have an even greater number, as well as being more fragrant. When the flowers open out, they have an innate elegance in the arrangement of their petals which is enhanced by their pristine colour and smooth surface. Some hold their flowers well clear of the surface, and make excellent, if short-lived, cut flowers.

If wild water lilies have flowers with so many petals quite naturally, what do we mean by double-flowered varieties? The answer is that, over the last 150 years, growers and breeders have raised and introduced forms with even more petals. But often – not always – the effect of adding extra petals is to render the flowers less elegant, less balanced, more dumpy – less charming and less romantic than are the flowers of the wild species, even though their shape may be so regular and formal that double water lilies seem almost artificial. For those varieties, 'more is less'.

The first European breeder to introduce new water lilies, mainly hybrids between *Nymphaea alba* and several North American species, was Joseph Latour-Marliac, who lived at Le-Temple-sur-Lot in Aquitaine. Latour-Marliac considered snow-white 'Caroliniana Nivea', which he introduced in 1893, to be double. It does have a few more petals than the wild species and they are very beautifully displayed – long and pointed, making a pure white starburst. 'Caroliniana Perfecta', which Latour-Marliac introduced in the same year, he described as 'very double', which it is not, but it has a wonderfully regular shape, with pink petals that are deeper coloured towards the base and give a dark pink glow to the centre of the flower where golden stamens burst open with yellow pollen. But by the time Latour-Marliac introduced 'Darwin' in 1909, many more of the stamens had been converted into petals which seem almost to crowd them out, and the introduction of 'Gloire du Temple-sur-Lot'

four years later showed a plant so full of narrow, pink, strap-like petaloids that it most resembles a double daisy with only a hint of yellow at the centre. Finally, 'Gonnère' came out in 1914, its petals so numerous that in Anglo-Saxon markets it was sold as 'Crystal White' and 'Snowball'. The effect of doubling is a great success: layer upon layer of brilliant white, pointed petals open out into a super-regular shape – a formal arrangement, from whatever angle it is seen, that marks it as one of the most beautiful of all water lilies.

Nymphaea 'Darwin'. All water lilies appear to be double, because all have more than five petals. True doubles arrange their petals in a regular, formal shape.

THERE IS ANOTHER TYPE OF FORMALITY to which double flowers lend themselves well, which is the formality present in plantings where repetition is of the essence. The much underrated author Jason Hill – a pseudonym for Frank Anthony Hampton (1888–1967), who was a psychiatrist as well as a garden writer – wrote in 1940 of using 'formal, stylistic flowers' to create 'the effect of a French flower painting or a Victorian posy'. Here he cited double-flowered crimson sweet williams, double potentillas, the 'Harpur Crewe' wallflower, double columbines, quilled daisies and, for autumn, Pompon chrysanthemums and Pompon dahlias. But the effect of such plantings is not confined to creating French flower paintings and Victorian posies, for these and other double-flowered plants are important contributors to 'mille fleurs' plantings, which is a term taken from the art of embroidery to describe a complicated floral pattern that is repeated at regular intervals. When they create a 'mille fleurs' design, gardeners assemble a group of perhaps six, eight or ten different plants which combine well together, and then repeat the grouping all the way round a formal garden such as a parterre. Even at its simplest, when annuals are bedded out in summer in public parks, they are arranged in regular patterns, partly so that each has an equal space to fill and partly because planting in formal lines increases the impression that the gardener is in control of his garden. Double flowers, as we have seen, often give a longer season of flower and more colour than singles and so are especially useful in such plantings.

Double tulips were never subject to the wild financial speculation called 'Tulipomania'; it was the flamed and feathered and curiously marked single tulips, not the doubles, that unhinged people's minds and opened their purses in the seventeenth century. Double-flowered tulips were certainly known at the time: Clusius, who was botanist to the Holy Roman Emperor Maximilian II, recorded double tulips in the 1580s and they are mentioned in the *Hortus Eystettensis* (1613), though they did not become fashionable until the last quarter of the seventeenth century, and then only as curiosities. Furber's *Twelve Months of Flowers* (1730) includes a red-and-yellow double tulip called 'Endroit' in his plate of April-blooming flowers. This variety is now lost, but the violet-purple double 'Bleu Céleste' (syn. 'Blue Flag') (1750) is still grown and noted for its exceptionally long season of flower – up to four weeks. Two double-flowered tulips are mentioned in Van Kampen's *Traité des Fleurs à Oignons* (1760): 'La Couronne Impériale' and 'Mariage de ma Fille', both of them white with red or crimson stripes or flares, not unlike the excellent modern 'Carnaval de Nice'. But most gardeners, according to John Hill in 1762, 'dispise double Tulips [and their] ragged multiplicity of ill shaped petals', even though when Thomas Jefferson was in Paris in 1786, he sent double tulip bulbs home to Monticello, his plantation in Virginia.

The main reason why double tulips were not popular was that they were particularly liable to keel over or break their stems in wet weather. And florists, who brought such plants as pinks and auriculas to perfection, considered double tulips too wayward in shape to be capable of elegance. This view was echoed in *The Book of the Tulip* (1929) by Sir Daniel Hall, who, while recognizing that double tulips are 'more lasting', considered that doubling a tulip destroyed its 'finest and most distinctive qualities'. He was probably thinking of 'Murillo', a stout pink double-flowered variety introduced in 1850, which produced so many colour-mutants that most of the double tulips grown a hundred years ago were still 'Murillo' or its sports. Hall described them as 'sturdy little martinets, with just that touch of the grotesque that appeals to the lovers of rococo', grudgingly admitting that they sometimes have their use 'under certain conditions of architectural garden design'. And they were 'chiefly used for forcing . . . [since] as cut blooms they yield pleasing masses of colour'.

So the main claim of double tulips to be regarded as bulbs for formal plantings rests on the mass of bright and different colours they offer over a long period in spring. Visitors to the Dutch bulb fields

ABOVE
Tulipa 'Murillo',
bred in 1850, was
the first modern
double tulip. It
is seen here with
some of its many
colour sports.

OVERLEAF
Tulipa 'Brest' is
grown mainly for
the cut-flower
market.

and, in particular, to the display gardens at Keukenhof see them at
their best, and the huge sweeps of 'Murillo' and its sports are one of
the most spectacular plantings in this most spectacular of gardens.
Most readily available today are bright red 'Stockholm', deep orange
'Orange Nassau', light red 'Crimsonia', magenta-red 'Electra', pure
white 'Schoonoord', red-with-white-edge 'Willemsoord' and the soft
pink 'Peach Blossom'. All are short-growing, early-flowering and
honey-scented. They mix well together, but less well with other
plants. In his autobiography *The Education of a Gardener* (1962), Russell
Page describes how he planted 'Peach Blossom' at an important
international show at Brussels in 1958, interplanting them with
Dicentra spectabilis and 'nearby . . . pink and white *Primula malacoides* . . .
then, finding that it looked a little too sweet, I peppered the whole of
this planting with . . . scarlet 'Holland's Glory' tulips.' Sir Daniel Hall
was firmly of the opinion that these early-flowering double tulips
were best planted entirely on their own.

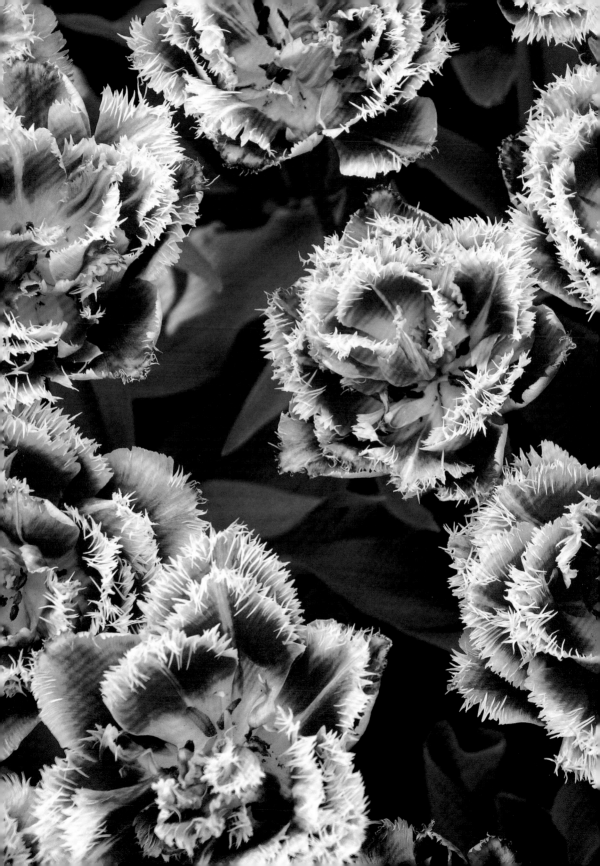

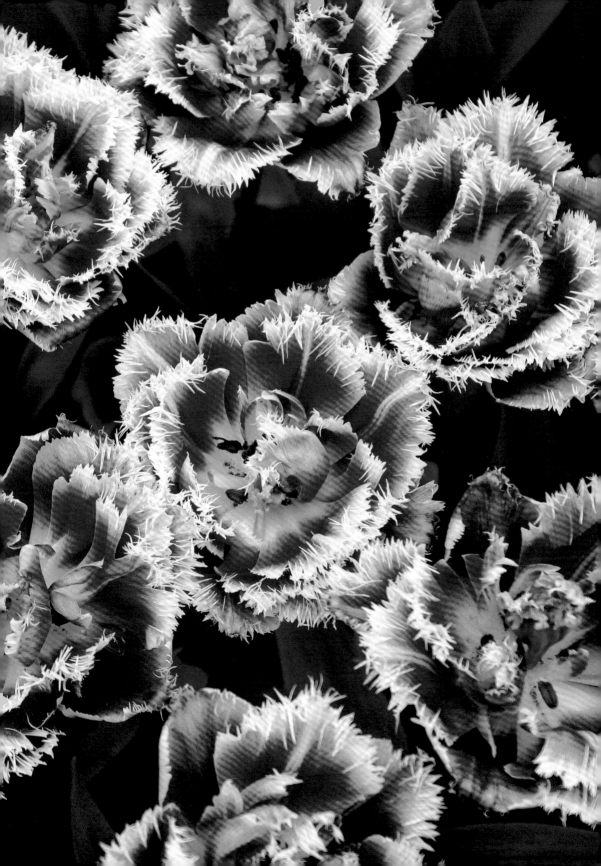

Late-flowering double tulips are widely used for bedding – the weather is more likely to be gentle in early May than in late March. Their stems are longer and stronger, and the flowers are larger, as well as being neat and tidy. As with the 'Murillo' clan, their great advantage over single-flowered tulips is their abundance of colour and their longer period of flower. These are the tulips one sees in their hundreds in public places, often emerging from a sea of forget-me-nots or interplanted with polyanthus. Sometimes they are described as 'peony-flowered' but that is inaccurate even though, when fully open, the Double Lates do have an air of extravagant opulence about them. What they offer is real substance, both outside in the garden and indoors when picked for arrangements. 'Bleu Céleste' (syn. 'Blue Flag') is really a pale violet colour, fading to dusky mauve: Gertrude Jekyll planted it with 'other purple tulips, purple Wallflower, dark purple Honesty . . . Solomon's Seal . . . [and] a few white Tulips'. It is now surpassed in popularity by modern varieties. 'Angélique' (1959) is deservedly the most widely grown, an elegant confection of pink, white and green; 'Mount Tacoma' (1924) is pure white, with long, strong stems, especially good for picking;

The flowers of *Tulipa* 'Double Flaming Parrot' start off as neat, formal buds, but eventually open out into wacky disorganized swirls.

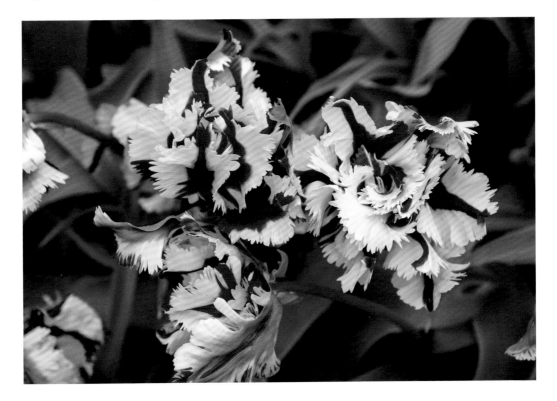

'Black Hero' (1984) could be taken for a double form of the purple-black 'Queen of Night'; 'Orange Princess' (1983) is a double sport of 'Prinses Irene' with orange petals, flared with red, and touches of yellow and green – and it has variegated leaves, too; 'Maywonder' (1951) is dark pink or pale crimson, occasionally with white stripes. But for real stripes nothing can beat 'Carnaval de Nice' (1954), whose extraordinarily bold combination of red flushes on a white ground makes it one of the most cheerful and cheering of all garden plants. Best seen in a mixed planting with forget-me-nots in temperate climates, or variegated periwinkle in the Mediterranean, it manages to combine brilliance, formality and even humour in its glorious striped double flowers.

THE FORMALITY OF SOME GARDENS depends not only on repetition but on balancing the design so that the eye is carried along a central axis and the plantings on either side present mirror images of each other. Tall avenues of trees were an important complement to the grand formal designs of the seventeenth and eighteenth century, which we now call the classical French gardens. In Mediterranean gardens, designers used elegant Italian cypresses. They are still planted to create a sense of movement and grandeur. But quite a different tree was popular in the middle of the last century to create a similar effect, not in grand landscapes but in small modern gardens governed by horticulture and a love of plants – the distinctively columnar Japanese cherry *Prunus* 'Amanogawa'. Two trees on either side of a path marked the beginning or end of a vista, while a short avenue of 'Amanogawa' applied the principles of planting a grand avenue of fastigiate poplars or cypresses but made its statement on a much more domestic scale. The flowers of 'Amanogawa' are delightful – large, semi-double and pale pink, but opening from darker pink buds and massed all along the branches of the stiff, upright tree. As so often with double-flowered plants, the extra petals greatly increase their impact in bloom. And they smell of freesias, too, while the tree has bronze-tinged young leaves and vivid autumn colour, but is seldom as much as 6 m/20 ft in height.

Standard roses provide another example of how double-flowered plants may impart formality to the design of a garden. Standards are roses that appear to be perched on top of a trunk, typically 1–1½ m/3–5 ft high, and are made by grafting the desired variety on the stem of a vigorous understock. Then, instead of growing as a bush, they appear as lollipop shapes and give both height and structure to a garden. They were immensely popular in the late nineteenth century, especially in formal rose gardens based on Italian Renaissance designs. The upright habit of the standard roses adds to the sense of formality, though they do require rather more careful management than bush roses.

ABOVE
Prunus 'Amanogawa' can be planted to make a floral avenue even in quite a small garden.

A final thought about formal flowers follows from the fact that most standard roses are popular Hybrid Teas or Floribundas. The way in which these two types of rose are used in the garden or as cut flowers affects the way we perceive them. When they are cut for flower arrangements, they appear formal and solid and their purpose is to create structure. By themselves, they are the antithesis of the romantic style of arranging flowers – imagine fifty identical flowers all in one vase – but when they are blended with other flowers that hold themselves more loosely, they lose their inherent awkwardness and become part of an arrangement that is largely romantic in character. Getting the right balance between formal and informal is not easy, and the same skill is needed when arranging the two styles in a border. The formal plants please the designer within us; the looser ones please the plant lover. There is room for both. More difficult to place are the showy and flamboyant flowers that occupy the next chapter.

RIGHT
La Roseraie de la Bagatelle, Paris. Standard roses, neat topiary and box-edged beds combine to create an air of formality.

6 The Showy and Flamboyant

SHOWY, ASSERTIVE AND DOMINANT, THESE ARE FLOWERS WHOSE SHEER MASS DICTATES THE NATURE OF A COMPOSITION. THEY ARE MUCH LOVED BY FLOWER ARRANGERS AND BY MODERN LANDSCAPERS, BUT THEIR OVERRIDING VALUE LIES IN THE SUBSTANCE THEY GIVE TO A GARDEN PLANTING.

In this chapter we look at double flowers whose outstanding character is their flamboyance. Size and colour have much to do with flamboyance, since a large flower always has more of an impact than a small one, and the colours of yellow, orange and scarlet are more pushy and insistent than gentle pinks and mauves; there is a brassy self-confidence about their demeanour that does not always associate with softer tones and neater shapes. These 'me-me-me' plants are best combined with others whose bold shapes or variegated leaves match their conspicuous presence. And the art of bedding – planting large masses of colour for seasonal display – relies heavily on double-flowered plants for their extra oomph and for the sheer flower power that transforms the conventional into the memorable.

IN SPRING, IT IS PLANTS WITH LARGE FLOWERS that get noticed and qualify for the epithet 'flamboyant'. Most spring flowers are neat and small, so a showy, large-flowered variety like the pure white double *Anemone coronaria* St Brigid Group 'Mount Everest' draws attention to itself; it grows to about 30 cm/1 ft, perhaps a little more, and has flowers 7 cm/3 inches in diameter. Because of its size Gertrude Jekyll considered it a fitting companion to early bulbs like scillas and hepaticas, but only if kept well to the back of a planting. The St Brigid Group contains most of the double and semi-double forms of this variably coloured eastern Mediterranean species: blue 'Lord Lieutenant' and magenta 'The Admiral' are other examples of excellent double-flowered florists' varieties, though the width and number of the sepals (anemones are one of those flowers whose petals are really converted sepals) are very variable.

Anemone coronaria 'St Brigid' is a group of double and semi-double anemones bred in Ireland.

The charming *Ranunculus asiaticus*, also native to the eastern Mediterranean, was widely developed as a florists' flower in the seventeenth and eighteenth centuries. Its colour is surprisingly variable in nature, which has given rise to a very wide range of double flowers, sometimes known as 'turban' ranunculus, up to 5 cm/2 inches in diameter and red, pink, yellow or white, with a

Hyacinthus orientalis 'Hollyhock' is one of the oldest double hyacinths still in existence.

great number of bicoloured varieties. It is hard to believe that such a slender, dainty and ephemeral wild flower, up to 45 cm/18 inches in height, can transform itself into such a flamboyant bedding plant by the converting of its stamens into extra sepals, but double ranunculus varieties also remain in beauty for much longer than the singles. In southern California, at Carlsbad, a large nursery fills a whole spacious hillside with rows and rows of them, each a different colour; a visit at the end of April offers probably the most spectacular sight a plant lover will ever see, far outclassing the Dutch bulb fields in their bright and brilliant colours. And yet, seen individually, in a pot on a windowsill, the double forms of *Ranunculus asiaticus* have a dainty neatness that is not so very removed after all from the grace of their wild ancestors. It is massed planting that converts the elegant into the flamboyant.

Hyacinths have for long been an integral part of spring bedding schemes. Their dense shape and compact height (30 cm/12 inches) impart a sense of solidity that is not always easy to accommodate on a smaller scale. All double hyacinths are varieties of *Hyacinthus orientalis*. Many, indeed, are sports of single varieties – the vivid rose-pink 'Hollyhock', for example, is a double-flowered sport of 'Distinction' – and used to be valued for appearing more densely crammed with flowers along the stem than the more open single-flowered varieties (modern singles pack their flowers much more solidly). Hyacinths took over from tulips as the plants that were sold at mad prices and, during

the eighteenth century, it was the doubles that were most expensive. In 1760 'Koning van Groot Britanien' ('King of Great Britain') retailed at £100 per bulb, the contrast between the white outer and the red inner petals accounting for its high value. Few double varieties have been introduced since the 1930s, and though there have been signs of a revival in recent years, hyacinths were at their most popular in the nineteenth century; some two thousand varieties were known in 1850, of which two-thirds were probably doubles. Cornflower-blue 'Crystal Palace', ivory-white 'Madame Sophie', pale pink 'Chestnut Flower', pink 'Rosette', dark pink 'Hollyhock' and blue 'General Köhler' are the ones most widely available today, and thus the most commonly used for spectacular bedding effects in public parks all over the world, especially in the flamboyant show gardens at Keukenhof in the Netherlands.

One of the most cheerful of spring-flowering herbaceous plants is *Doronicum orientale*, a vigorous, easy-to-grow composite whose flowers seem unusually tall when they open so early in the season. Its double-flowered variety, 'Frühlingspracht', flowers just as freely. Closer examination, however, reveals that it rather lacks the simplicity and freshness, so appropriate to their appearance in spring, of the single flowers with their slender ray florets. Nevertheless, it grows to at least 60 cm/2 ft and looks very well when boldly interplanted with tall dark red tulips. What it lacks in elegance it makes up in flower power.

IF A PLANT APPEARS SPECTACULAR, bold or flamboyant, this effect may be due to the scale of its planting. Size is important: a hose-in-hose primrose or a double-flowered celandine may be intriguing, but even if planted in thousands (which it is unlikely ever to be) it could never be called flamboyant. On the other hand, a solitary specimen of *Aesculus hippocastanum* 'Baumannii' (syn. *A. h.* 'Flore Pleno') covered in fluffy flowers may quite properly be called majestic, magnificent, splendid and even flamboyant. If the common horse chestnut is the most spectacular flowering species of tree that is hardy in the British climate, then 'Baumannii', its double-flowered form, is even more compelling. No other tree will grow to 30 m/100 ft and impress us for so long. Its white flowers open later and last longer than those of the single-flowered species and are held upright along the branches like the lights on a candelabra. Each flower on the conical inflorescence is a solid explosion of petaloids and stamens streaked with red and yellow. It is popular as a street tree because it bears no messy conkers and is taller and narrower in outline than the type. It is the only double-flowered horse chestnut,

though it was first discovered nearly two centuries ago, and a specimen in full flower is still the last word in stately self-confidence. It is, of course, far too large a tree to associate with others, but dominates a landscape by the scale of its display. A single well-placed specimen is far more effective than a woodland entirely planted with 'Baumannii' would be.

Aesculus hippocastanum 'Baumannii' is far too large for most gardens, but smaller trees achieve the same eye-catching flamboyance through the brilliance of their colours and the profusion of their flowers. European hawthorns (*Crataegus* spp). have been grown for many centuries as 'quickthorn' hedges to enclose a field because they grow fast and dense, while their thorns keep livestock within bounds and deter predators. The common hawthorn in flower presents a brilliant mass of white-flowered beauty and the oldest double-flowered form is *C. laevigata* 'Plena', well known from at least the end of the eighteenth century. More widely grown nowadays is the pink form, 'Rosea Flore Pleno'. Both the white and the pink double hawthorns reach 6 m/ 20 ft in height and have been popular as small trees for suburban gardens since the first half of the nineteenth century. When the frankly spectacular 'Paul's Scarlet', apparently a sport of 'Rosea Flore Pleno', was introduced in the 1850s, it quickly became one of the most widely planted of all garden trees, performing the function that Japanese cherries (*Prunus* cvs) would play in gardens from 1920 onwards. These hawthorns can also be used to support a vigorous climbing or rambler rose. The double yellow *Rosa banksiae* 'Lutea' often flowers at the same time, and benefits from the protection of the tree, but to prolong the season of interest, *Rosa* 'New Dawn' would be a good companion, flowering almost continuously through to late autumn. The double-flowered hawthorns do not produce as many berries as the wild European species (this may be an advantage in gardens), but nevertheless set enough seed to attract the attention of the Canadian plant breeders who were so impressed by the opulent brilliance of 'Paul's Scarlet' that they crossed it in the 1920s with the hardier North American

Crataegus laevigata 'Paul's Scarlet' is the brightest of all ornamental hawthorns.

species *Crataegus succulenta* to create a race of double-flowered thorns that would survive the severe winter cold of the inland states and provinces. Pale pink *C.* × *mordenensis* 'Toba' and its pure white seedling 'Snowbird' carry heavy crops of semi-double flowers, larger than those of their European ancestors but no less spectacular.

The same flamboyant beauty is found among ornamental cherries. The European native *Prunus avium*, from which our edible cherries have been developed and selected over many centuries, has a double-flowered form called 'Plena' that dates back at least to the seventeenth century when the Physic Garden in Edinburgh sent '2 Double floured Cherries' to the Earl of Morton in 1691 for planting at Aberdour Castle. *Prunus avium* 'Plena' manages to be elegant and delicate as well as showy. It is the individual flowers that have this elegance – there is nothing blowsy or formal about their daintiness, yet they are prolifically borne in substantial pendulous clusters that seem almost artificial and the tree as a whole makes a soaring, scintillating mass of white which lasts for longer than single-flowered types. Taller than the Japanese cherries, it reaches as much as 12 m/40 ft, sometimes even more; many gardeners judge it the best of all medium-sized garden trees.

One problem posed by many trees that flower spectacularly is that their glory may last for two or three weeks but leave us with an unexciting prospect for the rest of the year. Choosing a variety that offers good autumn colour is one way of alleviating the dullness, and many of the Japanese cherries are doubly valuable for the performance of their autumn leaves. *P. avium* 'Plena' also offers reliable autumn colour, when its foliage turns yellow, orange and scarlet over a period of several weeks. Small children find the fallen leaves irresistible.

The flowers of another *Prunus* species – *P. dulcis*, the almond tree – are exceptional both for their size and for their precocity. In much of the western Mediterranean, winter tourism is promoted by urging visitors to 'see the almond orchards in flower'. The petals are ruffled, varying between pink and white in colour, often with a crimson blotch towards the base, but the double-flowered form *P. dulcis* 'Roseopleno' is finer than any. Its flowers are about 5 cm/2 inches in diameter and pure rose-pink in colour, more semi-double than fully double because they still show an attractive little gathering of anthers at the centre. And, although the individual flowers are very pretty and delicately arranged, the overall effect of a tree in full flower is of startling

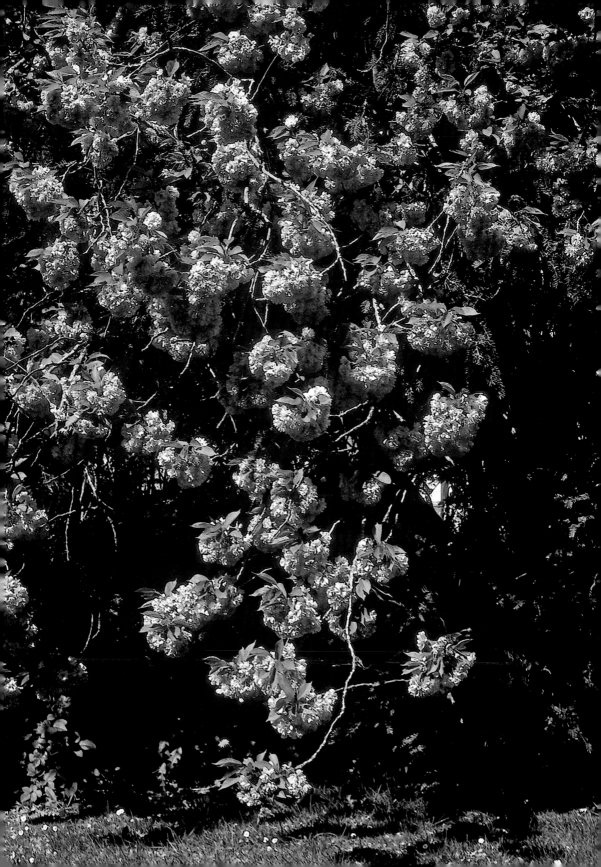

beauty – showiness – flamboyance, especially when seen against a deep Mediterranean sky.

Almonds and cherries are not the only fruit trees within the genus *Prunus*. Plums and peaches also belong here and the double-flowered forms of the latter, *P. persica*, are among the most vivid and brilliant of ornamental trees. They start with the advantage that the wild peach bears flowers of a most shocking bright pink, though smaller at 4 cm/1½ inches than those of the almond. Double-flowered forms date back several centuries – *Prunus persica* 'Plena' was already in commerce by 1636 – and 'Klara Meyer' is another old variety whose flowers are of the same colour as those of the fruit-bearing peach trees. Although ringed around with so many petals as to make it indisputably double, it manages to retain a few stamens that give interest to the centre of its nicely cupped flowers. 'Prince Charming' has flowers of a similar colour but is no more than semi-double, while the pale pink 'Helen Borchers' is fully double with ruffled petals that turn to a darker shade at their base. The best-known white form of flowering peach is 'Alboplena', grown since at least 1850, but there are many modern introductions, including 'Peppermint Stick', whose double white flowers are slashed with red stripes in the manner of an old camellia or Bourbon rose. Like ornamental almonds, these spectacular flowering peach trees need full sun, warmth and good drainage to perform well – in short, a Middle Eastern climate. They are widely grown in California and Australia, where many other varieties have been introduced in recent years. Generally speaking, double-flowered peach trees produce little or no fruit, but there is one exception: a very short-growing variety called 'Garden Beauty' (actually a nectarine, but nectarines are no more than smooth-skinned peaches) which is grown for its fruit but also has double flowers of bright, rich pink.

The double-flowered forms of everyday fruit trees have been developed as ornamental garden trees relatively recently. Japanese cherries, by contrast, are the outcome of many centuries of selection and cultivation and, as a result, show a much greater degree of variation than the forms of European and Central Asian species. Yet many flowering cherries were introduced into cultivation in the West as recently as the 1920s and it is hard to overestimate their influence upon gardens and gardening since they first burst into bloom in our grandparents' gardens. 'Kanzan' is perhaps the best known variety, and although it is not especially highly esteemed in Japan, it is grown in its millions in Western gardens, streets and parks – even as a

The large double flowers of *Prunus* 'Kanzan' are regularly borne in great quantities.

landscape tree alongside highways and motorways. Its double flowers, 5 cm/2 inches in diameter, come in very large clusters in mid- to late spring, and are a distinctive shade of pink, quite different from any other Japanese cherry, with an extraordinary brightness that is set off by a hint of purple in the buds. No matter where it is grown, the flowers are borne in vast quantities. Critics aver that it is overplanted and perhaps not always to everyone's taste, but it should be admitted that 'Kanzan' has a showy flamboyance whose blowsiness never verges on the vulgar. Its purple-leaved sport 'Royal Burgundy', a recent introduction that is now proving even more popular than its parent, has flowers of a slightly richer pink, magenta-tinged, but just as fluffy, flouncing and in-your-face as 'Kanzan' itself.

More typical of Japanese cherries is *Prunus* 'Shirofugen', said to have been cultivated in Buddhist temples as far back as the fifteenth century, with clusters of double flowers 5 cm/2 inches wide that open from pink buds and fade first to pale pink and then almost to white. 'Shirofugen' has an 'oriental' look that reflects the Japanese love of grace and subtlety, whereas *P.* 'Shôgetsu' (syn. *P.* 'Shimizu-zakura') appeals more to the Japanese for the transience of its beauty; it is one of the most showy of cherries, with masses of big, white, frilly, double flowers, opening from pink buds and hanging in large bunches on long stalks. Last of these magnificent Japanese cherries to flower is *P.* 'Ukon', whose semi-double or double white flowers have a pale

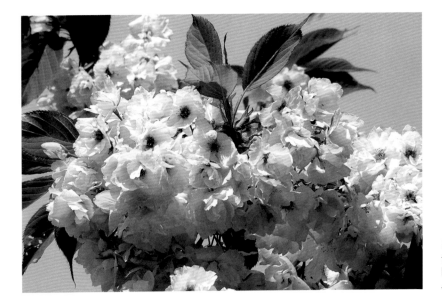

Prunus 'Ukon'. Last to flower and most beautiful of all the Japanese cherries.

green or greenish yellow tint that is unique among cherries. Such is the profligacy and flamboyance of its blossoming that, despite its late flowering, a single tree of 'Ukon' in its full spring glory outshines all other plants in a garden; moreover, its branches blend beautifully with almost every other flower when cut for indoor decoration. Showy it may be, but it is a good and welcome mixer too, in contrast to *P.* 'Kiku-shidare-Sakura' (*P.* 'Cheal's Weeping'), which eventually forms a flat-topped, gently pendulous tree, a shape much admired in Japan, and best appreciated on its own. An individual tree of *P.* 'Kiku-shidare-Sakura' makes an elegant specimen, but its rich pink flowers, full of fluttering petals, are agreeably blowsy and quite loud enough to demand praise for their bombastic beauty.

THREE FURTHER GENERA OF TREES AND SHRUBS are even more famous than Japanese cherries for the flamboyance of their spring flowering – magnolias, rhododendrons and camellias. The sheer size of their flowers is itself an extraordinary statement of self-confidence; they are the mainstays of most large gardens on suitable soils in temperate climates, growing together and filling a woodland garden with colour at a time when the world outside is brown and barren.

When we consider their beauty and their horticultural value, it comes as a surprise to be told that magnolias are primitive trees, one of the oldest and least evolved of all genera. Their flowers have no real petals: what we perceive as petals are sepals that perform the function of petals – rather confusingly, botanists call them 'tepals'. Double-flowered forms exist among almost all the many species and groups of hybrids, though they never generate such a mass of tepals as to produce a flower that is truly thick with them, nor are these double-flowered magnolias ever sterile. Most frequently seen are forms of *Magnolia stellata*, a hardy medium-sized shrub or twiggy tree (up to 3 m/10 ft in height) that flowers abundantly and is very useful in gardens where space is limited. Best known are such varieties as 'King Rose', 'Royal Star', 'Water Lily' and 'Jane Platt'; all have up to fifty curving strap-like tepals on a flower perhaps 13 cm/ 5 inches across, in white or shades of pink, and flower for several weeks in spring. Their flowers are delicate, dainty and charming, but magnolias flower on their naked branches in great profusion, especially after a hot summer, so that most of them are noted, above all, for their flamboyance. Many other magnolias have extra tepals, though none gives the overall appearance of bearing double flowers.

OVERLEAF
Double forms of
Magnolia stellata
are among the most
profusely flowering
of trees.

183

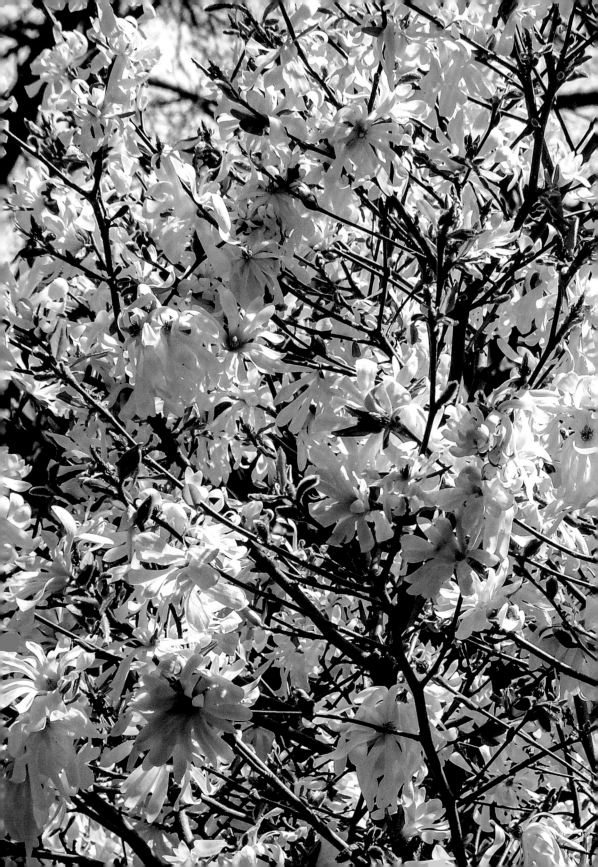

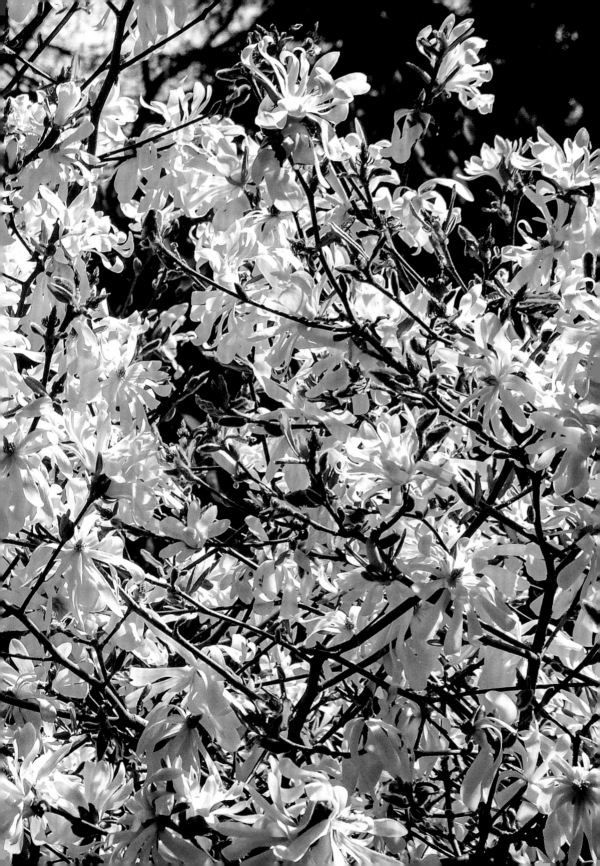

M. denudata 'Double Diamond', for example, resembles a water lily and *M. campbellii* 'Kew's Surprise' has two layers of dark pink tepals which give it a cup-and-saucer shape. Though but neither can really be said to be double, both flower in early spring and grow to a great height – 15 m/50 ft for *M. denudata* and twice that for *M. campbellii*. Walking through a woodland composed of either species when it flowers in late winter is one of the greatest experiences of a plant collector.

Where there are magnolias, you will usually find rhododendrons. There are several double-flowered varieties of 'proper' rhododendrons – the evergreen ones, rather than the deciduous azaleas. Most are neat shrubs for smaller gardens – *Rhododendron* 'Creamy Chiffon' is a very hardy hybrid of *R. yakushimanum* no more than 1.5 m/5 ft high, while *R. hirsutum* 'Flore Pleno', which was listed by John Tradescant as long ago as 1656, is a form of the low-growing alpine species (50 cm/ 20 inches high), and said to grow naturally on limestone rocks. *R.* 'Weston's Pink Diamond' is a modern hybrid – a stiff, erect plant with globular trusses of bright pink, frilly, heavily doubled flowers. But none of these could ever be considered truly spectacular. There is, however, an ancient hybrid called *R.* 'Fastuosum Flore Pleno' which is nothing short of miraculous in full flower, a proper stage-stealer even though its semi-double flowers are somewhere between lilac, mauve and purple in colour. This sterile hybrid between *R. ponticum* and *R. catawbiense* was bred in the 1840s in Ghent and comes into flower rather late for a rhododendron, often not until early summer, but it remains in bloom for longer than many single-flowered varieties. In 1937, the garden owner and journalist A.T. Johnson described a specimen in his garden in Wales as 'tumbling in a twenty foot cascade of blue-lavender'. It is hard to explain how so soft a colour can have such intensity, but the inner petals are darker than the outer ones, and this creates an impression of depth and solidity unique among rhododendrons.

Camellias are to winter what roses are to summer. Given the right climate and a shrewd choice of varieties, they will blossom from autumn to spring, and overlap with the roses at both ends of their season. But in one way they are better than roses because they have wonderful, glossy, dark, evergreen leaves that create the perfect setting for their sparkling flowers. The white flowers of *Camellia japonica* 'Alba Plena' are all the brighter for the glittering leaves that surround them. Thousands of varieties have been introduced since the first seeds came to Europe, perhaps to Portugal in the sixteenth century but more certainly by the early years of the eighteenth.

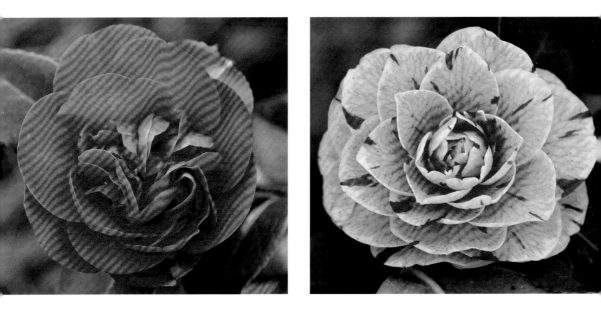

ABOVE LEFT
Camellia × williamsii 'Debbie'

ABOVE RIGHT
Camellia 'Contessa Lavinia Maggi'

Camellias had already been admired and selected for centuries in China and Japan but the first double-flowered varieties did not find their way to Europe until the end of the eighteenth century, transported by merchants of the East India Company.

Few sights are more spectacular in winter than a large, many-petalled camellia in full bloom. Even some of the oldest varieties are weighed down by their profusion of flowers – semi-double 'Adolphe Audusson', introduced 1877, is a good example, and reminds us that red camellias tend to be weatherproof, while white ones show every blemish that winter's frosts bestow upon them. Striped camellias like the incomparable 'Contessa Lavinia Maggi', fully double, and with red flecks on a white ground reminiscent of a carnation, bear the slights of intemperate weather better than many, but the flowers of all *C. japonica* varieties have a tendency to remain on the branch after they have finished flowering and turn an unsightly brown. It was the race of *C. × williamsii* hybrids, developed from crosses between varieties of *C. japonica* and *C. saluensis*, that supplied the solution, for the best of them drop their flowers as soon as they are spent. They are among the most dazzling of double-flowered plants: the blooms of 'Debbie', for example, resemble pink peonies, bright and sharp, 12 cm/ 5 inches in diameter and bursting with ruffled petals in early spring. However, there is no end to the list of excellent *C. × williamsii* hybrids with double flowers so scintillating that they stop you in your tracks

– dark pink 'Joan Trehane', dark red 'Ruby Wedding' and primrose-centred 'Jury's Yellow' – are just as compelling. They get even better as they grow, for a monumental camellia 6 m/20 ft high in full flower is infinitely more impressive than one that is half its size.

All camellias were at first thought by Westerners to need the protection of glasshouses heated, in some cases, to tropical levels of temperature. This ensured that they were regarded as high-value and desirable luxuries, grown and growable only by the very rich in special conservatories. When the sixth Duke of Devonshire commissioned Samuel Ware at Chiswick in 1811 to build the largest conservatory ever known (nearly 100 m/330 ft in length) and filled it, some years later, with camellias, it was a statement of power and wealth. Only gradually did garden owners and their gardeners realize that some camellias, mainly varieties of *C. japonica*, are hardy in most parts of the British Isles, though they may still benefit from some protection against winter damage in colder areas. And for those who garden in really warm climates, the modern *C. reticulata* hybrids from Australia and the United States – including semi-double 'Buddha', peony-shaped 'Miss Tulare' and fully double 'Valentine Day' – bear even larger flowers, of an opulence and vigour that is unknown among single-flowered varieties. Such is the transformation that may be wrought by centuries of breeding and selection in any highly hybridized genus – roses and dahlias as much as camellias.

THE SPLENDID WHITE FLOWERS OF THE DOGWOOD, *Cornus florida*, along with the redbuds, are the most visible and glorious sight of New England in spring. Actually, the flowers form a small greenish-yellow cluster right at the centre, while four large white bracts compose the 'petals' of what we suppose to be the 'flower'. Sometimes some of the true flowers produce elongated petals that resemble the bracts and these have been introduced as 'double' forms. 'Alba Plena' is perhaps the best known, but it is worth looking out for 'Bay Beauty' and *C. florida* f. *pluribracteata* too. All have a fuller look than the wild species, because they carry more outer bracts as well as the pretty arrangement of smaller ones at the centre. Sometimes these inner bracts curl over elegantly and touch each other at their tips. The wild single-flowered dogwoods can be somewhat one-dimensional, but these doubles have a substance and a fullness that draw your attention and flaunt their beauty. All fare best in a continental climate where winter cold is complemented by hot summers.

SPIRAEAS are not the most exciting of garden shrubs, though improved forms of some species have been cultivated in Chinese gardens for many centuries. Double-flowered *S. prunifolia* (syn. *S. p.* 'Plena') was sent to Europe by Philipp von Siebold from Japan in 1845 and from China by Robert Fortune in 1846; Fortune also introduced *S. cantoniensis* 'Flore Pleno' (syn. *S. c.* 'Lanceata') to Western gardens in 1849. These two varieties have the largest flowers in the genus, each about 1 cm/½ inch in diameter but borne in immense profusion on racemes that may be as much as 60 cm/2 feet long. When they flower, early in spring, there is no shrub to match them for their display of brilliant white, all the brighter for losing the slightly green stamens at the heart of the single-flowered species. 'Bridal Wreath' is one of their popular names, and though after their flowering they may sit dully in the garden all summer long, they do redeem themselves in autumn when the leaves turn tawny shades of orange and scarlet.

Kerria japonica 'Pleniflora', which has much bolder flowers than its wild forebear, was known to Western gardeners long before the single-flowered species.

Another shrub first known to Westerners in its double-flowered form is *Kerria japonica* (actually a native of China, not Japan) ,which was first sent to Kew in 1804. Its flowers were so full of petals that no stamen or stigma was visible and it was not until the single-flowered wild species arrived in England thirty years later that botanists were able to determine that it belonged among the Rosaceae. 'Pleniflora', as the double-flowered form was later named, produces its orange-yellow flowers all along its slender branches, and though for the rest of the year among the least conspicuous of shrubs, it is for three or four weeks in spring resplendent. It is easy to grow on any soil, quickly reaching 1.5 m/5 ft in height and width, but can be pruned to keep it shorter or slimmer. Not everyone agrees on its charm: Graham Stuart Thomas considered *Kerria japonica* 'Pleniflora' proof that 'it is an error to suppose that a double flower is always better than its type, for the multiplication of petals is frequently gained at the expense of grace and delicacy.' Nevertheless, the beauty of the individual flowers is

both graceful *and* delicate, while the overall effect of a specimen in full flower, though sometimes gawky in outline, is, at its best, a cascade of elegant colour, as spectacular from a distance as it is dainty in close-up.

FLAMBOYANCE AND SHOWINESS are relative terms. Plants may be quiet and refined in the general context, but noisy and brash within their own family. Some of the hardy herbaceous geraniums illustrate this distinction well. The general popularity of hardy geraniums is due in part to the way they seem so often to be in sympathy with other plants. They are easy to combine and make flattering companions, for example, with deutzias and old roses. But a few mix less well – the bright magenta colour and strappy petals of *Geranium* × *oxonianum* f. *thurstonianum* 'Southcombe Double' (not a name that trips easily off the tongue) make it difficult to accommodate sympathetically with other herbaceous plants – though it is a wonderful ground coverer, some 50 cm/20 inches high, and looks good in grass. For impact in meadow gardening, 'Southcombe Double' combines well with double forms of *G. pratense* and its relations, especially the paler selections like *G. pratense* 'Double Jewel', itself a fairly flamboyant mixture of white and purple. Some double geraniums die badly by hanging on to their faded brown flowers, but if you cut them to the ground after they have flowered, they soon start to produce plenty of new leaves and flowers. And the flowers last very well when cut, unlike single-flowered geraniums, which tend to drop their petals as quickly as you can put them in a vase.

Hemerocallis are known as day lilies because their flowers last for no more than one day, and this remains true of the double-flowered forms. Nevertheless, they are among the brightest and most joyful of garden flowers for many months of the year. Hemerocallis is one of those genera where the flower's 'petals' are actually made up from a mixture of sepals and true petals. A quick study makes this clear – the petals are the inner ones and are usually broader and longer than the sepals in between and behind them – but the upshot is that botanists tend to talk of all six of them as 'tepals' rather than petals. Day lilies are immensely popular, especially in North America, and there are now tens of thousands of varieties of all shapes and sizes; many are doubles, including some that have been cultivated in Japan for centuries. Easy to grow and always cheerful in colour, the best are flamboyant plants suited both to large-scale informal plantings and to more traditional herbaceous borders.

The most frequently seen double-flowered day lily is *H. fulva* 'Flore Pleno', first brought to Europe in 1860 but known to European visitors to Japan from the early eighteenth century onwards. The English plantsman E.A. Bowles considered it a wonderfully effective neighbour for *Veratrum album* but it is a striking plant in its own right, with large burnt-orange flowers that have yellow and reddish stripes running longitudinally down its tepals, often with darker patches on either side of the midrib. The tepals are layered up in groups of three but somewhat inconsistently; sometimes the arrangement is quite regular, almost formal, although in the form known as 'Green Kwanso' (which also has a sport with variegated leaves) the tepals are more wayward and the overall effect is somewhat shaggy. But their colour and size (up to 15 cm/ 6 inches across on a 60–100 cm/ 2–3 ft plant), together with the curving shapes of both flowers and leaves, turns the whole plant into a real eye-catcher. As they are vigorous almost to the point of imperial expansionism, but sterile (and therefore will not seed about), the double-flowered forms of *H. fulva* are excellent both for naturalizing and for modern herbaceous plantings. Among the many popular double forms introduced in recent years, the following are all superb, easy to grow and colourful: 'Apricot Beauty', not unlike *H. fulva* 'Flore Pleno'; crimson-red 'Double Firecracker'; clean, light yellow 'Double River Wye'; crimson 'Little Show Stopper'; and wonderful 'Siloam Double Classic', which is peach-pink with broad, rounded tepals and undulations that give it a crimped outline.

Hemerocallis fulva 'Flore Pleno' – bold, bright and easy to grow.

Double-flowered antirrhinums are something of a curiosity, because the way the flowers double up changes their structure completely. 'Snapdragon' is their popular name and, as every child will tell you, their chief charm lies in the way a flower seems to open its mouth when gently squeezed at the sides. When the flower doubles up the dragon's head is completely lost, replaced by a ruffled tussock of petaloids at the centre of an otherwise rather ordinary, open, five-

petalled flower. Sometimes the shape of these doubles is described as 'azalea-flowered'; it certainly lacks the distinctive character of proper snapdragons. One might therefore suppose that the phenomenon of doubling is not as valuable in antirrhinums as in many other plants, but this is denied by the enormous importance of snapdragons as components of spectacular bedding schemes. The taller forms that grow up to a metre (more than three feet) in height may need staking to protect them from blowing over, so modern snapdragons, many of them scented, have been selected for shortness and sturdiness. Twinny is the trade name of the best-known seed strain, only about 20 cm/8 inches high and available in an immense choice of brilliant colours – including bronze, yellow and bright violet. For real impact, a mix is the most effective, usually full of sweet, clear colours producing a distinctive, almost fizzy effect together, a combination that does not jar because of the unifying presence of deep crimson within the mix.

For sunny positions, gazanias are among the most spectacular of South African daisies, with large, exotic flowers all through the summer until the first frosts of autumn; their flowers – typically 10–12 cm/4–5 inches in diameter, on a plant that grows to 30 cm/ 1 ft – come in a wide range of colours but mainly in bright yellow, gold, bronze and orange, often with brilliant stripes and other markings that draw attention to their flashy colour combinations, quite unlike those of any other genus. Their bold shape and vibrant colours make gazanias invaluable both for bedding and for planting in containers, but they have one serious shortcoming – which is that they open only on sunny days and remain firmly clammed up in dull or rainy weather. Double-flowered forms get round this problem because the mass of extra ray florets prevents the flowers from closing. Among the most useful are the Sunbather strains – Sunset Lemon Spot, for example, and Sunset Jane – whose rusty orange and amber flowers are set off by silvery foliage.

THE POMEGRANATE IS A SHRUBBY TREE, 3–5 m/10–16 ft high, that revels in hot, dry summers. It has been cultivated in Mediterranean regions for so long that its early history is uncertain – it was certainly known to the Pharaohs, but is probably native to Persia and Afghanistan. Now it is grown all over the world, from China to Australia and in much of the southern United States. Apart from its luscious fruit, the pomegranate is noted for the brilliance of its

Typical
pomegranate
flowers are conical
and simple,
but the double
flowers of *Punica
granatum* f. *plena*
open flat and frilly.

flowers, which are uncompromisingly orange-vermilion in colour. But there is a most unusual difference between single- and double-flowered forms: the flowers of the typical pomegranate, grown for its fruit, are funnel-shaped, but doubles (*Punica granatum* f. *plena*) are full and flat, with lots of rather disorderly ruffled petals. When they first open, their overall appearance is almost heraldic, like a Tudor rose. As they continue to open out, the petals expand until the shape of the flower resembles a somewhat crumpled carnation – though not in colour, for the brilliant orange-red of the flowers remains throughout their long flowering period.

Double-flowered pomegranates have been cultivated as ornamental plants around the Mediterranean basin since at least the sixteenth century and valued as glasshouse plants in colder climates where they will not survive a winter outside. The English traveller Celia Fiennes saw a double white form in Staffordshire in 1698. *P. granatum* 'Alba Plena' is pleasant enough, but proof of the contention that albino variants of highly coloured flowers are dull by comparison with the brilliant types from which they sprang. Other double-flowered varieties include the large-flowered dark red 'Maxima Rubra' and a form with white-edged petals like an azalea, but rather unstable, variously known as *P. granatum* 'Legrelleae' or 'Mme Legrelle'. But none has the shining orange-vermilion brilliance of the original *P. granatum* f. *plena*. When they hang along the leafy twigs in great numbers and turn the branches into garlands, the flowers are

among the most striking examples of the ornamental superiority of double-flowered plants.

If camellias make spangled hedges of great beauty in winter and spring, then it is the varieties of *Hibiscus syriacus*, the American Rose of Sharon, that create the best flowering hedges of autumn. Indeed, they respond so well to clipping that they are grown as standards and trained into lollipop shapes in some of the best formal gardens of France and Italy. Though many of the best varieties were bred a hundred years ago in England, they fare better in drier countries with hotter summers, and their resistance to winter cold makes them valuable not just in temperate climates but also under continental conditions. Early in the nineteenth century, Jean, Lady Skipworth, grew a double white form in her garden in Mecklenburg County in Virginia. Hot dry summers produce the best flowering, but in cool climates and particularly those with wet autumns, the many-petalled cultivars may not open properly but hold the rain and become waterlogged and unsightly. Given the right conditions, however, there is a wealth of super-charged double-flowered hibiscus, from the early-flowering 'Lady Stanley' (semi-double, pink-flushed white with crimson-maroon central blotches and red veining) to the very late-flowering pale crimson 'Duc de Brabant' (a notably floriferous variety), so that one can enjoy a sequence of double-flowered hibiscus in the garden for up to three months.

Hibiscus is one of those genera whose flowers carry both their female and their male organs in the same projecting column, a prominent feature much beloved by hummingbirds. In double-flowered varieties the additional petals spring from the stamens along this central column. There are, as always, different degrees of doubleness. Semi-double forms like lilac-blue *Hibiscus syriacus* 'Ardens' keep the maroon blotch of their outer petals, as does 'Lady Stanley', an old variety first introduced in the 1870s; modern double-flowered varieties are larger and more regular in form. The crimson-purple flashes at the base of the petals are obscured, but the creamy white staminal column is transformed into extra petals and the flower as a whole acquires a richness that the single flowers lack. When it comes to choosing varieties for brilliant colour in late summer, there is a wealth of choice. 'Boule de Feu' dates back to the 1840s but is fully double, with large flowers and rather untidy ruffled petals reminiscent of an azalea. But nurserymen have recently begun breeding and introducing new varieties again,

most of which grow slowly to 2–3 m/6½–10ft. The best of the new introductions are the anemone-like semi-doubles Lavender Chiffon, White Chiffon and China Chiffon, whose flowers are larger and more regular in their shape and in the arrangement of their petals than older varieties. But best of all for brilliance is the spectacular *H. s.* 'Purpureus Variegatus', whose small, dark maroon flowers, so tightly full of petals, never open fully but remain as dense little buttons of darkness that show up vividly against the large grey-green leaves, splashed with large patches of pale cream variegation.

Only one shrub excels the glory of hibiscus for its late summer brilliance – the hydrangea. There are at least seventy species, but the great mop-headed varieties of *Hydrangea macrophylla* are so widely grown that these blowsy, double-flowered beauties are what the words 'hydrangea' and 'hortensia' conjure up in everyone's mind. Great numbers of different hydrangeas of every type have been introduced in recent years, so that this stalwart standby of Edwardian conservatories is now represented by more than a thousand cultivars. The 'typical' hortensias are still the most widely grown and, provided they can imbibe enough water, will make the most spectacular hedges and woodland plantings in late summer, whether as groups in sheltered conditions or in open, sunny positions.

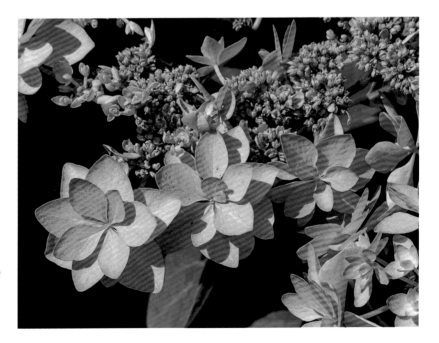

Hydrangea macrophylla Romance. The double forms of lace-cap hydrangeas have extra petals to the sterile florets.

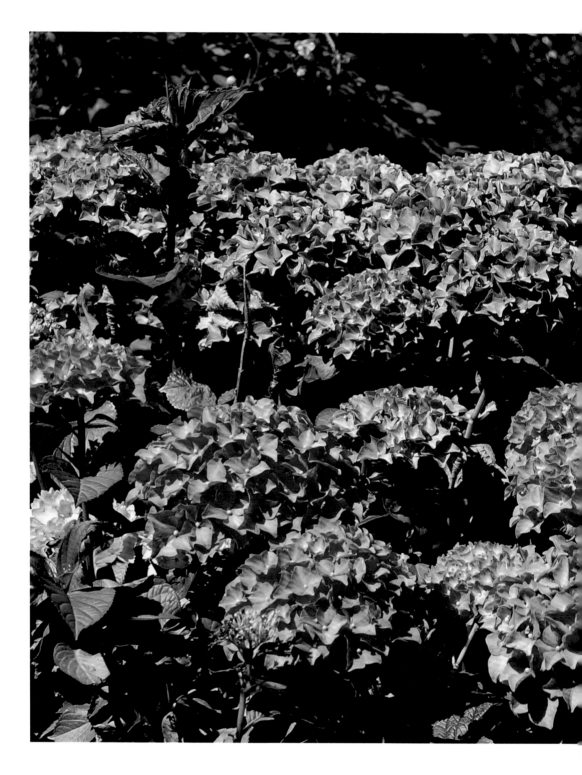

The typical 'hortensia' hydrangeas have more sterile florets in the centre of the inflorescence. This gives the flowers a domed shape.

Owners who welcome visitors to their gardens primarily to see their spring-time collections of rhododendrons, azaleas, magnolias and camellias have for long understood the usefulness of hydrangeas in extending the season of interest into the peak months of the summer holidays. Hardiness – or, more accurately, their susceptibility to cold – is the factor that limits their usefulness, but by choosing the toughest varieties, it is possible to mount a brilliant display in an inland continental climate. 'Générale Vicomtesse de Vibraye', for example, is one of the hardiest, and it is also worthwhile trying 'Altona' and 'Parzifal'. All will produce huge mopheads, especially if well fed, watered and pruned, though their colour will depend up the pH of the soil – tending to be blue in acid soils and pink in alkaline, with all sorts of intermediate shades including crimson and purple. 'Madame Emile Mouillère' is the exception, always pure white whatever its growing conditions, though, if you look carefully, you will see that the eye at the centre of each sterile floret is either pink or blue; it sets off the whiteness of the sepals to perfection.

Two further *Hydrangea* species, the only ones native to North America, are nothing less than spectacular when their double-flowered forms are in full splendour – *H. arborescens* and *H. quercifolia*. Both are hardier than *H. macrophylla* and its varieties – in fact, *H. arborescens* is one of the most cold-tolerant of all hydrangeas, hardy down to Zone 3 in the United States and consequently better known than hortensias among many North American gardeners. Improved varieties of all three species have been selected in recent years, and *H. quercifolia* **Snowflake** is one of those plants that catches the eye from far away. Its brilliant white panicles are large and long, and the individual florets open their sepals (up to forty-five in a floret) over a long season, piling up on each other in a haphazard pattern. *H. arborescens* 'Hayes Starburst' also has bright white sterile flowers, loosely packed into large corymbs, especially around the edges, with its ray florets massed in a starburst shape that justifies its name. Both varieties gleam in the woodland setting that suits them best, and draw attention to themselves so vividly that it would require a superhuman effort of will not to move closer to admire them.

The corymbs of *Hydrangea involucrata* have the same effect, though the colour of their ray florets is usually pink, while the insignificant fertile flowers are tinged with pale blue. *H. involucrata* 'Hortensis' is the best-known form with double flowers, an old Japanese cultivar, grown in the West for over a century. Like *H. arborescens*, it suckers freely, forming a handsome clump that cries out for appreciation.

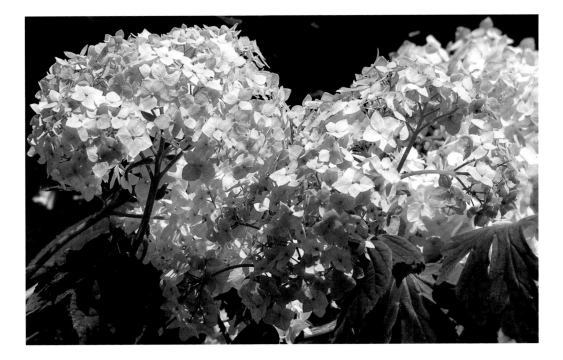

Hydrangea arborescens 'Grandiflora'. Double forms of *H. arborescens* are extremely useful in shade.

Hydrangea serrata is a Japanese species very similar to *H. macrophylla*, of which it is sometimes treated as a subspecies, though its plants are generally smaller and hardier, which makes it of considerable horticultural importance. The Japanese selected many varieties in the years before opening up to the West ('Schichidanka' was first described by Western botanists in the sixteenth century). Graham Stuart Thomas wrote that they were 'bred for subtlety not obesity', but modern introductions are more substantial – the fertile flowers of 'Miyama-yae-Murasaki' are surrounded by large, fully double, pink or blue sterile florets – and form massive clumps that are nothing less than flamboyant. They also have a curious habit of turning their sterile florets, held on long pedicels and always of the same colour as the sepals, in such a way that they reveal their undersides, which are usually differently coloured. The red tones of the leaves in autumn are a bonus.

Summer is the season when we start to notice fuchsias. We are so used to seeing fuchsias in hanging baskets, window boxes, patio pots and summer bedding schemes that we are inclined not to consider what wonderfully attractive confections they are. Single-flowered fuchsias are sober and elegant, but the frills and flounces of double-flowered varieties transport them into a different league – not just elegant, but

attractive, even seductive. The difference between a single flower and a double one is the difference between a pencil skirt and a ballerina's tutu. Which fuchsias will suit your garden is determined by climate; the choice is wider in mild and temperate parts of the world. For the widest colour range and the largest blooms, as much as 8 cm/ 3 inches, and even frillier skirts, there is a ballroomful of half-hardy and subtropical hybrids. Among the more tender varieties, only dependable in mild climates, are the immensely popular 'Swingtime', whose large double flowers depend for their effect on the contrast between the bright red outer petals (actually the calyx) and the ruffled, sparkling,

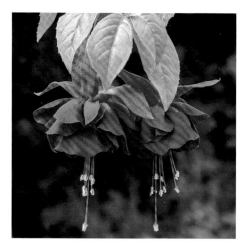

Fuschia
'Royal Velvet'

white inner petals (botanically the corolla), and 'Royal Velvet', whose crimson-red outer petals are burst open by frilly petticoats of deep purple inner petals. 'Pink Marshmallow' is another exceptionally feminine variety, with enormous flowers of palest pink on very long pendulous stalks and masses of white frills underneath. Varieties with variegated leaves make even more of an impact: 'Arcadia Gold', a gold-edged sport of 'Swingtime', is worth looking for, as is 'Felicity Kendall', whose flowers have pale pink outer petals and a gathering of episcopal purple for their corollas, all set off by leaves with yellow variegation.

The first fuchsias were plain and simple. Hybridists in the nineteenth century thought they could be improved and within a short time they became 'the most Victorian of all flowers'. *F. fulgens* was important in the breeding of hybrid fuchsias, which was begun in England by James Lye during the 1860s and independently by Victor Lemoine in France. However, *F. fulgens* appears in the ancestry of most of the less hardy varieties, while *F. magellanica* sired many of the hardier (but smaller-flowered hybrids. The corolla of a wild fuchsia consists of four petals rolled together or overlapping; doubles can have up to twenty or thirty petals. Hardiness is a prerequisite in Britain and much of the rest of the world. Some of the hardier double varieties, all widely grown and available from nurseries, are 'Dollar Prinzessin' (1910) with cherry-red calyces and rich purple petals; 'Eva Boerg' (1943), which is only semi-double but large, with a creamy pink calyx and pale purple petals; 'Dark Eyes' (1958), a proper double, whose red calyces contrast with the purple petals; and the popular

'Garden News' (1978), whose fully double flowers are magenta pink, set off by deep pink calyx segments.

MANY PLANTS ARE GROWN principally for seasonal bedding or in special situations like hanging baskets, window boxes and other containers for which colour is required in abundance. This is where double-flowered plants come into their own, for they offer extra petals, extra colour and a longer season of flower. The effectiveness of bedding depends upon planting large quantities of quick-growing, dependable plants that will flower and star for several months. The same holds good for containers, with the added requirement that each individual plant should complement the other and pull its weight in the composition as a whole.

Many people first encounter *Impatiens* as house plants – the 'busy Lizzies' that grow so obligingly and thrive upon neglect; every piece placed in a glass of water on the windowsill puts out roots (and thus are more plants made). It therefore comes as a surprise to learn that *I. walleriana*, the species to which busy lizzies belong, was not developed as a horticultural money-spinner until the 1960s, when Captain Claude Hope, an American living in Costa Rica, began to work on it with such success that in many countries, including the United States and the United Kingdom, its descendants are now the most popular of all bedding plants. Their range of colour is extraordinary, and includes every shade except pure yellow. Along the way, double-flowered varieties have been developed that are sold under such names as Fiesta Series (for example, Fiesta Appleblossom and Fiesta Blush) and Summer Ice Series (for example, Blackberry Ice and Cherry Ice), which also have variegated leaves. Seed strains are also available, under such names as Athena. Apart from being easy to propagate and quick to grow, the great quality of busy lizzies is their ability to flourish in dry, dark conditions where no other plant will make such a splash of colour. For illuminating a shady bed, right up to the trunk of a large tree, there is no better plant; white varieties reflect light – always so useful in deep shade – while the many brilliantly coloured ones make it possible to create impressive bedding where, until Captain Hope started work, no seasonal planting was possible. The double-flowered forms, as always, have the great advantage of intensifying the floral effect and outperforming the singles by the sheer quantity of their petals. And they are actually perennials, which means that in mild climates they can be kept from year to year.

Tuberous begonias as bedding plants are another success story. The first hybrid begonia was produced in 1868 in England and single-flowered, but the great French plant breeder Victor Lemoine introduced the first double tuberous begonia in 1874. Nowadays there is such a range of *Begonia × tuberhybrida* varieties that they are divided into no fewer than thirteen groups, of which the most important, with large, flamboyant flowers (up to 15 cm/6 inches in diameter), are the camellia-flowered forms, the ruffled, the rosebud, the fimbriated (with petals like a carnation) and the pendulous forms used for hanging baskets. Further divisions pick out varieties with marbled petals and those with margins of different hue. All have been developed and selected for the size of their flowers and the brilliance of their colours. They are the epitome of horticultural flashiness, highly artificial in their form but perfect examples of how doubles can be so much more effective than single-flowered plants, and how horticulturists have almost invariably sought to develop doubles of every important genus in order to increase their impact as garden plants.

Two further genera have been developed and raised to a most sophisticated level of horticultural excellence by the market for bedding plants – *Pelargonium* and *Petunia*. The common scarlet pelargoniums, known everywhere as 'geraniums', make up in brilliance what they lack in refinement and charm. Although double-flowered forms exist in other sections of this much-hybridized genus, it is among the zonal pelargoniums that most have been introduced. Zonal geraniums are known as *P. × hortorum* and are mainly the result of early-nineteenth-century crosses between *P. zonale* and *P. inquinans*. They thrive as individual plants in glasshouses and containers but are, above all, classic bedding plants, grown in their millions all over the world. They are the great staple of public gardens, where they are often planted in huge numbers – some have attractive foliage, too – to provide reliable non-stop colour for as long as the weather permits. Their colour range is phenomenal – white, pink, salmon, magenta and bicoloured but, above all, brilliant vermilion red – a colour that is recognized by everyone as *geranium* red.

Victor Lemoine introduced the first truly double-flowered zonal geranium, *Pelargonium* 'Gloire de Nancy', in 1866; the first double white form, 'Aline Sisley', followed in 1872. A race of ultra-double zonals started to emerge in the 1880s; known as the 'Rosebuds', they remain popular, but only succeed in the open air in dry climates where their tightly furled buds can expand properly. Pink-and-white 'Apple Blossom

Rosebud' was said to be Queen Victoria's favourite pelargonium; the modern 'Westdale Appleblossom' is more conspicuous because its leaves have white variegated edges.

Gardeners today are spoiled for choice (though that choice may well be limited by which pelargoniums the local nurseries have in stock). Doubles are often grown from seed, or sold as plugs or rooted cuttings, enjoyed for a season and then discarded. Drying them off and taking cuttings to see them through the winter is not done nearly as often as it was in the past, though some of the classic varieties have remained in commerce and are worth seeking out. 'Highfields Festival' is bright pink with a white 'eye'; 'Chelsea Gem' is less strident – a gentler pink – with leaves that are edged with white; 'Robe' has flowers of deepest scarlet; 'Orangeade' is the brightest imaginable orange; and 'Caroline Schmidt' is a classic vermilion geranium with white-variegated leaves. These are plants that respond well to individual cultivation, whether mixed into 'hot' plantings in a Mediterranean climate (they look surprisingly good

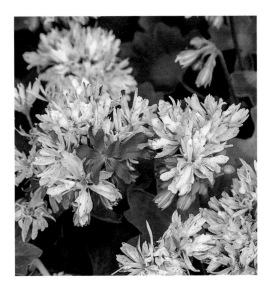

Pelargonium 'Snowbob' is all the more striking for its tendency to revert to the scarlet form.

with cacti), trained up a wall in a cold glasshouse in England, or grown in pots and containers for summer display. To see them at their best, to understand their true capabilities and to use them as their breeders intended, there is nothing more satisfying than to grow them in vast swathes, whether as bold plantings in public parks, or as seasonal filling for grand terraces and parterres, where their brash luminescence sweeps aside all competition and confirms them as the greatest summer bedding plants ever given to mankind.

One further group of pelargoniums is celebrated for its brilliant display. The ivy-leaved varieties, mainly bred from *P. peltatum*, have long, loose stems (rather brittle – it is easy to break a piece off unintentionally) that trail and make them immensely popular for hanging baskets and other containers. The flowers are less substantial than the zonal pelargoniums, but very prolifically borne and no less bright in colour. They are, above all, planted in great masses,

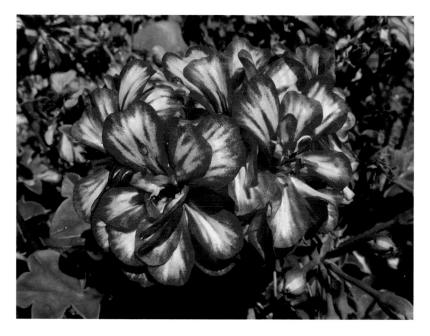

Pelargonium peltatum. A fine semi-double form of the ivy-leaved geranium.

all of the same variety, in the window boxes of Europe's mountain regions. Summer in the Alps is greatly enlivened by the appropriately named 'Roi des Balcons', the best of the scarlet varieties, though single flowered; among the many excellent doubles are vermilion 'Yale', pink 'La France' and maroon 'Rio Grande'. All have been bred to amaze and to please – by the profusion of their flowering and the radiance of their colouring.

Pelargoniums were central to the Victorian love of bedding out plants for summer and autumn display. They were colourful and easy to propagate, and produced their first flowers on very young plants, as did petunias, also widely used as bedding plants. Garden petunias are known as *Petunia × hybrida* and all descend principally from two species, both native to South America – the large, white, night-scented *P. axillaris* and the smaller, violet-flowered *P. integrifolia*. Double-flowered forms emerged quite quickly after breeding began in the 1830s, but they tended to be heavy and very susceptible to rain damage, and although they can be propagated by taking cuttings, gardeners have always preferred to grow petunias from seed. The strain that promised double petunias produced no more than 25 per cent of seed-grown plants, and when Gregor Mendel's rules of heredity became known, it was clear that 'doubleness' was controlled by a simple recessive gene. Only when breeders developed

a plant that carried a dominant gene for double flowers was it possible to develop strains that consistently produced double-flowered petunias. Nowadays, doubles appear in every modern strain of petunia, though the best are the large-flowered Grandifloras (10–12 cm/4–5 inches across), and an immense choice is available: Cascadia, Conchita, Double Wave and the double-flowered trailing Surfinia Series are vegetatively propagated, and sold in pastel pink, white, purple, red and lilac. All are impressive, colourful and substantial. Many have frilly petals, bright stripes and multicoloured edges, whose colour effects are increased by the doubling, but it is their solidity that distinguishes them from the singles. Few plants manage to be both frivolous and serious at the same time, but double petunias succeed. 'Flamboyant' is not quite the right word for them, but they certainly set out to grab your attention with their bright colours and flouncing shapes and, though seldom employed nowadays on the scale that our Victorian ancestors enjoyed for bedding, double petunias are brilliant show-offs among the hanging baskets and containers that grace our more modest gardens today.

Formal gardens in Victorian times depended not just upon growing garish bedding plants for their summer effects, but also upon taking large potted plants from the glasshouse and placing them outside as part of the display. It is a ritual still carried out by many gardeners today, albeit on a smaller scale, and one of the stalwarts of this mobile magnificence has for long been brugmansias, known to an older generation as daturas. Brugmansias have long trumpet-shaped flowers, often pendulous – they hang straight down – and in many double forms, including the wonderful white *B. arborea* 'Knightii', the doubling takes the form of a hose-in-hose shape which emphasizes the elegance of their long, curving petal-tips. The same mixture of flamboyance, elegance and size – the flowers are at least 30 cm/1 ft long – is found in *B. × candida* 'Tiara', whose flowers change from white to pale apricot as they age. So exotic and glamorous do these brugmansias appear to us that it should be remembered that the single-flowered forms are similar in size and only marginally less impressive – a classic example of a flower that makes its mark through sheer largeness.

Annuals also have a part to play in summer bedding. Cultivated strains of *Portulaca grandiflora* draw attention to themselves by the brilliance of their flowers. All are double, or at least semi-double, and their range includes shocking pink, apricot, orange, yellow and

magenta. The plants are insignificant – small, creeping annuals with fleshy leaves that indicate their near-desert origins – but their flowers are a great asset in hot, dry conditions and modern strains like the Sundial Series have been bred to cope with cooler, more temperate conditions. *Portulaca* is, like *Impatiens*, one of those plants that relies upon scale for the best effects: cover a large area with them and you have a green carpet studded with cheerful flowers 5 cm/2 inches in diameter. Two further names to look for are the Fairytales and Sundance Series: the American garden writer Henry Mitchell (in *The Essential Earthman*, 2003) calls them 'small taffeta explosions', all the more dramatic for the contrast between their yellow petals and their bright pink or orange puff of staminodes.

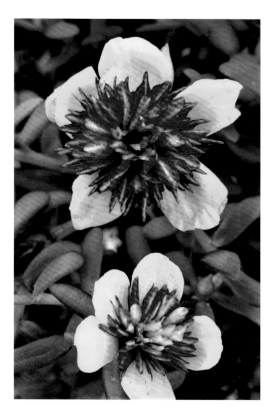

Portulaca grandiflora. The Fairytales strain produces flowers with an explosion of dark pink staminodes.

THERE ARE PLANTS WHOSE FLAMBOYANCE is seen in every flower; most double flowers are the result of selection, and some genera have been bred specifically to make them more flamboyant. Dahlias are a good example. Gertrude Jekyll wrote in 1899 that 'the Dahlia's first duty in life is to flaunt and to swagger and to carry gorgeous blooms'. Alice Coates called it 'this brilliant barbaric flower' and the American Baroness Eleanor Perényi wrote in 1981, 'to me they are sumptuous . . . and I love their colors . . . and, yes, their assertiveness.' Christopher Lloyd's use of dahlias in the Exotic Garden at Great Dixter did much to make these plants fashionable again. And climate change – especially the longer summers – has been influential too; in many of the warmer parts of Britain, dahlia tubers can be given a thick mulch and left in the ground to overwinter.

The more formal dahlias, like the Pompon and Waterlily types, are dealt with in chapter 5, but the Cactus and Collarette types belong here, for they are loved for their flamboyance, their size and their daring shapes and colours. Both in the garden and in the vase – they

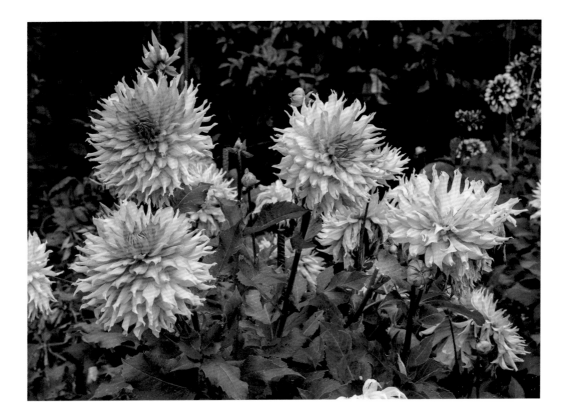

Dahlia 'Hamari Gold' has large, flamboyant flowers that bring a border alive in autumn. They are also useful for cutting for the house.

are among the best of all cut flowers – their bravado makes them welcome everywhere. The most widely grown class of dahlia is the Decorative: these often have a slight twist to their petals that makes them less geometrically perfect than, say, the Pompon dahlias, but increases their spectacular visibility. Giant Decoratives include the sumptuous deep red 'Zorro' and 'Hamari Gold', which changes from pale yellow at the edges to orange at the centre, while popular among the Large Decoratives (only marginally smaller) are lemon-yellow 'Hamari Sunshine' and vermilion-red 'Kenora Valentine'. They are one of the great glories of the late summer border, even if they do have to be staked carefully to prevent them from bending under their own weight. They also need to be picked when windy weather is forecast, but fortunately there are always more buds ready to open. Cactus and Semi-Cactus dahlias also make a big statement. Cactus varieties have ray florets that are quilled and pointed; Semi-Cactus are slightly less spiky and halfway to being Decorative – they are popular with growers and very pretty, sometimes almost fluffy-looking. The flowers range in size from miniature (less than 10 cm/4 inches) to

a showy giant size (over 25 cm/10 inches). Rich unfading dark red 'Altami Corsair' has flowers 15–20 cm/6–8 inches across and is notably free-flowering, while 'Dana Iris' has slightly smaller flowers but lots of them, also strong red; both mix well with deep yellow 'Hamari Accord' – red and yellow are the colours of late summer.

Though scarcely semi-double, the Collarette dahlias have a circle (or 'collar') of small florets or petaloids around the edge of the central disc. If, as often happens, these are of a different colour from the real outer petals, the overall effect is bizarre, baroque and simply stunning. 'Lilian Alice' is a good example – it has deep purple outer petals with a raspberry edging. The centre is yellow and the collar is cream with raspberry flecks, making it a real eye-catcher. 'Christmas Carol', as the name might suggest, has scarlet outer petals and a yellow centre, and the Christmas effect is completed by the white and red speckled collar florets. In the case of the strangely named 'Pooh – Swan Island', the scarlet petals are yellow tipped, but the collar is of the same yellow, giving a brilliant overall effect. Most Collarette dahlias grow to 80–100 cm/2½–3½ ft and have flowers 10–15 cm/ 4–6 inches wide. Though they do tend to draw attention to themselves, they also work well in some of the more flamboyant new-wave exotic plantings.

Rudbeckia laciniata 'Goldquelle' is a useful ingredient of these modern herbaceous plantings. Its bright yellow double flowers resemble those of a chrysanthemum, and the black central cone so typical of rudbeckias is transmuted into a mass of extra petals so that the seed heads make no appearance. Some forms of *R. hirta* are often sold as double or semi-double seed strains; they are too short-lived for permanent plantings, but the dwarf-growing double form 'Maya' is a very effective bedding plant, best treated as an annual.

Two further members of the daisy family are useful late-flowering plants, either as perennials or as seasonal bedding – gaillardias and heliopsis. *Gaillardia pulchella* is a hardy, short-lived perennial, usually grown as an annual, but its hybrids, alongside the truly perennial *G. aristata*, include a number of excellent double varieties that shine out by their brilliance in late summer and early autumn. Sundance Red and yellow-and-red Sundance Bicolor, for example, carry multi-petalled flowers in bright colours. And *Heliopsis helianthoides* var. *scabra* 'Goldgefieder' is a long-flowering, very hardy and undemanding semi-double form (it hardly ever needs dividing), with many thick rows of ray florets.

Rudbeckia hirta 'Double Delight'. Seed strains and cultivars of this species produce brilliant double forms, both yellow and orange.

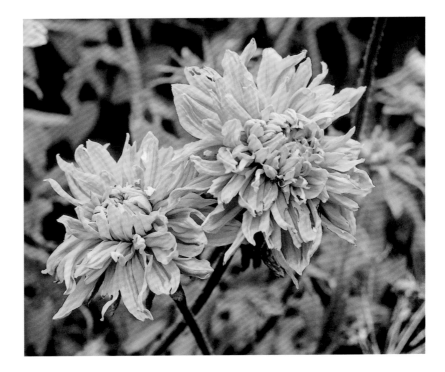

In the daisy family or Asteraceae, as we have seen, a mass of tiny tight-packed individual flowers is normally surrounded by a ring of ray florets that act as petals and attract potential pollinators. When, however, the ray florets are joined by many others florets in the centre, the inflorescence acquires a new shape and, by the same process, the colour of the florets takes precedence over the colour of the central disc. Common sunflowers, *Helianthus annuus*, are grown in huge numbers for their seed, from which an important oil is extracted, and typically show a ring of sunny yellow petals around a wide, brown centre. The inner flowers are insignificant but fertile, and fill the central disc with a complex swirling pattern that opens out over several weeks. If those tiny flowers are converted into petal-bearers, the sunflower transforms itself into a huge puff of yellow, so that the whole inflorescence takes on the shining colour of the outer petals and the brown centre is lost to view. By 'doubling' the flower, you also double its impact; a double sunflower is nothing short of dazzling.

Agricultural sunflowers, grown for their oil, reach about 2 m/6½ ft in height and giant strains will easily attain 4 or 5 m/up to 16 ft, but many of the double sunflowers selected for gardens are much shorter; this makes them more sturdy, and frees them from the need for

staking. Double sunflowers are not always regular in their outline and some even have the look of a floor- or dishmop, but the variation between plants is part of their charm – they have character. They have been known since at least the nineteenth century and ancestors of the modern varieties can be identified in some of Van Gogh's paintings of sunflowers. *H. annuus* 'Shine' (syn. 'Double Shine') grows to 1.5 m/5 ft and produces a mass of furry-looking, narrow pointed petals at its centre, surrounded by 'normal' petals. Perhaps the most popular strain of sunflowers now is *H. annuus* 'Teddy Bear', which may grow to no more than 60 cm/2 ft and, when fully open,

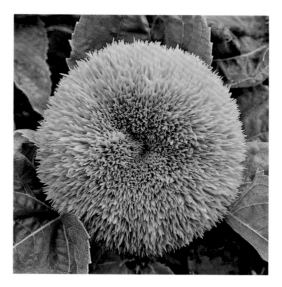

The flowers of *Helianthus annuus* 'Teddy Bear' have no central disc, just a mass of petals, borne on a plant much shorter than most sunflowers.

has a fluffy rounded mass of golden petals – hundreds of them. The first double-flowered sunflower to be developed that is deep red in colour was *H. annuus* 'Double Dandy'; it is popular with both amateur gardeners and professional growers because its flowers, when cut, do not shed their pollen. This is a particular advantage since other sunflowers tend to produce and shed lots of pollen. It, too, is short-growing, seldom more than 60 cm/2 ft in height. Nurserymen have also selected branching sunflowers with several flowers on a stem, which shows how far the species has developed in cultivation; but whatever their height and whatever their size and colour, the flamboyance of double-flowered sunflowers is a joy both in the garden and in the vase.

Not all sunflowers are annuals: *H.* 'Capenoch Star' is a single-flowered perennial variety that sometimes develops an anemone-centred form, while the richly yellow *H. × multiflorus* 'Meteor' is always anemone-centred. The best is *H.* 'Loddon Gold', whose bright golden-yellow flowers, up to 15 cm/6 inches across, are fully double, while the popular *H.* 'Monarch' has no more than a few extra ray petals, slightly twisted and golden yellow. Even so, these perennial varieties grow tall and wide (as much as 3 m/10 ft high), and fill the late summer border with their bright colours.

SOME OF THE SAME BRILLIANCE is seen in the double-flowered forms of the common nasturtium, *Tropaeolum majus*, first introduced to Spain from Peru in the 1680s and soon to be grown throughout the rest of Europe and in North America. Although commonly described as annuals, and usually grown every year from seed, nasturtiums are in fact perennial plants, which means that interesting seedlings can easily be propagated from cuttings. Double forms were reported from the 1720s onwards and some of the vigorous modern seed strains, like the Gleam Series and Jewel Series, include semi-double forms in a very wide range of colours. Most plants will grow to several metres in length and they are sometimes referred to as 'climbing' nasturtiums because they will find their way up a fence or hedge to a considerable height by twisting their long leaf-stalks around any available support, and their juicy stems seem to grow ever faster as the autumn nights lengthen. These doubles and semi-doubles lack the helmet of the single-flowered varieties but retain their strident colours, though it is difficult to find seed strains that produce flowers of a consistently pure orange-red – the true nasturtium colour that the French call 'capucine'.

Fully double nasturtiums are sterile and have to be propagated from cuttings. *T. majus* 'Darjeeling Double' is one of the best, a vigorous trailer or climber with rich yellow flowers continuously borne and packed with petals. Most of the named double-flowered varieties, however, are shorter-growing, including *T. majus* 'Hermine Grashoff', whose flowers form neat, scarlet rosettes. Being sterile, it will flower continuously, and all the more abundantly if its growing tips are periodically pinched out. The soft apricot colour of its Irish sport 'Margaret Long' is less striking, but both are major

Tropaeolum majus Gleam Series (RIGHT) is a seed strain of slightly double nasturtiums, while *T. m.* 'Hermine Grashoff' (FAR RIGHT) is a true double, almost unrecognizable as a nasturtium, that has to be perpetuated by taking cuttings.

standbys of floral displays in public places, where brazen, look-at-me flamboyance is what visitors expect. That flamboyance increases as the days shorten and the likelihood of a killer frost comes closer, but in warmer climates nasturtiums will flower all through the winter, the brilliance of their colouring undimmed and unchecked by cold.

FLAMBOYANT DOUBLE-FLOWERED PLANTS also have a place in the modern landscape plantings that are sometimes known as 'German' or 'Dutch' but more frequently as 'New'. These designs use mass to create scale – an illusion of size – and to suggest a vast prairie within a small compass. Such plantings are now widely encountered, especially in public parks, because they are thought to require very little maintenance. Moreover, they need a large area to be effective and can indeed be very impressive. They take many forms, but usually involve planting a limited number of different herbaceous plants, chosen for their vigour and their ability to survive neglect while still looking attractive and 'natural'. The plantings come together very quickly as a matrix; however, over the years that follow, some taxa inevitably seem to prove more vigorous than others, with the result that, if left indefinitely, all other plants will eventually be overwhelmed by the one most successful. Keeping a balance and maintaining aesthetic integrity require both intervention and, in the first place, careful planning based on knowing which plants will jog along together in some degree of harmony and balance. Successful plants seed themselves, and the plantings can then become very mixed up and quickly look weedy. These communities are designed on the principle of copying nature, and many double flowers do not look natural enough to belong within them. However, several varieties of herbaceous plants with double flowers are all the more useful in such compositions for being double. Many are sterile, or at least less prolific, and though this will not affect their vigour when the clumps expand towards their neighbours, it will guarantee that they do not seed themselves in parts of the design where they are not welcome. Gardens are, after all, artificial communities of plants, even those that seek to imitate nature, and double-flowered plants often have more impact than single. They add weight and substance, they magnify the overall effect, and they transmute the transient and the everyday into the permanent. They remind us that a touch of flamboyance

Dahlias – here at Great Dixter in Sussex – bring colour and brilliance to a border.

is sometimes exactly what is needed to turn the commonplace into something of brilliance.

This showing-off is as remote as can be imagined from the amiable and companionable plants that are the subject of the next chapter.

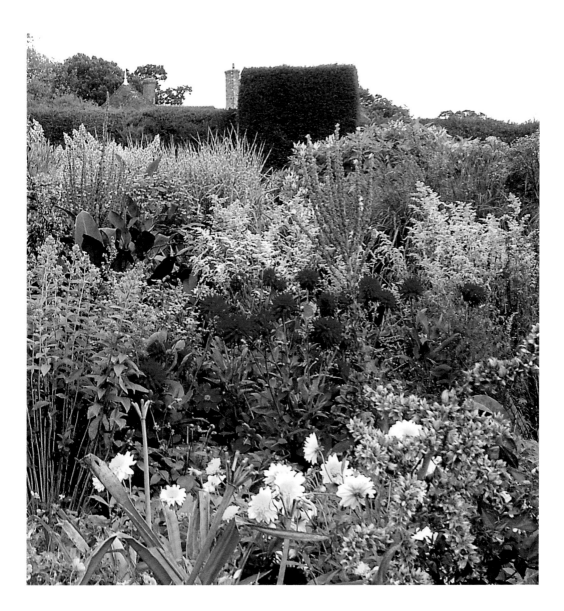

7 The Companionable

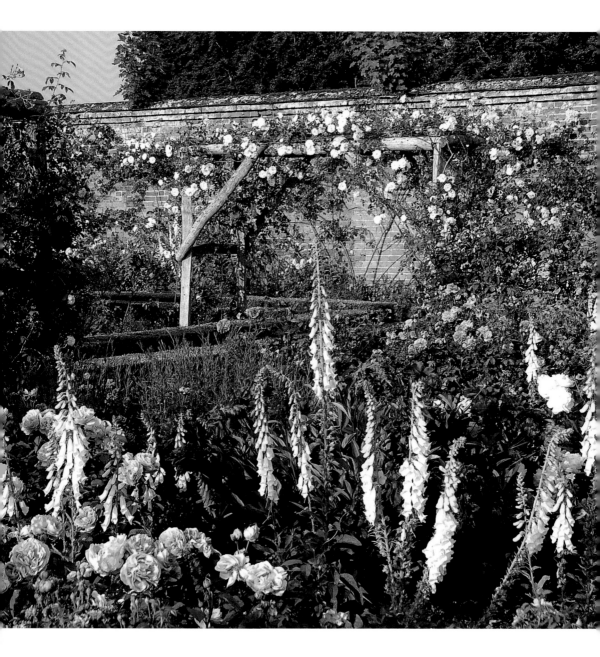

ON THE WHOLE, THE FLOWERS OF THESE PLANTS TEND TO BE HELD IN FAIRLY OPEN ARRANGEMENTS, SO THAT THEY NATURALLY CREATE THE DRIFTS OF COLOUR WHICH ARE SUCH A FEATURE OF MODERN, NATURALISTIC STYLES OF PLANTING AND FOR WHICH GERTRUDE JEKYLL IS SO FAMOUS.

They may be more conspicuous and assertive than their single counterparts, but not all double flowers are strident show-offs. Many plants with double blooms have quite a modest air, though their extra petals do mean that they are never completely self-effacing. Both as cut flowers and in the garden, many of these diffident but not *too* diffident doubles are at their best as members of a supporting cast, rather than as solo performers. Doubles that are dazzlingly flamboyant, sumptuously romantic or very strictly formal usually insist upon a position in the limelight; the less ostentatious sorts of doubles are members of the all-important chorus, without whom the performance would be altogether less impressive and satisfying.

That these companionable double-flowered plants are valuable enhancers of other plants is due as much to their habit of growth as to the structure of their individual blooms. In contrast to plants such as dahlias, peonies and tulips, which often carry only one or two strikingly shaped flowers on each clear or sparsely branched stem, companionable doubles characteristically produce fairly low-key flowers on stems or subsidiary stalks that branch quite freely.

Branching stems and rather modest flowers are both features which create an impression of diffuseness and imprecision, and it is the lack of clear-cut outlines that allows many companionable doubles to meld so successfully with other plants. When flowers are exceptionally small and carried on myriad spreading, branching stalks, then a quite distinctive, ethereally gauzy impression is created (for examples, see gypsophilas and thalictrums on pages 132–133). These plants, with their billowy masses of flowers, are also valuable in creating plant partnerships. So too are plants with modest flowers of a particular, rather prim or 'old-fashioned' form, though these quaint and charming doubles (see chapter 3) are usually best positioned where their often intricate blooms can be admired at close quarters, rather than 'lost' in large drifts.

Mottisfont Abbey in Hampshire. The red flowers are double peonies, a perfect match for the pink and white roses. The white spires are foxgloves; no double foxgloves of any kind have ever been found.

EARLY-FLOWERING DOUBLES that make good planting companions include certain daffodils. Some of the most companionable of these springtime favourites are varieties that produce several flowers on each stem. *Narcissus* 'Cheerfulness' (1923) produces three or four softly shaped, creamy-coloured flowers on each of its 38–45 cm/ 15–18 inch stems. Though best known perhaps as a cut flower, this unusually strong-stemmed double daffodil makes a good garden plant too. Christopher Lloyd was one of the first to recognize its suitability for growing in grass. It makes an unexpectedly successful partnership with bluebells (*Hyacinthoides*), for example, while also looking good alone, in soft sweeps, beneath small open-canopied trees. Its very sweetly scented flowers, each about 5 cm/2 inches across, open in succession within each cluster. Similar daffodils include the predominantly white 'Sir Winston Churchill' (1966) and the smaller-flowered, more richly coloured 'Yellow Cheerfulness' (1938), both of which are around 38 cm/15 inches tall. All these daffodils are at their best in cool climates and moisture-retentive soils (in hot climates the flowers of double daffodils may well fail to open properly).

Narcissus 'Yellow Cheerfulness'. A vigorous and strongly scented tazetta type with double flowers.

Double daffodils with solitary flowers can also be companionable; the best mixers usually have flowers that are not too neatly or densely double.

The most useful companionable plants tend to have more than one decorative feature and often this allows them to enhance several other plants over an extended season. As well as semi-double, rose-magenta flowers, *Bergenia* 'Abendglut' (1950) produces bold, evergreen leaves, which turn deep maroon-purple in winter if the plant is grown in an exposed site. During the latter half of spring, it is the flower clusters, on top of their stout, reddish, 30 cm/1 ft stalks, which steal the scene, but the foliage acts as a handsome foil to other plants throughout the year. Similarly, the double-flowered rock cress, *Arabis alpina* subsp. *caucasica* 'Flore Pleno', produces loose sprays of clean white blooms late in spring but its plush grey-green foliage is a useful if slightly untidy ingredient of plantings in all four seasons. A novelty back in the first years of the twentieth century, this small, easily grown sun lover creates an overall effect of pretty grey-and-white coolness but, close up, each 1 cm/½ inch bloom reveals a complete extra bud at its centre.

For lovers of variegated foliage, there is a double-flowered form of lesser periwinkle – *Vinca minor* 'Silver Service' – which can provide a year-round carpet of greyish-green, white-edged leaves in addition to semi-double blue flowers from spring into summer; some of these jaunty blooms may be up to 5 cm/2 inches wide. Other double-flowered varieties have plain green foliage: 'Azurea Flore Pleno' produces lilac flowers which, at their fullest, form pretty pompons, while 'Multiplex' tends to have just one extra set of plum-coloured petals in each bloom. Though very accommodating, these vigorous little subshrubs flower best in fairly sunny or only lightly shaded positions. They have been popular for several centuries (John Gerard grew a double purple late in the sixteenth century), and a range of double-flowered varieties – variegated as well as plain-leaved – has been cultivated since the early eighteenth century.

TOWARDS THE END OF SPRING, a splendidly companionable double bramble comes into flower. Viewed at close range, the many-petalled, magenta-pink rosettes of *Rubus spectabilis* 'Olympic Double' seem irrepressibly showy. But these flowers, each about 5 cm/2 inches across, are dispersed among bright green, veined leaves on top of 1.5 m/5 ft thickety masses of stems, so that the overall effect is

neither assertive nor formal. Indeed, this fairly vigorous, non-fruiting variety of salmonberry, which was collected on the Olympic Peninsula, Washington State, in the early 1960s, is probably most suitable for informal plantings – on the edge of light woodland, for example.

As accompaniments to shrubs that flower in late spring and early summer, there are two double-flowered bulbous plants that look well in informal parts of gardens – and in tidy beds and borders too. One is *Camassia leichtlinii* 'Semiplena', a variety of quamash that produces slender, 90 cm/3 ft spires of creamy-white stars. These long-lasting, sterile flowers remain decorative from the last days of spring well into the early weeks of summer. The other late spring bulbous double is *Narcissus poeticus* 'Plenus', 'a flower unsurpassed for beauty and value by any of the more modern Daffodils', wrote Gertrude Jekyll in 1921 (and, she might have added, one that has been admired from the beginning of the seventeenth century at least). This extra-petalled variety of the poet's narcissus, which grows about 40 cm/16 inches high, has variable flowers but they are usually about 4–5 cm/ 1½–2 inches wide and pure white, often rather untidy, but always sweetly fragrant and exceptionally long-lasting both in the garden and when cut. In warm, dry regions this can be a disappointingly shy-flowering plant; it seems to be at its best when planted deeply in cool soils and grown in mild, moist climates.

For informal plantings in consistently damp or wet pieces of ground, there are double-flowered varieties of two vigorous, leafy plants which, in their single forms, tend not to be quite conspicuous enough to hold their own with other moisture-loving plants, such as *Rheum* (ornamental rhubarb) and *Rodgersia*. The extra floral parts of bright yellow *Iris pseudacorus* 'Flore Pleno' (yellow flag) and frothy white *Filipendula ulmaria* 'Flore Pleno' (meadowsweet) make them more effective garden plants; they also prevent them from being unmanageable self-seeders. Some gardeners will also appreciate the fact that, in its double form, the meadowsweet's heads of tiny white blooms have little of the rather cloyingly sweet scent of the species' single flowers. Both these plants are in bloom during the earlier part of summer; they are happy in sun or partial shade and usually grow somewhere around 75–100 cm/2½–3¼ ft high.

As summer gets into its stride, many gardens swell into a comely intermingling of roses and campanulas and hardy geraniums. Certain varieties of these plants, both single and double, are among the most versatile of all planting companions. The double-flowered varieties of

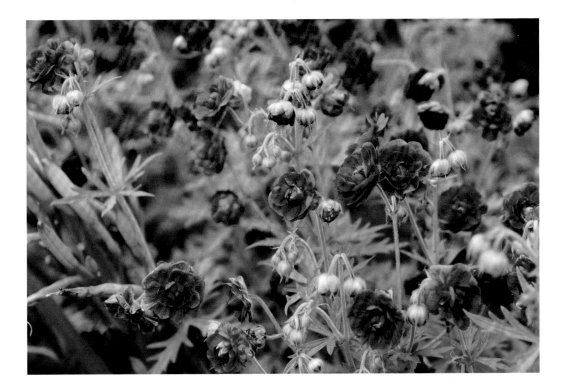

Geranium pratense 'Plenum Violaceum' is best cut back after flowering – the leaves as well as the dead flowers. It will then flower again.

meadow cranesbill (*Geranium pratense*), for example, are easy to grow, mix exceptionally well with other plants, and look equally at home in cottagey plantings and in more sophisticated borders. Compared with the singles, the double meadow cranesbills are rather neater plants, with much longer-lasting, more substantial-looking flowers which never produce bothersome amounts of self-sown seedlings. However, they do hang on to most of their faded flowers, whereas the singles shed their spent petals quickly; this is a less conspicuous drawback when the plants are grown informally in sunny areas of grass – where they are thoroughly at home.

Varieties like 'Plenum Caeruleum' and 'Plenum Violaceum', which were last popular during the nineteenth century, are now in favour again. The former plant's loosely double flowers are a soft lavender-blue, while the latter's tighter rosettes – which open a little later – are rich violet. Among the newer *pratense* or *pratense*-type doubles, Summer Skies (1998), with pretty, fully petalled flowers of pale violet-blue and cream, is widely available, and white-flowered 'Laura' (2004) makes a more vigorous substitute for the old, weak-growing 'Plenum Album'. All these plants carry their flowers in branched heads well above

clumps of deeply cut foliage. The older doubles and 'Laura' grow up to about 90 cm/3 ft high, while Summer Skies is around 60 cm/2 ft high; they all produce flowers that are roughly 2.5 cm/ 1 inch wide.

For a small-flowered double geranium that is lower growing and rather more shade tolerant, there is G. *himalayense* 'Plenum'. Not all gardeners enjoy the indeterminate pinkish violet-purple tints of its numerous, slightly untidy flowers ('not a very reassuring colour', wrote Christopher Lloyd in *Christopher Lloyd's Garden Flowers*, 2000) but its mats of attractive, lobed leaves make good ground cover and the foliage takes on reddish tones each autumn – all of which adds up to a good value plant. (For hardy geraniums with showier double flowers, see G. × *oxonianum* f. *thurstonianum* 'Southcombe Double' and G. *pratense* 'Double Jewel', on page 190.) These reliable and adaptable doubles mix well with a wide range of other plants, including astrantias, roses (old and new), day lilies, hostas, eryngiums and various grasses.

As midsummer approaches, another band of companionable plants, the taller-growing campanulas, comes into flower. Not so easily grown, nor perhaps quite such good mixers as the double geraniums, they are nevertheless usually regarded as essential companions for roses in particular. Some of these campanulas have flowers of a curious hose-in-hose or cup-and-saucer arrangement and are best planted where the blooms can be viewed at close quarters. However, the more straightforward doubles and semi-doubles of the peach-leaved bellflower (*Campanula persicifolia*) make admirable companions. Indeed, during the eighteenth and nineteenth centuries, these sorts of doubles were much more popular than the single-flowered varieties. The most companionable varieties have flowers that are neither very large nor very densely petalled and which, being well spaced, create slender, airy spires of colour. Purplish blue 'Pride of Exmouth' and paler and more delicately coloured 'Bennet's Blue', for example, both produce dainty, rather shallow bells, each about 3 cm/1¼ inch wide. At 5 cm/2 inches wide, the white flowers of 'Alba Coronata' are larger but their semi-double, 'cup-in-cup' arrangement is simple, and here, too, the effect is gentle and unassertive. All these varieties of campanula grow to about 45–75 cm/1½–2½ ft high.

Taller, woody plants that make sympathetic companions for roses – and for campanulas too – include deutzias, of which there are several double-flowered varieties. Pruned hard immediately after flowering,

Deutzia scabra 'Candidissima' is a good midsummer companion for old roses.

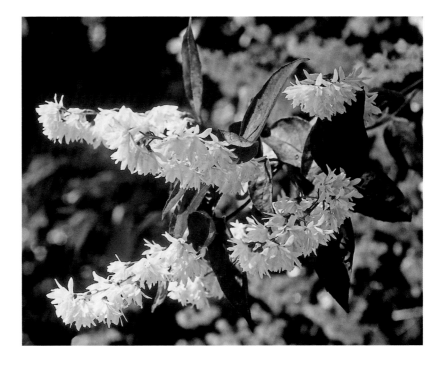

these easily grown shrubs will foam the following year with masses of starry little flowers for several weeks from early in summer. At the National Trust for Scotland's garden at Malleny they are part of a design that mixes them with old roses and geraniums. Here they become, in effect, the shrubby equivalent of perennials since, not being stars themselves, they make flattering companions for other plants. The arching growths of chalk-white *Deutzia × magnifica* (*c.* 1909) and pink-flowered 'Rosea Plena' produce a more relaxed effect than the rather more upright varieties such as *D. crenata* 'Pride of Rochester' (before 1881) and *D. scabra* 'Candidissima' (1867) and 'Plena' (1861). Of these last three plants, 'Candidissima' is perhaps the most conspicuous and distinctive, with its relatively slender clusters of pure white flowers. The flowers of the other two varieties are also white but they emerge from pink or purplish red buds, and a soft version of this coloration is retained on the outer petals. Despite the fact that the bark of older specimens of these plants may peel quite attractively, all these shrubs are really just one-season wonders. At around 2.4–3 m/8–10 ft high and only a little less wide, their generous summer display may not quite make up for their lack of interest at other seasons, except possibly in larger gardens. However, they all have a second use as cut flowers. Provided their leaves are

pulled off, as those of philadelphus should be, the spikes of deutzia flowers in shades of pink or white lend elegance and structure to large arrangements and combine well with such romantic flowers as roses, peonies and irises.

DEUTZIAS, CAMPANULAS AND HARDY GERANIUMS: all these plants make very congenial partners for roses. But what of roses themselves? Although there are plenty of show-stopping roses, there are also numerous double-flowered varieties that are particularly well suited to mixing and mingling in plantings of various styles. The choice is enormous, but the examples of companionable roses that follow give an idea of the qualities which make certain varieties more convivial than others.

Though a short flowering season put paid to the popularity of varieties of *Rosa spinosissima* (Scots or burnet rose) by the end of the

Rosa spinosissima 'Double White' flowers several weeks before the main flush of roses, and has a delicious lily-of-the-valley scent.

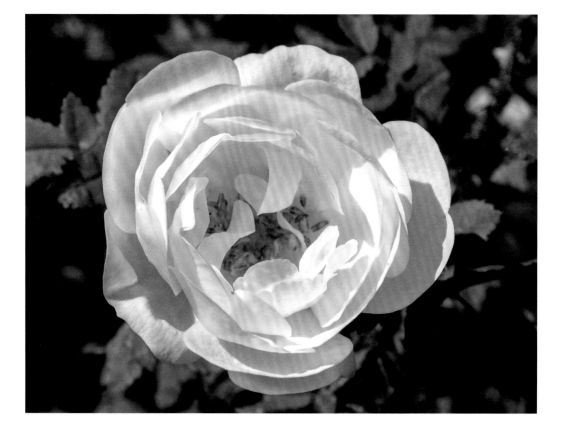

nineteenth century, these very hardy roses have just the right air of unpretentious grace to make them lovely additions to informal planting schemes. The most readily available form is the double white. Its delightful, globular blooms, each only about 4 cm/1½ inches wide and loosely constructed, open very early in summer and exude a lily-of-the-valley scent, unique among roses; they are followed by shiny black hips. The plant makes a very prickly thicket of growth which is quite at home in light and infertile soils.

An even older rose with stronger flowers that combines well with other plants is the late-eighteenth-century Alba, 'Céleste'. At 1.8 m/ 6 ft or so, this vigorous, rounded shrub is taller than the double white Scots rose. Its semi-double 8–9 cm/3–3½ inch flowers are carried in clusters and are sweetly and spicily scented. They are of a perfect, clear shell-pink which, with the distinctly greyish foliage, makes this rose easy to place, particularly in pastel schemes. Pale shell-pink flowers that open over a rather longer season – from early summer into midsummer – are produced by 'Fritz Nobis' (1940). Each deliciously spicily scented bloom is about 8 cm/3 inches across and not too densely double. The flowers appear in generous quantities on a vigorous, bushy plant about 1.5–1.8 m/5–6 ft high; they are followed by numerous orange-red hips. Much-admired 'Nevada' (1927) is a still larger and more handsome plant, at about 2.4 m/8 ft high, and its golden-stamened, creamy flowers are even bigger (10 cm/ 4 inches wide). But these blooms are thoroughly informal-looking semi-doubles that fit well both in 'wild' gardens and in substantial plantings of a more formal character. This sort of relaxed semi-double flower – which partners the big blooms of early large-flowered clematis so successfully – is also found among such ramblers as 'Rambling Rector' (before 1913). The richly fragrant, 4cm/1½ inch flowers of this extremely vigorous plant are carried in huge clusters and, as a considerable bonus, are followed by orange-red hips.

Most of these roses flower just once, either in early summer or in the few weeks straddling early and midsummer, although 'Fritz Nobis' does perform for rather longer than most and 'Nevada' produces another, smaller flush of flowers in late summer. But there are huge numbers of companionable roses with much more extended flowering periods, and they come in all shapes and sizes. The vigorous, upright climber 'Golden Showers' (1957), for instance, flowers much longer than any rambler, from early summer through into autumn, and though the blooms can be up to 10 cm/4 inches across, they are such

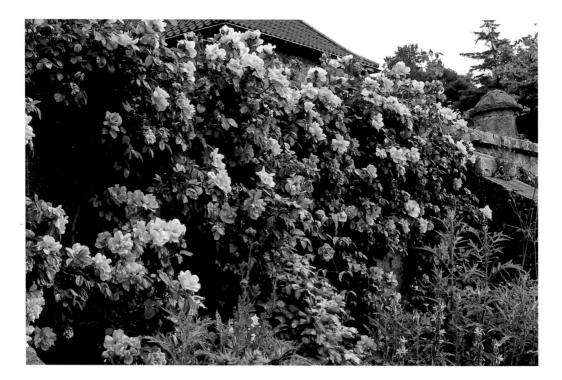

wide-open semi-doubles that they never eclipse the various clematis with which they look so very becoming. Semi-doubles of similar informality can also be found among easy-going shrub roses such as the Rugosas. The widely planted 1.5 m/5 ft 'Blanche Double de Coubert' (1892), for example, produces its sparkling white, gently and irregularly semi-double blooms throughout the summer and autumn months – though most generously in midsummer – and may well flower again in autumn. Each up to 10 cm/4 inches wide, the flowers are deliciously sweet-scented.

Rosa 'Golden Showers' has a long flowering season.

The most companionable of the fuller-petalled double roses tend to be those that carry their flowers in fairly open sprays or clusters. If there is such a thing as the archetypical companionable rose, then surely it must be the famous Floribunda 'Iceberg' (1958), an enhancer of thousands upon thousands of flower arrangements and planting schemes around the world. Both 'Iceberg' and the vigorous 'Climbing Iceberg' (1968) flower for months on end with their loosely double 8 cm/3 inch blooms of ivory-white held in many-stemmed clusters. Judiciously chosen, some other not-too-stiff Floribundas with not-too-dense flowers can work well in mixed plantings. But none is quite so flatteringly companionable, nor so widely available, as 'Iceberg'.

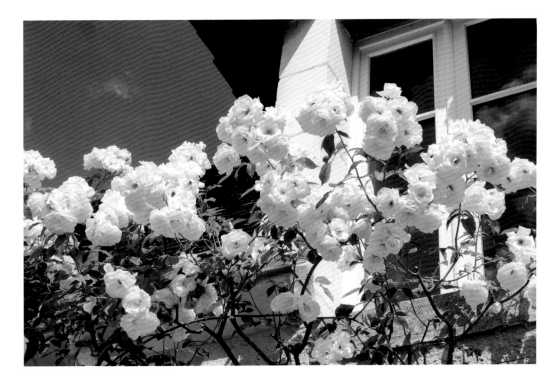

Rosa 'Climbing Iceberg', the archetypal companionable rose.

For excellent scent, as well as a long flowering season, the Hybrid Musks provide several outstandingly attractive varieties that all mix well with other plants. They are usually around 1.5 m/5 ft high and, generally, they have a relaxed air about them; borne in lavish trusses, their flowers are most numerous in midsummer. Those of 'Buff Beauty' (1939) are a delicate, caramelized apricot-yellow, while the 8 cm/3 inch semi-double blooms of more densely branched 'Penelope' (1924) open a warm pink, fade to palest cream and are followed in autumn by pretty pink hips.

More recently introduced roses that integrate well with other plants are to be found among Ground Cover varieties. Mostly low and spreading or mound-forming, these long-flowering, low-maintenance plants include popular mid- to pale pinks such as Bonica 82 and Surrey (1988), with their loose, rather frilly flowers, each 6–8 cm/ 2½–3 inches wide.

White, pale pink and soft yellow are easily accommodated colours and, not surprisingly, the colours of many of the most companionable roses – roses that associate happily with, for instance, artemisias, campanulas and perennial foxgloves, and lavenders and catmints.

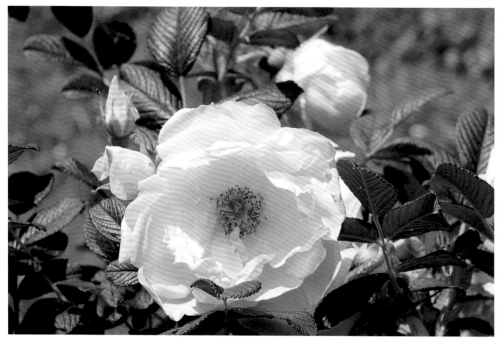

Rosa 'Blanche Double de Coubert' often flowers well again in autumn.

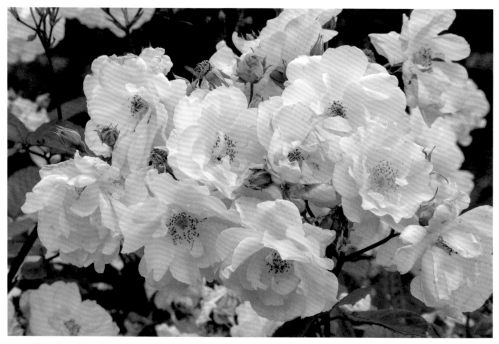

Rosa 'Penelope', perhaps the best of the Hybrid Musks.

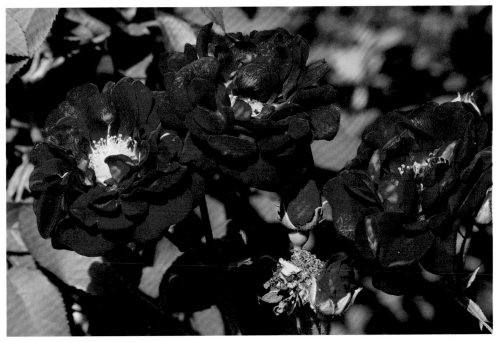

Rosa 'Tuscany'. An old Gallica rose, very sweetly scented.

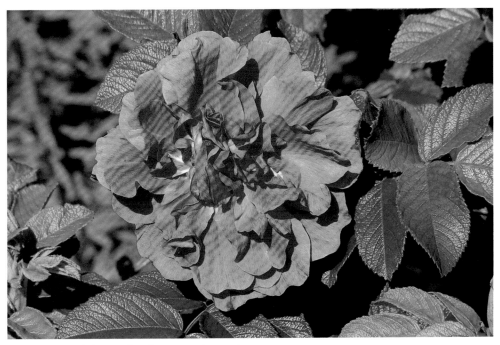

Rosa 'Roseraie de l'Haÿ'. Ultra-fragrant and a good repeater.

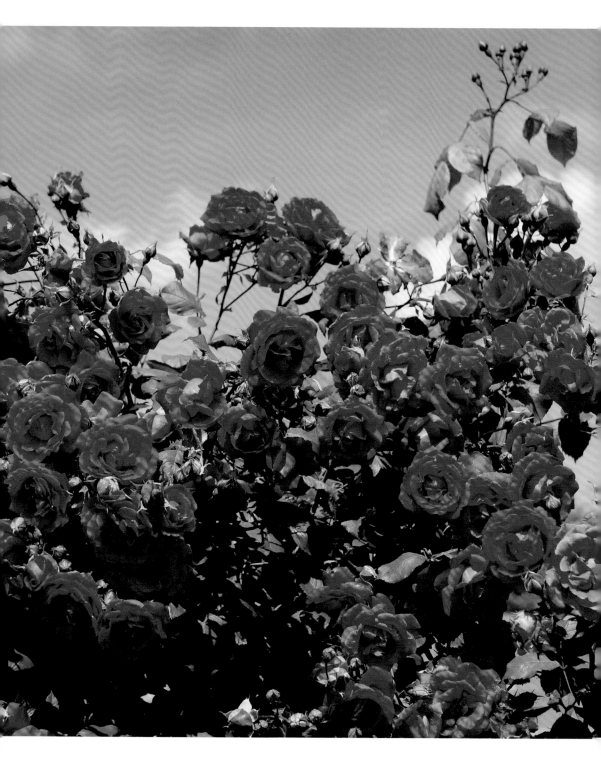

But there are deeper and brighter coloured roses that make good planting partners too. They include big, tough plants for large-scale schemes, such as the Rugosa 'Roseraie de L'Haÿ' (1901) with its rather dishevelled and wonderfully fragrant purplish pink flowers. They also include medium-sized shrubs like the golden-stamened, velvety crimson-maroon 'Tuscany' (*c*.1600) and the carmine-pink apothecary's rose (*Rosa gallica* 'Officinalis'; before 1400), both of which are richly scented Gallicas. For brighter, sharper pinks and reds, there are, for example, low ground-covering plants such as Pink Flower Carpet (1989) and, among climbers and ramblers, 'Paul's Scarlet Climber' (1916) with its sprays of vividly coloured semi-double flowers. With these roses deeper notes can be sounded by using ingredients such as dark purple foliage, plum-coloured masterworts (*Astrantia*) and rich red day lilies (*Hemerocallis*). And enlivening effects can be produced by adding the rich violet-blues of clematis and violas, for instance, and the clean lime greens of lady's mantle (*Alchemilla*) and spurges (*Euphorbia*).

THE ROSE MAY BE THE WORLD'S FAVOURITE flower, but it is not every gardener's favourite plant. Proponents of the 'new naturalism' movement, for example, have little time for roses, and rely almost exclusively on perennials and grasses to achieve the relaxed, seemingly uncontrived effect they desire. Amongst the perennials they use there are, perhaps surprisingly, some doubles and semi-doubles. These include the so-called rose- or clematis-flowered columbines (varieties of *Aquilegia vulgaris* var. *stellata*), some avens (*Geum*) and some herbaceous cinquefoils (*Potentilla*). Single or double, all of these adaptable, easily grown perennials associate well with a wide range of other plants. But if they are not to 'disappear' when planted alongside bigger, coarser perennials and broad sweeps of ornamental grasses, then their pretty flowers need the sort of additional visual weight that extra petals or petal-like structures can provide.

The flowers of *Aquilegia vulgaris* var. *stellata* and its many variants are made up of numerous, pointed sepals surrounding yellow stamens. 'Nora Barlow' (see page 129) is about 75 cm/2½ ft high with flowers 4 cm/1½ inches or so wide and is named after Charles Darwin's

Rosa 'Paul's Scarlet Climber' combines particularly well with blue flowers and purple-leaved plants.

LEFT
Aquilegia vulgaris
var. *flore-pleno*
'Ruby Port'. All
columbines
are excellent
companion plants.

granddaughter, a Cambridge geneticist who lived to be 103. It was popularized in the 1970s from a plant growing in her garden, but it is actually a modern manifestation of a very old variety that Parkinson (1629) called the 'Rose Columbine'. Another Cambridge don, Edith Saunders, wrote in 1912 that it had 'a continuous kind of hose-in-hose arrangement', which is a very neat description of the tightly locked structure: four or five flowers seem to be stuck together as one and the contrast between the green petal-tips, the predominant crimson colour and the white sepals is both intriguing and eye-catching. It is said that 90 per cent of its seedlings come true from seed, but that will depend upon the extent to which it is cross-pollinated by other varieties. Popular varieties of these rose- or clematis-flowered columbines include, as well as 'Nora Barlow', *A. vulgaris* var. *stellata* 'Ruby Port'. Both carry their flowers on slender but stiff stems which rise above clumps of lacy foliage; 'Ruby Port' is slightly smaller altogether. Seed strains with such names as 'Blue Barlow' and 'Rose Barlow' are now available. Easy to grow in sun or light shade and any well-drained soil, with interestingly coloured and informally shaped flowers, the rose-flowered columbines make versatile partners for many other plants. Recognizing the versatility of 'Nora Barlow' in particular, one of the high priests of naturalistic planting, Dutch plantsman Piet Oudolf, observed in 2003 that there is 'nothing wild about this double

RIGHT
Aquilegia vulgaris
var. *stellata* 'Blue
Barlow'. 'Barlow'
combines well with
spring-flowering
shrubs and other
herbaceous plants.

variety, but it would still look good in the wildest garden.' Indeed, the *stellata* columbines in general are so versatile that they make very agreeable partners for the alliums, irises and early-flowering roses of more traditional, less naturalistic planting schemes too.

Piet Oudolf also uses extra-petalled geums in his plantings, and the free-flowering, brick-red 'Flames of Passion' (2003) is a semi-double which he himself selected at his nursery in Holland. Older favourites include clear, sunny yellow 'Lady Stratheden', rich scarlet 'Mrs J. Bradshaw' and pure orange 'Prinses Juliana' (1923). The long, branched flower stems of these varieties are around 45–60 cm/1½–2 ft high; they are topped with rosette-shaped flowers, most of which are fairly full looking semi-doubles about 4–5 cm/1½–2 inches across. Opening in succession over several weeks from late spring or earliest summer, these flowers are excellent for providing bright punctuation points in richly coloured planting schemes. In sunny places and well-drained, moisture-retentive soils, particularly in cool-summer climates, the plants often flower again in early autumn and many varieties produce moderately attractive, wispy seed heads too. For reliably moist ground there is *Geum rivale* 'Leonard's Double', with small, nodding, but variably double flowers of a gentle coppery pink, and 'Bell Bank', which is a lower-growing, pink-flowered *rivale* hybrid, recently rediscovered.

Potentilla 'William Rollison' is a good mixer for summer borders.

Like many geums, herbaceous cinquefoils (*Potentilla*) are easy-going, companionable perennials and a good source of warm colours. Highly popular in the late nineteenth century, when dozens of single- and double-flowered varieties were available, they fell from favour during the twentieth century. However, a revival of interest in 'hot' and very dark colours has made these plants increasingly popular in recent years. The first of the doubles (actually a semi-double) – 'Gloire de Nancy' – was introduced by Victor Lemoine in 1854, and its tawny orange flowers still decorate gardens today.

However, deep red 'Monsieur Rouillard' and red-orange 'William Rollison' (both 1880) are now more readily available, and the really deep, maroon- or mahogany-reds such as 'Volcan' and 'Emilie' have become very popular. For weeks in summer these plants throw up 30–38 cm/12–15 inch sprays of 3 cm/1¼ inch cup-shaped flowers above their clusters of strawberry-like leaves. On the whole, their habit of growth is fairly loose and they tend to look their best growing through and among other low plants, such as the darker-leaved selections of *Heuchera*. Though they are easy to please, they prefer sunny sites and well-drained, moisture-retentive, fertile soils that do not become hot and dry.

As well as the herbaceous cinquefoils described above, there are a few shrubby cinquefoils with extra-petalled flowers. These shrubs – single or double – are easily grown and exceptionally long-flowering; however, some gardeners regard them as rather characterless and, as such, mere padding for planting schemes. None of the varieties with additional petals is very widely available and, in any case, only early and late in the season are the flowers, each 2.5 cm/1 inch or so across, reliably semi-double; at other times during their long summer-into-autumn flowering period they are single. Many of these 'doubles' are North American: the yellow-flowered 'Mount Townsend', for instance, was found in the wild in Washington State in 1994; 'Snowbird' has white blooms, and low-growing 'Floppy Disc' produces pink flowers that later fade to white.

The spiderworts (*Tradescantia*) are another group of long-flowering plants with a habit of growth that some gardeners find less than satisfactory. Their slender leaves become increasingly untidy as the season progresses, but these undemanding perennials are useful, particularly in less formal parts of gardens – on the sunnier edges of woodland gardens, for instance. In moist soils and cool-summer climates, their pretty, three-petalled flowers open in succession throughout the summer months. At up to 5 cm/2 inches wide, the rich violet-blue, double blooms of *T. virginiana* 'Caerulea Plena' are larger and more conspicuous than their single equivalents and there is, therefore, a better balance of flowers to foliage. *Tradescantia virginiana* or 'Virginia Silk Grass' was one of the earlier plants to arrive in Britain from North America: by the mid-seventeenth century a reddish purple double was in cultivation. A blue double resembling 'Caerulea Plena' appears in the 1730 plant catalogue, *Twelve Months of Flowers*.

ALL THE COMPANIONABLE DOUBLES described so far are, potentially at least, long-term inhabitants of gardens, but double-flowered annuals and short-lived perennials can also be valuable additions to mixed plantings. These fleeting members of the garden scene give gardeners the opportunity to try something new each summer, which, of its nature, will be short term but, if successful, can be repeated in the future. The varieties of short-lived doubles that make the most convivial partners for other plants are plants that create a soft, obviously ephemeral effect by having, for instance, a rather open habit of growth, or flowers that are small and of an unsophisticated shape. If they have finely divided foliage, this too can help them combine attractively with all sorts of different plants.

Many companionable annuals are Old World favourites which have been grown for centuries. Double larkspurs (*Consolida*), for example, were popular throughout the seventeenth and eighteenth centuries. During the nineteenth century they were widely used, in their dried state, as 'chimney flowers' (that is, as decorative fillers of empty fireplaces in summer), and since they retain their flower colour exceptionally well after drying, they are still very popular as 'drieds'. Present-day varieties that fit in well with other plants in the garden include 30–45 cm/1–1½ ft *C. ajacis* 'Frosted Skies', with its relatively open, well-branched spikes of loosely and lightly doubled flowers and lovely blue-and-white bicolouring. Some of the taller double larkspurs, which are usually about 60–90 cm/2–3 ft high, are also good in mixed plantings: many of the selections of 'Giant Imperial' Series, for example, are well branched and their double flowers, in the classic 'delphinium' colours, are carried in slender spikes. All these upright, feathery-leaved plants are thoroughly at home in light soils and sunny places, and they are excellent for cutting and drying.

During cultivation over the centuries, the intricate flower heads of annual cornflowers (*Centaurea cyanus*) and of sweet scabious or pincushion flowers (*Scabiosa atropurpurea*) have acquired extra floral parts. These tend to have denser, fuller flowers than the 'gappy' flowers of the species, sometimes because they have more marginal florets, sometimes because the central, shorter florets are enlarged and slightly different in form, and sometimes because both changes have taken place, offering flat or hemispherical flowers with enough substance not to get 'lost' in mixed plantings. This is particularly pertinent in the case of the deeply coloured varieties of these

Centaurea cyanus 'Black Ball' is the darkest of the annual cornflowers, but the flowers still stand out well.

plants: *Centaurea cyanus* 'Black Ball', for example, has flower heads of a sumptuously dark, chocolatey maroon. *Scabiosa atropurpurea* is naturally dark purple, and many strains seek to offer the darkest conceivable shade – hence such names as 'Chilli Sauce' and 'Ace of Spades', respectively a deep red-maroon and an almost black maroon-purple. Lighter, brighter colours are also available, mainly in mixtures: in *Centaurea cyanus* mixtures, including the low-growing (38 cm/15 inch high) 'Florence' series, there are various shades of blue, pink and white; 'Blue Diadem' has 8 cm/3 inch wide blooms of rich blue. The *Scabiosa atropurpurea* mixtures, usually called simply 'Double' or 'Dwarf Double' in catalogues, also offer flowers that are white, blue and pink. Some tall strains are also available – each has its place in the garden, but taller plants create a crowd of slender, weaving stems above the sparse foliage, which makes for a gentle, diffuse mass that is a good accompaniment for other plants. And the dense, hemispherical heads contrast strikingly, for example, with the upright spires of paler-coloured penstemons. Since *Scabiosa atropurpurea* is more of a short-lived perennial than an annual – winter wet is its greatest enemy – individual plants are also available from nurserymen. All these wiry-stemmed plants make good cut flowers, and whatever their height they are easy to grow in sunshine and in well-drained soils that are reasonably fertile.

European gardeners have enjoyed double and semi-double varieties of *Glebionis coronaria* (formerly *Chrysanthemum coronarium*) since at least the eighteenth century; by the mid-nineteenth century, the most popular of these appealingly pretty and unpretentious annuals was the double white. Double-flowered mixtures in white and shades of yellow were, until recently, readily available but an

outstandingly attractive pale yellow semi-double called 'Primrose Gem' seems to have ousted them in terms of popularity. The delicate colouring of its golden-eyed, 5 cm/2 inch blooms, lovely in itself, can be used either to give extra clarity and freshness to light-toned planting schemes or to provide an enhancing contrast to deep rich colours. Clothed in deeply lobed, bright green foliage, the much-branched stems of this sun-loving plant are about 30–45 cm/1–1½ ft high, and the unusually pretty daisies open in succession from midsummer to early autumn.

The range of short-lived but long-flowering companionable plants widens considerably, and interestingly, when New World plants are taken into account. Many of these plants have daisy-like flower heads in some shade of sunny yellow, but the strikingly large yet graceful daisies of Mexican *Cosmos bipinnatus* are either white or some shade of pink or burgundy. The varieties 'Psyche Mixed' and 'Psyche White' produce semi-double and single blooms, and though the flower heads are 8–10 cm/3–4 inches wide they have relatively few extra petals and an almost buoyant, airy look. In addition, these are tall plants (about 1.2 m/4 ft high), with quantities of fresh green, very finely divided leaves and a well-branched, open habit of growth, and all these features ensure that these annuals look entirely comfortable alongside longer-lived plants. The more densely but still variably doubled flowers of *C. bipinnatus* 'Double Click' (2005) may have lost some of the elegance of the singles and semi-doubles, but they are useful where the balance of a mixed planting calls for red-pink-and-white notes to be sounded more forcefully. Picked in bud, all these cosmos make stylish cut flowers, but the fullest doubles are particularly long-lasting.

Varieties of *Cosmos bipinnatus* need a sunny, sheltered site to grow well, but really hot summers are needed for varieties of *C. sulphureus* to flower freely. The widely branching stems of these shorter-growing, smaller-flowered plants end in semi-double daisies, each usually around 4–5 cm/1½–2 inches wide. The commonest flower colours are sizzling oranges and yellows, as in the Sunny Series plants for example, but several varieties, such as 'Polidor' and the Ladybird Series, include bright scarlets too. The plants all have rich green, slender-lobed foliage but they vary in height from up to 75 cm/2½ ft ('Polidor'), 30–38 cm/12–15 inches (Sunny Series), and some are as little as 25–30 cm/10–12 inches (Ladybird Series). Their freely branching habit of growth means that these are

Cosmos sulphureus Dwarf Ladybird Mix. A semi-double strain of this annual for hot, sunny conditions.

excellent plants for delivering spots of brilliant colour – against the big, purple leaves of some cannas, for instance, or among the long yellow leaves of such grasses as *Carex elata* 'Aurea' .

Bidens, another American daisy with bright yellow flowers and finely dissected foliage, is so companionable that it is hard to think of it except as weaving and rambling and tumbling among other plants. However, *B.* 'Pirate's Treasure' is a recent hybrid which has a much more compact, mounded habit of growth than the familiar *B. ferulifolia* of innumerable hanging baskets. It also has sprightly semi-double flowers, each about 4 cm/1½ inches across, on fairly upright stems so that the whole ensemble is more conspicuous and self-contained. As well as looking good in pots and other containers, it could make an interesting, long-flowering if short-lived addition to sunny gravel garden plantings where the soil does not become too dry.

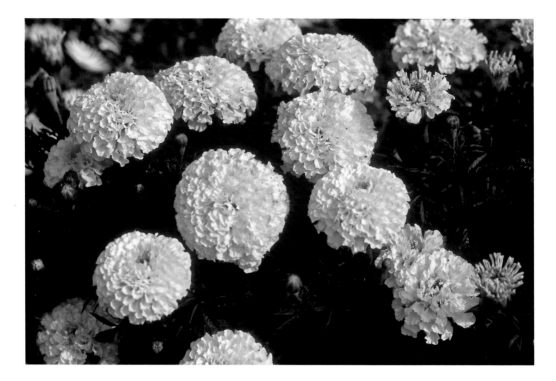

Perhaps the most widely grown of the short-lived American daisies are zinnias (which are Mexican in origin) and so-called African and French marigolds, which are derived from *Tagetes erecta* and *T. patula* respectively (both of which are native to central parts of the American continent). It might seem unlikely that any of these plants could possibly be conceived of as companionable and indeed some zinnias belong among those flowers that are loved for their regularity and formality – see chapter 5. However, not all marigolds and zinnias have big, dense, stiffly petalled blooms in eye-watering colours. This may be an accurate description of the flowers of many African marigolds ('those superlatively double African Marigolds that look like india-rubber bath sponges offend me most of all,' wrote E.A. Bowles in *My Garden in Summer*, 1914), but many French marigolds have relatively small flowers (around 5 cm/2 inches wide) that are quite loosely double or semi-double. The most versatile varieties are, perhaps, those such as Safari Series and Queen Sophia Series which, at about 25–30 cm/10–12 inches high, are not too squat and low-growing, and which include plants with bicoloured blooms in shades of burnt orange, deep red or rich mahogany with yellow and amber edgings.

Tagetes erecta 'Vanilla', cool and elegant, is a useful pompon. Its smell is less acrid than that of most African marigolds.

It was French marigolds of these deeply glowing colours that 'made the best effect' in Gertrude Jekyll's opinion. Double marigolds, including bicoloured varieties, have been grown in British gardens since the eighteenth century; a deep yellow double African marigold and a mahogany-red and yellow French marigold were both illustrated in 1730 in that most elegant of all plant catalogues, *Twelve Months of Flowers*. But it was Gertrude Jekyll's sophisticated use of marigolds, African as well as French, that led to the really widespread popularity of these plants.

Like the bicoloured French marigolds, bicoloured varieties of zinnia, such as *Z. haageana* 'Persian Carpet', are especially valuable for creating harmonious planting schemes, since their constituent colours can each be repeated as another ingredient of the overall plan, thereby producing a satisfying integrated whole. The velvety deep reds of this particular mixture's 4 cm/1½ inch, double and semi-double flower heads could be echoed in, for instance, the red-purple foliage of certain *Heuchera*, while the yellows could be repeated in the little stars of *Bidens ferulifolia* or the flat, horizontal flower heads of various *Achillea*.

Some single-colour zinnias are also easy to incorporate into mixed plantings: *Z. elegans* 'Envy' produces double and semi-double blooms, each about 5 cm/2 inches wide, in a distinctive, pale chartreuse colour, and the plants are a useful 60 cm/2 ft high. Smaller-flowered white zinnias also make good mixers; they include *Z.* 'Profusion White', with its neat, yellow-eyed, semi-double blooms, each up to 5 cm/2 inches wide. Profusion Series plants are well branched and grow about 35 cm/14 inches tall; they are available in shades of orange and a bright, reddish magenta-pink, as well as white.

In flower size, these companionable zinnias are more like the original doubles, which appeared in France in the mid-nineteenth century, than the spectacular, 12 cm/5 inch mammoths which were such a prominent feature of mid-twentieth-century seed catalogues. All the zinnias and marigolds mentioned above are usually in bloom from early summer or midsummer on into early autumn, but to flower well for many weeks they need a really sunny site and a light rich soil.

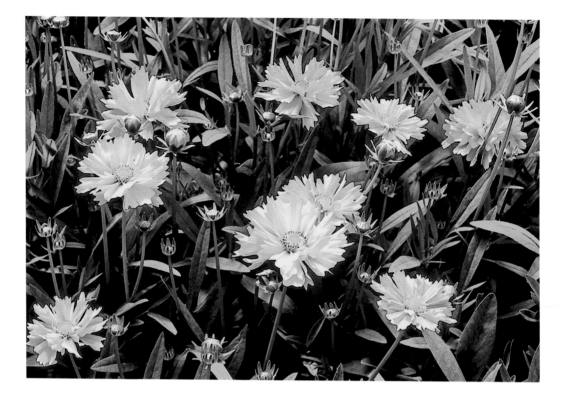

ONE GROUP OF NEW WORLD DAISIES straddles the annual/
perennial divide: varieties of *Coreopsis grandiflora* are short-lived
perennials that are often treated as annuals or biennials since they
flower soon after sowing and are at their best in their first year. Their
slender, upright stems rise, about 45–60 cm/1½–2 ft high, above
clumps of slim leaflets, and though there are usually large numbers
of their rich yellow, fringed, daisy-like flowers (each about 5 cm/
2 inches across), the effect is never stiff or cramped. Varieties with
extra-petalled flowers deliver heart-warming yellow in such generous
quantities that not only do their blooms look radiant with reds and
oranges, but they are almost equally potent with bright blues and
violets. The most densely petalled variety is 'Sunray'. 'Early Sunrise'
(introduced 1989) is a popular semi-double with more informal,
slightly ruffled-looking flower heads, while newer developments
include semi-double 'Rising Sun', which has red-brown markings on
its yellow ray florets. Each of these extra-petalled varieties produces
double flowers when grown from seed, though there may be some
variations in flower colour and in floriferousness. These are not
demanding plants but they are at their best in not-too-dry a soil

Cheerful semi-
double *Coreopsis
grandiflora*
'Early Sunrise'
combines well with
blues and purples,
as well as reds
and oranges.

and full sun. If deadheaded, they can bloom from early summer to early autumn, with 'Early Sunrise' the first into flower. They are all excellent for cutting.

Longer-lived yellow daisies with extra petals – varieties of sunflower (*Helianthus*), false sunflower or ox-eye (*Heliopsis*) and coneflower (*Rudbeckia*), for instance – tend to have big flower heads of such brassy colouring that they are really too showy to be companionable, except perhaps in very large-scale planting schemes. However, some of these perennials produce double flowers of a more easily accommodated size or in the kind of cooler, paler yellow that can enhance a wide range of other colours. The rather shaggy, fully double flowers of *Rudbeckia laciniata* 'Goldquelle' (1948), for instance, are of a bright, clean yellow with cooling touches of green in the centres of the immature blooms. Each flower head is about 9 cm/3½ inches across. Fully double yellow daisies which are more modest in size (about 5 cm/2 inches wide) include the neat, yolk-yellow hemispheres of *Heliopsis* 'Asahi', and for plantings where less densely petalled flowers would be more suitable, there are semi-doubles such as *Helianthus* 'Gullick's Variety'. Though the dark-eyed, mid-yellow blooms of this sunflower are large (up to 12 cm/5 inches wide), the slightly uneven arrangement of their ray florets creates an attractively informal and lively effect. Semi-double *Helenium* 'Double Trouble' (2006) has sunny yellow flower heads which are each only 5 cm/2 inches wide, but here too the 'petals' are unevenly arranged, in this case around tawny central cones, and the impression created is almost of fluffiness.

All these daisy-like flowers add melting, glowing light to plantings and their basically circular shapes contrast well with the erect spires of mulleins (*Verbascum*) and *Ligularia*, and the upright plumes of some grasses, including varieties of *Calamagrostis* and *Miscanthus*. They begin to open in mid- or late summer, starting with the *Heliopsis* and ending with the *Rudbeckia*, and they continue on into early autumn. The plants range in height from about 75 cm/2½ ft for the *Helenium* and the *Heliopsis*, to over 1.5 m/5 ft for the *Helianthus*; the *Rudbeckia* is around 1 m/3–3½ ft tall. They are all tough, reliable plants but they need sunshine and fertile soil if they are to act as really floriferous companions in the border.

For supplies of summer daisies in some cooler colours, there are the fleabanes (*Erigeron*). Even in the varieties that have additional rows of outer florets, the flowers of these perennials are simple, open-faced semi-doubles with sizable yellow 'eyes'. The 'eyes' are surrounded

by very slender ray florets whose fineness imparts a certain air of softness to the plants. This means that, though they are able to flatter such plants as lacy-ruffed, thistley *Eryngium alpinum*, which are more flamboyant than they are, they do not distract attention from them.

Most varieties of these fleabanes are at their free-flowering best during early summer and midsummer, but they often continue to bloom generously until the beginning of autumn. Their flower colours range from the lavender-blue of 'Azurfee' and the light, bright, but somewhat variable pink of 'Rosa Juwel', for instance, to the vibrant violet-blue of 'Dunkelste Aller' (1951) and the even darker violet of 'Schwarzes Meer' (1970). As long as they have sunshine and a reasonably fertile and moisture-retentive soil, these neat, clump-forming plants are easy to grow. Their flowers, each about 4–5 cm/1½–2 inches wide, are carried in an openly branched arrangement on strong, upright stems about 45–60 cm/1½–2 ft high; they are good for drying as well as cutting, and they are attractive to butterflies.

Erigeron 'Dunkelste Aller' flowers for six weeks in early summer, but needs dividing every two or three years.

Compared with the fleabanes' flowers, the bobbly little white blooms produced by double sneezeworts (*Achillea ptarmica*) are less obviously

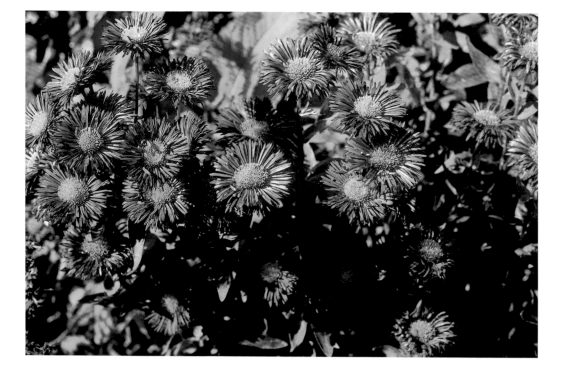

daisy-like: they are each only 1 cm/½ inch across and if they have 'eyes', then these tend to be inconspicuous. The flowers are held in loose, branched clusters on top of stiff stems so that, in effect, they are rather like heavyweight gypsophila. They are almost as useful as gypsophila, both in the garden and – fresh and dried – as cut flowers, and the plants have long been part of the garden scene: since the late sixteenth century in Europe and since at least the early nineteenth century in America. Their flowers are valuable for providing small cumuli of clean colour in planting schemes featuring cool blues and silvery greys, while with hotter colours, such as clear reds and oranges, they have a conspicuous 'sharpening' effect.

Achillea ptarmica 'The Pearl' is pleasantly invasive; it combines well with everything.

There is some confusion over the names of the half-dozen or so double-flowered varieties of sneezewort, including commonly listed *Achillea ptarmica* The Pearl Group 'The Pearl'. When correctly named, this should be a vegetatively propagated plant, up to 75 cm/2½ ft high, with neatly doubled flowers of an immaculate, sparkling white. Plants sold as *A. ptarmica* The Pearl Group 'Boule de Neige' are usually seed-raised and therefore more variably double; they may be taller too. The name *A. ptarmica* The Pearl Group 'Nana Compacta' is most

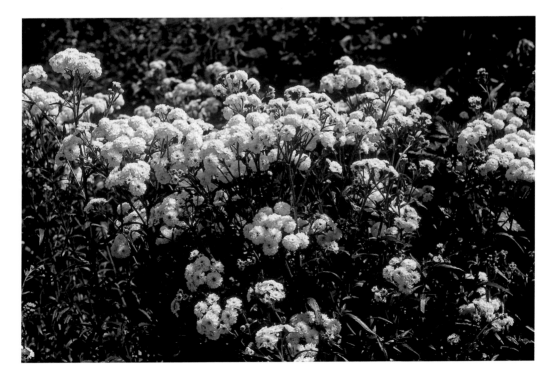

often attached to plants which grow about 38 cm/15 inches high and produce semi-double flowers. In rich, moist soils double sneezeworts may spread quite widely and they are vigorous even in ordinarily moisture-retentive conditions; they are happy in sun or a little shade and they flower from about midsummer through into early autumn.

The double-flowered variety of hemp agrimony, *Eupatorium cannabinum* 'Flore Pleno', also has small, double daisies in branched heads but, at around 1.2 m/ 4 ft high, it is considerably bigger than the sneezeworts, and it is altogether a more rugged-looking plant. Its robust good looks allow it to associate comfortably with big grasses and drifts of globe thistles (*Echinops*) and late monkshoods (*Aconitum*). For several weeks from mid- or late summer, its red-tinged stems and slender-lobed, hemp-like leaves are topped with soft masses of pink flowers (the flower colour varies a little; some forms are a rather stronger pink than others). Like the species, it is at home in damp soils and sunshine, but it is altogether a more definite and decorative plant and, being sterile, is never a self-seeding nuisance.

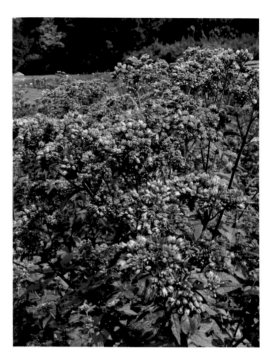

Strong-growing *Eupatorium cannabinum* 'Flore Pleno' is a great improvement on the single form.

BEFORE THOSE QUINTESSENTIALLY autumnal daisies, asters and chrysanthemums, get into their stride, another band of late perennials comes into flower. Often referred to collectively as Japanese anemones, the various forms of *Anemone hupehensis* var. *japonica* and *A.* × *hybrida* are long-flowering and adaptable enhancers of other plants and disarmingly lovely in themselves. Bowles, in *My Garden in Autumn and Winter* (1915), proclaimed that *A. japonica* was 'a plant I should like to grow every known form of', adding boldly, 'even some of the very double ones'.

The first Japanese anemone to be recorded by Europeans was *A. hupehensis* var. *japonica*, a naturalized semi-double variety with deep purplish pink petals (correctly tepals). Living specimens were

eventually introduced to Britain by the plant collector Robert Fortune in the early 1840s. Cultivars of this plant begin to open their flowers during the final weeks of summer and, as with all Japanese anemones with extra petals, much of the graceful charm of their blooms is due to the conspicuous rings of golden stamens surrounding small, central green 'cones'. Popular extra-petalled varieties include the floriferous 'Pamina' with rich pink, 5 cm/2 inch wide flowers, tinged with plummy, reddish purple tones; 'Rotkäppchen', which has less tidy, dusky red-pink flowers, some of which may be nearly 8 cm/ 3 inches across, and the long-flowering 'Prinz Heinrich' (1902). This last plant, which seems now to be indistinguishable from the variety 'Bressingham Glow', has flowers 6 cm/2½ inches wide, with narrow petals of a fruity, purplish pink.

Softer pinks, and white, are the province of *A. × hybrida* varieties such as the vigorous and potentially invasive 'Königin Charlotte', with 8 cm/3 inch flowers ('so lovely that I cannot bring myself to root any of it out', confessed Bowles). This plant was introduced in 1906, as was the white-flowered but otherwise rather similar 'Géante des Blanches'. An earlier, American white, 'Whirlwind' (1887), has 'busier' flowers, each about 6 cm/2½ inches across, with narrower petals. One of the more intriguing light pinks is 'Lady Gilmour' which, in addition to its irregular, 6–8 cm/2½–3 inch flowers, often produces leaves that are curled and crisped like parsley, though this is not a stable, reliable feature. Some deeper pinks are also available: they include 'Serenade', 'Margarete' and 'Montrose'. The naming of Japanese anemones is, in general, problematic but it is unusually complicated in the case of these last two plants. When correctly named, the flowers of both varieties have numerous petals: the blooms of 'Margarete' are smaller and more regular than those of 'Montrose', which are about 8 cm/3 inches across.

Japanese anemones are both elegant and unpretentious. They therefore manage to look equally at home in classic borders, cottage gardens and naturalistic plantings. Flowering generously into mid-autumn, they complement and are complemented by asters, sedums and late clematis. The pink-flowered varieties echo the red tones of most purple foliage in a particularly satisfying way. Light shade and moisture-retentive soils seem to suit Japanese anemones best but they are almost as happy in sunshine and in any reasonable soil. Their wide-branching, wiry stems rise well clear of clumps of handsome, lobed foliage. Most varieties are about 60–90 cm/2–3 ft tall but some,

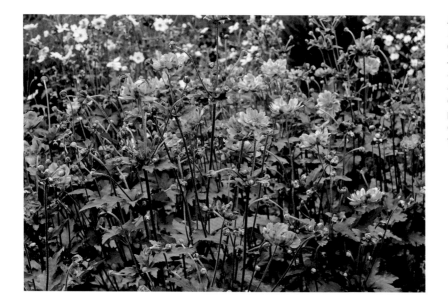

*Anemone ×
hybrida* 'Königin
Charlotte'.
Japanese
anemones are
among the best
companion
plantings for soft-
coloured autumn-
flowering roses.

including 'Königin Charlotte' and 'Géante des Blanches', are often
around 1.2 m/4 ft.

Many parts of the world are now experiencing longer, warmer
autumns and this change in weather patterns has resulted in
greater interest in late-flowering plants, including chrysanthemums
and asters. Both these classic ingredients of autumn borders make
good cut flowers, as well as adding their own distinctive colourings
to mixed plantings. Their palettes overlap somewhat, but asters are
predominantly cool and clear in their colouring, while more of the
warm, russety hues are to be found among chrysanthemums; both,
in their own way, seem appropriate to the dew-drenched mornings
and the sometimes misty, sometimes crisp atmosphere
of autumn.

Many of the thousands of chrysanthemum varieties with extra petals
are neither hardy nor reliably perennial and, in any case, their often
massive and densely petalled blooms make them stand out rather than
blend in. Trouble-free perennial chrysanthemums of a companionable
nature are to be found principally among the varieties that are variously
classified as Koreans or Rubellums. Many of these plants are single-
flowered and some newer varieties in particular are short-lived, but
semi-double 'Duchess of Edinburgh' (1948) and double 'Emperor of
China' (which may well be an ancient Chinese cultivar) are good garden
plants. The yellow-disced flowers of the former are an opulent crimson-

red, while the latter produces dark, wine-red buds that unfurl to reveal somewhat quilled petals of a soft, silvery pink. In both cases the flowers are about 6 cm/2½ inches across. They are carried on branching stems which are relaxed to the point of floppiness and therefore need support. At about 1.2 m/4 ft, 'Emperor of China' is the taller of the two. It is in flower from mid-autumn to early winter and, as an added attraction, its foliage takes on crimson tints during that period. 'Duchess of Edinburgh' flowers throughout early and mid-autumn and grows 60–75 cm/2–2½ ft tall.

Some early-flowering, outdoor Pompon chrysanthemums are also possible candidates for companionable doubles but these are rather stouter and stiffer than the plants mentioned above and, especially when their flowers are full pompons, they can seem quite formal. However, some semi-pompons may be useful, for instance with late-flowering shrubs, such as mid-blue *Caryopteris*, and grasses, including *Pennisetum* with its fuzzy bottlebrush flower heads. Heathery pink 'Mei-kyo' (1950s), its sport the light bronze-orange 'Bronze Elegance' (1973) and *its* sport lemony yellow 'Nantyderry Sunshine' (1991) all have small flowers (3–4 cm/1¼–1½ inches wide) with visible yellow discs. The plants are around 60–75 cm/2–2½ ft high and in bloom from early or mid-autumn through until late autumn. Like 'Duchess of Edinburgh' and 'Emperor of China', these semi-pompon chrysanthemums need full sun and well-drained soil.

Numerous varieties of aster are both companionable and perennial. These tough and sturdy plants were popularized in the late nineteenth century by William Robinson, who saw how well their sheaves of daisy sprays suited the more relaxed style of planting he advocated. Double and semi-double asters are mainly mid-twentieth-century introductions, derived principally from mildew-resistant *Symphyotrichum* (formerly *Aster*) *novae-angliae* (New England aster) and mildew-prone *S. novi-belgii* (New York aster, Michaelmas daisy). There have been very few conspicuously extra-petalled varieties of *Aster amellus* (Italian starwort), and it seems probable that the true form of lavender-blue *A. a.* 'Bessie Chapman', introduced in the late 1920s, is now extinct. Especially long-lasting as cut flowers, the more densely petalled blooms of double and semi-double asters make particularly effective contributions to large-scale borders. Their cloudy drifts of colour are successful at complementing colours and shapes as varied as the solid, dusty pink heads of some *Sedum* (stonecrop), the slender red spikes of *Persicaria amplexicaulis* 'Atrosanguinea' (a variety of red bistort) and the elegant, saucer-shaped blooms of Japanese anemones.

They all appreciate a moisture-retentive soil and a sunny position and are at their best in equable, cool-summer climates. Most varieties flower during the early and middle parts of autumn, though 'Patricia Ballard' and 'Fellowship' begin to bloom in late summer and mid-autumn respectively.

The first formally named fully double Michaelmas daisy was pale lavender *Symphyotrichum novi-belgii* 'Beauty of Colwall' (1907). Rarely grown nowadays, it has been by replaced by similarly coloured 'Marie Ballard' (1955), the multi-rayed flowers of which contrast most attractively, in colour and in form, with the simpler, more open daisies of rich yellow *Rudbeckia fulgida* var. *deamii* . Most *novi-belgii* cultivars – which are, in fact, a large group of hybrids of varied ancestry – have visible central yellow discs and are semi- rather than fully double. Popular varieties include 'Fellowship' (pale, mauve-tinged pink; 1955), 'Patricia Ballard' (a brighter mauve-pink, with only the earliest flowers each season being double; 1957) and 'Winston S. Churchill' (purplish red; 1950). These varieties, and 'Marie Ballard' too, are about 90–100 cm/3–3¼ ft high with flowers approximately 5 cm/2 inches wide. As with chrysanthemums, lower-growing asters were first developed in the 1920s as autumn-flowering plants for use in First World War cemeteries in Europe. Semi-double varieties of these smaller asters are mainly mid-1950s to mid-1960s introductions. They include bright, purplish red 'Jenny', lavender-blue 'Lady in Blue', mauve-pink 'Little Pink Beauty' and white 'Snowsprite', all of which grow 30–40cm/ 12–16 inches high. Their flowers are about 4–5 cm/1½–2 inches wide.

Compared with the *novi-belgii* cultivars, *novae-angliae* varieties are generally rather taller, often being 1.2 m/4 ft or more high, and they have shaggier, less evenly shaped flowers which may also be slightly smaller. Their less orderly appearance means that they fit comfortably in wildflower and prairie-style plantings. Most cultivars are single-flowered but there are several semi-doubles, including the highly popular 'Andenken an Alma Pötschke' (1969), which produces vivid cerise-pink flowers; clear, rose-pink 'Barr's Pink' (about 1920) and purplish crimson 'Septemberrubin' (1951) are also widely grown. Semi-double or single, they are all very attractive to butterflies.

PRAIRIES ARE FASHIONABE WILD PLACES; MOORS ARE NOT, it would seem. The final group of companionable doubles – varieties of moorland-inhabiting heather – has fallen so far from grace that it

Aster novae-angliae 'Andenken an Alma Pötschke': its tall stems and vivid colouring look best among rough shrubs and boundary plantings.

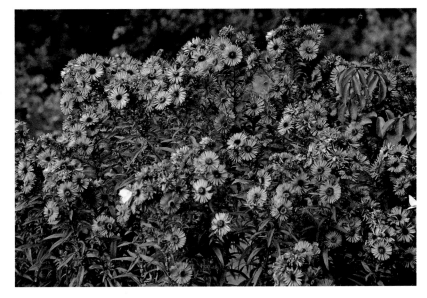

is often treated as a horticultural joke. And yet, in open upland settings and acid soil, heathers (*Calluna vulgaris* and its varieties) are altogether more appropriate than perennials from the prairies. (The genera *Erica* and *Daboecia* – correctly, heaths – are rarely double-flowered; but see page 258.)

Sweeping masses of heathers teamed with other tough, dry-textured moorland plants, such as *Carex* (sedge), *Deschampsia* (tufted hair grass) and varieties of *Pinus mugo* (dwarf mountain pine), create natural-looking schemes for cooler, higher-altitude gardens. Even the double-flowered forms of *Calluna* are suitable for naturalistic plantings since there is nothing flashy or flamboyant about their tiny flowers but the extra petals certainly generate greater floral impact. These extra petals also make the dense flower sprays much more effective as fresh cut material – they dry well, too. The most popular varieties flower very freely, usually starting in late summer or early autumn, and last for weeks. They also make efficient, hummocky ground cover approximately 30–45 cm/1–1½ ft high. 'H. E. Beale' (mid-1920s) has shell-pink blooms; the flowers of 'Peter Sparkes' (1955) are slightly deeper pink; and 'Kinlochruel' is a pure white with bright green foliage that becomes bronzed in winter. The varieties 'Dark Star' and 'Dark Beauty' are semi-doubles with crimson and deep cerise-pink flowers respectively. But the effect of doubling the flowers of their near relations the *Daboecia* heaths is less easy to commend, for the bells appear bloated by the layers of extra petals. These, and other oddities, are the subject of the next chapter, on rare and curious plants.

8 The Rare and the Curious

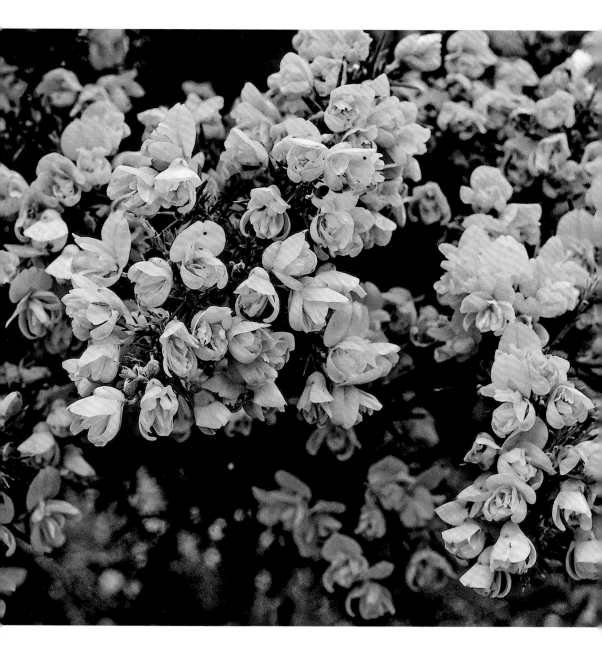

The doubling up of flowers often brings a doubling of pleasure. Many are the flowers that look all the better for the extra petals. No one would deny that wild roses have an innocent prettiness and grace when their five petals open out to the sun, but doubling the number of their petals brings extra gravity, more substance and, many would say, more beauty to the flower. Double flowers usually offer a greater mass of colour and a more complex arrangement of their petals that we find attractive; many of our most popular gardens plants exist largely as sophisticated doubles rather than simple singles. Roses, dahlias, Japanese cherries, chrysanthemums and carnations are just some of the important genera that we tend to expect with double flowers.

But double flowers are not always an improvement on their single-flowered antecedents. There are whole families like the legumes whose distinctive shape is altered as a result of doubling, if not unattractively, then sometimes rather unpredictably. Doubling does not always add to our perception of beauty. Nor does it always produce a more useful flower for gardeners, even if the new forms are interesting to plantsmen. Sometimes the changes are so insignificant that they add no value to what is already offered by the singles; on other occasions doubling is rather successful and introduces pleasing new shapes and forms. And occasionally they are in a sense self-defeating: a plant that is grown for the fruit that it bears may lose its potential to crop well if a variant is cultivated for its double flowers. In this chapter are a quite number of double-flowered varieties that probably deserve to be 'rare' – others, indeed, were thought so ugly and useless in the past that they quickly became extinct. Such plants are clearly beyond the redemptive interest of even the keenest plantsman. But others that change the form of their flowers almost beyond recognition may achieve great popularity, however surprising we may find this; the double-flowered forms of antirrhinums may have lost their distinctive snapdragon shape but they also appeal to new markets.

Ulex europaeus 'Flore Pleno'. The double-flowered form of our native gorse is showy and does not seed around, but it is just as prickly as the single type.

PERHAPS THE PLANTS FOR WHICH THE PROCESS of doubling changes their flowers most dramatically are the members of the Leguminoseae or pea family. The extra petals come at the price of losing their typical leguminous morphology, though the results are somewhat unpredictable and differ from genus to genus. Not all find favour with gardeners. Double sweet peas (*Lathyrus odoratus* cvs) were once a feature of late nineteenth-century US seed catalogues but contemporary reports suggest that their shape was not as elegant as that of typical flowers. None are known today; their popularity, if it ever existed, was short-lived, quite overtaken by the rise of the ruffled elegance of Spencer sweet peas.

The double-flowered form of gorse, *Ulex europaeus* 'Flore Pleno', is a legume that works rather well: the standard petal at the top of the flower that imparts the typical hooded effect is retained, but the stamens turn into further petals, which means that the lower parts of the flower (the 'wings' and the 'keel') show the effect of doubling, with many more rich yellow petals than normal. It is a good plant for thin soils and associates surprisingly well with azaleas. Although it will grow to 1.2 m/4 ft it has the advantage of being sterile, so it will never become a pest; indeed, it can only be propagated by taking cuttings, a task rendered unpleasant by prickles that are more numerous than leaves.

No such problem arises with the double-flowered form of the closely related dyer's broom, *Genista tinctoria* 'Flore Pleno', which also has a profusion of extra petals that give the whole plant a denser appearance: it has no prickles. It also tends to grow shorter and wider than the single-flowered type of dyer's broom. A shrub in full flower is a mounded mass of rich golden yellow – and the single-flowered form is one the prettiest of British native plants.

Wisterias are also members of the pea family, though this may be hard to believe when contemplating their beautiful flowers. Their double-flowered forms come from Japan, selected over centuries by gardeners in that most civilized of countries. Only two are commonly seen in the West and they are the varieties of *W. floribunda* known as 'Violacea Plena' (or just 'Plena') and 'Black Dragon', though there is a tendency now to revert to the original Japanese names, 'Yae-fugi' (which, according to the International Code on the Taxonomy of Cultivated Plants, is an invalid cultivar name) in place of 'Violacea Plena', and 'Yae-kokuryû' (which is acceptable) for 'Black Dragon'. Naming is not the only problem these heavy double wisterias

Wisteria floribunda 'Black Dragon'. Double-flowered wisterias are more substantial than single ones, but the individual flowers are untidy.

encounter, for they have been utterly mixed up by Western nurserymen ever since they were first introduced, and there is no way of knowing whether what you are buying is correctly named unless it is in flower at the time. However, both varieties share their essential characteristics, including the shape of their flowers. These are untidy, with perhaps too many petals curving off at strange angles, even though they still manage to be recognizable as legumes. The colour contrast between the lilac petals and their purple backs is agreeable, but the racemes are thicker and denser, with none of the elegance of more typical wisterias but rather more 'flower power'. These floral attributes do not affect their ease of cultivation, and they can be pruned and trained as any other wisteria.

The genus *Cercis* – 'redbuds' in North America but 'Judas trees' in Europe – produces small leguminous flowers in spring before the trees break into leaf, and these often emerge from older parts of the tree, like its trunk, which one might otherwise suppose to be incapable of producing flowers. The rich pink flowers stand out like jewels against the dark bark – seeing the wild redbuds in flower is one of the great joys of New England in spring. There is only one double-flowered form, the rarely seen *Cercis canadensis* 'Flame', which was discovered in the wild in 1902 in Illinois and is currently being used to develop double-flowered hybrids by crossing it with other species, notably the European *Cercis siliquastrum*. The flowers of 'Flame' are female-sterile – it is the pistil that doubles up to produce extra petals – but produce plenty of pollen. The extra petals come at the expense of the typical pea-shaped flower, which changes into a thick untidy cluster of petals, slightly darker at the centre than usual, but never a thing of beauty. On the plus side, it should be said that the overall effect of a tree in full bloom is brighter and stronger; seen from a distance, 'Flame' has a lot more colour and overall substance than the wild *Cercis canadensis*. It survives hot summers and cold winters in a well-drained position and grows to as much as 8 m/26 ft tall.

Many are the double forms of plants that have at some time been recorded by botanists and gardeners but are now extinct. No doubt they were not sufficiently useful or beautiful to be propagated and conserved, though some authorities argue that any aberrant form of a plant is worthy of interest and therefore of preservation. Writing in the mid-seventeenth century, John Rea mentioned a double form of rosemary, *Rosmarinus officinalis*; double and semi-double forms of *Anemone pavonina* were well known and even quite popular in the seventeenth and eighteenth centuries; Margery Fish grew a double-flowered form of woad, *Isatis tinctoria*, as recently as the 1950s. All these are now either very rare or actually extinct, as is the double-flowered form of *Ranunculus gramineus* that Parkinson grew in the seventeenth century. Were all these mutant flower forms worthy of conservation? The double-flowered *Anemone pavonina* would certainly have been beautiful, but any argument for conserving the others would have to rest upon the scientific value of preserving all natural variants rather than their horticultural value. After all, if our ancestors had not considered the first rose or dahlia with more than five petals to be worth growing and preserving, our gardens would be much poorer today. But what about real weeds – the pests that we spend many hours removing? One of the most rampant of undesirable plants if you live in a temperate climate with rather heavy soil is the creeping buttercup, *Ranunculus repens*. Why, you might wonder, would anyone wish to grow a double-flowered form of it? And yet *Ranunculus repens* var. *pleniflorus* has its admirers, and is a plant that is quite widely available in garden centres: 'very vigorous indeed' is the laconic comment of one nurseryman.

Ranunculus repens var. *pleniflorus*, the double-flowered creeping butterfly, is handsome but rather over-vigorous.

Plants must be commercial to survive. There is immense competition for space in people's gardens. Many of the plants that may be classified as 'curious' are also rare. Green roses and proliferating daisies do not appeal to everyone – why buy an oddity instead of a plant that is universally considered beautiful? It follows that

the annals of botany and horticulture are threaded through with descriptions of curious plants that are either rare or can now be presumed extinct. Three double forms of *Campanula* illustrate this. *C. isophylla* 'Flore Pleno' is a double-flowered form of a pretty trailing species that is useful in containers and hanging baskets. One might suppose that the double form would be popular because of its longer flowering period and more densely colourful flowers, but it has not been seen in cultivation for several years now. The same is true of *C. poscharskyana* 'Multiplicity' – hardy and easy to grow, it should be immensely popular with gardeners but is apparently extinct. Little *C. rotundifolia* is native both to North America and to Europe (some consider it the original 'bluebell of Scotland') but its double-flowered form, *C. r.* 'Flore-pleno', is rarely seen now. Reginald Farrer knew it a century ago, but it has not been offered by European nurserymen for some years and, though it is available in the United States, it is not the popular alpine plant that it might be. It is hard to be sure of the reason why such plants are no longer grown. Competition from more interesting forms is certainly a possible explanation, and so are problems of cultivation, though there is no reason why these double forms should not be as easy to grow as the single. A more likely explanation is that people think these double forms lack the grace that one associates with the ordinary 'bellflower'. One of the effects of mutation from single to double campanula is that the petals are often no longer joined together but separated – in other words, the bellflower is no longer shaped like a bell.

Aubrietas provide a good example of how fashion may reduce the range of plants we grow in our gardens; they were all-purpose standbys in post-war gardens, easy to grow and dependable in bloom, as indeed they still are. As recently as 1990 a journalist could list seven doubles in a survey of easily found aubrietas. Today, almost the only double-flowered aubrieta is 'Bob Saunders' (syn. 'Schofield's Double') with large, reddish-purple flowers, and a couple of semi-double varieties, 'Bressingham Pink' and 'Greencourt Purple'. It is difficult to understand why they have lost their shine for present-day gardeners. The plants themselves are as accommodating and generous as ever: it is impossible to overpraise the sheer impact of a double-flowered, bright purple aubrieta tumbling down a garden wall in April.

Any genus that is widely grown commercially is bound to produce a number of variations that growers notice and seek to develop.

Cyclamen provide a good illustration of this. Many species and forms are grown in gardens, but the only one that has been developed by breeders is *C. persicum*, one of the prettiest but also one of the least hardy, and its principal market is as a colourful house-plant in winter. It is available in innumerable colours, sizes and shapes, generally with much larger and broader petals than are found in the wild species. Recent developments include the somewhat tentative launch of some double-flowered forms, but these have not been an unqualified commercial success. Sometimes they just have a few extra petals and look more crammed with colour than usual, but when these new florists' cyclamen are more obviously double, they tend to lose their shape; the petals are too numerous to fold themselves back in the distinctive jaunty manner that makes the whole genus so charming. The doubling up of flowers does not always bring an improvement to their appearance: double cyclamen are still regarded as curiosities rather than plants of great beauty. That said, they have a growing popularity in Japan, and the Japanese often perceive beauty in flowers long before the rest of the world catches up with them.

FASHION IS SELDOM THE ONLY REASON why some double-flowered varieties disappear from commerce. Problems with cultivation are much more common, and these usually afflict both single and double varieties without distinction. Pyrethrums, now lumped in with common tansy and chamomile as *Tanacetum* (*T. coccineum*), were popular herbaceous plants a hundred years ago, and there were scores of double-flowered varieties among them, dating back at least to the middle of the nineteenth century. They probably reached the height of their popularity in the 1920s and 1930s, when pyrethrums were a commercial cut flower, but almost all stocks were wiped out by a viral disease in the 1970s and only a few remain. Pyrethrums also need staking – at least, the double ones do – and require fairly frequent division to retain their vigour. So their popularity continues to diminish, and the only double-flowered varieties that are sometimes seen nowadays are white-flowered 'Aphrodite', which won a First Class Certificate from the RHS in 1887, and pink 'Vanessa', dating from 1961. Both have anemone-flowered centres that form a fairly neat mass of little petals. Whether they will still be available commercially in ten years' time remains to be seen.

The place of pyrethrums in the garden has to some extent been taken by the many varieties of *Echinacea purpurea* and among them

Echinacea purpurea 'Coconut Lime' owes its colouring to the mass of slightly leafy petaloids that emerge around the edge of the central cone.

are several curious but very useful doubles. The central cone of 'Coconut Lime', for example, has a mass of little petaloids that match the green tinge of the ray florets – not exactly an example of phyllody (the abnormal development of flower parts into leaves), but getting close to it. 'Doubledecker' (correctly called **Doppelgänger**) has a circle of ray florets near the top of the cone; these are not as large as the main florets, but similar to them in shape and colour. Not all the flowers on a spike develop this pink hat, but no one seems to know why. 'Fancy Frills', by contrast, has extra ray petals around the base of the cone, but they are held rather untidily, curving hither and thither and varying in length; 'Pink Double Delight' produces thin, curving ray petals and a circle of lesser petals, also at the base, but in 'Razzmatazz' the whole cone turns into a hemisphere of numerous, densely packed, pink petals surrounded by an outer ring of ordinary petals. 'Razzmatazz' is therefore the most 'double' of echinaceas, though by turning the whole central cone into a mass of petals one of the essential distinguishing features of the species is sacrificed. Many new varieties of *Echinacea purpurea* have been bred and introduced in recent years, with different flower colours, shapes, heights and

branching habits; it is a plant in an active phase of horticultural development that mocks the decline of pyrethrums.

THE RARE DOUBLE-FLOWERED FORM of *Daboecia cantabrica* 'Charles Nelson' is quite different in structure from other double heathers. Instead of bursting open the corolla, the effect of doubling has been to fatten it enormously, with further corollas layered up one inside each other. Charles Nelson, the Irish plantsman who found it in the wild in County Galway, described its flowers as 'dumpy, bloated blossoms', explaining that, instead of the normal eight stamens and a style, there are numerous petal-like segments – about eight concentric whorls of them – and a mass of green filaments in the middle where the ovary should be. Yet the odd thing about this variety is that, when they first open in early summer, the flowers are usually single and perfectly formed, with eight stamens and no extra petals.

This variability occurs also among members of the daisy family. Sometimes, for example, you may read about a double-flowered form of *Catananche caerulea*, but the number of the petals is affected by physiological factors associated with growing conditions; the plants that bear double flowers one year often carry none next year. The same is true of another composite, *Argyranthemum* 'Peach Cheeks', whose flowers vary from simple singles through to anemone-centred doubles, all on the same plant. Likewise, the corn marigold, now known as *Glebionis segetum*, sometimes produces extra petals around the edge of the flower, though never from the central disc. The beautiful sky-blue flowers of the common chicory plant, *Cichorium intybus*, also vary in their petalage – look at a colony of several plants and the variation is immediately noticeable, though it does not seem a constant feature. Nor is this natural variability confined to members of the daisy family: hollyhocks such as *Alcea rosea* 'Crème de Cassis' can have singles, semi-doubles and doubles all on a single stem.

The most extraordinary example of odd behaviour among double-flowered plants is the tendency of almost all the large double clematis to produce double flowers when they first open in early summer, but nothing but single ones by August or September. The first of these large-flowered clematis hybrids started to emerge from English nurseries during the 1860s: among their more important parents were a white, semi-double variety of *Clematis patens* called 'Fortunei' and another Japanese variety called 'Standishii', also considered

a derivative of *C. patens*. But Robert Fortune's discovery in China of the blue-flowered *C. lanuginosa* stimulated the surge in clematis hybridization that followed, and it is among the progeny and remoter descendants of these Chinese and Japanese introductions that we see further evidence of inconsistency even today among clematis varieties.

It is not unknown to see a mixture of double, semi-double and single clematis flowers all on one plant at the same time: the beautiful mauve *C.* 'Louise Rowe' (1983) is one of the very few varieties that do this. But most large-flowered double clematis start off double and get more and more single as summer runs on. All the great names of the 1870s and 1880s have this weakness, from 'Countess of Lovelace' (1872), 'Duchess of Edinburgh' (1874) and 'Belle of Woking' (1888) onwards. Their flowers are huge – 12–18 cm/5–7 inches, fully double and complex in their colours and patterns when they first open in May or June, but by summer's end they are indistinguishable from single-flowered clematis. It is a tendency, almost certainly genetically determined, that turns up even among modern introductions, and to those who are not aware of the phenomenon, it can be a source of considerable puzzlement and heartache. Very few large-flowered clematis were introduced after the first batch of hybrids in the nineteenth century until after the Second World War, when breeders in England, Poland and Japan got to work again. They tended at first to use the older hybrids as parents, which meant that the well-known varieties 'Vyvyan Pennell' (1959), 'Veronica's Choice' (1973) and 'Prinsesse Alexandra' (1995) all suffer from the defect – if defect it be – of producing only single flowers after the first glorious flush. More recently, breeders have tried to select seedlings that will produce double flowers all through the season – 'Denny's Double' (1993) is as close to consistent

Most double clematis are only double in summer – the autumn flowers are single. But 'Denny's Double' produces double flowers in autumn as well.

doubleness as they get – though the performance of all clematis in cultivation varies enormously according to climate, soil, position and many other factors that gardeners find perplexing. If, for example, 'Louise Row' is planted in the sun, its flowers fade very quickly to white but if lilac-pink Josephine (1998) is planted in the shade its flowers will often be green. Double clematis are nothing if not cussed, and yet their flowers are so large, so elegant, so exquisite in their colours and shadings that one can forgive them anything. Perhaps it is best to think of them is as single-flowered plants, and judge them on their merits in autumn – and then to give thanks for their extraordinary display of double flowers in early summer.

THE WILD EUROPEAN STRAWBERRY, *Fragaria vesca*, has probably been cultivated for thousands of years and there are many delicious selections that should, if possible, be grown in every garden – 'Baron Solemacher' is perhaps the best known. Double-flowered variants have turned up from time to time, but have no value to the consumer because their fruits are usually rather small. Two remain in cultivation: 'Multiplex' and 'Muricata'. The flowers of 'Multiplex' are semi-double, with a ruff of white petals around the central disc which eventually expands to become the strawberry. The fruit, however, is very much smaller than in other strains of the alpine strawberry, and has rather a dry texture; the main sensation is of pulp and pips instead of the juicy fragrance of 'real' alpine strawberries. Nevertheless, the variety is sometimes praised by keen plantsmen and its bright green leaves make good, nearly evergreen ground cover, about 15 cm/6 inches high. Most soils and sites are suitable but light shade and reasonably moist soil are ideal. 'Muricata' is a much more eccentric variety. Its flowers seem to be composed entirely of green, leafy parts. The petals are transformed into bracts, forming a very pretty ruff, and the fruits

Fragaria vesca 'Muricata'. The Plymouth strawberry is bristly and therefore inedible, but it appeals to plantsmen as a curiosity.

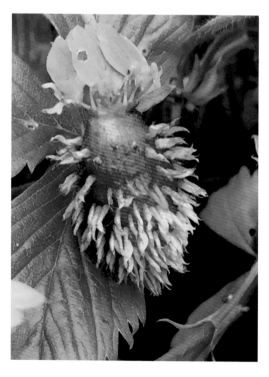

are covered in spiky green bristles rather than seeds, which make it rather disagreeable to eat. It is known as the 'Plymouth Strawberry' because it is still found in woodlands around the city of Plymouth in Devon; since it is completely sterile, its survival in the wild suggests that it is a clone of enormous vigour that has survived by propagating itself vegetatively. Nevertheless, *Fragaria vesca* 'Muricata' has a long history. John Tradescant the Elder is credited with being the first, in 1627, to appreciate its unusual construction, and it was described by Parkinson in his *Paradisi in sole paradisus terrestris* in 1629, then listed by Tradescant in his catalogue for 1634. It remained – and still remains – a curiosity, being grown by Canon Ellacombe, the great nineteenth-century plantsman, at his garden at Bitton in Gloucestershire and later by E.A. Bowles, who admitted it to his exclusive 'Lunatic Asylum'. So it is a good example of a double-flowered plant with very little ornamental value and, certainly, no commercial value to fruit growers that has nevertheless been kept in cultivation by generations of keen and curious plant lovers.

As with *Rubus spectabilis* 'Olympic Double' (see chapter 7), the double-flowered forms of brambles can transform a nonentity into an emblem of substance and beauty. Gertrude Jekyll could write as long ago as 1902 that some 'of the best plants for the open pergola are . . . double-flowered Brambles.' Typical *R. rosifolius*, for example, has flowers of about 4 cm/1½ inches across – not large, but attractive enough because the petals do not overlap; indeed, they do not even touch each other, but allow the green sepals to show through between them. In *R. r.* 'Coronarius', however, many of the stamens are converted into petaloids and create a multi-petalled white ruff around the greenish middle. The petals are often pleated and sometimes ragged at their tips, in a way that calls to mind a damask rose – roses are, after all, fairly closely related to the blackberry family. 'Coronarius' was introduced to England from Penang in 1807; as the wild form had not by then been seen in the West, it was not classified – *could* not be classified – for several years. Some double-flowered brambles are less exciting: double forms of *R. parviflorus* occur from time to time, and these are in cultivation in both Europe and North America, but they are really only semi-double and, though elegant and graceful in flower, they lack the oomph of fully double varieties. But there is one variety that has been admired by lovers of the curious for many generations: *R. ulmifolius* 'Bellidiflorus'. The species is a prickly blackberry, common in Mediterranean regions but hardy in continental climates, with small pink flowers that

are not worth a second glance. But 'Bellidiflorus' is a form with so many little strap-shaped petals – hundreds of them splaying out neatly from a greenish centre like a pink starburst, with darker pink shadows between the petals giving substance to the whole flower – that it can fairly be said indeed to resemble a double daisy, which is what 'Bellidiflorus' means. The flowers are little more than about 1 cm/½ inch across, but come in large panicles. The plant is easy to grow in any soil, and arches up as high as 3 m/10 ft. Inevitably, E.A. Bowles considered the plant demented and admitted it to his 'Lunatic Asylum'.

Rubus ulmifolius 'Bellidiflorus'. The flowers of this 'lunatic' blackberry resemble daisies and are pretty enough, but the plant is over-vigorous and does not produce fruit.

The double-flowered form of flowering currant, *Ribes sanguineum* 'Plenum', is occasionally seen, but it has little to recommend it beyond curiosity value. The flowers give the impression of a more intense colour than the single type, though there are many varieties with stronger colours in the first place. The individual flowers form a pretty rosette, but have lost the white stigmas, filaments and anthers that usually add charm and contrast to the shape of the single-flowered forms. Easy to grow, and a dependable harbinger of spring, it is nevertheless rare, even among enthusiastic collectors of botanical oddities.

The double-flowered form of the common European elder, *Sambucus nigra* 'Plena', is a curiosity that might have slightly more value than at first supposed. There is nothing to distinguish it, when seen from afar, from the common elder, now a shrubby weed in much of the world. Close up, however, the differences are very marked. It becomes clear that the stamens have been converted into extra petaloids and completely cover the central stigma (which is still there underneath). This gives it a slightly brighter, denser, cleaner overall look than the type. Only very rarely does it set a few fruits, but the presence of extra petals makes the flowers valuable for syrups and cordials – fewer are needed, though elderflowers of any sort are seldom in short supply. And it is said to have a stronger scent than the wild, single form. But it remains a curiosity and cannot compete in horticultural value with the many *Sambucus* varieties that have interestingly

shaped and coloured foliage – some of the purple-leaved ones even have pink flowers, which make a very pretty pink cordial. Breeders have been working to produce many better varieties in recent years and it can only be a matter of time before we see a purple-leaved elder with double, pink flowers. All elders are easy to grow in any soil and most climates, quickly reaching 3 m/10 ft in height and spread.

Two further curiosities of this kind are the double form of bird cherry, *Prunus padus* 'Plena', whose flowers are only semi-double and have to be looked at closely before the extra petals are apparent, and the double blackthorn or sloe, *P. spinosa* 'Plena', which is a better garden plant partly because, like the species, it flowers heavily, and partly because its extra petals give the whole flower much more substance. Wild blackthorn has narrow petals which are not wide enough to overlap or even for their edges to meet and touch each other, but the double form has a continuous circle of petals, two or three rows deep, which form a charming background for the long anthers. Neither the bird cherry nor the sloe is often seen, even in the gardens of keen plantsmen, who tend to prefer other selections such as the purple-leaved sloe, *P. spinosa* 'Purpurea', and the pink-flowered bird cherry, *P. padus* 'Colorata'. Both species, though very different, are hardy natives of much of Europe and easy to grow in any soil; *P. spinosa* makes a thorny bush 4 m/13 feet high, while the thornless *P. padus* will reach at least three times that height.

SOME WILD PLANTS PRODUCE an unusually high proportion of double flowers within any given population. The cuckoo flower, *Cardamine pratensis*, is a case in point: if you walk through a damp meadow in spring in many parts of Europe – and the species is also naturalized in North America – you may see considerable variation in the size, colour and doubleness of individual plants. Other populations, however, remain uniformly single. There is no apparent explanation for this, though it does seem that the species is evolving quite fast and that different forms already have different numbers of chromosomes. The best have for centuries been propagated and offered by nurserymen – 'Edith' is a double pink, while 'William' is darker and also double, and the ordinary 'Flore Pleno' is not to be despised.

Many plant lovers keep an eye out for unusual wild plants, and a woodland full of snowdrops in winter, or of wood anemones or trilliums in spring, is an invitation to look for larger forms, colour

variations, odd shapes – and doubles. Their chances of survival
in the wild are slight, but the pleasure that their discovery, study
and conservation in cultivation give to the plantsman is immense.
Celandines – *Ficaria verna* – are fertile hunting ground for spotters
of the unusual. In some ways, the simple, golden celandines are
also the perfect garden plant, because they appear very early in
the year and open brightly in the sun; then, by late spring, they die
back and disappear, not to be seen again until next year. Gardeners
everywhere regard them as weeds, which seems a poor way to treat
a plant that gives so much colour under the blue skies of March
and never competes for space with plants that might be considered
more important. But plant spotters have discovered many charming
variants among celandines that they have dug up, preserved,
multiplied and introduced to our gardens as named varieties. As long
ago as 1665, the plantsman and nurseryman John Rea told of finding
a double-flowered variety of *Ficaria verna* in a field and distributing it.
F. v. 'Collarette' is one of the neatest, because all its stamens have been
transmuted into overlapping little petaloids that form a neat circle
around the green centre and contrast with the sepals behind. It is one
of the prettiest of all spring flowers and sterile, too, which means that
gardeners need not fear that its seedlings will spread and take over
their gardens. Other double forms, including *F. v.* Flore Pleno Group
and 'Double Bronze', just have a much larger number of strap-shaped
petaloids than the wild types, but with a few stamens that do not

Ficaria verna
'Collarette' is
an anemone-
shaped form of
the common
celandine. It is
a dependable
garden plant and
has the advantage
of not seeding
itself around.

convert into petaloids and remain instead at the centre of the flower. These forms, and others, often resemble a daisy or a pompon rather than the anemone shape of 'Collarette'. The sepals of celandines have the shiny glazed surface seen in many members of the buttercup family, especially within *Ranunculus* itself, but the sepal backs are variously coloured too, ranging from green and grey to brown. Some of the double-flowered forms are especially attractive when the flowers are only half open and the sepal backs can be admired for their colours; the sepals of 'Double Mud', for example, are brown and curl over like a globe artichoke. But strangest of all is 'Green Petal', where every part of the flower has been transmuted into a leafy structure – sepals, stamens and stigma all appearing as loosely held, green petaloids, often twisted in shape, though with a yellow base and stalk. At its best, it is a charming muddle of green petals; at its worst, just weird.

Probably the widest range of floral oddities is to be found among our native primroses, cowslips and their hybrids. Hose-in-hose forms, leafy sepals and straightforward doubles abound – and not only are they strange and fascinating to examine but they are, without exception, beautiful. New varieties may be grown from seeds, but there are also many double primroses, both ancient and modern, which are sold as plants with cultivar names. The most immediately engaging are the hose-in-hose primroses and polyanthus, in which the sepals are replaced by petals, so that the flower seems to emerge

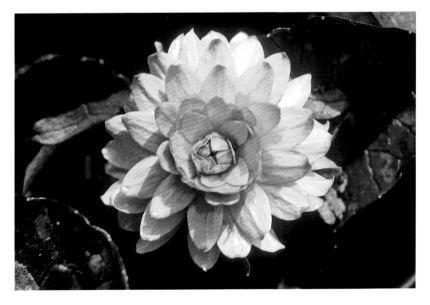

All members of the *Ficaria verna* Flore Pleno Group are very good early-spring-flowering garden plants.

not from a green calyx but from another flower. The petal-like sepals are exactly the same colour as the real petals, which immediately doubles their flower power in the garden. Variations are classified under such charming seventeenth-century names as 'jackanapes', 'galligaskins' and 'pantaloons'. Jack-in-the-greens are not double, but every flower is subtended by foliolate sepals – in other words, every primula flower is backed by five little leaf-like structures forming a ruff beneath. All are normally sold as seed strains, of which the best known come from the long-established breeders Barnhaven. Good varieties are named and promoted from time to time, but they tend to fade from commerce after a few years, though a hose-in-hose form of *P. elatior* is not infrequently encountered and, rather more often, a hose-in-hose form of 'Wanda', an old *P. × juliana* cross.

Double primroses (see also chapter 3) have been grown by curious gardeners for several centuries, though their popularity waxes and wanes. Jason Hill (1932) wrote that double primroses 'have a distinct character, perhaps because double flowers in their particular range of cool, fresh colours are rather rare' but, quite apart from the range, they appeal because they are old-fashioned garden plants – their charm evokes the cottage gardens of Olde England. There was another revival of interest in them in the 1980s, but later (partly because large-scale growers considered their cultivation too labour-intensive in terms of feeding, watering and dividing) they were less frequently to be seen and went out of fashion again. There was another complication, which was that many of the old varieties seem to tolerate disease, and perhaps also to carry it, whereas the flood of wonderful new double varieties introduced in the 1980s had no resistance to it. The virus made no difference to the appearance or vigour of the varieties that tolerated it, but weakened and killed off those that did not. Nowadays the modern varieties are micropropagated, while the older ones are cultivated in the traditional manner. This means that they need to be split frequently and replanted in fresh soil in a different position; otherwise they start to look thin and dwindle and finally disappear. Scientists have not yet found a reason for this phenomenon, but it also affects polyanthus and was responsible for the disappearance of the famous 'Persian Carpet' planting of polyanthus in the nuttery at Sissinghurst.

Double primroses are sterile, because all the sexual parts of the flower are converted into petals, and the gene that produces doubleness is a simple recessive. This means that the only way to

raise double primroses from seed is to cross two single-flowered plants that are known to carry the gene for doubling; it also means that, in accordance with Mendelian principles, only 25 per cent of the resultant seedlings will be double. The double primroses that are widely found in catalogues and garden centres, where they are very hard to resist, are modern introductions, often from Barnhaven seed, and are thought to fill a gap in the market that the older varieties cannot satisfy. Many are propagated by tissue culture and sell in tens of thousands every year. It might be said that they have a 'modern' look about them in the same way that Floribunda roses look modern while Gallicas do not – it is not so much a question of shape or flowering but of colour. These modern double primroses often derive their colours from the best modern single-flowered strains, and these have a range and sophistication that was never present in the genuinely old varieties.

Primula Belarina Amethyst Ice is typical of the best modern double primroses micropropagated for mass sales.

The popularity of primroses, cowslips and their highly bred descendants has resulted in many different strains that are recognized as distinct types. Polyanthus are perhaps the most ubiquitous and, since all the fertile *Primula* species and hybrids are very free with their pollen, a large number of hybrids have arisen that carry the characteristics of more than one strain. Double-flowered polyanthus have been known for about three hundred years, and were bred by Cockers of Aberdeen in the 1890s: 'Bon Accord Purple' is still available commercially. They are more weather-resistant than double primroses; the stout single stem of a polyanthus helps rain to drain away. Another popular type is the 'gold-laced' polyanthus, known since at least the seventeenth century, which is actually a form of cowslip, *Primula veris*, with no apparent input from other species in its ancestry. Gold-laced primulas are very dark coloured – maroon, almost black – but the edges of the petals are tricked out with gold piping and make an elegant contrast. Nowadays, several double-flowered forms of gold-laced primulas are available: 'Elizabeth Killelay' is perhaps the best known, with 2 cm/¾ inch wide flowers of a colour combination and pattern that are, intriguingly, both opulent and prim, but whether the combination of two special

formats, doubling *and* gold-lacing, is really an improvement on either of them is at least a question worth asking.

All these double primroses, cowslips and polyanthus benefit from frequent lifting, division and replanting in fresh soil to maintain their vigour. 'Frequent' means at least once a year, but some growers will tell you that they are best when split twice a year, once immediately after flowering and then again in autumn. Odd, quirky and sometimes hard to please they may be, but they are also among the most heart-lifting of all garden plants.

The double-flowered lesser bindweed, *Calystegia hederacea* 'Flore Pleno', is worth serious consideration by keen gardeners. Anyone who has weeded a summer border will know the single-flowered form and wonder, perhaps, whether the double-flowered form is better behaved. The answer is that it needs to be planted where it can be trained to ramble, twine or climb up whatever the owner wishes, rather than finding its way inextricably into the roots of herbaceous plants from which it proves impossible to eradicate. And it is also worth thinking how pretty are the flowers of the wild single form – delicately pink, trumpet-shaped bells. In the double form, sometimes sold as 'Pink Sensation', the extra petals break open the corolla. Though sometimes slightly tousled in appearance, the flowers open out neatly and appear darker in colour than those of the single form – this is the effect of dark pink shadows forming between the petals. Suddenly, this noxious weed becomes a desirable plant but, yes, it is just as invasive as the single form.

Most people know of the genus *Ipomoea* as blue, trumpet-shaped flowers nicknamed Morning Glory. In cool climates they are grown as summer annuals, but in frost-free climates (including much of the Mediterranean) they will flower through most of the winter, too. The flowers last for less than a day, opening their spiral-shaped buds in the morning and closing up forever in late afternoon. Few flowers of this size (they may measure as much as 8 cm/3 inches in diameter) have such thin and delicate petals. All five petals have prominent midribs, often of a slightly different colour, which help to guide pollinators to the centre but, of course, the petals are not separate structures but fused together into one beautiful funnel-shaped corolla. And it is that delicate trumpet of blue, translucent in the sunlight, that is the chief joy and value of the plant. It is therefore fair to consider whether a double-flowered Morning Glory could be better in any way than the single form. If they had a hose-in-hose structure,

they could be attractive. If their extra petals were like a double-flowered calystegia's, giving the flower a ruffled centre and a new depth of colour, that too might be acceptable. Alas, the double forms of *Ipomoea* seen today (but they are few and rare) are at best peculiar and at worst downright hideous. Their elegant corollas are broken, twisted and warped, so that the flowers look as if they are dying even before they have opened. But they have their devotees, and especially in Japan, where unusual mutations often have a following among plant lovers, though it is hard to know whether such aberrations are considered beautiful or merely curious. For many plantsmen, of course, all curiosities are beautiful.

LILIES AND OTHER MEMBERS of the lily family are important plants, both for the cut-flower trade and in the garden. The remarkable beauty of modern double-flowered lily varieties is celebrated in chapter 4, but some of the older double forms are better regarded as curiosities. Double forms of the best-known species have been grown for centuries. The double form of the Madonna lily, *Lilium candidum* 'Plenum', was known in the seventeenth century and popular by the early eighteenth. The ovary and style at the centre of the flower are replaced by an elongated protuberance with lots of small curved petals – and the scent is minimal. 'Curious but not beautiful' was the verdict of the American horticulturist Joseph Breck in 1858; Gertrude Jekyll concurred: 'a wretched, misshapen thing not worth growing', she commented. She had a better opinion, however, of the double tiger lily, *L. lancifolium* (syn. *L. tigrinum*) 'Flore Pleno', which she described as 'about the only Lily that we have in a good double form'. In this species, the doubling is confined to a few extra petals at the centre of the flower – the real petals reflex prettily and are substantial structures. The flowers are a gentle tangerine colouring overall, with very dark stems and petals of palest apricot when the buds are

Lilium lancifolium 'Flore Pleno' was the only double lily of which Gertrude Jekyll approved. It is, however, scentless.

just opening. It does not set seed (actually, it is triploid, which may suggest that it is a hybrid) but produces dark bulbils in its leaf axils from which new plants are easy to propagate. It looks very handsome when grown in pots.

Double forms of the closely related *Fritillaria* turn up from time to time and John Loudon was growing more than one double form of *F. meleagris* in 1829. The double-flowered form of *F. camschatcensis* sometimes known as 'Multiflora' loses the elegant pendulous bell that characterizes most fritillaries and sports a few extra petals that give it a hose-in-hose effect before the flower opens out to become a messy eruption of little petaloid segments. Double-flowered forms of the crown imperial are occasionally seen but *F. imperialis* 'Prolifera' (syn. 'Crown upon Crown') has two tiers of flowers, which is seldom as exciting as one hopes: the stem goes on growing from the middle of the wreath of leaves that normally tops the flowers and forms a second crown, complete with green topknot, above it. But the second circle of flowers struggles to grow enough above the first and the usual result is more of a congested oddity than a glorious bonus.

Considering their popularity among gardeners, there are few double flowers among the many varieties of *Hosta*. The best is a double form of *H. plantaginea* called 'Aphrodite', whose white flowers are prettily arranged and scented, too. They transform a hosta that is usually grown for its ornamental leaves into a first-class flowering plant. Double-flowered *Agapanthus* varieties do exist, but are of variable quality. Most commonly seen is *A. praecox* 'Flore Pleno', known in Europe since the 1870s but not such a good plant as the single type. Its flowers tend to hang down under the weight of their extra petals and, in rainy weather, fill up with water that spoils them. *A. praecox* 'Two Times Blue' is a paler colour but also too heavy for its stems, while the only double form of snowflake, *Leucojum vernum* 'Gertrude Wister', is not really double at all but just has a few extra petals.

There are, however, some good double *Muscari* varieties. The typical narrow-mouthed bell shape of *M. armeniacum* is replaced in the variety called 'Blue Spike' by an open rosette of petals. The inflorescence is broader than single-flowered grape hyacinths but the overall effect is attractive – a rare example among liliaceous plants of a doubling that is both curious and pretty. *M. armeniacum* 'Fantasy Creation' is rather lumpier, once likened (in an RHS trial) to 'a miniature purple sprouting broccoli'. And, though not strictly double-flowered,

Muscari comosum 'Plumosum'. In this fluffy, feathery form of grape hyacinth, all the petals are transmuted into filaments.

M. comosum 'Plumosum' has an aberration that gives it an elegant, feathery effect. Instead of bearing petals – there are none – the whole flowering spike is covered in airy branching filaments, as strange and curious in construction as can be imagined.

Trillium grandiflorum occurs as a wild plant over a very wide area of North America and is the most popular and widely grown species in gardens, so it is not surprising that several double-flowered varieties have from time to time been spotted and introduced. *T. grandiflorum* 'Flore Pleno' is the best and most widely available. Its flowers are large (up to 7 cm/nearly 3 inches across) and all the more substantial for their extra petals, which are sometimes prettily ordered in a series of ever-smaller overlays and sometimes in a rather more disorganized arrangement. It relishes exactly the same sort of conditions as typical *Trillium grandiflorum* and will flourish in light shade (trilliums are natural woodlanders) and grow to about 40 cm/15 inches in height, flowering just as the trees above break into leaf.

Double flowers are quite rare among the *Iridaceae*, members of the iris family, though a few exist in the genus *Iris* itself (see chapter 4). Crocuses are no less popular as garden plants, yet no double-flowered crocus is known to exist. They turn up as oddities very occasionally, but usually as the result of some sort of physiological damage to the corm; the flowers are found to be single when they bloom the following year. Indeed, a double-flowered crocus in a batch of bought corms may indicate that the plant was not grown in cultivation but collected in the wild. But autumn-flowering crocus, as most gardeners know, are often confused with colchicums, which, despite their superficial similarities, are much closer botanically to lilies than to irises. Double flowers are more commonly found among *Colchicum* and some of the double varieties are very beautiful. Others are not. One Scottish nurserywoman used to refer to *C. autumnale* 'Alboplenum' as 'old bones' and she had a point – the colour of this double-flowered form is not a pure white, but has a slightly sickly

Colchicum 'Waterlily' is a spectacular bulb that flowers late in the year. Its heavy flowers are best supported by low-growing herbaceous plants.

yellow tinge in the bud. When it opens out, however, it is a fine flower, with narrow, strap-like petals, somewhat irregularly arranged. The pink-flowered *C. autumnale* 'Pleniflorum' is less macabre and sparkles in the sun when it opens out completely, though its petals are all of different lengths. But best of all is a hybrid of unknown origin called *Colchicum* 'Waterlily', one of the largest of all colchicums, whose name describes its flowers well. Double-flowered colchicums need to be grown among low herbaceous plants that will help to support their heavy flowers; they tend to keel over in wind and rain, and the heavy flowers of 'Waterlily' are particularly susceptible. They are best planted in semi-wild positions where they can be supported by long grass or short herbaceous plants.

WHEN NEW PLANTS – new to the West – started to come out of China in the late 1700s, and from Japan after 1854, it was not always apparent to Western botanists that some were cultivated forms rather than species; *Camellia reticulata* was first known from the variety 'Captain Rawes' and *Rosa chinensis* from 'Slater's Crimson'. Not for many years (over two hundred in the case of *Rosa chinensis*) was the original wild species rediscovered and properly described. There is, however, one double-flowered plant for which the original species

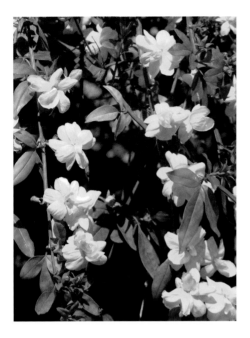

ABOVE
Jasminum mesnyi
with its hose-in-
hose flowers comes
from south-west
China. A single-
flowered form has
never been found.

OVERLEAF
Clematis florida
var. *sieboldiana* is
a spectacular late
summer flowerer.
Sometimes its
flowers revert
or mutate to
resemble the green
and white cultivar
known as *C. florida*
'Flore Pleno'. No
one knows why.

has never been found – *Jasminum mesnyi*, a handsome scrambling shrub from south-west China, first introduced to the West in 1901. Its buttercup-yellow flowers are up to 5 cm/ 2 inches in diameter and usually only semi-double, but they have a hose-in-hose structure like some primroses and azaleas except that they seem never to set seed, even though the flower usually has stamens. In some ways it resembles a large-flowered selection of the well-known winter jasmine, *J. nudiflorum*, but there are too many differences for it to be accepted as a cultivar of that much hardier species. So it remains something of an oddity – a mystery as yet unsolved.

Among the many native plants cultivated by Chinese and Japanese gardeners before they were seen in the West is *Clematis florida*. It was never developed in the way that European nurserymen worked with other *Clematis* species from about 1850 onwards, but the first form of it to arrive in the West was *C. florida* 'Flore Pleno', greenish white and very double, sent from China by Carl Thunberg in 1776. It has a very large number of sepals and petaloids, all neatly arranged and ranging from white on the edges to green towards the centre. Even more extraordinary are the flowers of *C. f.* var. *sieboldiana*, introduced by Siebold in 1836, which have a dome of bright purple petaloid stamens and creamy white sepals. The stamens, which are slightly reminiscent of the passion flower, tend to remain for a week or so after the white outer sepals have fallen and, as with 'Flore Pleno', the flowers are unusually long-lasting. But the strangest feature is that shoots of *sieboldiana* sometimes bear flowers that resemble 'Flore Pleno' while, more especially in the autumn, the flowers of 'Flore Pleno' produce the purple stamens of *C. f.* var. *sieboldiana*. The two varieties are clearly closely related, but it is not clear which came first or which was originally a sport of the other. Either way, both continue to be grown, and are still deservedly popular today.

The fully double tree and herbaceous peonies are completely irresistible to those with the horticultural version of a sweet tooth.

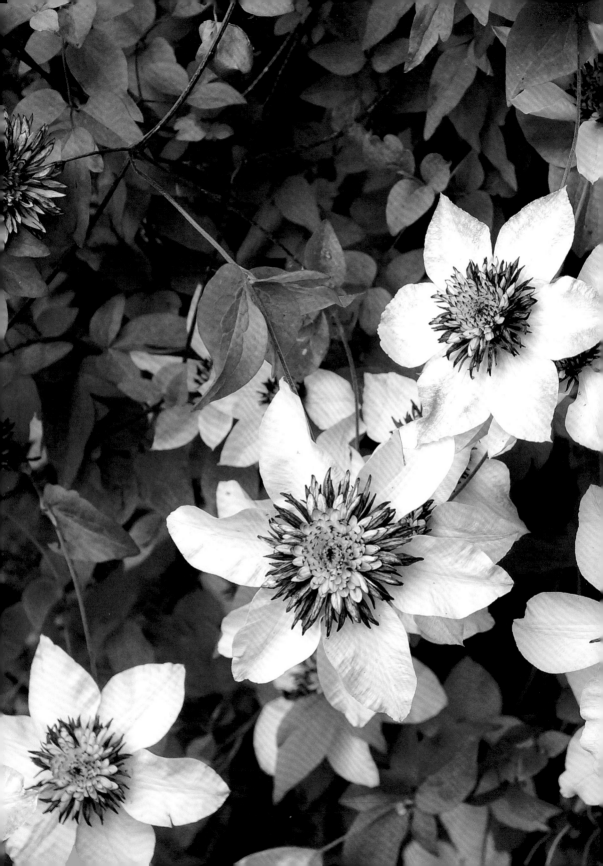

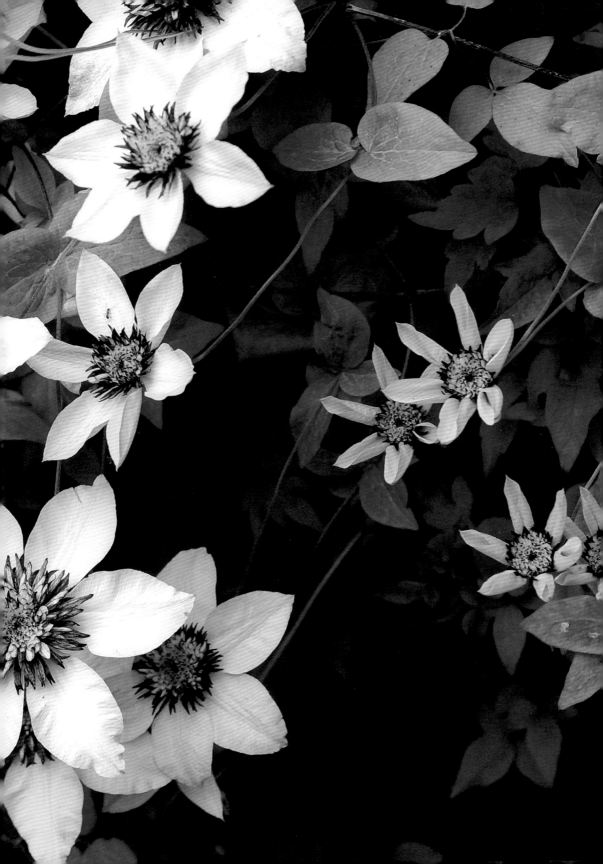

However, the tree peonies somehow manage to have presence, even when potentially vulgar, because of the combination of their extra petals and their huge size. Graham Stuart Thomas summed up their charm succinctly when he described them as 'at once sumptuous and subtle'. The degrees of doubleness are fairly strictly defined. The least double peonies are described as Japanese in style and have large anthers and broadened filaments. If the anthers and their filaments are massed around the carpel as a circle of small petaloids, often making a dramatic contrast, then the form is known as 'anemone type'. Next up the scale of doubleness comes the semi-doubles, some of whose filaments have turned into petaloids. Then comes the 'bomb' type of flower, whose petaloids are developments of both the stamens and the carpels, but are clearly still different from the outer guard petals. And finally, there are the fully double peonies in which all the stamens and carpels have changed into broad petals indistinguishable from the guard petals.

Flowers do not come more rare than some of the double-flowered tree peonies. The first forms of *P. suffruticosa*, the shrubby 'Moutan' peony, to reach the West from China were all double-flowered. One of the most persistent problems with these, perhaps the most beautiful of all peonies, is that they are not easy to cultivate. For nearly two hundred years, named varieties of *P. suffruticosa* from China or Japan have been exported to Europe or North America, but failed to survive. Even today, when one looks at the catalogues of what is on sale, there are almost no names that were in similar lists twenty years ago, and every seller seems to offer different varieties, so that none is sufficiently widely known and grown to be recommended as dependable everywhere in cultivation.

Chinese gardeners raised many double-flowered crosses between *Paeonia suffruticosa* varieties and the single-flowered yellow *P. lutea* tree peony, and these are known in the West as *P. × lemoinei* hybrids, because they were first sold by Lemoine of Nancy in about 1900. It is not clear, however, which ones (if any) were actually raised in France rather than being imported from China. A few have proved to be more persistent in gardens than the *P. suffruticosa* forms. Most widely available of these hybrids is *P. × lemoinei* 'Souvenir de Maxime Cornu' (syn. 'Kinkaku'), which has huge, deep yellow flowers with not-very-subtle red edges to the petals, and is also deliciously fragrant. So far as varieties of *P. suffruticosa* are concerned, the most widely available at the moment are 'Godaishu' (large and white, with prominent

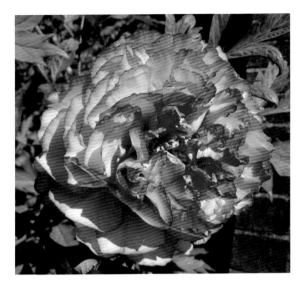

Paeonia x *lemoinei* 'Souvenir de Maxime Cornu' is an old Chinese hybrid that has proved itself much easier to cultivate than most tree peonies.

yellow stamens), 'Taiyo' (deep pink and semi-double) and 'Yachiyo-tsubaki' (with coral pink flowers and bronze-purple young leaves). But whether any of them will still be available in ten years' time is a fair question to ask. There are many reasons why plants are rare in gardens, but difficulty of cultivation is not often one of them; the beautiful tree peonies may be the exceptions that prove the rule.

THE PHENOMENON WHEREBY petals and other parts of flowering plants become leafy and capable of photosynthesis, giving a green appearance to the flower, is called phyllody. It occurs as an occasional aberration in many different plants, but it is not common as a permanent attribute. *Adonis multiflora* 'Sandanzaki' is one of the best examples of how phyllody can add both beauty and interest to an already beautiful flower. *Adonis* species belong to the buttercup family but are characterized by flowering very early in spring and by carrying very finely divided leaves; the contrast between the boldness of their flowers and the daintiness of their foliage is one of their great charms. *Adonis multiflora* has a bright yellow flower which normally has between ten and twenty sepals that operate like petals; they have the shiny reflective sheen of buttercups, plus a touch of green and brown on their backs. The variety called 'Sandanzaki' is rather more double, because all the stamens are converted into narrow, green petaloids, forming a green circle that contrasts with the yellow of the sepals. Other *Adonis* species have also produced double-flowered forms: the semi-double flowers of *Adonis* 'Fukujukai' open from bronzy buds, surrounded by a ruff of feathery leaves, and look more substantial than the single forms. No one could deny that the single-flowered forms of *Adonis* are among the most brilliant and breathtaking harbingers of spring (they look good with early tulips like *T. greigii*), but Margery Fish was not alone in saying that the double forms are even more beautiful.

Another member of the Ranunculaceae, the buttercup family, that exhibits the phenomenon of phyllody is *Anemonella thalictroides* 'Green

Hurricane'. Its sepals, normally white and petal-like, are converted into green bracts, while the flower's centre displays a whirl of green styles surrounded by spatula-shaped stamens that are coloured both green and white. The whole arrangement is curly and skew-whiff, which adds considerably to its curiosity value.

Herbaceous plantains – *Plantago major* – are a serious weed of lawns and have been carried to every continent where Europeans have settled, but there is a form called 'Rosularis' which is a delight to most gardeners who know it, and especially to plantsmen. Colour-conscious designers and gardeners love its stylish outline and its ease of cultivation. Flower arrangers use its green flowers to give bulk to their compositions. It is hard to imagine how this can be, since the normal inflorescence of a typical plantain is a thin, green rat's tail of no merit or interest whatsoever. Close examination, however, reveals that each tiny flower on the spike as a whole is underscored by an equally tiny green bract. In the form 'Rosularis', these bracts grow much larger than normal, and keep on growing until each resembles a rounded leafy 'petal' underneath the flower. The mutation has another feature, which is that the flower spike is shorter – so short (15 cm/6 inches) that it is compressed into a whorl of leafy bracts and ends up looking rather like a neat green rose – hence the name 'Rosularis'. And, finally, the bracts have the effect of closing off the tiny flowers so that pollen cannot get in or out and the plant has no option but to pollinate itself. Seedlings of *Plantago major* 'Rosularis' therefore come true, which explains why the aberrant plant known to Gerard in the 1590s (and probably for many years previously) is still widely grown and admired today. And a bonus for gardeners is that it does not seed itself about too carelessly.

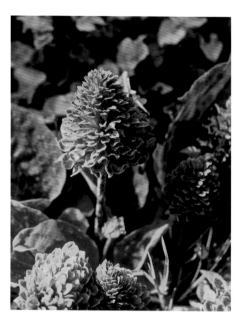

Plantago major 'Rosularis' is a real plantsman's plant, much loved for its green architectural structure but botanically no more than a form of the greater plantain.

One of the best examples of phyllody is *Rosa chinensis* 'Viridiflora', the Green Rose. Every part of its flowers – the petals, anthers and styles – are strangely transmogrified into green, leafy structures. 'Viridiflora' is actually a sport that occurred in the 1830s of the ancient pink 'Old Blush', probably the world's most popular China rose even today, but the mutated form has no colour except green. Then, after it has

opened out, it acquires some bronzy tints, especially at the tips of what one might imagine to be its petals were they not so hard and green and un-petal-like. The flowers of 'Old Blush' open out quite fully, die and drop their petals in the normal way, but 'Viridiflora' remains on the bush for many weeks without changing. And, since 'Old Blush' flowers almost continuously – right through the winter months in warm climates – so too does 'Viridiflora'. It is hard to imagine that just one mutation could have had such a far-reaching effect on the appearance of a flower, and yet the change to the plant's DNA is so minute that scientists have not yet been able to isolate the gene responsible. Apart from its flowers, 'Viridiflora' is still 'Old Blush' – it has the same leaves, the same prickles, the same hardiness and the same vigorous branching habit. It is easy to grow, and especially in a warm situation, where it will reach 80 cm/2½ ft. The human eye treats green as a recessive colour, which means that we tend to discount the leaves of a plant and describe its colour by reference to its flowers, so 'Viridiflora' is not conspicuous from a distance. But its flowers look wonderful when surrounded by the brilliant, silvery, feathery leaves of *Artemisia* 'Powis Castle' and are always a talking point when cut for the house.

There is a phenomenon that sometimes occurs in cultivated roses called 'proliferation'. It is not exactly a doubling of the petals, because it first appears as a growth coming up through the middle of the

Rosa chinensis 'Viridiflora', the Green Rose, and the only rose that is truly green. All its floral parts have become green and leafy, so it remains handsome for many weeks both on the bush and as a cut flower.

flower. The stigma and carpel at the centre are replaced by what appears to be another flower stalk, with a second flower-bud growing out of what should be the centre of the flower. Most authorities treat it as an aberration but it does seem that some varieties are genetically wired to produce proliferous flowers or, at least, have a tendency to do so. One of the oldest examples is a Gallica rose known as 'Prolifère', which was first introduced in about 1760. Proliferation is also quite commonly seen in the elegant 'Spray Cécile Brünner', and on 'Madame Isaac Péreire', a fat Bourbon rose famed for its sweet scent. Proliferation in 'Madame Isaac Péreire' usually affects only the first flush of roses, leading some to conclude that the phenomenon has a physiological cause like cold temperatures at the time when buds are forming. However, few other Bourbon roses are affected by it, except 'Madame Ernest Calvat', a paler pink sport of none other than 'Madame Isaac Péreire', which suggests that some roses, if only a few of them, have a genetic predisposition towards proliferation. But it seldom affects the whole bush, and usually appears quite randomly – only on a few of the flowers. Nor does it always return next year so that, in the case of most rose varieties, proliferation is a one-off occurrence. Nevertheless, the phenomenon, when it does make an appearance, is an intriguing curiosity, interesting rather than beautiful.

Rosa Exciting. A novelty such as this – it has gross exserted carpels – can prove quite a money-spinner as a cut flower.

Another aberration sometimes arises when the carpel of a rose and often the stamens are much enlarged, appearing as a large green disc. The petals that surround it are often shorter than normal. Usually this form of proliferation is rather disagreeable to look at, but there are occasions when it gives the centre of the rose an encrusted, jewel-like appearance which is attractive, though far removed from conventional expectations of what a rose should look like. Heredity is much less of a factor in these cases, and usually there is a ready physiological explanation for the abnormality. That said, the leading French rose breeders Meilland (who gave us 'Peace', properly known as 'Madame A. Meilland', in 1945) have bred a stable cultivar that can be relied upon to carry conspicuous exserted green carpels even under glasshouse conditions. It is called Exciting, and is a long-stemmed orange-vermilion rose for florists, strictly a cut-flower speciality. It is popular in Japan.

Proliferation occurs in other plants, and can sometimes be stabilized as a seed strain, which presupposes that this unusual flower form may in some cases be an inherited characteristic. *Bellis perennis*

'Prolifera', the hen-and-chickens daisy, is a stable form of the European lawn daisy. It has a central flower (actually a mass of tiny flowers, since daisies are composites) with quite a number of much smaller daisies (the 'chickens') arising from the edge, usually alongside the ray florets. Sometimes a chick or two starts to grow from the central disc florets or from a leaf axil, and sometimes the hen itself is double, but each chick has its own little stalk and any number from five to twelve of them surround the hen. The flower as a whole is much larger than normal, and thus more conspicuous, but nevertheless the overall effect is not exactly spectacular. Nor is it particularly attractive – or unattractive, come to that. It is just a curiosity, an oddity that intrigues for a minute or two and is then forgotten. And, in order to keep it growing and flowering vigorously, it needs to be divided annually and moved to fresh soil.

The proliferating form of common marigold, *Calendula officinalis* var. *prolifera*, has the same structure as the daisy. The subsidiary flowers on this plant, sometimes called the hen-and-chickens marigold, have short stalks that emerge from beneath the 'hen' and sometimes from within the flower too. It is perhaps not quite such a satisfactory plant as the hen-and-chickens daisy because it tends to have fewer chickens (though this varies) and has a slightly scrawny overall appearance. Though an annual, it is an old plant, and was known to Gerard at the end of the sixteenth century, but in modern times it has been taken up by Japanese plant breeders, always interested in unusual forms and varieties, and is now widely grown in Japan as a cut flower.

The opium poppy 'Hen and Chicks' provides another example of an unusual mutation. The flowers of 'Hen and Chicks' are single and lilac like typical *Papaver somniferum*, but when the seed capsules develop, some of the stamens turn into mini-capsules. In a good example, these little capsules surround the large central capsule completely and resemble a mother hen with her brood of chicks nestling all around her. The effect is charming, and amusing, and the curious shape of the whole capsule makes 'Hen and Chicks' highly valued for dried-flower arrangements.

All these forms of common garden plants – the daisy, the marigold and the poppy – are just as easy to grow as the original types, which they resemble in every other respect (height, leaves, habit of growth), apart from their hen-and-chickens flowers.

HELLEBORES ARE AT PRESENT in a very active state of development. They are one of those flowers that, being fashionable, are currently hybridized and improved on a large scale by nurserymen (and, to an extent, by amateurs too) all over those parts of the world where they will grow. The main focus is upon *H. orientalis* and its descendants, which are lumped together under the name *Helleborus × hybridus*. Hellebores are easy to grow; they tolerate shade and clump up like other perennials. Their flowers are borne in winter and spring in a wide range of colours, including white, green, yellow, pink and purple. Spotted forms are highly prized, as are those that hold their flowers up to the light instead of hanging their heads modestly.

Double hellebores with extra sepals last for many weeks in early spring.

Hellebores are members of the buttercup family, and their 'petals' are really the sepals. The flowers no longer carry real petals, because they have evolved into nectaries. 'Double' forms arise when the nectaries change back to petals; anemone-centred forms occur when the nectaries are only slightly enlarged. In fact, the situation is more complex than this, because there are doubles that have twice the number of sepals as the species *and* keep their nectaries intact. And, as well as changing form, the nectaries can become more conspicuously coloured, thereby adding to the decorative quality of the flowers. A few picotee-edged or dark-veined doubles have also appeared. Such is the demand for hellebores that some have been commercially micropropagated. In the course of micropropagation a double-flowered form of *H. niger*, like some double-flowered hostas, may produce triple and quadruple flowers, which suggests either that slight genetic changes may take place during micropropagation or that doubling is partially caused by environmental factors. The latter hypothesis is bolstered by the discovery that, like some clematis hybrids (*Clematis* and *Helleborus* both belong to the buttercup family), some strains of hellebores produce doubles and semi-doubles early in the season but single flowers later. In fact, they may even have double, semi-double and single flowers all together on the plant at the same time.

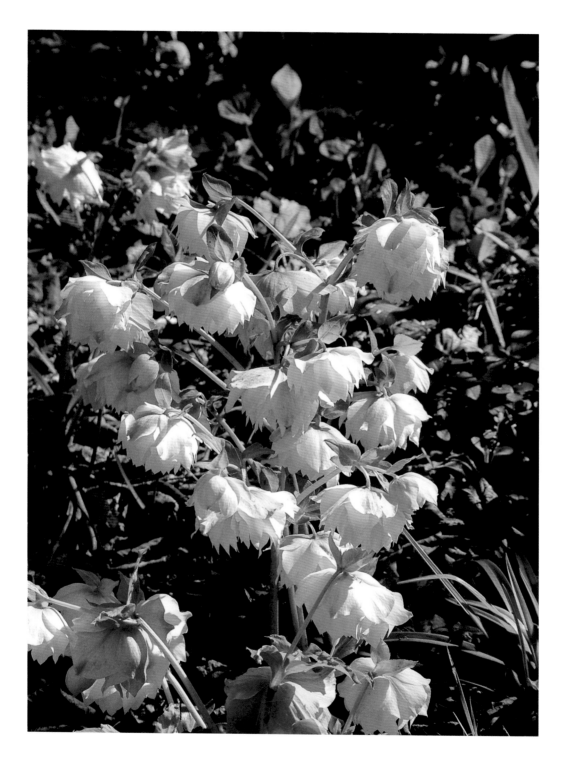

If hellebores are grown in such numbers, and demand for them is so strong that nurserymen resort to micropropagation, why are they placed in this chapter about 'Rare and Curious' plants? The answer is that named varieties are very few, and almost all hellebores are sold as unnamed seedlings. It follows that no two plants are ever exactly the same. Visit a nursery in spring, when hellebores are offered for sale as flowering plants, and you will see fellow gardeners carefully assessing each plant and evaluating the formation of its flowers before deciding which, if any, to acquire. Be that as it may, double forms have been found in the wild from time to time, and it is generally accepted that the first person to propagate and sell double hellebores was the English nurserywoman Elizabeth Strangman after her discovery in the wild in 1971 of two double forms of *H. torquatus*. She named them 'Dido' and 'Aeneas'. Spare a thought for these ancient lovers: almost all today's double hellebores are their descendants.

These unnamed hellebore seedlings, each of them unique, are usually sold as plants from well-known seed strains. The leading ones include the Party Dress Group, the Heronswood Doubles, the Ashwood Hybrids and the Harvington Doubles; taken together, these account for most of the double hellebores sold today. A few individual varieties have been named, micropropagated and sold on a wide scale, most notably 'Mrs Betty Ranicar', which was discovered in a Tasmanian garden and has almost pure white 'petals' with some green shading, and pink-flowered 'Tutu', which is an anemone-centred selection (and perhaps not the most exciting of plants). It is also worth looking out for the German-raised 'Günther Jürgl', which, instead of nodding its head, holds its flowers upwards and outwards. Meeting it for the first time can be rather a startling experience, but upward-facing singles have been around for some years now, and no doubt there will be many more upright doubles in the near future.

Many curious plants deserve to be rare. Some curious doubles are widely appreciated in a particular market or climate, but are not acceptable to aesthetic traditions or cultural conditions elsewhere. And it is one of the fascinations of horticultural history to see how a plant that was selected and preserved by fastidious gardeners in one corner of the world may be taken up and developed in another. A love of curiosity is the hallmark of plantsmen and plantswomen everywhere.

Helleborus 'Mrs Betty Ranicar' has lots of extra sepals, brilliantly white with only a touch of green.

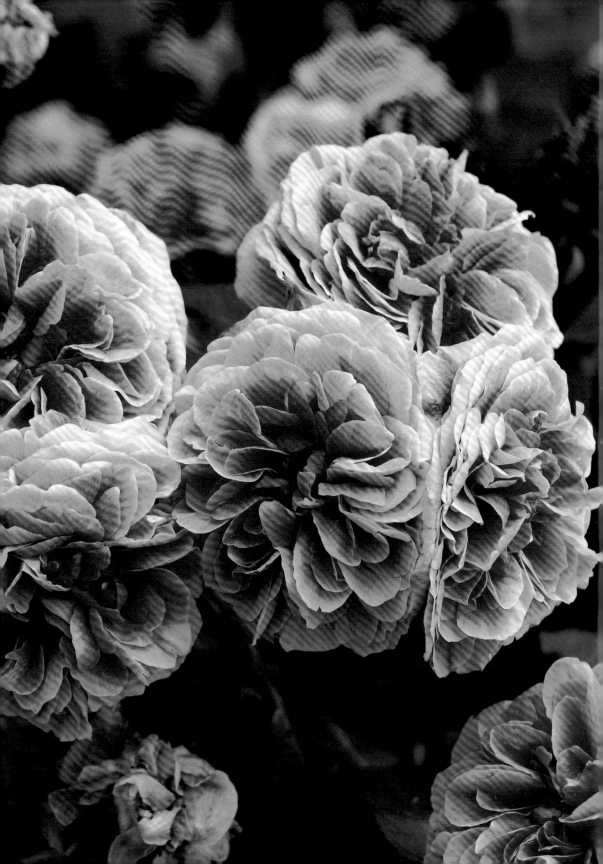

Epilogue

We tend to assume that many of the best plants in our gardens will have double flowers. Indeed, for many genera, the 'typical' flower we think of is a mass of petals. From earliest times, double flowers have usually been more highly valued than single. Whenever a new type of flowering plant has been introduced into cultivation and selected for improvement, the possession of double flowers is one of the qualities that nurserymen and plant breeders seek to inject. Forms with extra petals are no more difficult to grow in a garden than the original wild species, but they do give more solidity and colour to the composition, and last longer in flower.

It is clear throughout this book that gardeners and flower lovers owe a great debt to the Chinese and Japanese gardeners who developed so many garden varieties of native plants and gave us the formal shapes that remain ideals of beauty among such very different genera as chrysanthemums, roses and camellias. But it should not be overlooked that, in a similar way, the double flowers of dahlias and zinnias, two genera that come from the Americas, were developed in the West and acquired shapes that are as complex and formal as the flowers developed by Far Eastern gardeners.

Nevertheless, the deliberate hybridization of plants was seen for many centuries as an interference with the natural order that God created for the benefit of mankind. It was inherently sinful, and Thomas Fairchild, who made the first artificial cross in 1717 by pollinating a sweet william with a carnation, lived in fear of divine punishment. A century later, however, adventurous and curious botanists and nurserymen began to regard hybridization as a blessed opportunity to improve upon God's handiwork. The twentieth century brought an acceleration of plant breeding in response to the demand from defined markets like bedding plants and, as Nicola Ferguson anticipated at the end of the second chapter of this book, modern laboratory techniques have multiplied yet further the possibilities for the development of new floral forms.

Double flowers remain rare or completely unknown among several genera of horticultural importance. It would be pleasing to have double-flowered forms of such trees as catalpas and paulownias or, among shrubs, of weigelas, cestrums and ceanothus, and for lupins and foxgloves among herbaceous plants. And, though difficult to visualize, it is fair to anticipate the eventual development of orchids with double flowers. One hundred years hence, a book such as this would have many different plants to celebrate and, perhaps, many different ways in which to articulate their uses.

Rosa Gertrude Jekyll, consistently voted 'England's Favourite Rose', is also popular and successful in many other countries and climates.

Index

Page numbers in **bold** refer to illustrations.

Picture Credits

With the exception of those listed here, all the images in this book are in private collections or in the public domain. The publishers have made every effort to contact holders of copyright works. Any copyright holders we have been unable to reach are invited to contact the publishers so that a full acknowledgment may be given in subsequent editions. For permission to reproduce the images below, the publishers would like to thank the following:

Alamy Stock Photo: 25 (Garden World Images), 135 (Avalon/Photoshot License), 271 (Garden World Images)
L'Arboretum du Chêne-Vert: 262
Bakker Hillegom B.V.: 39
Paul Barney: 260
Baumschule Lorenz Von Ehren, Hamburg: 172
Tim Davis, International Waterlily Collection: 165
Mark Dwyer, Rotary Botanical Gardens, Wisconsin: 254
Ecclesbourne Valley Hardy Plants: 134
Juris Egle: 69
Garden World Images: 167 (N. Pasquel), 235 (Floramedia), 267 (Geoff du Feu)
Romain Gérard, Les Jardins d'Ewen: 142
Harku Valla Aiaselts, MTÜ, Estonia: 264
Jamie Harris: 277

Kelvin Harrison, Just Plants, Hastings, New Zealand: 84
Bernie Herron: 206
Kenneth Ingebretsen: 133
Gerry Kiffe, PlantMaster (www.plantmaster.com): 204
Nicholas Marshall, Dobbies Garden Centres: 178
Chris Martin: 200
Charles Quest-Ritson: 1, 2, 4/5, 8, 15, 22, 27, 29, 32, 33, 35, 47, 49, 55, 56, 57, 61, 62/3, 64, 66, 71, 77 below, 80, 86, 90/91, 92/3, 94/5, 98/9, 100, 103, 104, 105, 106, 108/9, 113, 114/5, 117, 119, 121, 122, 123, 127, 128, 129, 138, 139, 140, 144, 147, 148, 149, 150, 151, 155, 160/61, 163, 168/9, 170, 173, 176, 180, 182, 184/5, 187, 193, 195, 196/7, 199, 203, 207, 213, 214, 216, 219, 222, 225, 226, 227, 228/9, 231, 232, 249, 250, 253, 259, 265, 272, 273, 274/5, 278, 279, 281, 283, 284, 286, 296
The Royal Horticultural Society: 244
Southern Business Express (www.seedman.com): 42
Heidi Sund: 79 left
Sue Taylor: 211 right
© Victoria and Albert Museum, London: 97
VisionsPictures: 137, 158, 174, 257
Wikimedia Commons: 210 (photograph by Mike Peel www.mikepeel.net)
Woolmans Plants: 145
Iris Wright & Graham Mills: 50